STALIN'S FINAL FILMS

STALIN'S FINAL FILMS

Cinema, Socialist Realism, and Soviet
Postwar Reality, 1945–1953

Claire Knight

CORNELL UNIVERSITY PRESS ITHACA AND LONDON

First published 2024 by Cornell University Press

Library of Congress Cataloging-in-Publication Data

Names: Knight, Claire, 1980– author.
Title: Stalin's final films : cinema, socialist realism, and Soviet postwar reality, 1945–1953 / Claire Knight.
Description: Ithaca : Cornell University Press, 2024. | Includes bibliographical references and index.
Identifiers: LCCN 2023042164 (print) | LCCN 2023042165 (ebook) | ISBN 9781501776175 (hardcover) | ISBN 9781501776199 (epub) | ISBN 9781501776182 (pdf)
Subjects: LCSH: Stalin, Joseph, 1878-1953—Influence. | Motion pictures—Political aspects—Soviet Union. | Motion pictures—Censorship—Soviet Union. | Motion picture industry—Government policy—Soviet Union. | Motion picture industry—Soviet Union. | Communism and motion pictures—Soviet Union. | Socialist realism in motion pictures.
Classification: LCC PN1993.5.S65 K57 2024 (print) | LCC PN1993.5.S65 (ebook) | DDC 791.430947—dc23/eng/20231031
LC record available at https://lccn.loc.gov/2023042164
LC ebook record available at https://lccn.loc.gov/2023042165

To my dad, Graham

Contents

Figures

For more images relating to *Stalin's Final Films* and the Stalin cult in particular, please visit the author's website at https://claire-knight.com.

Acknowledgments

The existence of this book is testament to a great many people and institutions and the considerable support they offered over too many years to admit readily in polite company (the burgeoning gray hairs reveal all, however!). Underpinning the entire endeavor was the financial support of the Social Sciences and Humanities Research Council of Canada, the Benson & Carslaw Studentship at Emmanuel College, University of Cambridge, and the Cambridge Commonwealth Trust, without which I would not have undertaken the postgraduate research that formed the basis of this monograph. The same is also true of my supervisor, Emma Widdis, who took a major punt on an enthusiastic but naive history student who did not yet know a word of Russian. I am forever grateful for her faith in that foolhardy youth, as well as her wisdom and generosity over the years hence. Julian Graffy was the most stellar external examiner a student of Soviet cinema could hope for, and his input helped set that early draft on its way to becoming what I hope will now prove to be a decent book. His passion for and intricate knowledge of the topic continue to inspire!

I was able to revise and expand this monograph considerably in large part thanks to the support of St Antony's College, University of Oxford, and the Max Hayward Visiting Fellowship. It was an honor and pleasure to call the Russian and Eurasian Studies Centre home during 2016–17. From 2018 onward, the Department of Russian and Czech at the University of Bristol took on that role, providing a convivial environment in which to complete new chapters and polish off the project. Three cheers for the Three Musketeers and D'Artagnan! It has been a joy to work and teach with the UoB team.

I also wish to thank the archivists and staff at Gosfilmofond and RGASPI in Moscow for their assistance, including rushed photocopy orders and help with getting the reels properly loaded onto the monumental film viewing machines. On that note, also a word of heartfelt appreciation to Polly Jones and Alexander Titov for organizing the Russian Archives Training Scheme, which included a (really quite riveting) behind-the-scenes tour of both archives. This trip was absolutely formative and did an excellent job of equipping young researchers to navigate the world of Russian and Soviet archives. *Da zdravstvuiet* RATS!

For their eagle eyes and insightful feedback on far too many pages, I am indebted to Galina Mardilovich and Daniel Green, writing (and accountability) partners extraordinaire. They demonstrated firsthand the beauty of and necessity

for "socialist competition" when tackling the impossible task of becoming the author of a book. The baton is yours now! To comrades in arms Daniel Wolpert, Alexandra Vukovich, Muireann Maguire, Samantha Sherry, Daria Mattingly, and Allegra Funsten: thank you for inspiring me, teaching me, keeping me laughing and thinking alike, and expressing your enthusiasm for this project in those occasional moments when I could not. Finally, I am particularly grateful to Maria Belodubrovskaya for such a close and careful reading of the entire manuscript, and incisive feedback that strengthened this work to no end.

Last but by no means least, to my parents Shirley and Elliott Moncada, thank you for raising me to routinely bite off more than I can chew and, upon realizing it, just keep chewing. And to my parents Graham Knight and Maria DiCenzo, I hope you will consider this book part of your legacy as superlative academics with a skill for raising up the next generation of scholars!

Note on Transliteration, Film Titles, and Archival References

This book uses the Library of Congress (simplified) transliteration system, with two exceptions: first, names for which another anglicized form is well established, as with Beria, Tolstoy, Mayakovsky, Eisenstein, studio names without the soft sign (e.g., Mosfilm rather than Mosfil'm), and simplified bureau names (e.g., Politburo rather than Politbiuro); and second, when citing English-language publications of Russian origin that use a different transliteration system. Films are referenced using the most common English translation of the title. At the first mention of a film, the English title is followed by the transliterated Russian title, any English variant titles, the last name of the director, and the year of release rather than the year of production, since these dates often differed dramatically during the late Stalin era. The first reference to an archival repository gives the full name of the institution, after which point the acronym or short title is used. I have opted to separate the *fond* (collection), *opis* (inventory), *delo* (file), and *list* (page) with a forward slash rather than listing out the abbreviations for each level in the hierarchy, so rather than RGASPI f. 17, o. 132, d. 88, l. 2, the reference reads: RGASPI 17/132/88/2.

STALIN'S FINAL FILMS

INTRODUCTION

It was early summer in 1950, and Stalin was not pleased. He had just returned from vacation to find that the Minister of Cinema, Ivan Bol'shakov, had effectively approved a film for release without his consent. Although Bol'shakov screened the film for the leader without mentioning that licensing was underway, Stalin was wise to the ruse. As the film concluded, he turned to those gathered in his private Kremlin theater: "Here again you want to deceive me," he accused, "but it's impossible to fool me!" The room went silent, the air heavy with dread, as Stalin rose and headed for the door. Only a few years earlier, the top official in the cinema industry, Boris Shumiatskii, had been executed in the Stalinist purges, and purging was now progressing once again, with the cultural intelligentsia firmly in its sights. Cinema was risky business in the Soviet Union. But perhaps not on that day in 1950. As Stalin reached the doorway, he turned and addressed his audience: "Well," he paused dramatically, "you made the right decision!" With that, the fate of the film—and of Bol'shakov—was affirmed. Or was it?[1]

This anecdote encapsulates what was, on one level, the defining feature of the postwar Soviet film industry: its domination by a leader who asserted his authority as the ultimate arbiter of what Soviet audiences were permitted to see. It relates the near exception that proves the rule—the one instance after the war in which a domestic feature film almost reached screens without Stalin's prior approval, and

1. This anecdote comes from Bol'shakov's assistant and experienced film editor, Grigorii Mar'iamov, *Kremlevskii tsenzor: Stalin smotrit kino* (Moscow: Konfederatsiia soiuzov kinematografistov "Kinotsentr," 1992), 13–14.

the evidence that such a thing was impossible in the leader's final years. Stalin had always been invested in cinema, but his involvement in the medium intensified after the war. In these years, the development of the cinema industry was marked by a cultural purge that he instigated, dramatic policy reversals that he supported, and a tightening of censorship and centralization that ensured that all roads in the production process led to him, culminating in private screenings at the Kremlin or his dacha. Stalin's presence on screen was likewise magnified in these years, as the Stalin cult film came into its own as a genre and cinema took on a leading role in proliferating the cult, showcasing the new postwar iteration of a Stalin who had escaped the shadow of Lenin to stand alone as the architect of victory. Late Stalin-era Soviet cinema was fundamentally Stalinist.[2]

But this is only part of the story. Returning to the anecdote, the most intriguing facets of this tale lie beyond its narrative bounds, in what came before that harrowing moment in Stalin's Kremlin theater, and what came after. When we delve into why this situation arose in the first place and what actually happened to that film, it becomes clear that Stalinism was not the sole driving force of postwar cinema nor even necessarily always the most salient. Instead, there were other considerations at play that were equally formative for late Stalin-era cinema and that warrant reexamining a period of film history that has tended to be dismissed on account of its Stalinism.

Let us begin with the first question: Why, in this particular instance, did the Minister of Cinema break with his usual practice of consulting Stalin before approving a film for release? To answer this, we must consider the topic of the film and the calendar of Soviet holidays. The film, directed by Vsevolod Pudovkin, was a biography of Nikolai Zhukovskii, a pioneering scientist in hydro- and aerodynamics who was celebrated by the regime as a forefather of Soviet aviation and naval power. Meanwhile, July 16 was the Day of the Naval Air Fleet of the USSR—a celebration with which Zhukovskii came to be associated during the 1950s.[3] For maximum effect both ideologically and at the box office, the

2. This is the dominant lens through which late Stalin-era Soviet cinema has been analyzed in scholarship. See, for instance, Mira Liehm and Antonín Liehm, *The Most Important Art* (Berkeley: University of California Press, 1980), 70; Peter Kenez, *Cinema and Soviet Society, 1917–1953* (Cambridge: Cambridge University Press, 1992), 227, 243; Jay Leyda, *Kino: A History of the Russian and Soviet Film* (London: Allen and Unwin, 1960); Lilya Kaganovsky, "Stalinist Cinema 1928–1953," in *The Russian Cinema Reader*, vol. 1, *1908 to the Stalin Era*, ed. Rimgaila Salys (Boston: Academic Studies Press, 2013), 228; Tony Shaw and Denise Youngblood, *Cinematic Cold War: The American and Soviet Struggle for Hearts and Minds* (Lawrence: University Press of Kansas, 2010), 41; Ian Christie, "The Director in Soviet Cinema," in *Stalinism and Soviet Cinema*, ed. Derek Spring and Richard Taylor (New York: Routledge, 1993), 163; Evgenii Margolit, *Zhivye i mertvoe: Zametki k istorii sovetskogo kino 1920–1960s* (St. Petersburg: Masterskaia "Seans," 2012), 365.

3. The exact date of this holiday vacillated throughout the Soviet period between August and July but was celebrated on the third Sunday of July from 1946 to 1959. In Russia today, it is observed on the third Sunday of August. As confirmation of its date of observance in 1950, see A. Vasilevskii, "Prikaz Voennogo Ministra Soiuza SSR," *Stalinskii sokol*, July 16, 1950: 1.

premiere of Pudovkin's *Zhukovskii* needed to coincide with the union-wide holiday. Time was of the essence in order to maximize the viewership and ideological impact of this historical biographical film. Soviet film production was concerned not only with satisfying Stalin's preferences but also with engaging audiences and current events, for reasons both political and financial.[4] This tension between gaining Stalin's approval, on the one hand, and the need to serve audiences and disseminate official ideology in a timely manner, on the other, underlay the entire history of the Soviet film industry, including these years of peak Stalinism.

The fact that postwar Soviet cinema was not all about Stalin was made equally clear by what happened after that day in the Kremlin theater. As a result of Bol'shakov's break with unofficial protocol, the film was duplicated and distributed in time for the holiday, reaching screens on July 13, 1950—where it was a decided flop. Despite garnering a Stalin Prize of the second degree, the film did not do well enough at the box office to make the annual ranking of top feature films. The masses did not flock to see *Zhukovskii* that holiday weekend, and critics likewise ignored it. Pudovkin's film may have satisfied Spectator Number One, but not many others. At the end of the day, Stalin's endorsement was not enough to make *Zhukovskii* a success.

There is far more to the story of postwar Soviet cinema than the scenes in which Stalin played the starring role. The aim of this book is to bring these other plotlines into focus while also reexamining Stalin's role in cinema—both behind and before the camera—in order to highlight the depth that persisted in late Stalin-era films. This book is about much more than what its short title, *Stalin's Final Films*, conveys. It is also about socialist realism and the transformation of the official aesthetic that took place in these years as filmmakers sought to engage audiences and respond to popular demand. It is about Soviet postwar reality and how films both acknowledged and denied it, redefining history and lived experience in specific ways—often, but not always, in keeping with official ideology. This book is about a cinema that was Stalinist, yes, but also one that was distinctly postwar, unique in its expression of socialist realism and the positive hero, and, perhaps most surprisingly, popular. Let us consider each of these three defining features in turn.

A Cinema of Postwar Recovery

Late Stalin-era cinema has a reputation for retreating into the past. To avoid the difficulties of navigating censorship and risking the regime's approbation, it is

4. *Aktual'nost'*, or topicality, was one of the pillars of socialist realism, the official aesthetic of the USSR, and of official discourse more generally. It required intentional engagement with current events and, more to the point, party resolutions responding to contemporary circumstances.

said, filmmakers turned to the relative safety of the prerevolutionary period and to biographies of choice historical figures in particular. But this is a misconception. While it is true that there were more historical biographies produced after the war than ever before, they nevertheless accounted for only 17 of the 135 feature films released during Stalin's final years, or less than 13 percent of cinema production. Even including the handful of theatrical and literary adaptions, folktales, and fairy tales that were set outside of the Soviet period, it remains that the majority of postwar films were concerned with the contemporary world: they were set in the 1940s and 1950s.[5]

As such, late Stalin-era films were fundamentally postwar in nature. They were in constant dialogue with the legacies of the war and how it was won, with the practical and ideological crises and opportunities that it presented for both the regime and Soviet society. Rather than simply returning to the same priorities, themes, and aesthetic strategies as prewar cinema, Soviet films after the war were distinctive, being firmly rooted in their historical moment. They responded to the same kinds of issues that dominated other national postwar cinemas: social dislocation and alienation, physical destruction, economic breakdown, demographic crisis, and the loss of an ideological center. Yet while other, better-known postwar cinemas—German *trümmerfilm*, Italian neorealism, Japanese cinema under American censorship—express the zeitgeist of a defeated nation, Soviet postwar cinema responded to the destruction of war from the perspective of a victorious regime. Despite this distinction, the cinema of the victors was faced with the same practical challenges and ideological crises that confronted defeated nations.

As the cinema of victors, Soviet postwar films extended the wartime triumphs to the demobilized home front, resolving all war-related problems. Frequently, films accomplished this by modeling the state-determined process of recovery. This is true of the rural films, for instance, which exemplify economic and agricultural recovery through protagonists who put the regime's resolutions into practice. They amalgamate collective farms, construct hydroelectric power stations, and adopt cutting-edge technology and animal husbandry techniques to lead Soviet agriculture into a new era of abundance. Even more often, though, films solved the complex issues of demography, demobilization, and physical de-

5. The common misconception in scholarship of postwar cinema as consisting primarily of historical films likely derives from the Soviet regime itself. In April 1946, Stalin's right-hand man within the Central Committee, Andrei Zhdanov, accused filmmakers of fleeing from contemporary life at the cinema conference he organized at Stalin's behest (see chapter 1). In the coming months, this messaging was picked up by other officials as well, including Minister of Cinema Bol'shakov, and effectively laid the groundwork for Stalin's criticism and banning of Sergei Eisenstein's historical masterpiece, *Ivan the Terrible Part II*, in September 1946. For an interesting discussion of the connection between the regime's sudden hostility toward historical film in 1946 and *Ivan the Terrible Part II*, see Evgeny Dobrenko, *Late Stalinism: The Aesthetics of Politics*, trans. Jesse M. Savage (New Haven, CT: Yale University Press, 2020), 87–99.

struction by presenting an alternate reality: love triangles with one woman and two men in a context where women outnumbered men by more than two to one in the countryside; veterans integrating seamlessly into the villages that most never returned to, even when they did survive the front; abundant produce amid rationing and shortages; intergenerational harmony at a time when youth crime and disengagement were on the rise. Meanwhile, the complications of assimilating new lands and peoples into the USSR and neighboring states into the socialist sphere are smoothed over by an emphasis on brotherhood and shared political values. In other words, Soviet postwar cinema engages with the legacies of the war—the social, economic, and political consequences of occupation, destruction, death, and trauma—by depicting their resolution. This is the varnished reality that Nikita Khrushchev so criticized when condemning the cinema of late Stalinism. It is also not in the least surprising.

What is surprising, however, is that this varnished reality was more nuanced than might be expected. The lacquer applied by postwar cinema was pervasive but also pointed and precise. It was layered neither indiscriminately nor evenly across the canvas of postwar reality. Instead, films targeted specific issues, either resolving them implicitly or acknowledging problems more directly by having them serve as the challenges that are overcome by the protagonist. This book pays particular attention to what was varnished and in what ways and, in light of historical context, posits to what ends the lacquer was applied. It argues that, rather than being disconnected from history or wildly utopian, the cinema of Stalin's final years was future-oriented, postulating a perfected scenario that was nevertheless grounded in reality, however tenuously. The abundant harvests of cinematic farms were always the fruit of next year's planting, not this year's, and the advanced technology on screen really did exist, albeit only in prototype.

The varnishing or perfecting of reality in postwar films was rooted in the theme of recovery—from the war itself, but more so from the way in which it was won. During the conflict, the regime granted a number of concessions to liberal reform in order to facilitate the war effort, including measures like decentralization, devolution of authority to regional and industry heads, loosening censorship, and permitting traditional and nationalist values and symbols to displace Marxist-Leninist, Stalinist, and socialist realist discourse. Once victory was assured, the state began signaling to the public that, contrary to popular expectations, the reformist trend would not continue and liberal allowances would be rescinded.[6]

6. For discussions of wartime liberalization, see Jeffrey Brooks, "Pravda Goes to War," in *Culture and Entertainment in Wartime Russia*, ed. Richard Stites (Bloomington: Indiana University Press, 1995), 9–27; David Brandenberger, *National Bolshevism: Stalinist Mass Culture and the Formation of Modern Russian National Identity 1931–1956* (Cambridge, MA: Harvard University Press, 2002);

As a form of official communication, cinema was both a target and a tool of this reimposition of Stalinist strictures. That is to say, cinema was subjected to proscription, while also serving as a prescriptive voice directed toward Soviet society. This was a knife's edge on which filmmakers and industry personnel were accustomed to balancing, but one that attained a new degree of keenness in the context of postwar recovery. Thanks to rising ticket sales and expanded distribution after the war, cinema served as a pivotal means by which the official vision of postwar Soviet culture was promoted to the public. As a result, Soviet postwar film can be defined as a cinema of recovery.

The regime's bid to recover lost ground in political, ideological, and cultural terms hinged on addressing three urgent questions, each of which implicated a significant number of films and in fact preoccupied the majority of the films that topped the box office. The first of these questions concerned the definition of the war narrative itself and whom to credit for victory. This was complicated by the need to encourage continued mobilization—at least in a cultural, if not a military, sense—in light of the burgeoning Cold War. From the regime's perspective, the war narrative was ongoing and victory incomplete, making its representation on screen all the more challenging, particularly since popular perceptions did not necessarily align with the official view. The war films and spy thrillers dealt directly with this set of quandaries.

Equally pressing was the question of how to represent Stalin in the new era and reestablish his central position in Soviet ideology following his rather muted media presence during the war. Crucial to this project was the task of defining the leader's relationship with the Soviet people—they were, after all, the "other" in contrast to whom his image was delineated. Had the struggle for victory and its attainment affected the dynamic between Wise Father Stalin and his Soviet children in any way? The films that address this question most pointedly are the Stalin epics, that is, films in which Stalin himself was written into the script, and, more implicitly, the rural dramas and comedies that showcase the Stalin cult of the 1940s and early 1950s.

The final challenge to preoccupy Soviet cinema was the representation of everyday life after the war and recovery from the devastating conflict. Films explored postwar reality almost exclusively through narratives set in the countryside. This trend contrasted starkly with earlier cinema, which practically fetishized the journey from rural periphery to urban center as the path from

Nina Tumarkin, *The Living and the Dead: The Rise and Fall of the Cult of World War II in Russia* (New York: BasicBooks, 1994). For the reactionary turn after the war, see Elena Zubkova, *Russia after the War: Hopes, Illusions, and Disappointments, 1945–1957* (London: M. E. Sharpe, 1998); Mark Edele, *Soviet Veterans of World War II: A Popular Movement in an Authoritarian Society, 1941–1991* (Oxford: Oxford University Press, 2008); Mark Edele, "Soviet Veterans as an Entitlement Group, 1945–1955," *Slavic Review* 65, no. 1 (2006): 111–37.

ignorance to enlightenment and therefore the crux of the New Soviet Person's developmental arc. Postwar rural films reverse this journey, redefining typical Soviet life along the way and ensuring that rural films became a dominant genre in Soviet cinema. The collectivized countryside became the image of triumphant Soviet life in the era of victory.

The tightest, most rigorous system of censorship and centralization in the history of cinema to that point developed in part to facilitate the Soviet regime's response to these three vital issues: establishing the war narrative, defining the leadership of Stalin, and depicting postwar reality. Yet, the results were not the consistent, let alone cohesive, cinematic oeuvre that we might expect. This was particularly the case for war films, which spawned not one but two new genres in the quest to define the war narrative and its hero. Variety persisted in the Stalin cult and rural films as well, at times leading to incongruous and even conflicting imagery. In fact, the films usually considered most representative of the era, *The Fall of Berlin* and *Cossacks of the Kuban*, were far more the exception than the rule when it comes to postwar cinema. Postwar cinema remained dialogic, retaining a modicum of diversity and artistry amid the ideological artifice in its representation of the contemporary Soviet Union.

A Cinema in Search of a Postwar Positive Hero

It was not only the cost of war but also victory itself that posed its challenges for the regime, particularly in the realm of aesthetics and meaning making. Victory ushered in a crisis of completion for the official aesthetic, socialist realism, necessitating a fundamental redefinition of its core narrative elements. This was significant because, from its inception in 1934, socialist realism had served as not only a representational system but also an interpretive one, shaping the Soviet worldview. The function of the official aesthetic was not merely to present ideologically orthodox narratives and protagonists for popular consumption but to provide a framework by which Soviet audiences would conceptualize their own lives and the grand sweep of Soviet history. In this sense, a crisis in socialist realism challenged the very basis of official discourse.[7]

7. For more on the impetus of socialist realism to redefine reality, see Evgeny Dobrenko, *Political Economy of Socialist Realism* (New Haven, CT: Yale University Press, 2007). There is much debate among scholars as to whether Stalinist discourse (to which socialist realism is integral) genuinely shaped the perspectives and mindsets of Soviets or was simply adopted as a survival strategy. Either way, it remains that the regime sought to use the official aesthetic to fashion ideal New Soviet Men and Women. Key works in the subjectivity/identity debate include Stephen Kotkin, *Magnetic Mountain: Stalinism as a Civilization* (Berkeley: University of California Press, 1995); Jochen Hellbeck,

It is important to consider the historical rootedness of socialist realism before examining the implications of victory in 1945 for it and the regime. The official aesthetic was inaugurated at a time when the Soviet leadership was both undertaking to reconstruct reality and anticipating imminent, cataclysmic confrontation with the powers of world capitalism. Preparation for the impending conflict dominated policy making and shaped the mindset of the leadership, fueling the vigilance campaigns, Stalinist purges, and paramilitary fitness culture movement of the 1930s, while also wreaking havoc on foreign policy. It also informed socialist realism. While the paramilitary movement prepared the bodies of the Soviet people, socialist realism was intended to prepare their hearts and minds to build and protect socialism, readying them to brave the sacrifices to come.

Socialist realism did this by modeling the journey of the positive hero, a figure who stood in for every New Soviet Man and Woman, as he or she progressed from political ignorance to enlightenment. According to this narrative, individual and national development alike were predicated on the sacrifices of everyday Soviets as they confronted a continual stream of challenges and overcame them under the faithful tutelage of a seasoned political mentor. The result of such selfless perseverance was not only victory in the task at hand—be it constructive or defensive, and sometimes both—but also the positive hero's attainment of political maturity and the prestige that comes with it (the privilege of mentoring a younger worker, for example, or the freedom to have a bit of romance in life). This narrative arc was so foundational to socialist realism that Katerina Clark has dubbed it the master plot and identified it as the essence of the aesthetic.[8] In other words, rather than endorsing a particular style or even method of art, the official aesthetic was at its core a narrative structure—and one that was vital to conceptualizing Soviet identity and history.

Victory in the Great Patriotic War represented the ultimate, real-world fulfillment of the master plot. The conflict itself was the greatest challenge any Soviet hero could hope to encounter in either fiction or reality and served as the most fiery forge imaginable, testing and proving the political mettle of the Soviet people. Their victory in this dire test marked the narrative completion of

"Fashioning the Stalinist Soul: The Diary of Stepan Podlubnyi (1931–1939)," *Jahrbücher für Geschichte Osteuropas* 44, no. 3 (1996): 344–73; Sarah Davies, *Popular Opinion in Stalin's Russia: Terror, Propaganda, and Dissent, 1934–1941* (Cambridge: Cambridge University Press, 1997); Igal Halfin, *Terror in My Soul: Communist Autobiographies on Trial* (Cambridge, MA: Harvard University Press, 2003); Sheila Fitzpatrick, *Tear Off the Masks! Identity and Imposture in Twentieth-Century Russia* (Princeton, NJ: Princeton University Press, 2005); Jochen Hellbeck, *Revolution on My Mind* (Cambridge, MA: Harvard University Press, 2006); Timothy Johnston, *Being Soviet: Identity, Rumour, and Everyday Life under Stalin, 1939–1953* (Oxford: Oxford University Press, 2011).
 8. Katerina Clark, *The Soviet Novel: History as Ritual* (Chicago: University of Chicago Press, 1981), 6.

official Soviet discourse since the 1930s, and of all that the regime had prepared the New Soviet Men and Women to face and overcome. The master plot had been fulfilled. So what came next?

For a generation raised on the socialist realist master plot and encouraged to conflate its "revolutionary reality" with actual, historical reality, it was only natural to expect the same kind of rewarding outcome from their heroic wartime victory as that presented in the novels, films, and art of the official aesthetic. Social historians have long since documented the prevalence of such expectations and the ways in which they were voiced in the postwar period, with Elena Zubkova's pioneering work, *Russia after the War: Hopes, Illusions and Disappointments*, giving this phenomenon due recognition in its very title.[9] But what has not yet been explored are the implications of these expectations for the narrative that justified them in the first place, that is, the master plot of socialist realism. For alongside the well-known postwar cries for continued reform, decollectivization, and a loosening of censorship was also a call for the stories and heroes of socialist realism to reflect the newly achieved maturity of the Soviet people. What was needed was a sequel—the next installment to follow on from the classic narrative of socialist realism, and one that was suited to the new era of victory.

This call for the reconceptualization of socialist realism was raised by voices from across the social spectrum, bridging the divide between state and society that plagued other reformist agitation in the postwar USSR. It was a common feature of official discourse, appearing prominently in resolutions and speeches made by the regime's top propagandist, Andrei Zhdanov, for instance, throughout the cultural purges that bear his name, the Zhdanovshchina. "We have changed and matured," he explained, "together with those supreme transformations that have radically changed the face of our country." As such, he continued, writers must "demonstrate the new elevated quality of the Soviet people," while filmmakers, he later added, must respond to the fact that the "Soviet viewer has grown up."[10] This sentiment resounded within the film industry as well, with leading film director Ivan Pyr'ev, for example, observing that "in the 1920s and 1930s we shot many scenes of Soviet people. We understood the substance of these people, their internal world . . . and now, shooting scenes or looking at scenes of these comrades, it seems that our people of the years 1945–1946 are mentally older in many respects than the people of the 1930s."[11] This view even

9. Zubkova, *Russia after the War*.

10. A. A. Zhdanov, "Doklad t. Zhdanova o zhurnalakh 'Zvezda' i 'Leningrad,'" *Pravda*, September 21, 1946, 4; Andrei Artizov and Oleg Naumov, eds., *Vlast' i khudozhestvennaia intelligentsiia: Dokumenty TSK RKP(b)-VKP(b), VChK-OGPU-NKVD o kul'turnoi politike: 1917–1953 gg.* (Moscow: Demokratiia, 1999), 602.

11. Quoted in Zubkova, *Russia after the War*, 96. From an April 1946 meeting of the Central Committee.

permeated beyond the political and cultural elite, and among the general popu-lace as well, becoming a basic premise in the collective consciousness of post-war society. It is visible among midlevel apparatchiks or state functionaries, professionals, soldiers, collective farmers, and students, as well as in the letters sent to *Pravda* in response to Mikhail Chiaureli's film *The Fall of Berlin* and their strenuous critique of a positive hero who begins his journey in a state of imma-turity (see chapter 5). After 1945, the hard-won maturity of the victorious So-viet people demanded new heroes and new character arcs of the aesthetic that conceptualized Soviet reality. Socialist realism needed an upgrade.

Victory posed a fundamental question to socialist realism regarding the na-ture of the stories it told. In this way, it sparked a crisis of representation in an aesthetic that translated abstract ideology into accessible narratives for popular consumption. Now that the most daunting and highly anticipated challenge to Soviet existence had been overcome, what remained for the victorious hero to accomplish? What might the Soviet man and woman yet mature into? And most of all, how could the next stage of socialist development be fashioned into a fitting master plot if immaturity no longer provided the starting point, and preparation for war, the key rationale? Postwar films engaged diversely, yet consistently, with these questions and with the search for the follow-on story of the proven, politi-cally mature protagonist. The films of late Stalinism are threaded through not simply with pat answers to these dilemmas but also with failed attempts, dead ends, and, occasionally, rather surprising (if short-lived) successes. In this sense, postwar cinema was a pioneering cinema, in search of a new expression of so-cialist realism.

The Popular Cinema of Stalin's Final Years

In exploring the historical and aesthetic distinctiveness of late Stalin-era cin-ema, this book focuses on a specific type of film: popular cinema. Instead of of-fering a survey of the period, it privileges the films and genres that were popular among Soviet audiences and concentrates on the final, licensed version that hit the big screen rather than earlier iterations censored during production. Popular films are ostensibly the success stories of a regime that sought to shape the So-viet mindset through cultural production and engender the mass consumption of socialist realist media. What, then, did the regime convey through the films that audiences rendered popular, and how was this accomplished? Which films did Soviet viewers actually watch, and what might they have seen in them? By examining popular cinema specifically, we are able to assess the supposedly most

effective expressions of official discourse while also approaching the notoriously elusive question of audience reception.

But can we really speak of a popular cinema under Stalinism? After the war, cinema-going reached new heights, enabling several films to shatter the box office records established by the classics of the 1930s, including Stalin's favorite film, *Chapaev* (Vasil'ev and Vasil'ev, 1934). The statistics are impressive, yet, as every student of Soviet history knows well, they are also potentially misleading. Do box office rankings mean anything in a context where cinema is a nationalized industry; where the state oversees every aspect of production, distribution, and promotion; and where there is no market economy driving studio competition? It has been proposed that in the Soviet case, blockbusters were essentially manufactured through distribution policies and print runs. Added to this, relatively few Soviet feature films were released during Stalin's final years, totaling a mere 135 from January 1945 to March 1953, or an average of 16 per year. Such were the conditions under which, as the Soviet film critic Maya Turovskaya once quipped, it was conceivable that "everybody saw everything," meaning that ticket sales were a function of scarcity rather than popularity.[12]

Despite these circumstances, we can indeed speak of a popular cinema, for several reasons. To begin, it was not the state alone—or rather, Glavkinoprokat, the agency tasked with the duplication, distribution, and promotion of films— that determined screening practices. While it is true that the state assigned print runs and supplied film reels to cinema theaters, once those reels were in the hands of theater managers, the actual screening was up to them. And like theater managers the world over, they tended to pay attention to popular demand. The Soviet system may have lacked a capitalist-style market, but this did not mean that there was no interest in profitability. In fact, under the Soviet policy of cost accounting, or *khozraschet*, local managers across all industries were expected to balance their budgets, ensuring that their factory, shop, or theater remained economically viable.[13] For this reason, ticket sales mattered, and theater managers routinely resorted to classic marketing methods to maximize the number of bums on seats, from supplementing paltry official promotional materials with

12. Oksana Bulgakowa, "Kollektive Tagträume/Collective Daydreaming," in *Traumfabrik Kommunismus: Die visuelle Kultur der Stalinzeit/Dream Factory Communism: The Visual Culture of the Stalin Era*, ed. Boris Groys and Max Hollein (Frankfurt: Schirn Kunsthalle, 2003), 258; Evgeny Dobrenko, "Late Stalinist Cinema and the Cold War: An Equation without Unknowns," *Modern Language Review* 98, no. 4 (2003): 929; Maya Turovskaya, "The 1930s and 1940s: Cinema in Context," in *Stalinism and Soviet Cinema*, ed. Richard Taylor and Derek Spring (New York: Routledge, 1993), 42. All details on release rates are derived from Aleksandr Veniaminovich Macheret, ed., *Sovetskie khudozhestvennye fil'my: Annotirovannyi katalog*, vol. 2, *Zvukovye fil'my, 1930–1957* (Moscow: Iskusstvo, 1961).
13. In practice, this expectation was enforced inconsistently during Stalin's leadership, yet it remained a key principle of Stalinist economics in word if not always in deed.

handmade advertising, to adding extra screenings for crowd-pleasers in the morning or late at night, to dropping unpopular films from the lineup, regardless of how ideologically significant they may have been.[14]

Audiences likewise retained a modicum of agency when it came to ticket purchases, even during the worst of *malokartin'e*, the film shortage that plagued the latter half of the late Stalin era. Feature film release rates plummeted in 1949, with the result that sixteen of the ninety-nine months covered in this book passed without a single feature film premiere, while forty-one months offered only one new title.[15] Yet, cinemas did not screen only new Soviet features but also 1930s classics, popular science and other documentaries, foreign films, and eventually also cinematically filmed theater. Though the selection may have been meager, Soviet viewers did retain the capacity to choose.

And choose they did! This is made clear through a comparison of distribution rates and ticket sales.[16] The films of 1950 provide an apt case study, revealing that audiences ignored not only Pudovkin's *Zhukovskii* that year but other "ideologically significant" films as well, while demonstrating a clear preference for certain genres. Let us begin with the most ideologically significant film of the year, Chiaureli's Stalin epic, *The Fall of Berlin* (*Padenie Berlina*). The two-parter enjoyed by far the largest print run of any postwar film up to that point, with a total of 4,976 copies, easily outpacing the next-highest runs of 3,281 copies for another two-part Stalin war epic, *Battle of Stalingrad* (Petrov), from the previous year, and 3,521 copies for Sergei Gerasimov's two-part war film, *The Young Guard*, from the year before that. *The Fall of Berlin* was the most enthusiastically distributed film of the late Stalin period, with workers' clubs even being encouraged to arrange dedicated screenings. Yet, despite such clear advantages, the film placed only third at the box

14. These practices are detailed in letters of complaint, like the one found in the Russian State Archive for Social and Political History (RGASPI) from N. Mikhailov, the General Secretary of the Communist Youth League (Komsomol). Mikhailov lambastes theater managers from the far reaches of the USSR for these nefarious tactics, listing among the offenders cinemas from Moldova to Latvia, Kaliningrad to Altai, Tula to Tver, Kyiv and Simferopol' to Tbilisi, Gor'kii, Vladimir, Rostov, and Sverdlovsk, Vilnius and Tallin to Kaliningrad and Lviv, Riazan' to Voronezh and Stavropol', to name a few. Mikhailov took particular exception to the cinema "October," in Barnaul', Siberia, for privileging a handful of foreign films over the classic revolutionary drama *Lenin in 1918* (Romm, 1939) and Chiaureli's Stalin cult film *The Vow* (*Kliatva*, 1946), which screened for only two days and one day, respectively. See RGASPI 17/125/576/57-58.

15. Soviet audiences were provided with a choice of new feature releases for forty-two, or just under half, of the months between January 1945 and March 1953. For release dates of films, see Macheret, *Sovetskie khudozhestvennye fil'my*.

16. The key sources I rely on for this data are *Domashniaia sinemateka* by Zemlianukhin and Segida, and Sergei Kudriavtsev's *Kinanet* webpage, both of which are widely used within scholarship. I supplement these with the (rather sparse) archival material on distribution rates and patterns for the period held in RGASPI 17/125/576, 17/132/88, and 17/133/338. Sergei Zemlianukhin and Miroslava Segida, eds., *Domashniaia sinemateka: Otechestvennoe kino 1918–1996* (Moscow: Dubl'-D, 1996); Sergei Kudriavtsev, "Poseshchaemost' otechestvennykh i zarubezhnykh fil'mov v sovetskom kinoprokate," *Kinanet LiveJournal*, accessed February 4, 2014, http://kinanet.livejournal.com/689229.html.

office, with 38.5 million viewers. In comparison, *The Young Guard* took first place in 1948 with 79.1 million viewers, while *Battle of Stalingrad* did not even rank. This disparity alone between distribution rates and viewership is enough to challenge a straightforward correlation between state practices and box office results, but there is more. Rather than *The Fall of Berlin*, it was the comedy-adventure *The Brave Ones* (*Smelye liudi*, Iudin) that took first place in 1950, with 41.2 million viewers despite circulating in only 2,125 copies. Second place went to Ivan Pyr'ev's musical comedy *Cossacks of the Kuban* (*Kubanskie kazaki*), with 40.6 million viewers for 2,193 copies. Meanwhile, the 2,039 copies of the year's big-budget historical biography, *Musorgskii* (Roshal'), failed to attract enough viewers for the film to rank at the box office, while thrillers distributed in comparable numbers, *Secret Mission* (*Sekretnaia missiia*, Romm, 2,021 copies) and *Conspiracy of the Doomed* (*Zagovor obrechennykh*, Kalatozov, 2,027 copies), ranked fourth and seventh, respectively.[17] As these examples demonstrate, box office rankings were not simply a function of distribution; viewer selection was also decisive. For this reason, it is possible to discuss a "popular cinema" in the late Stalin period, using box office rankings as a general guide.

A clear pattern emerges when considering these popular films: they were overwhelmingly set during the 1940s or 1950s. They were contemporary films, depicting the battlegrounds, occupied lands, and command headquarters of the recent war, and the fields, villages, and collective farms of postwar recovery. They also included Chiaureli's trilogy of Stalin cult films (but not those made by other directors). Only one of the historical biographies ranked at the box office—Ihor Savchenko's ode to Ukrainian poet Taras Shevchenko—alongside a handful of literary and theatrical adaptations set before the Revolution, and several folktales and fairy tales. Instead, the popular cinema of Stalin's final years embraced the current day, navigating the narratives of wartime struggle and postwar recovery directly rather than through allegories proffered by the past. When purchasing their tickets, Soviet audiences chose to see their era, their life and times, on the big screen. This book seeks to explore what it was they saw—how state cinema depicted Soviet reality of the 1940s and 1950s.

Scholarly Contribution and Methodology

Stalin's Final Films is the first volume wholly dedicated to postwar Soviet cinema. It is positioned at the crossroads between key revisionist tendencies. On the one hand, there is the lively rethinking of early Stalinist cinema that began

17. RGASPI 17/133/338/152.

with the rediscovery of Stalinist musicals in the 1990s, but which has not yet extended to the postwar period.[18] On the other, there is the reconsideration of the late Stalin period that began with the 1990s generation of Russian social historians, carried over to the West, and has since spread to encompass the realms of political and economic history.[19] This book takes up the trailblazing work of both these revisionist undertakings and shifts the focus to a period of film studies and a sphere of history, namely cultural, that have yet to be treated in a comprehensive manner. As such, it seeks to expand and refine our understanding of both the cinema of the late Stalin years and the period itself, particularly with regard to official culture, socialist realism, and the regime's navigation of the political, ideological, and cultural legacies of the Great Patriotic War.

With regard to the official aesthetic, this book builds on the foundational work of Katerina Clark on the Soviet novel, relying on the framework that she popularized for analyzing the structure and characterization of socialist realist narratives, centering on the master plot and positive hero. This book distinguishes, however, between postwar socialist realism in literature, as discussed by Clark, and what was seen on screen. The transformation of socialist realism in postwar cinema was more far-reaching and involved greater experimentation than Clark found in the novels of the period. While postwar socialist realism is a rather baroque continuation of its earlier iteration for Clark, this book considers the late Stalin era to be a distinctive phase in the development of the official aesthetic. In this regard, it is in line with Evgeny Dobrenko's work on late Stalin-

18. Post-1945 films are rarely discussed in monographs dedicated to Stalin-era cinema, even when they focus on a specific director whose works spanned the entire period. Such is the case, for instance, with Salys's excellent volume on Grigorii Aleksandrov, whose *Spring* (*Vesna*, 1947) is not mentioned. Salys does, however, analyze the film in a more recent article. Indeed, in the past few years, individual films from the postwar period have begun to garner greater attention in journals, which is an encouraging and much warranted development. Rimgaila Salys, *The Musical Comedy Films of Grigorii Aleksandrov: Laughing Matters* (Chicago: University of Chicago Press, 2013); Rimgaila Salys, "Grigorii Aleksandrov's *Spring*: The Last Musical Hurrah," *Studies in Russian and Soviet Cinema* 12, no. 2 (2018): 114–35. A notable exception to this tendency is Anna Toropova's fantastic book on Stalinist cinema and emotions, which integrates postwar films into each chapter—and is all the richer for it! See Anna Toropova, *Feeling Revolution: Cinema, Genre, and the Politics of Affect under Stalin* (Oxford: Oxford University Press, 2020).

19. Key works in the new historiography of the late Stalin era include Zubkova, *Russia after the War*; Juliane Fürst, ed., *Late Stalinist Russia: Society between Reconstruction and Reinvention* (London: Routledge, 2006); Juliane Fürst, *Stalin's Last Generation: Soviet Post-war Youth and the Emergence of Mature Socialism* (Oxford: Oxford University Press, 2010); Mark Edele, "More Than Just Stalinists: The Political Sentiments of Victors 1945–1953," in *Late Stalinist Russia: Society between Reconstruction and Reinvention*, ed. Juliane Fürst (London: Routledge, 2006), 168–91; Mark Edele, *Stalinist Society, 1928–1953* (Oxford: Oxford University Press, 2011); Johnston, *Being Soviet*; Donald Filtzer, *Soviet Workers and Late Stalinism* (Cambridge: Cambridge University Press, 2002); Yoram Gorlizki and Oleg Khlevniuk, *Cold Peace: Stalin and the Soviet Ruling Circle, 1945–1953* (Oxford: Oxford University Press, 2005); Julie Hessler, *A Social History of Soviet Trade: Trade Policy, Retail Practices, and Consumption, 1917–1953* (Princeton, NJ: Princeton University Press, 2004).

ism and aesthetics, which calls attention to the uniqueness of postwar socialist realism. But whereas Dobrenko argues for a socialist realism that grew ever farther from reality and its audience as it aestheticized politics and culture to extreme ends, this book approaches socialist realism as a fundamentally historical phenomenon. It focuses on the relationship between the aesthetic and its contemporary context and considers postwar socialist realism to be in dialogue with both its audience and historic events, more so than ever. The distinction lies in the fact that where Dobrenko's work is concerned with the mechanisms of meaning making and how these transformed after the war, this book is interested in the meaning itself or the content of socialist realism, and the shifting definitions of two themes in particular: postwar reality and Soviet heroism.[20]

This book is also intended to bridge scholarly disciplines, namely, between history and film studies. It brings together historical contextualization with close reading in the manner adopted by film studies (and adapted from literary studies) to develop a historically activated reading of the cinematic text.[21] The goal of this approach is to identify and draw out the most significant themes and intriguing features of postwar cinema given the historical context in which it was fashioned and experienced by Soviet audiences. It is an attempt, then, to recapture a sense of the potential meanings and implications of these films when they were first screened. Much of the time, this involves casting light on the kinds of implications borne by a specific plot point or type of imagery that would have been obvious to contemporary viewers, but which may be easily overlooked by audiences today, either because they do not seem to be particularly noteworthy or because their distinct features have blurred into a sort of white noise that is deemed simply "Stalinist." This book interrogates what may often seem to be tired Stalinist rhetoric or clichés, revealing the hidden significance of details as mundane as discussions about clover planting and bovine grazing, the rank attained by demobilized veterans who are returning to village life, and the choreography of a teenage partisan's dance sequence as she entertains the Nazi occupiers. The meaning of these details may have been lost to the average viewer today, but they offer useful points of entry into the complex messaging these films engaged in.

20. Clark, *Soviet Novel*; Katerina Clark, "Socialist Realism with Shores: The Conventions for the Positive Hero," in *Socialist Realism without Shores*, ed. Thomas Lahusen and Evgeny Dobrenko (Durham, NC: Duke University Press, 1997), 27–50; Dobrenko, *Late Stalinism*.
21. With this term, I am adapting Janet Staiger's notion of historically activated readings of film reviews as a means of approaching the film texts themselves. See Janet Staiger, *Interpreting Films: Studies in the Historical Reception of American Cinema* (Princeton, NJ: Princeton University Press, 1992).

Chapter Overview

The structure of this book centers on the three categories of film that dominated the postwar box office: war films, Stalin epics, and rural comedies and dramas. Each of these genres (I use the term loosely) is treated in a pair of chapters, with the first chapter providing an analytical overview of key themes in evidence among all the popular films of the genre, and the second, a case study of the single, highest-ranked film. In other words, rather than being selected as exemplars of their genre, the case study films were chosen for their popularity, and each one is in fact exceptional rather than typical of its genre, if not within postwar cinema as a whole.

Chapter 1 establishes the context for the remainder of the book by providing an overview of film industry history during the years 1945 through to March 1953. Cinema was subjected to the regime's efforts to reestablish Stalinist orthodoxy and facilitate financial recovery from the war during these years, and subsequently became a vital means by which the official line on such matters was propagated. This made for a period of cinema history that was rife with internal tensions and conflicting practical, ideological, and economic priorities. The result was a series of dramatic policy reversals that distinguish this period from what had gone before.

Chapters 2 and 3 analyze the most popular type of cinema during these years: war films. Chapter 2 explores the ways in which these films responded to the need for an official narrative of Soviet victory and a clear definition of the form of heroism that made it possible. The discussion concentrates on three distinct categories of war film: the battle film, the Great Family film, and the spy thriller. Chapter 3 narrows the focus with a case study of Sergei Gerasimov's *The Young Guard* (1948)—a masterpiece in meaningful sound design. The film was censored exhaustively, yet it manages to explore the trauma of war on its own terms through its use of sound, silence, and song. This chapter argues for the subtle layers of meaning to be found in listening to postwar cinema with an ear for the more evanescent silences and "sound things" (as Gerasimov called them) that constitute the cinematic soundtrack.

Chapters 4 and 5 address the Stalin cult on screen—or rather its decisive return, since Stalin's image virtually disappeared from visual culture during the war. When he reappeared, he did so a changed man. Chapter 4 investigates this transformation and outlines the specifically postwar permutations of Stalin's image in film. Chapter 5 takes a closer look at the most infamous of the Stalin films, *The Fall of Berlin*, paying particular attention to its contemporary reception. Published reviews and archived viewers' letters from across the USSR reveal that audiences retained a sense of agency with regard to the film, voicing their criticism and suggesting edits and improvements to its representation of Stalin

and particularly the Soviet people. The result is a popular reading of the Stalin cult's most grandiose text that may come as rather a surprise to the film's twenty-first-century viewer.

Chapters 6 and 7 discuss films set in the countryside. Rural films came into their own after 1950, filling the void created by the retreat of war films from the screen. Chapter 6 posits that the main function of rural films was the symbolic reclamation of lands and people groups alienated by the war. Rural cinema also promoted a new iteration of the positive hero, now an experienced officer rather than a well-meaning but immature recruit, with a master plot adapted to suit his matured state. Chapter 7 is dedicated to Ivan Pyr'ev's controversial *Cossacks of the Kuban* and its images of abundance. Rural films are routinely identified as those most guilty of "varnishing reality," yet this is a misconception that can be traced back to Pyr'ev's unique musical. This chapter explores why the film deemed most typical of rural cinema—and the postwar period as a whole—was actually an exception, and how its fairy-tale take on the harvest came about.

Through a combination of overviews of popular genres and close reading of key films, this book seeks to enliven our sense of the most Stalinized of Stalinist cinema. It seeks to resurrect the era of Soviet cinema long considered dead in order that it may take up its place alongside the vibrant cinema of the 1930s, the evocative films of wartime, and the creative masterpieces of the Thaw era.[22] This is why each of the case studies adopts a differing approach to film analysis: to demonstrate the range of fruitful avenues for investigation available when approaching postwar cinema. Soviet cinema, as a form of official communication, consists of the intentional combination of potent visual imagery and sound in order to effect a desired response in the audience.[23] With this in mind, each of the three case study chapters focuses on one of these components—imagery, sound, or popular reception—revealing the riches that remain to be mined amid this neglected era of film history. The goal of this book, then, is nothing short of ensuring that the films of 1945–53 will no longer be given short shrift in monographs on Soviet cinema, university film courses, and cinematic retrospectives. It is my hope that it will entice new viewers to these films and inspire students and researchers alike to explore the final films of the Stalin era.

22. On the artistic death of Soviet cinema, see Kenez, *Cinema and Soviet Society*, 207.
23. Toropova, *Feeling Revolution*, 3–5.

THE POSTWAR CINEMA INDUSTRY, 1945–1953

In 1944, cinema returned to Moscow. Through the course of the year, the film industry made its way back to Leningrad and Kyiv too, crossing mountains and steppes from its temporary homes in Kazakhstan, Uzbekistan, and Tajikistan during wartime evacuation.[1] It was anything but a triumphant return, however. Film workers were greeted not by familiar sets and soundstages and a seamless transition back into prewar working groups but by broken-down buildings stripped of furnishings and fittings, and reduced ranks of cadres that cast into sharp relief the cost of supplying the war front with cinema personnel to chronicle victory. For the second time in five years, the industry was rebuilt from the ground up, only this time without the clarity of direction lent by the urgency of war. But this return to now unfamiliar home studios was not the end of the journey. Thanks to the victorious Red Army, Soviet cinema marched on even farther, beyond the heartland of the USSR to the freshly minted Baltic republics and studios in Tallinn, Riga, and Vilnius; and in 1946, yet farther still, across the Soviet border to Prague and the soundstages of the well-equipped Barrandov Studios.[2]

1. After a year of preparation, Mosfilm and Lenfilm returned to Moscow and Leningrad from their wartime evacuation base in Alma-Ata, Kazakhstan, in early 1944, thus dissolving the wartime merger that had produced the Tsentralnaia obedinennaia kinostudiia khudozhestvennykh filmov (Central United Film Studio or TsOKS). Kievskaia kinostudiia and Soiuzdetfilm followed suit by the end of the year, returning to Kyiv and Moscow from their respective temporary homes in Tashkent (Uzbekistan) and Stalinabad (Tajikistan).

2. In 1946, Mosfilm and Tbilisi Film Studio began using the state-of-the-art Barrandov Studios in Prague, filming there parts of *The Vow* (*Kliatva*, Chiaureli, 1946), *The Stone Flower* (*Kamennyi tsvetok*, Ptushko, 1946), *Spring* (*Vesna*, Aleksandrov, 1947), and *Tale of a Siberian Land* (*Skazanie o zemle Sibirskoi*, Pyr'ev, 1948). RGASPI 17/125/576/112.

This 3,500-mile journey, with its elements of return and departure, restoration and expansion, reclamation and co-option, was a foretaste of the tortuous path ahead for the film industry as it navigated the conflicting practical, ideological, and economic imperatives of the postwar landscape. The legacies of the war were not straightforward, meaning that cinema's peacetime development was anything but consistent. Instead, the history of the film industry in these years was fraught with conflict, contradiction, and tension, while yet being seasoned with innovation under unprecedented constraint. It was not a single-act tragedy at the hands of Stalin but rather a serial melodrama, rich in intrigue and rife with plot twists. It was a period rooted in paradox: while on the one hand, a devastated economy and the regime's ideological anxiety constricted the cinema industry relentlessly, on the other, the emergence of the USSR as a global superpower and the development of new film technologies compelled it to expand. Competing economic and ideological priorities multiplied the incongruities of film policy, as concerns for cost-effectiveness, profitability, ideological orthodoxy, and artistry proved frequently to pull in differing directions. As a result, the tale of the postwar Soviet cinema industry is anything but simplistic.

This chapter seeks to present the full drama of the period. So while it centers on the primary plotline of intensifying censorship and the resultant production slowdown and film famine, it also explores three lesser-known, pivotal subplots: the economics of film production, major policy reversals, and cinematic innovation. As will be shown, these three themes are closely related to censorship and the film famine, but by no means unambiguously, at times reinforcing the constrictive imperative of the period while, at others, offsetting or even alleviating it. When brought into focus, these three subplots enrich the story of the postwar film industry, revealing it to be a challenging yet nonetheless dynamic period for Soviet cinema.

1944–1946: Whither Soviet Cinema?

The return of Soviet film to Russia and Ukraine did not equate to the reinstatement of business as usual. Instead, it marked the beginning of a yearslong process of reconstruction suffused with shortages and rendered erratic by mixed messages from the Communist party leadership. In practical terms, the war had reduced the cinematic workforce to less than half its prewar standing, with only 49,400 of the former 104,800 film workers still employed in the industry by 1945 as directors, cinematographers, actors, set and costume designers, crew members, technicians, administrators, and film-related factory workers. The

state of film equipment was not much better since the manufacture of cinema-related goods had been suspended during the war, while countless cinematographers and their cameras had also perished at the front. When evacuated to Central Asia, studios had been established as little more than technical bases and were ill equipped to deal with the extreme weather conditions of their adopted locales. Film stock was scarce, particularly from late 1944 onward, when the remaining celluloid factories were either converted to the production of more valued commodities—agricultural machine parts—or crippled by disruptions in the electrical supply.[3]

Shortages plagued the screening of films as well. For instance, depleted celluloid stocks so limited the print runs for each new release that by December 1944 even the wartime average of four hundred copies per film was no longer feasible. Damage to theaters and projectors diminished the capacity for film showings even further, with the number of working projectors across the USSR in late 1945 being barely half of what it had been in 1941. The greatest losses were incurred in the countryside, where only 44 percent of projectors weathered the war, as opposed to 69 percent in urban areas. Sound projectors were hit particularly hard, with half surviving the conflict, but a significant proportion of those having been rendered mute due to the unavailability of parts and technicians to repair and operate them properly. Consequently, it was not just the cinemas located in formerly occupied territories that suffered from equipment losses. While occupied Ukraine and Belorussia lost 70 percent and 65 percent of their projectors, well-protected Azerbaijan and Kazakhstan still lost 57 percent and 55 percent, respectively.[4]

These challenges were exacerbated by the general state of scarcity and imbalance that typified the Soviet economy after four years of mobilization for the front. It was difficult not only to film and screen new features but also simply to stage them. The materials required for set construction were practically unsourceable for an industry that was effectively deprioritized in the campaign for postwar reconstruction. Despite the March 1944 resolution charging various commissariats with supplying the cinema committee in aid of film production, studios were still left scrambling.[5] Resolutions were one thing, but the capacity to fulfill them was quite another. What scant supplies of cement, lumber, plywood, nails, and paint remained in the USSR in 1945 were earmarked for rebuilding the more than 31,000 industrial enterprises, 1,700 cities and towns,

3. Natacha Laurent, *L'œil du Kremlin: Cinéma et censure en URSS sous Staline, 1928–1953* (Toulouse: Privat, 2000), 125.

4. Laurent, 126–27; Central Statistical Board of the USSR Council of Ministers, *Cultural Progress in the USSR: Statistical Returns* (Moscow: Foreign Languages Publishing House, 1958), 300–302; RGASPI 17/125/576/48. The RSFSR accumulated 42 percent losses.

5. Valerii Fomin, *Kino na voine: Dokumenty i svidetel'stva* (Moscow: Materik, 2005), 671.

and over 70,000 villages and hamlets destroyed by the conflict, not for render-ing a quaint village *bania* set for the camera.[6] Clothing and furniture were re-quired to dress and furnish a society that had survived the past four years with scarcely any light industry to speak of, not to outfit fictional communities. Ex-cept, of course, that filmmakers nevertheless *did* need to populate the socialist realist Soviet landscape with neatly dressed, well-housed partisans, veterans, and everyday heroes and heroines of labor.

Film studios therefore confronted the same conundrum that was taxing man-agers and industry heads in every sector: supplying for and completing tasks allocated by the center in the absence of sufficient financial and material provi-sion. And, like their counterparts in manufacturing, studio administrators quickly found a solution in the form of the black market. Film workers begged, borrowed, and bartered needed supplies from friends, family, and contacts while carpenters, costumers, and other skilled workers were paid in kind rather than currency. This led to the arrest and exile of no small number of industry work-ers following the enactment on June 4, 1947, of new petty theft laws under which bartering and exchange were considered theft. Similarly, subsequent charges of nepotism against numerous administrators regarding the employment of skilled personnel may well have stemmed from a partiality shown to crew members who could bring supplies as well as expertise to the job. Regardless, the film industry was left to self-finance both production (to some measure) and its own recon-struction (to an even greater extent). In the spirit of the centralized economy, a mere third of the revenue from screenings was fed back into the cinema indus-try, while the remaining two-thirds—amounting to 2 billion rubles in 1946, for instance—was transferred to Gosbank (the Soviet State Bank, or Gosudarstven-nyi bank SSSR) to subsidize recovery in higher-priority sectors.[7]

Nevertheless, the Committee for Cinema Affairs did manage to turn a sub-stantial profit in the early months of peace. Although the archival record fails to shed much light on how this came about, there are several possible contrib-uting factors, most of which relate to the rapid accommodation of Ivan Bol'shakov, the head of the committee and soon to be Minister of Cinema, to peacetime cir-cumstances. At the behest of Anastas Mikoian, commissar of foreign trade, Bol'shakov speedily reworked the pattern of film distribution, reallocating films previously circulated through the Red Army—which held film screenings at a reduced rate or even for free—to sectors wherein the audience paid full price, either at home in the Soviet Union or abroad. In fact, the USSR was the first of the Allies to begin screenings in Occupied Germany, with lucrative results. It

6. Melvyn Leffler, "The Cold War: What Do 'We Now Know'?," *American Historical Review* 104, no. 2 (1999): 513.

7. Laurent, *L'œil*, 193, 226.

also pursued an advantageous film exchange agreement with Britain, France, and the United States.[8]

The linchpin of cinematic solvency, however, was more likely the same factor that was key to the recovery of other industrial sectors: the requisitioning of property from recently acquired and occupied territories. The Red Army shipped hundreds of train carloads of manufactured goods (including film stock and cameras), raw materials, skilled personnel, and machinery back to the former home front in Ukraine and the Russian Soviet Federated Socialist Republic. Entire factories were relocated eastward from Germany to the Soviet heartland. By the end of 1946, the Soviet film industry was on the way to economic recovery despite its deprioritization and indeed exploitation in the state's reconstruction strategy.

This achievement was all the more noteworthy given the ambivalence of party directives on the political development of film in the early postwar years. Would the cautious concessions to liberalization granted during the war remain in place or perhaps even expand, or would they be quashed in the return to normalcy? Would the decentralization necessitated by wartime conditions persist, or would recentralization be swift and complete? Based on key film policies introduced during 1944–45, the Central Committee of the Communist Party seemed to be responding yes—on all counts.

The first of these cryptic developments was the formation of the Artistic Council of the Committee for Cinema Affairs in a series of reforms taken during August and September 1944.[9] This turn of events seemed to presage both vigorous recentralization and a surprising degree of liberalization in the censorship process. The new council was positioned to serve as the most centralized film censorship body yet organized, but it was also staffed overwhelmingly by filmmakers and other members of the artistic intelligentsia. The twenty-nine council members included nine directors: Grigorii Aleksandrov, Sergei Eisenstein, Sergei Gerasimov, Ivan Pyr'ev, Vsevolod Pudovkin, Mikhail Romm, Ihor Savchenko, Mikhail Chiaureli, and Sergei Vasil'ev. Several actors, writers, and composers, a cinematographer, a

8. Laurent, 126; Laurence Thaisy, *La politique cinématographique de la France en Allemagne occupée, 1945–1949* (Villeneuve-d'Ascq: Presses universitaires du Septentrion, 2006), 111–12.

9. The full title of this Artistic Council at its inception was the Khudozhestvennyi sovet komiteta po delam kinematografii. The Sovet narodnykh kommissarov SSSR (Sovnarkom) or Council of People's Commissars of the USSR was renamed the Sovet Ministrov SSSR (Sovmin) or Council of Ministers of the USSR on March 20, 1946, meaning that commissariats became ministries. At this point, the Komitet po delam kinematografii became the Ministerstvo kinematografii—a shift that was reflected in the full title of the Artistic Council. For more on the origins of the ministry's Artistic Council, see Natacha Laurent, "Le Conseil Artistique du Ministère Soviétique du Cinéma (1944–1947)," in *Le cinéma "stalinien": Questions d'histoire*, ed. Natacha Laurent (Toulouse: Presses universitaires du Mirail, 2003), 71–80; Maria Belodubrovskaya, *Not According to Plan: Filmmaking under Stalin* (Ithaca, NY: Cornell University Press, 2017), 104–5.

bureaucrat, and two Major Generals accounted for the rest.[10] Tasked initially with reviewing completed films, the Artistic Council was answerable directly to the Second Secretary of the Central Committee Andrei Zhdanov, and the Central Committee's Department of Agitation and Propaganda (Agitprop); it also presented its recommendations to the party's Politburo and Orgburo. In theory at least, this development introduced the capacity for more consistent, less idiosyncratic censorship than had hitherto been the case.

Added to this was another seeming indication of continued liberalization conveyed by the January 1945 release of Konstantin Iudin's *Four Hearts* (*Serdtsa chetyrekh*)—a film banned by Zhdanov in May 1941 for its frivolous depiction of Soviet military life. The rehabilitated romantic comedy was a relative hit at the box office, securing fifth place with 19.44 million Soviet viewers. It was subsequently the fourth film screened in Occupied Germany in June 1945 before becoming the Soviet representative in the formal Allied film exchange finalized in February 1946.[11] While its redeemed status was not advertised, its lingering on the shelf would have been known to any diligent reader of the Soviet magazine *Ogonek*, which published a laudatory review of *Four Hearts* in May 1941 prior to its disgrace. The film's tarnished past was known throughout the industry as well, since Iudin barely ceased petitioning the Central Committee and other authorities on behalf of his film from the moment of its rejection. With its licensing in 1945, the banned prewar film became a poster child for postwar Soviet cinema, both at home and abroad.

Together, these two developments in the practice of film censorship may have appeared to be harbingers of a more autonomous phase in cinematic production—but only if taken superficially. In reality, these decisions contained limitations and concealed motivations that undermined any inclination toward meaningful liberalization. The Artistic Council, despite appearing to return censorial authority to filmmakers, was not vested with the power to determine the fate of a single film. Instead, it was limited to making recommendations, with final decisions still belonging to higher authorities. Charged simply with "elevating the artistic and ideological level of fiction films," the Artistic Council members were left without a clear sense of their responsibilities and debated their own purpose

10. Specifically, the remaining twenty members consisted of actors B. A. Babochkin, N. K Cherkasov, B. P. Chirkov, A. D. Dikii (who occasionally played Stalin), N. P. Khmelev, and N. P. Okhlopkov; writers B. L. Gorbatov, L. S. Sobolev, K. M. Simonov, and N. S. Tikhonov, as well as secretary of the Writers' Union D. A. Polikarpov; Major Generals M. R. Galaktionov and N. A. Talenskii; composers T. N. Khrennikov, Iu. A. Shaporin, and D. D. Shostakovich; the artistic director of the Piatnitskii choir, V. G. Zakharov; cinematographer A. N. Moskvin; artist V. E. Egorov; and Bol'shakov as the chair. Fomin, *Kino na voine*, 430–36.

11. Jamie Miller, *Soviet Cinema: Politics and Persuasion under Stalin* (London: I. B. Tauris, 2010), 68–69, 135; Thaisy, *La politique cinématographique de la France en Allemagne occupée*, 112, 201.

as much as the films they were assigned to review.[12] What is more, by September 1946, it became clear that the Artistic Council's review of films served rather like an exam wherein the filmmakers who thought themselves in the position of examiners were in fact those under scrutiny, being appraised by the Central Committee as to their ability to identify political errors accurately and consistently (discussed further later in this chapter).

The release of *Four Hearts* was similarly restricted in its liberalizing implications. It did not serve as a precedent for the release of other banned films, nor did it augur the admission of greater lightheartedness into postwar film—in fact, the comedy genre struggled for survival during Stalin's final years, with another "frivolous" picture, Iulii Raizman's comedic adventure *The Train Goes East* (*Poezd idet na vostok*, 1948), being heavily criticized by censors and the press. Indeed, as Anna Toropova has shown, the Stalinist comedy was to face its demise in the postwar period, leaving the problem of Soviet laughter to subsequent generations of filmmakers.[13] Instead, the licensing and promotion of *Four Hearts* had much more to do with the specific contexts of domestic demobilization and the occupation of East and Central European territories than with changing attitudes toward entertainment and censorship. Before the war, Zhdanov had condemned the film for presenting the face of the Red Army as a Don Juan, an "attractive, fun-loving military who are busy courting and performing all kinds of services."[14] The world would judge Soviet power according to this film and, Zhdanov implied, find it to be lacking. This was a legitimate diplomatic concern in the wake of the Winter War debacle in Finland during 1939–40. Launched by the Soviets on a pretext and culminating in an embarrassing stalemate that the Western press dubbed a moral victory for the Finns, the Winter War endued the Red Army with a reputation for ineptitude and buffoonery. The comedic take on Soviet military life presented in *Four Hearts* threatened to confirm such dismissive assessments of the Red Army abroad, and possibly at home as well.[15]

By December 1944, however, the situation had changed. Allied victory was assured, and mounting tensions were threatening the frangible coalition. Nazi newsreels had distributed chilling images of the massacre of German civilians by the advancing Red Army, while rumors and reports of wide-scale rape perpetrated by Soviet soldiers against German women called into grave question

12. Laurent, "Le Conseil Artistique," 73.
13. RGASPI 17/132/88/26; Toropova, *Feeling Revolution*, 76–83.
14. Katerina Clark et al., *Soviet Culture and Power: A History in Documents, 1917–1953* (New Haven, CT: Yale University Press, 2007), 275. Eisenstein's notes on the meeting are reprinted in Bernard Eisenschitz, *Gels et dégels* (Paris: Centre Pompidou, 2002), 117–19.
15. Claire Knight, "The Making of the Soviet Ally in British Wartime Popular Press," *Journalism Studies* 14, no. 4 (2013): 476–90.

the image of the heroic, righteous Red Army man that had gained such traction in Allied media since June 1941. The British and American delegations were growing increasingly skeptical of Soviet intentions regarding the occupied territories, particularly Germany. The former "saviors of Europe" were now being seen in a more menacing light. In this context, the release of *Four Hearts* abroad becomes a strategic maneuver to help construct a pro-Soviet counternarrative amid burgeoning diplomatic and popular distrust. Meanwhile, at home, the silliness of the film fit neatly with other late wartime films, which laughed off the trauma of war as a lark and posited a smooth transition back to everyday life for the demobilized soldier, complete with romance and the performance of "all kinds of services" for the community.

1946–1947: The End of Equivocation

In April 1946, the political direction of postwar film development began to emerge more clearly. At this time, Zhdanov and Georgii F. Aleksandrov, a leading ideologue and head of Agitprop, were given three months to reassert ideological control over the arts on behalf of the Central Committee. This mandate followed hard on the heels of the renaming of the Committee for Cinema Affairs as the Ministry of Cinema, and—somewhat less auspiciously—a film production plan deemed "insufficient." As such, it is no wonder that the gaze of the two party leaders fell with particular heaviness on the cinema industry. On April 26, the pair hosted a conference of cinema professionals, ostensibly to seek their input on avoiding future failures. From this consultation, Zhdanov and Aleksandrov concluded that Soviet cinema was in decline in all areas: ideologically, artistically, and technically.

The two leaders initially adopted the familiar tactics of a redrafted production plan, administrative purging, and structural reorganization, but these proved ineffectual. Sterner measures were called for across the arts and not just cinema. At a meeting of the Orgburo on August 9, Stalin and Zhdanov determined to target the artistic intelligentsia more directly. The first part of the meeting was dedicated to literature and theater, and particularly to criticism of the journals *Zvezda* and *Leningrad* (and, more specifically, Anna Akhmatova and Mikhail Zoshchenko). The two writers were vilified for vapidity and vulgarity, while theater was accused of insufficient engagement with reality and distributing Western bourgeois propaganda. The remainder of the meeting, during which Stalin took the lead more explicitly, focused on cinema and condemned films by Leonid Lukov, Vsevolod Pudovkin, and Sergei Eisenstein. Over the coming

weeks, the Orgburo's criticisms were expanded and fashioned into three distinct resolutions targeting each artistic medium and launching the comprehensive cultural purge known as the Zhdanovshchina.[16]

The last of these three, the resolution of September 4, 1946, "On the film *The Great Life* [*Bol'shaia zhizn'*]," was dedicated to exposing the failures of the cinema industry. The document banned Lukov's *The Great Life* outright while chastising three more titles and admonishing film workers for their irresponsibility in producing such ideologically flawed works. *The Great Life* and Grigorii Kozintsev and Leonid Trauberg's *Simple People* were slated for treating the theme of postwar reconstruction in an insufficiently proletarian manner: characters in both films used their own hands and physical strength to rebuild infrastructure rather than the latest in machine technology. Eisenstein's *Ivan the Terrible Part II* likewise drew a little too close to Soviet reality, with its analogy between the indecisive tyrannical tsar and the current leadership veiled thinly enough to catch Stalin's notice. Only the fourth target, Pudovkin's *Admiral Nakhimov*, recovered from the fallout of the resolution, securing a screening license after significant editing and reshoots transformed the ebullient ballroom sequences from exemplars of "bourgeois frivolity" into forums for terse, ideological dialogue.[17]

The September 4 resolution unleashed a two-month wave of administrative purges, culminating in another resolution in December 1946 that tasked the Minister of Cinema with "rationalizing" film production. What is most interesting about this follow-up resolution is not so much its call for additional purges of ineffectual personnel, or the charge to further centralize decision-making, but rather the ultimatum it presented to Bol'shakov, who was threatened with dismissal should he fail to improve release rates and profit margins through his reforms. This is a telling injunction and is linked directly to the discussions that resulted in the September 4 film ban, during which Stalin underlined the financial losses incurred by the supposedly error-ridden productions. The implication was that such financial wastage needed to be prevented in the future, and

16. K. M. Anderson and L. V. Maksimenkov, *Kremlevskii kinoteatr: 1928–1953: Dokumenty* (Moscow: ROSSPEN, 2005), 747–51; François de Liencourt, "Le théâtre, le pouvoir et le spectateur soviétiques," *Cahiers du monde russe et soviétique* 2, no. 2 (1961): 187. In attendance at the initial August meeting of the Orgburo were thirty-six party officials as well as a handful of filmmakers, including Pyr'ev, Pudovkin, Chiaureli, and Kalatozov. As a result of the discussions, in addition to the bans in literature and film, plays by Somerset Maugham, Tristan Bernard, and other foreign playwrights were purged from the repertoires of Soviet theaters, and later, in early 1948 as the cultural campaign progressed, Vano Muradeli's opera *The Great Friendship* and a number of composers were also added to the blacklist.

17. Anderson and Maksimenkov, *Kremlevskii kinoteatr*, 763–67. See also Joan Neuberger, *This Thing of Darkness: Eisenstein's Ivan the Terrible in Stalin's Russia* (Ithaca, NY: Cornell University Press, 2019). For more on the generation of this resolution and Stalin's leading role in taking the cinema industry to task, see Dobrenko, *Late Stalinism*, 87–90, 128.

indeed, from this point onward, matters of economy gained greater salience in official discourse pertaining to the film industry.[18]

To this end, the December resolution posited increased centralization as a means of reducing costs and improving resource management. According to the preamble, unnecessary, erroneous, and deliberately falsified expenditures were endemic to the industry, which was also dogged by unproductivity as the central studios supposedly delayed or interrupted filming for much of the year and crowded the bulk of production into the final quarter, while studios in the republics simply languished.[19] Increased centralization was intended to correct such imbalances, while tighter censorship would not simply identify and excise errors—the Central Committee had proved itself fully capable of doing so without assistance on September 4—but rather identify and rectify them *earlier* in the process, before committing them to valuable film stock.

Such was the theory. In practice, the December 1946 reforms did not bear the anticipated financial fruit. Errors were not caught soon enough, and fixing them continued to prove costly. In a report submitted in May 1948, the head of the Ministry of State Control (Ministerstvo gosudarstvennogo kontrolia SSSR), Lev Mekhlis, detailed the alarming expenditures involved in vetting film productions. He calculated that in 1947, the rejection of thirteen screenplays and rewriting of two more represented losses of 720,000 rubles, while rewrites and consultants for the script of *Taras Shevchenko* (Savchenko, 1951) cost 126,000 rubles. Similarly, expenses for reshooting and reediting four Kiev Film Studio productions that same year amounted to 3 million rubles as several background actors were replaced at the request of the Artistic Council. Considering that the average film production ran to 4 or 5 million rubles at this time, it was clear from Mekhlis's report that intensified centralization and censorship had not resolved the preponderance of financial wastage in the film industry.[20]

A final resolution in April 1947 rounded out the regimen of reform initiated by the September 4, 1946, ban by remolding the Artistic Council into a more puissant tool of inspection. By this point, its remit had already been extended to vetting screenplays in order to catch errors earlier on.[21] The April 1947 reform ensured that the Artistic Council's responsibilities were entrusted to more politically

18. Stalin brought up expenditure at the outset of the Orgburo's discussion with Pyr'ev, Kalatozov, Lukov, Savchenko, and P. F. Nilin regarding *Bol'shaia zhizn'*, stating that the 4.7 million rubles allocated to the film was a lot of money. Kalatozov, who answered the leader's inquiry as to the budget, did not argue with his assessment. Anderson and Maksimenkov, *Kremlevskii kinoteatr*, 761. See also Anderson and Maksimenkov, 773–75; Laurent, *L'œil*, 196–97.

19. Anderson and Maksimenkov, *Kremlevskii kinoteatr*, 785–88; Laurent, *L'œil*, 228.

20. Laurent, *L'œil*, 230.

21. Anderson and Maksimenkov, *Kremlevskii kinoteatr*, 775–79.

reliable types and replaced members of the artistic intelligentsia with critics, editors, and functionaries from the Central Committee, Agitprop, and Komsomol, most of whom were party members. Four original members survived the reshuffle, none of them filmmakers, while Bol'shakov was rendered a silent member and was replaced as council head, first by Aleksandr Egolin, a literary critic and Deputy Chief of Agitprop, and subsequently, in January 1948, by Leonid Il'ichev, the editor of *Izvestiia* and a bitter opponent of Bol'shakov. At the same time, the purview of the reformed Artistic Council was extended even further to include all drafts of screenplays, rushes, budgeting, and, when deemed appropriate, aesthetic and technical features such as casting, set design, costumes, makeup, lighting, and props.[22]

Complementing the tightening of censorship for films in production was an attendant trend in promotion once a film was ready for release. After the war, the once prolific range of dedicated film periodicals was reduced to *Iskusstvo kino* (*Cinema Art*), which enjoyed a print run of approximately fifty thousand, but cinema news featured in a range of other publications as well. This changed after the newspaper *Vechernii Leningrad* (*Evening Leningrad*) printed an unfortunate still from Sergei Iutkevich's work-in-progress *Light over Russia* (*Svet nad Rossiei*) that depicted Lenin in a diminutive position in relation to the film's engineer hero. In response to this misstep, the party Sekretariat forestalled all future advance promotion of new films, as of October 4, 1947.[23] In practical terms, this meant that *Iskusstvo kino* could no longer publish a list of films in production at the beginning of each new calendar year, nor could the press even intimate that particular films were in production, although in late 1949 *Pravda* took to announcing when a film was under review for licensing by the Ministry of Cinema. Stills were rarely published after 1947, except from older films, bringing an end to *Iskusstvo kino*'s short-lived postwar venture as a glossy film magazine.[24]

The April 1947 resolution affected not only the film press, however, but also the General Directorate for the Mass Printing and Distribution of Films, or

22. Artizov and Naumov, *Vlast' i khudozhestvennaia intelligentsiia*, 620–21. In addition to heritage members Gorbatov, Zakharov, Leonov, and Galaktionov were added the previously mentioned Egolin and Il'ichev, as well as Agitprop officials Polikarp Lebedev (art department), V. P. Stepanov (film department), and E. N. Gorodetskii; the secretaries of the Central Committee of the Komsomol Nikolai Mikhailov and of the propaganda section of the Moscow city committee, N. N. Danilov; literary critics David Zaslavskii, Vladimir Shcherbina, and Vladimir Ermilov, who also edited *Literaturnaia gazeta*; as well as Aleksei Surkov, a writer and the editor of *Ogonek*, and Liudmila Dubrovina, head of children's literature publishing.

23. The film itself was ultimately shelved, officially for its inadequate depiction of Lenin. Dobrenko makes a compelling case that it was rather for taking Lenin as a primary subject in the first place, and not Stalin, that the film never saw the light of day. See Dobrenko, *Late Stalinism*, 124–25.

24. Josephine Woll, *Real Images: Soviet Cinema and the Thaw* (London: I. B. Tauris, 2000), 7; Anderson and Maksimenkov, *Kremlevskii kinoteatr*, 795. *Pravda* published only thirty-one notices of films under review, however, between late 1949 and the death of Stalin, and nineteen of those were for foreign films rather than domestic productions, so it was by no means a reliable advance notification system for Soviet film screenings.

Glavkinoprokat (Glavnoe upravlenie massovoi pechati i prokata kinofil'mov), further complicating its task of promoting films and cinema-going. Because films were only granted final approval days ahead of their premiere, it became close to impossible for Glavkinoprokat to produce a sufficient amount of high-quality publicity material for new films—let alone duplicate the film prints themselves, for which it was also responsible—and organize for their transport to its 108 regional offices in time for premieres. The organization of preview screenings became a distant memory, meaning that potential reviewers had to wait until the films were on general release in order to see them. Consequently, many films screened days and occasionally weeks before there was a hint of their existence in the press. Such restrictions hardly aided Glavkinoprokat or the Ministry of Cinema in their attempts to render cinema more profitable through effective film promotion. They were, however, conducive to ensuring the ideological soundness of all film-related printed materials, be they reviews, posters, or promotional postcards.[25]

And so it was that within twelve months of Stalin's commissioning of Zhdanov and Aleksandrov to restore the Central Committee's ideological control of the arts, Soviet cinema entered its most closely centralized and censored phase.

1948–1952: Film Famine

The results of the intensified inspection of film production came at a cost that would plague Stalin-era cinema to its final days: *malokartin'e*. The era of film famine took hold in earnest in 1949 and persisted until the death of Stalin. Prior to this point, film production rates had roughly maintained wartime levels, but this holding pattern ended abruptly in 1949, when the number of new Soviet-made feature films plummeted, reaching an all-time low of nine in 1951—three of which were made the previous year.[26] This sudden decline was the result of long-standing systemic problems, combined with a deliberate reduction of production rates in mid-1948. In short, the film famine was artificially induced. And like the much more devastating grain famines of the Stalin era, the primary causes of the film shortage remained unacknowledged at the time, as policies that undermined production were instead valorized as the means to ensure Soviet cinematic supremacy. This is

25. Laurent, *L'œil*, 212–213.

26. The war years saw an annual average of twenty-seven titles, with thirty-three in 1942, twenty-three in 1943, and twenty-four in 1944 even while the studios were in the process of relocating. Meanwhile, there were twenty-four new releases in 1945, eighteen in 1946, twenty-four in 1947, and twenty-two in 1948, followed by a precipitous drop in 1949 with twelve releases, thirteen in 1950, nine in 1951, and ten in 1952. These figures exclude filmed concerts and theatrical performances and are compiled from Macheret, *Sovetskie khudozhestvennye fil'my*.

not to say, however, that the problem was ignored completely but rather that official discussion of the industry's ailments never probed too deeply and was confined instead to relatively safe, superficial explanations.

Screenwriting: The Official Explanation

According to the official line, the slowdown in production was due to a severe shortage of decent scripts and screenwriters. In reality, this was hardly a new problem, being in fact endemic to the film industry throughout the Stalin period, as Maria Belodubrovskaya has shown in her compelling study, *Not According to Plan*. Nevertheless, it was the inadequate state of screenwriting that was bemoaned both publicly and behind closed doors at the Ministry of Cinema. The crisis in screenwriting was sufficiently acute after the war to warrant the Central Committee's consideration of soliciting screenplays from the public in open contests, while directors resorted to writing their own scripts with increasing frequency. The crisis was not, however, due to a lack of trained and willing individuals, as was often claimed. For, despite a desperate need for their expertise, by 1946 less than 10 percent of graduates from the screenwriting program at VGIK, the All-Union State Institute of Cinematography in Moscow, were working as screenwriters.[27] Instead, the heart of the problem was the unfeasibility of screenwriting as a profession. The particular bureaucratic and payment structures involved in screenwriting rendered it challenging at best for inexperienced writers to secure employment—a situation that only worsened as censorship tightened. This is because screenwriters were not employed in permanent posts as members of a film studio but instead worked according to contracts negotiated separately for each script, which were agreed on the basis of a synopsis. In other words, screenwriters worked on speculation. Once signed to a contract, they received a 25 percent advance on the contracted amount, which fell some-

27. For an analysis of the ideological and industrial roots of this problem, see chapter 4 of Belodubrovskaya, *Not According to Plan*. For public statements of concern, see, for example, the article "K novomu pod"emu sovetskogo kinoiskusstva," *Pravda*, 28 August 1952, 3, cited in Belodubrovskaya, 149. For complaints within the system, see RGASPI 17/125/467/71; 17/125/638/28-33; 17/132/427/74-75; 17/132/427/113-114. Shepilov and Egolin of Agitprop also identify the inability of new directorial talent to secure opportunities working on feature films as a considerable problem. Regarding contests, see, for example, RGASPI 17/132/427/78; Anderson and Maksimenkov, *Kremlevskii kinoteatr*, 909. This idea was bandied about and occasionally put into practice during the 1920s and 1930s (Belodubrovskaya, *Not According to Plan*, 61). Ivan Pyr'ev was one such director who wrote the initial draft of his own film's screenplay—for *Tale of a Siberian Land* (*Skazanie o zemle Sibirskoi*, 1948)—to near disastrous effect when he was accused of plagiarism by a veteran and amateur screenwriter. RGASPI 17/125/639/259-278. In terms of employment rates among screenwriting graduates, only seven out of eighty found work within the industry in 1946. In comparison, 82.5 percent of directorial graduates (143 out of 173) were employed in their chosen profession that year. RGASPI 17/125/467/72.

where between 30,000 and 80,000 rubles.[28] Yet, young writers found it difficult to procure what was essentially a substantial investment from cautious studio screenplay departments (or, following procedural changes in 1948, the Ministry of Cinema itself) that preferred to work with proven writers who had several films to their name, or "prestige" authors with credentials established in journalism, literature, poetry, or theater.[29] The remainder of the author's commission was paid in stages and relied on the script's successful navigation of a dense system of inspection, with an honorarium if and when the film was released. Few screenplays survived the rigorous review process. Official estimates in 1946 posited that one in three screenwriters could expect to attain final approval for a screenplay each year, but by 1947 this ratio was wildly optimistic. Of the sixty-three screenplays commissioned by studios that year, twenty-five were presented to the Ministry of Cinema, of which only ten met with approval, putting the success rate for contracted screenplays at 16 percent. What is more, there were roughly 150 screenwriters working at the time, meaning that less than 7 percent of writers boasted a successful screenplay that year.[30]

The delayed payment structure, contingent as it was on passing censorship, meant that writers could not make a steady living at screenwriting. Since average production times lengthened from several months to two or three years, even the most experienced and prolific screenwriters averaged only three successful scripts during the entire late Stalin era. Few recent graduates had the studio or Ministry connections and the financial cushion necessary to embark on such a risky career path.[31] As the realities of a career in screenwriting settled in, graduates instead

28. RGASPI 17/125/639/118-119. This figure was revised downward in 1951, when contracts for original screenplays was capped at 60,000 rubles, and for screenplays adapted from a novel, play, or other source, at 40,000 rubles RGASPI 17/133/338/148.

29. This was particularly the case after the war when, by 1946, the average age of screenwriters had climbed from thirty-three years in 1936 to forty-three years—a full two decades older than the average new VGIK graduate. This figure lends an air of legitimacy to concerns within the industry that new talent was not able to break into the screenwriting profession. Instead, the industry was simply aging up. RGASPI 17/125/467/72. On the ideologically motivated preference for "prestige" writers, see Belodubrovskaya, *Not According to Plan*, 159–63.

30. Laurent, *L'œil*, 230; RGASPI 17/125/467/71; RGASPI 17/125/639/119. Regarding honoraria, for films released in 200 copies, a further 50 percent of the original payment was awarded; for 300 copies, 75 percent; 500 copies, 100 percent; 1,000 copies, 150 percent; and more than 1,000 copies, 200 percent.

31. For instance, 75 percent of screenplays in development were immediately rejected in early 1948 when contracting changes came into effect. Kenez, *Cinema and Soviet Society*, 212. Among the most successful screenwriters of the period were Mariia Smirnova and Boris Chirskov, who each saw three of their scripts filmed and screened: Smirnova, with *The Village Teacher* (*Sel'skaia uchitel'nitsa*, Donskoi, 1947), *Story of a Real Man* (*Povest' o nastoiashchem cheloveke*, Stolper, 1948), and *The Country Doctor* (*Sel'skii vrach*, Gerasimov, 1952); and Chirskov with *The Great Turning Point* (*Velikii perelom*, Ermler, 1946), *The Invasion* (*Nashestvie*, Room, 1945), and *Cavalier of the Golden Star* (*Kavaler Zolotoi zvezdy*, also known as *Dream of a Cossack*, Raizman, 1951). The preference during these years was for single-authored screenplays (Belodubrovskaya, *Not According to Plan*, 160), but many screenwriters found success through collaboration, with the most proficient being Konstantin Isaev,

fled the profession, turning to the greater stability offered by posts that were cen-
trally assigned, like that of editor (that is, censor). Such positions had the added
benefit of training new screenwriters in the ways of censorship and equipping
them (theoretically) to avoid the delays of rewriting and rejection caused by "er-
rors" in scripting once they attempted to negotiate their first contract. In the
meantime, recent graduates found themselves implicated in vetting the work of
more experienced colleagues rather than the other way around—one of the great
ironies of Soviet film censorship.[32]

Censorship: The Unacknowledged Factor

Underlying the official reason for the film famine was the unspoken one: the
complex web of implications stemming from censorship. The problem was not
so much the outright banning of films, which happened only rarely.[33] Instead,
the issue was that increasingly rigorous censorship prolonged film production,
meaning that fewer and fewer films managed to complete the process. This is
largely because film censorship was not a stand-alone machine. It boasted no
equivalent to Glavlit, the centralized agency that oversaw literary censorship, but
was instead diffused throughout the cinema production system, fully embed-
ded within each stage of film development and consequently given to time-
consuming repetition. This meant that censors went by an array of job titles,
none of which was in fact "censor"—a term that is markedly absent from the ar-
chival record. Rather than censorship, the processes of scrutinizing, editing,
excising, demanding rewrites, and denying approval for screenplays and films

who collaborated on three of his five scripts: *The Scout's Feat* (*Podvig razvedchika*, Barnet, 1947),
Victorious Return (*Vozvrashchenie s pobedoi*, Ivanov, 1948), and *Secret Mission* (*Sekretnaia missiia*,
Romm, 1950). Isaev was the sole author of his final two scripts, *May Nights* (*Maiskaia noch', ili Uto-
plennitsa*, Rou, 1952) and *Sadko* (Ptushko, 1953). Evgenii Gabrilovich was equally prolific, cowriting
Our Heart (*Nashe serdtse*, Stolper, 1947) and *The Return of Vasilii Bortnikov* (*Vozvrashchenie Vasiliia
Bortnikova*, Pudovkin, 1953) and working with the directors for *In the Name of Life* (*Vo imia zhizni*,
Zarkhi and Kheifits, 1947). Indeed, the heavy involvement of directors in developing the final shoot-
ing script under what Belodubrovskaya has termed the "director-centered mode of production"
unique to the USSR meant that it was not unusual to credit the film's director as a coauthor (Belodu-
brovskaya, *Not According to Plan*, 91–92). Petr Pavlenko's scripts were particularly prone to this,
with all three of his postwar pieces being credited also to their directors: *The Vow* (*Kliatva*, Chiau-
reli, 1946), *The Fall of Berlin* (*Padenie Berlina I & II*, Chiaureli, 1950), and *Glinka* (*Kompozitor
Glinka*, also known as *Man of Music*, Aleksandrov, 1952), which was completed by Natal'ia Treneva
after Pavelenko's death in 1950. Tellingly, each of these five leading screenwriters was well estab-
lished before 1945, having already produced over twenty successful screenplays between them. For
screenwriting credits for Soviet films, see Macheret, *Sovetskie khudozhestvennye fil'my*.

32. RGASPI 17/125/467/72. For more on a screenwriter-turned-editor (censor), see Claire
Knight, "Nelli Morozova on Censors, Censorship and the Soviet Film Famine, 1948–52," *Slavonic
and East European Review* 96, no. 4 (2018): 704–30; Belodubrovskaya, *Not According to Plan*, 91, 142.

33. These were *Light over Russia* (*Svet nad Rossiei*, Iutkevich), *The Star* (*Zvezda*, Ivanov, 1953),
and *The Fires of Baku* (*Ogni Baku*, Zarkhi, Takhmasib, and Kheifits, 1958), in addition to the three
shelved in September 1946.

were considered part of film production, integral to achieving the mandate to create good films that Soviet audiences would enjoy, that is, films that were ideologically correct and artistically substantive, in addition to being well acted, shot, and edited, using the latest technology whenever possible (particularly color film stock). These were the elements that, it was believed, would ensure a film's popularity and therefore profitability at the box office. From the official perspective, the inspection and interference that effected censorship were framed in terms of the state's collaboration with filmmakers to produce what it deemed to be politically, aesthetically, and economically worthwhile cinema.

The foundations for the close scrutiny of cinema were well developed by the postwar period, though the bureaucratic structures that facilitated the tightest phase of Soviet film censorship were not finalized until 1947, following the year of rigorous restructuring and public chastisement discussed earlier. Despite the intent of streamlining film production, this season of reform multiplied the stages of censorship from nine in 1946 to "twelve or fourteen circles of hell" by mid-1947, as film editor and memoirist Nelli Morozova describes with a telling degree of nebulousness—not even those working in censorship were clear on what precisely it entailed! Five of these stages occurred at studio level, as first the editor, then the editorial council of the screenplay department, head of the screenplay department, artistic council of the studio, and director of the studio weighed in on the quality of the project. The process was then repeated at ministry level as the work was screened by the ministry's General Directorate, the Artistic Council's screenplay commission, and the Artistic Council itself, followed by the Deputy Minister and Minister of Cinema. The final word was shared between the Minister and the Artistic Council—at least officially. Stages would often be repeated several times before a project was released to the next step in production. According to a complaint letter sent to G. F. Aleksandrov from the secretariat of the Union of Writers, scripts were vetted twice over: first as a *literaturnyi stsenarii*, or dialogue script, then as a *rezhisserskii stsenarii*, or shooting script, complete with technical cues. At each level, anywhere from a single to over a dozen individuals added their input, frequently requiring comprehensive revisions before advancing to the next stage.[34]

Morozova's tally of the "circles of hell" in film production takes into account what were in reality unofficial checks, as studios continued to inspect scripts even after Bol'shakov streamlined studio-level censorship in keeping with the December 1946 resolution. This can be seen as another example of the institutional and individual self-preservation that had flourished in the film industry of the 1930s when unpredictable discipline from above exposed administrators to the

34. Nelli Morozova, "A sud'i—kto?," *Iskusstvo kino*, no. 1 (1994): 136; Laurent, *L'œil*, 175, 182.

constant risk of loss of life or livelihood. As Jamie Miller demonstrates, such a capricious work environment inspired bureaucrats to duplicate censorship unofficially and shrink from decisive decision-making, instead deferring responsibility to higher levels of administration. Both strategies were attempts to minimize the possibility of being in error and reaping the consequences.[35] This remained a valid concern during the cultural purges of the postwar period and helps to account for why Bol'shakov struggled to accomplish his assignment of "liquidating" excess stages of censorship in the studios. Meanwhile, at the higher reaches of the system, decision-making was fraught with arbitrariness as officials sought to anticipate the responses of their superiors (and one superior in particular!) to direct their input.

Morozova recounts just such an incident involving critic D. I. Zaslavskii, who led the Artistic Council in approving an adventure film that featured a "clever enemy." This villainous character presented a clear ideological paradox that should have earned the film immediate rejection. Morozova and her fellow editors identified the problem easily—the doctrine of Soviet superiority made it impossible to depict an intelligent foe, to the point of necessitating conflictlessness (*beskonfliktnost'*) in film plotting—and waited in anticipation for the fallout of Zaslavskii's erroneous approval. The mistake was caught and the film returned to the Artistic Council, whereupon Zaslavskii shamelessly blamed his young grandsons for his faulty ruling. They had watched the film with wide-eyed wonder, and he had seen it through their eyes rather than from his own more mature perspective, which, of course, he now expressed in rejecting the film without hesitation. It disappeared into oblivion. With this example, Morozova accounts for the unpredictability of censorship through the idiosyncratic approaches of individual censors, the pressure to conform to a critical perspective, and the challenges to filmmaking posed by ideological premises that, taken to their logical end, contradicted the basic building blocks of cinematic plotting.[36]

So far this discussion has concentrated on the official workings of the censorship system, but its informal machinations are equally pivotal for understanding the effects of censorship in slowing film production and limiting the number of titles approved for release in these years. The most well known of these informalities were the manifold unofficial stages of scrutiny, of which two in particular stand out, from near the end of the production process. Both were the domain of a formidable individual, the first being a virtual unknown (within scholarship at least), Lidiia Galameeva, who headed a "special sector" that perused each feature film following its conditional acceptance by the Artistic Council, before it passed

35. Laurent, *L'œil*, 230; Miller, *Soviet Cinema*, 5–26.
36. Morozova, "A sud'i—kto?," 137. Sadly, Morozova does not provide a title for this lost film.

on to the Minister of Cinema. Galameeva was known as Bol'shakov's Cerberus, the fearsome guard dog regulating access to the Minister of Cinema and what was officially the final stage of censorship—only officially, however, since in reality the last word lay with a second unofficial arbiter, Stalin.[37]

The Soviet leader's late night Kremlin film screenings are now a familiar feature of Soviet film histories, thanks to lively accounts from memoirs by Grigorii Mar'iamov, Nikita Khrushchev, and Stalin's daughter, Svetlana Allilueva. The practice began in the 1930s and intensified after the war, when a collection of over ten thousand foreign films captured by the Red Army (known as trophy films) broadened the possibilities for cinematic divertissement among the political elite. Film screenings became the standard *digestivo* to the elaborate feasts hosted most nights by Stalin, and it fell to the Minister of Cinema to provide an appropriate selection of titles. According to Morozova, Bol'shakov exploited this regular access to "the court" to aid in achieving his primary official responsibility as Minister of Cinema, namely, releasing new Soviet films. He would read Stalin's mood at the Kremlin screenings and, when the moment seemed opportune, bring out a new domestic production in hopes of eliciting that elusive final nod of approval so necessary for securing a screening license. Stalin's judgments were rarely straightforward (or even verbalized!), leaving Bol'shakov to determine precisely what was problematic to the critical eye of the ultimate censor. Often the verdict was based on an incomplete viewing, which further complicated the process of "correction." Added to this was the necessity of distinguishing between what Stalin did not enjoy personally, but nevertheless deemed fit for public screening, and what was not acceptable in either regard. Was that disgruntled noise from the leader politically significant or just an expression of his dislike of puns?[38] Occasionally, Bol'shakov would have to wait for Stalin to withdraw to his dacha in Sochi in order to find his disposition more amenable. The Minister coordinated his holidays with the leader so that he could arrange viewings at the dacha, and when the time seemed right, he would order a film awaiting approval to be flown in for Stalin's consideration. As a result, the final stage in the production process could reportedly take several months to half a

37. Morozova, 138, 143–44.
38. This example is for demonstration purposes only: as far as I am aware, Stalin expressed no enmity toward puns. He did, however, routinely approve films he did not like, as with Iudin's *The Train Goes East*, although it struggled to pass censorship and was panned in the Soviet press, perhaps coincidentally or perhaps not. Stalin also withheld approval for films that he enjoyed, albeit primarily foreign films, as with the Hollywood Westerns that were among the trophy film collection in significant numbers but which he deemed too dangerous for public consumption on ideological grounds. Only five were screened. On Iudin's film, see RGASPI 17/125/575/113; Mar'iamov, *Kremlevskii tsenzor*, 14; Toropova, *Feeling Revolution*, 79–82. On Hollywood Westerns, see Claire Knight, "Enemy Films on Soviet Screens: Trophy Films during the Early Cold War, 1947–52," *Kritika: Explorations in Russian and Eurasian History* 18, no. 1 (2017): 135.

year as Bol'shakov carefully chose his moment, leaving film directors to haunt the halls of the ministry in the meantime, hoping to overhear even the faintest whispers as to the fate of their films.[39]

Stalin's involvement in censorship may not have been defined in an official capacity, but it was central in practice, to the point where his presence was implied virtually throughout the filmmaking process. This was particularly the case during Il'ichev's tenure as the head of the Artistic Council, since he was a masterful dissembler, according to Morozova's account. Unlike the more direct Bol'shakov, Il'ichev skillfully eluded committing to a position on a film unless (and until) he was confident of Stalin's opinion. In this way, Stalin's reaction—both anticipated and actual—routinely shaped ministry-level decision-making and determined which films were viewed by Soviet audiences.[40] This does not mean, however, that the censorship machine was merely performative or reliant solely on the one who spoke the final word. For although authorities such as the Minister of Cinema and the Artistic Council were denied the ability to officially complete the censorship process and grant a screening license, they nevertheless retained the capacity to shape and reject film projects—a prerogative that was exercised thoroughly.

Further convoluting film censorship was the proclivity for continual interference by interested parties who, motivated by everything from budget problems to personal agendas, exploited informal and semiofficial connections in the attempt to influence the fates of individual films. Disregard for the established hierarchy of film production is in evidence throughout the archives of specific films and cinema policies. For instance, although studios were answerable to the state's Ministry of Cinema, records reveal that studio heads frequently appealed to the party's Agitprop department or Central Committee instead. Similarly, Ministries of Cinema in the republics appealed not just to the Ministry of Cinema for the USSR but also to the Council of Ministers of the USSR, the Council of Ministers for the Russian republic (an odd choice), and also the party's Central Committee and its individual members. Andrei Zhdanov, Georgii Malenkov, and Kliment Voroshilov received numerous personal appeals from lower-ranked party members and cinema workers requesting that they intervene in practically every aspect of the film industry, which they did, disrupting Bol'shakov repeatedly in his management of the Ministry of Cinema.[41] Following Zhdanov's death, Malenkov (acting on behalf of the Central Committee) consulted V. S. Kruzhkov in Agitprop and A. N. Sazonov in the Central Committee cinema department in addition to Bol'shakov on cinematic matters, often excit-

39. Mar'iamov, *Kremlevskii tsenzor*, 7–14; Morozova, "A sud'i—kto?," 139.
40. Morozova, "A sud'i—kto?," 138.
41. Multiple examples can be found in RGASPI 17/133/338.

ing contradictory recommendations and a flurry of memos, not to mention—reading between the lines—heated tempers.

These tendencies toward interference and forgoing bureaucratic protocol had proliferated since well before the war both in the cinema industry, as Joan Neuberger demonstrates in her ongoing research on creative networks, and throughout the Soviet system as a whole, as Nikolai Ssorin-Chaikov and Sheila Fitzpatrick reveal in their studies of patronage networks and appeals to the leadership.[42] The convolutions in postwar film censorship were therefore part of a broader Soviet bureaucratic trend. But the alacrity with which top officials interfered in cinema specifically must also be considered in light of the power struggle that absorbed the party leadership during Stalin's decline. Film was crucial to the political-ideological battleground of what Gorlizki has termed "party revivalism," with censorship and its ability to confirm the orthodoxy of a particular political stance proving a valuable tool.[43] The professional and personal animosity between Minister of Cinema Bol'shakov and members of Agitprop and the Central Committee—particularly G. F. Aleksandrov and Malenkov—not to mention the rivalry between Malenkov and Zhdanov in the early postwar period, help account for the propensity for one body to criticize, undermine, or circumvent another in the film production process.

The Masterpieces Policy: Deliberately Induced Film Famine

The peculiarities of censorship certainly exacerbated the postwar downturn in film production, aggravating the script shortage and drawing out the filming and editing process by years at a time. But the film famine was also instigated deliberately from above by the Politburo in its drastic revision of the 1948 production plan. Passed on June 14, 1948, this resolution canceled twelve features already in development and called for the immediate cessation of any filming that might be underway on them. It also announced that production rates would be reduced significantly from that point onward. "Better to have fewer but better films," it intoned, echoing Lenin's (generally neglected) axiom with regard to industrial production. Henceforth, the film industry would shift its priorities from quantity to quality. And with that, the founding principle of the Soviet cinema industry to outproduce Hollywood was abandoned. Rather than one hundred new features

42. Nikolai Ssorin-Chaikov, "On Heterochrony: Birthday Gifts to Stalin, 1949," *Journal of the Royal Anthropological Institute* 12, no. 2 (2006): 355–75; Sheila Fitzpatrick, *Everyday Stalinism: Ordinary Life in Extraordinary Times: Soviet Russia in the 1930s* (Oxford: Oxford University Press, 1999), 109–14.

43. Yoram Gorlizki, "Party Revivalism and the Death of Stalin," *Slavic Review* 54, no. 1 (1995): 1–22.

per year, the goal was lowered to approximately twenty-five, which translated into ten new films per year in practice, as fewer scripts were commissioned and projects approved for development. It was this policy that inaugurated the most intensive season of film famine. It also effectively made a virtue of systemic problems, rebranding low output as an intentional, ideologically justified strategy, and nullifying both the need and the recourse to address these issues in any meaningful way. The production plan of June 1948 was thus far more than a ratification of reality; it was a major turning point in Soviet film history.[44]

The official rationale for this dramatic policy shift was the will of the people. Supposedly, Soviet viewers were clamoring for films of higher ideological and artistic quality, and to satisfy this demand, the resolution proposed concentrating efforts and resources onto a modest number of masterpieces. This was almost certainly a pretext—and a rather nebulous one at that (a point that will be explored further later). Instead, as Belodubrovskaya points out, this "masterpieces policy" can be traced back to an outburst by Stalin over a draft of the 1948 film production plan. According to the memoirs of Deputy Chief of Agitprop Dmitrii Shepilov, who was serving as de facto chief during Zhdanov's decline, Stalin declared: "The Ministry of Cinema conducts incorrect policy in film production. . . . They want to make sixty films a year. We do not need this. This is incorrect policy. We need four or five features a year, but good ones, outstanding ones. . . . We should make fewer films, but good ones. Here, I am looking at the [1948] plan of film production. How much rubbish is planned here!"[45] Apparently, someone at the meeting took the hint and redrafted the plan, which was ratified three days later.

There is another element to the rationale provided by the resolution, however, that is neither ideological nor a matter of the leader's preferences, but rather financial. The preamble to the revised production plan defined the problem of ideologically and artistically weak films—the ones that were so disappointing to Soviet viewers—in economic terms, castigating them for their inability to recoup their expenses or turn a profit. The resolution proposed a twofold solution, combining impetuses of both budget keeping and profit making. The first measure, reducing the rate of film production, was essentially the culmination

44. Artizov and Naumov, *Vlast' i khudozhestvennaia intelligentsiia*, 635–37. The resolution excluded three more feature films from the approved film list, and a number of documentaries as well.

45. Translated and cited by Belodubrovskaya, *Not According to Plan*, 48. (Belodubrovskaya presents a fascinating account of the impact of Stalinist perfectionism on the cinema industry that in many ways culminated in the masterpieces policy.) See also Dmitrii Shepilov, "Vospominaniia," *Voprosy istorii* 5 (1998): 24–26. Morozova too credits the policy to Stalin, demonstrating at the very least that there was a common belief among industry workers that the leader was to account for the radically disruptive policy. Morozova, "A sud'i—kto?," 140.

of the steadily intensifying drive to preempt errors earlier in the production process to avoid wasted investments. With the masterpieces policy in effect, errors or "weaknesses" were spotted well before pen even touched page, let alone before light exposed the film stock, as the mandate for commissioning new productions was essentially halved. This represented tens of millions of rubles in prospective savings for the Ministry of Cinema budget, considering that the average black-and-white feature cost 4 to 5 million rubles, while more significant works required 8 to 10 million rubles.[46]

The second measure was concerned with ensuring profitability, and effectively limited productions to those that could be entrusted to the experienced hands of established directors. These proven professionals, it was assumed, made films that appealed more readily to audiences, while weak films were the result of inexperienced direction. In this sense, the masterpieces policy followed the logic of the blockbuster: good films sell tickets. Multiplying ticket sales was the most viable option for increasing the industry's revenue after the war, as other strategies were mooted with good reason: raising ticket prices risked dissuading viewers from attending the cinema; increased film distribution was impossible, given the persistent shortage of film stock; and the October 1947 directive minimizing press coverage prevented extensive promotion campaigns, apart from the most exceptional of circumstances, as with Chiaureli's ode to Stalin, *The Fall of Berlin*.[47] Attracting more viewers (and repeat views) was the surest way to increase profitability, which meant creating masterpieces.

It was a seemingly straightforward tactic but for the conundrum that lay at its heart: What constituted a good film? Apart from associating weak productions with inexperienced directors and poor box office results, the resolution itself offered little indication of what made a film into a masterpiece. No audience surveys were conducted to discern which genres or themes were popular among the viewing public. Instead, "better films" translated into more closely censored films (ensuring ideological quality) and greater use of advanced cinema technologies (improving the artistic quality). This was the era of color film and stereoscopic or 3D cinema. Although the development of color film stock had been

46. Laurent, *L'œil*, 171. Of course, production was already underway in the case of four feature films, and one was ultimately released, so the matter of reducing expenditures for 1948 at least was not so straightforward.

47. One of the advantages of the reduction in film production was the capacity to duplicate the "few films" in larger print runs. According to a report from 1952, every single film released in 1950 and 1951 (apart from four titles, which are not included in the list) was distributed in over 2,000 copies, a feat previously impossible even for the most ideologically and politically significant films. For the sake of comparison, the 1948 box office leader *The Young Guard*, despite selling more tickets than any other Soviet-made feature film throughout the late Stalin period, secured only 1,700 copies for Part I and 1,821 copies for Part II. RGASPI 17/133/338/152.

a pressing matter since the end of the war, it was not until the film famine that color pictures became common, and even dominant.[48] While only one or two color films at most were released annually during 1945–49, the rate jumped to between seven and nine per year once the masterpieces strategy was fully in effect, during 1950–52. Combined with the reduction in production, this meant that color films constituted nearly 54 percent of feature film releases in 1950, 100 percent in 1951, and 38 percent in 1952, holding steady at over 42 percent in 1953, with a Soviet record-breaking seventeen color films. Stereokino or stereoscopic (3D) film also continued to receive particular attention during the production slowdown, having been prioritized as early as 1945.[49] The first full-length feature, *Robinson Crusoe* (*Robinzon Kruzo*, Andrievskii), premiered in 1947, with two more releases in 1948, one the following year, and two in 1952—a genuine achievement in the context of *malokartin'e*.[50]

Overall, the masterpieces policy had an immediate and profound effect on the film industry. While it is possible that Stalin had this tactic in mind for a while before its introduction, he did not employ his usual methods of "dosage" or foreshadowing significant policy changes through incremental amendments or hints dropped in the press.[51] Zhdanov and other top officials, for instance, continued to stress the need for increased film production rates as late as January 1948. This meant that when the call for fewer films came, it was a shock. In her memoirs, Morozova likens the policy to an earthquake, spreading peril and panic throughout the hallways of studios and the Ministry of Cinema. Film workers flooded the ministry, guards neglected to check passes, men fainted and sobbed, and an ambulance stood at the ready in front of the ministry building as directors Aleksandr Dovzhenko and Lev Arnshtam suffered heart attacks. Film workers—assistant directors, camera operators, artists, production managers, and writers—found themselves out of work overnight as entire production wings within studios were closed and projects were abruptly shelved, practically in midshot. The sudden redirection from quantity production to mas-

48. A. S. Troshin, "Iz stenogrammy konferentsii po tsvetnomu kino," in *Istoriia otechestvennogo kino: Khrestomatiia* (Moscow: Kanon+, 2012), 378–82.

49. RGASPI 17/125/373/10-14.

50. Nikolai Mayorov, "A First in Cinema . . . Stereoscopic Films in Russia and the Soviet Union," *Studies in Russian and Soviet Cinema* 6, no. 2 (2012): 237–38. Even so, the Ministry of Cinema came under repeated fire from the press for not progressing more rapidly with the new format of cinema during 1946–49. RGASPI 17/125/467/92-139; 17/125/575/25-38; 17/132/426/145-189.

51. Belodubrovskaya, *Not According to Plan*, 47. For a discussion of the intermittent rumblings during the 1930s within the industry regarding the advantages of focusing on mastery rather than quantity, see Belodubrovskaya, 12–51. The term "dosage" is used by Sheila Fitzpatrick, who notes that Stalin routinely signaled upcoming policy changes or the replacement of a colleague by undermining them gradually in official decision-making and/or the press before replacing them. Sheila Fitzpatrick, *On Stalin's Team: The Years of Living Dangerously in Soviet Politics* (Princeton, NJ: Princeton University Press, 2015), 35–36.

terpieces was more than simply an admission of the existing state of the film industry, ratifying the reality of slowed production. Instead, it curtailed production abruptly, pushed people out of the industry, and escalated the perennial film shortage into outright famine.[52]

Casualties of the Film Famine: Two Case Studies

The turn to "fewer but better films" had immediate practical and conceptual implications that threw into sharp relief the paradox at the heart of the policy.[53] The production histories of two of the immediate casualties of the policy provide an apt illustration, as officials approached the question of determining quality from differing angles. Filming was already nearing completion for *The Girl from Natsikhvari* (*Devushka iz Natsikhvari*), directed by Nikoloz Sanishvili, when it was struck from the production plan, while Aleksandr Rou's adaptation of Pushkin's *Tale of Tsar Saltan* (*Skazka o tsare Saltane*) was well underway as a major production. A lively exchange among party and industry officials ensued in the weeks and months following the exclusion of these films from production, as petitions were submitted both to restore and abandon the projects. What is most illuminating about these case studies is the range of discourses used by officials in supporting their positions, all of which were in keeping with the priorities promoted by the masterpieces policy, while yet contradicting one another.

Tbilisi Film Studio had completed 90 percent of *The Girl from Natsikhvari* by the time it was excluded from the production plan. This crucial detail was unknown to the Politburo at the time, however, so when the cultural department of Agitprop learned of the wealth of existent footage some weeks later, it determined to review it. Deputy Chairman of the Council of Ministers Kliment Voroshilov oversaw this process for some unknown reason (his political portfolio was unrelated to cinema, though he was a well-known patron of the arts) and,

52. Morozova, "A sud'i—kto?," 140. The impact was still being felt in 1950, when Gor'kii studio employee S. T. Antipov wrote to Malenkov to sound a note of concern regarding the high rates of film workers who were unemployed and underemployed at the studio as a consequence of this policy. RGASPI 17/132/427/74-79.

53. The illuminating central thesis of Belodubrovskaya's *Not According to Plan* highlights the paradoxical nature of the masterpiece policy from a slightly different perspective, namely, that of cinema industry development. Belodubrovskaya points out that mastery in filmmaking comes through the process of making and learning from mistakes and an ensuing high volume of mediocre productions, rather than from strict adherence to perfectionism. By requiring every work to be flawless, the Stalinist approach to cinema closed off the surest avenue to improved film production, rendering the achievement of masterpieces that much more difficult. See Belodubrovskaya's chapter 1 in particular.

deeming the work to be ideologically and artistically inoffensive, recommended to Malenkov, the chairman of the Council of Ministers, that production resume. After all, 3 million rubles had already been invested, and the film's completion was projected to require only 414,000 rubles more. It was on these grounds and with the expectation of future royalties that Voroshilov argued successfully for the comedy's reinclusion in the plan, along with three others for which production had been suspended.[54]

Meanwhile, Candide Charkviani, First Secretary of the Georgian Communist Party, dispatched a telegram to Zhdanov on July 5 requesting that the Ministry of Cinema—with which Zhdanov had no official ties—require the film's cancellation since it had already run half a million rubles over budget and was interfering with the studio's ability to finance another project.[55] Zhdanov was ailing at the time and soon died, leaving the telegram to gather dust for some months before finally being transferred to the party Sekretariat on November 4. A week later, Agitprop confirmed to Malenkov that production had resumed. (The Ministry of Cinema was not consulted.) The archives are silent after this, but nearly a year later, on September 26, 1949, a new film depicting the joyful life of a collective tea plantation premiered in Tbilisi under the title *Fortunate Encounter* (*Schastlivaia vstrecha*), directed by Sanishvili. Following Georgian release, the film was dubbed at Gor'kii Film Studio and screened on limited release in Moscow. Although it is unclear who ultimately approved its completion, Stalin certainly must have winked his agreement at some point in August or September 1949, perhaps from the comfort of his dacha. With agencies representing party and state, All-Union and republic alike weighing in on this film, production took twenty-two months for local release and approximately two years for Russian-language screening—a typical production time for the period.[56]

Aleksandr Rou's *Tale of Tsar Saltan* underwent a similar journey, but with a negative outcome. After its initial exclusion from production, the fairy tale was reinstated in anticipation of future profits, thanks to Voroshilov's aforementioned intervention. The film's release was intended to coincide with the 150th anniversary of Pushkin's birth, and millions of rubles had already been invested in the ornate sets, costumes, and color film stock warranted by so culturally and politically significant a production. The project was 40 percent complete and required an additional investment of 3 million rubles—a reasonable figure considering the

54. RGASPI 17/132/88/64-65; 17/132/90/64-67.
55. RGASPI 17/132/90/10. This was *Keto i Kote* (Tabliashvili and Gedevanishvili), which experienced an even more fraught production history than Sanishvili's film, and did not see the light of projectors until 1953.
56. It is unclear as to precisely when production resumed again, but this was likely not until sometime after October 8. RGASPI 17/132/90/11, 62–63, 69. See also RGASPI 17/132/427/1-2. The film is now available on YouTube.

eminence of the production and its subject matter. As of November 1, however, filming had yet to recommence. Dismayed by this extended delay, screenwriter and Artistic Council member Boris Gorbatov addressed Malenkov with a request for filming to continue, providing several pages of detailed acclamation for the project by way of convincer. Malenkov conveyed the request to Bol'shakov, copying in the Sekretariat and D. T. Shepilov of Agitprop, whereupon Bol'shakov, who took the long view like Voroshilov, reinstated filming in anticipation of a revenue of 40 to 50 million rubles. Six weeks later, however, Shepilov and his colleague Pereslavtsev also replied to Malenkov, denigrating the existing footage for lack of poetry and general inartistry. Pushkin deserved better. The Agitprop officials also highlighted the production's failure to remain on budget and raised suspicions regarding Gorbatov's motivations: apparently his wife, Okunevskaia, held a lead role in the film—a detail that the Artistic Council member neglected to mention in his lengthy appeal. Shepilov and Pereslavtsev closed their indictment with the assurance that the footage was so poor that neither the Politburo nor the Council of Ministers need review it. Malenkov presumably sided with Shepilov and Pereslavtsev as the film was never completed.[57]

These case studies demonstrate two key tendencies in postwar film production, the first being the tendency to disregard bureaucratic protocol. Officials who were tangential at best to film production intervened in both productions in an attempt to influence their fate, while those who were ostensibly in authority (most pointedly, Bol'shakov) were ignored or cut out of the decision-making process. Although a clear structure on paper, film production was in practice reliant on informal networks and persuasive appeals rather than consistent procedure, even when it came to matters as seemingly straightforward as implementing a Politburo resolution to cancel a production.

The second tendency illustrated by these case studies was the growing prominence of economic discourse in decision-making, which added a new layer of complexity (and potential conflict) to the way industry priorities were conceptualized. Keeping to a strict budget and turning a profit often entailed opposing strategies, while competing approaches to assessing profitability also caused friction. On the one hand, Bol'shakov (and in the specific instances just described, also Voroshilov) favored the discourse of profitability over that of cost-effectiveness and operated under the assumption that any film screened in the USSR would produce a profit—a judgment that, in relation to the late Stalin era at least, generally proved accurate. Bol'shakov routinely recommended continued investment in productions under review, be it during Artistic Council discussions or in reports to the Central Committee. On the other hand, Central

57. RGASPI 17/132/90/71-73, 76-77; 17/132/70.

Committee and Agitprop representatives like Shepilov, Pereslavtsev, and, more prominently, Il'ichev, routinely advocated abandoning projects.[58] These party officials were more sensitive to budgets and considered profitability to be dependent on artistic and ideological quality, infusing the matter with a subjective element where Bol'shakov considered only arithmetic. This distinction between the Ministry of Cinema and party committees regarding the economics of film production mirrored their contrasting roles and agendas within the industry. The central purpose of the Ministry of Cinema was, after all, to release films, while Agitprop and the Central Committee were occupied primarily with ideological quality control. Although it is impossible to know whether economic considerations instigated particular decisions in film production or simply reinforced them, what is clear is that by the time the film famine set in, discussion of financial matters had become integral to both the decision-making process and the relationship between the Ministry of Cinema and the party committees to which it was accountable. Even under a command economy, there was no escaping the mighty ruble—even if only as a discursive tool.

In sum, the archival record of these two projects illustrates the way in which factors beyond the already elaborate censorship system further complicated the production process, including the supposed solution to the problem, the masterpieces policy. Also worth noting is the absence of Stalin from the discussions, demonstrating that although he crowned the censorship system, as it were, the most critical decisions were often made earlier in the process, without his involvement. In this sense, film production and censorship implicated far more than the eye of the Kremlin.

Innovative Cinema

Despite drastically reduced production rates, the quest to create profitable cinema was not wholly frustrated during the film famine. To the contrary, it was achieved to an unprecedented extent, with ticket sales reaching record-breaking levels by the early 1950s. More people in the Soviet Union were watching films than ever before. It is just that this accomplishment belonged not only to orthodox socialist realist fare but also to somewhat more unconventional productions. For it was during the film famine that two immensely popular new expressions of Soviet cinema emerged and managed to fill the coffers, helping to keep the film industry alive and positioning it for renewal once the production system

58. For the former, see, for example RGASPI 17/125/468/81-85. Bol'shakov stresses the need to be releasing films rather than holding them back for pointless reasons (l. 85). For the latter, see, for instance, RGASPI 17/132/90/74-77.

was eventually reformed. These were foreign films, both looted and legally im-
ported, and cinematically filmed theater productions.

Trophy Films and Legal Foreign Imports

In tandem with the masterpieces policy, a second major policy reversal was also
enacted in the summer of 1948, pertaining to the screening of foreign films. Al-
though the Soviet film industry had relied on foreign films to subsidize the de-
velopment of revolutionary cinema during the 1920s, film imports virtually
ceased in the early 1930s as the regime strove for autarky across all industries,
including cinema. From that point on, foreign films had numbered no more than
a handful per year and were approved on a case-by-case basis. The revised pro-
duction plan of 1948, however, changed all this and ushered in an era of rela-
tively extensive foreign film screening. The plan, approved in mid-June 1948,
commissioned the processing of six foreign films as part of the official strategy
for the development of Soviet cinema, in what was a highly unusual and possi-
bly unique mention of non-Soviet films in a production plan. That this reversal
of approach to foreign films coincided with the advent of the "fewer but better
films" strategy implies that the Central Committee appreciated the risks of the
masterpieces policy in leaving Soviet audiences hungry for films and curtailing
box office earnings—a likelihood only confirmed by the subsequent resolution
on August 31, 1948, approving an additional fifty foreign films for processing
and release on Soviet screens.

These particular foreign films were distinct from those that had come before
in that they were not legally imported; rather, they were *trofeinye*, or captured
films, taken as war booty by the Red Army from archives in Germany and East
Europe. These trophy films, as they are most commonly known, consisted pre-
dominantly of 1930s Hollywood and 1940s German Universum Film Aktienge-
sellschaft (UFA) films, with a sizable collection from France as well, and titles
from twenty-five more countries.[59] Initially, the trophy film collection was con-
ceived purely as a teaching aid for VGIK and a source of entertainment for Krem-
lin elites. But in late 1946, the experiment in releasing these unlicensed films
began, as two German musicals were screened, followed by four more American
and German trophies in 1947. This muted release pattern was in keeping with the
method by which foreign imports had been handled throughout the 1930s and
1940s, serving as a modest supplement to domestic productions and mainly
taken from the popular genres of comedy, musical, and adventure. The revised

59. Claire Knight, "Stalin's Trophy Films, 1946–56: A Resource (Updated)," *KinoKultura*,
no. 56 (April 2017), http://www.kinokultura.com/2015/48-knight.shtml.

production plan for 1948 likewise approved a mere half dozen more films for release, meaning that the decision a few weeks later to release fifty trophy films over the next eighteen months marked a dramatic break with established practice.

Although sudden, the decision to flood Soviet screens with foreign films was by no means irreconcilable with the regime's economic and ideological priorities for the postwar cinema industry. The financial benefits of screening unlicensed films are clear, even if Hollywood films had to be confined to the closed network of workers' clubs and houses of culture (*na zakrytyi ekran*), so as not to call international attention to what amounted to their illegal distribution. German films of the Nazi era were fair game for public screening (*na shirokii ekran*), since the licensing institutions for these films had not survived the war—at least not as such. There were some costs involved in processing the films of course, to cover editing, copying, subtitling the Hollywood films, and dubbing the German ones. Even so, in early August, Bol'shakov estimated that trophies circulated on the closed network would garner 35 to 40 million rubles in profit apiece, while the publicly screened films would average 50 to 60 million rubles. Based on this estimate, the Minister of Cinema was held personally accountable by the August 31 resolution on trophy film release for guaranteeing a total profit of 750 million rubles from the venture—a tidy little nest egg for Gosbank.[60]

The decision to release trophy films was also in keeping with Soviet ideology, and specifically with the regime's approach to the cultural front of the Cold War. Trophy films were carefully selected from a pool of 10,669 titles with two briefs in mind: first, they were chosen for their potential compatibility with the Soviet worldview, as with historical films about European revolutions, Nazi anti-British and anticolonial films, and Great Depression–era Hollywood films that critiqued capitalism and revealed the social ills haunting America. What better way to critique the Cold War enemy than through their own films?[61] Second were the films chosen for their entertainment and educational value, particularly musical comedies, literary adaptations, and historical biographies of key European cultural figures. These were considered to be apolitical—perhaps misguidedly so, given the vaunted place that musical comedies in particular held for many of the younger generation who subsequently became dissidents. Nevertheless, these "apolitical" entertainment films, with their grand historical sweep, cultural cachet, and technical and artistic excellence, fed into the discourse around Soviet socialist realism as a world culture, capable of assimilating and mobilizing the crowning achievements of human creativity to its own purposes,

60. RGASPI 17/132/92/5; Artizov and Naumov, *Vlast' i khudozhestvennaia intelligentsiia*, 639–40; Laurent, *L'œil*, 236.
61. RGASPI 17/132/429/55.

or what Katerina Clark has termed the "Great Appropriation."[62] In both cases, whether selected for political or cultural value, trophy films were censored closely, while many featured introductory captions that put a distinctly Soviet spin on what viewers were about to see, as with *Tarzan*, where the eponymous ape man was transformed into a socialist realist positive hero in the spontaneous stage of political development: "Tarzan, as a man unspoiled by bourgeois civilization, opposes himself to the cruel and greedy American and British business dealers."[63] In this way, trophy films were thoroughly censored and repackaged for Soviet audiences, effectively transforming them into Soviet adaptations fit for the Cold War.[64]

Thanks to the approval of another twenty-five releases in 1949, Sovietized trophy films dominated the influx of foreign films until 1951. At this point, however, during the nadir of the film famine, licensed imports began to replace trophies. These films hailed from the newly nationalized cinemas of Hungary and Czechoslovakia and from filmmakers in Austria, Italy, and France who were sympathetic to the socialist cause. Such films were amenable to the Soviet worldview and were even often made according to socialist realist (or compatible) conventions, though even so, they were carefully censored at the Gor'kii film studio, just as trophies were. In terms of release rates for foreign films, from 1948 to 1952, trophy films screened at a rate of 1.4 per domestic production, outnumbering Soviet-made films ninety-three to sixty-five, with twelve trophies ranking at the box office, and the remainder bearing more modest results. Meanwhile, from 1951 to 1952, ten licensed imports ranked at the box office, attracting just over half as many tickets sales as new Soviet titles. In 1952, in the wake of the worst year of the film famine, foreign trophy and import films together accounted for 80.7 percent of ticket sales. It was one of the *Tarzan* films released that year that sold the greatest number of tickets during Stalin's final eight years, reaching 42.9 million to edge out the top Soviet-made contender, *The Young Guard Part II*, by half a million. In short, foreign films, both licensed and looted, played a pivotal role in keeping cinema alive as a viable industry through the worst of *malokartin'e*.[65]

62. Katerina Clark, *Moscow, the Fourth Rome: Stalinism, Cosmopolitanism, and the Evolution of Soviet Culture, 1931–1941* (Cambridge, MA: Harvard University Press, 2011), 8, 22–23.

63. Archive of the President of the Russian Federation (APRF) 3/35/74/90-94, reprinted in Irina Kondakova, "Tarzan—chelovek, ne isporchennyi burzhuaznoi tsivilizatsiei," *Istochnik* 4 (1999): 100–1.

64. For more on the censorship of trophy films and how they aligned with Soviet Cold War ideology, see Knight, "Enemy Films on Soviet Screens."

65. For more on the specific statistical breakdown of the trophy film collection and screening practices, see Knight, "Stalin's Trophy Films." See also, particularly for licensed foreign imports, Kudriavtsev, "Poseshchaemost' otechestvennykh i zarubezhnykh fil'mov v sovetskom kinoprokate."

Cinematically Filmed Theater

Fortifying the flood of foreign films was a new type of production, the *fil'm-spektakl'* or cinematically filmed theatrical performance. In fact, it was a *spektakl'* released just days after Stalin's death, *Liubov' Iarovaia* (Frid), that outsold every film of the period, foreign or domestic, even outpacing *Tarzan* by a cool 3.5 million for a total of 46.4 million tickets sold. Pioneered in 1951, cinematically filmed theater took advantage of a rich repository of established artistic production, capturing popular performances from the leading theaters of the Soviet Union. *Fil'my-spektakli* played a critical role in sustaining the Soviet cinema industry in both economic and practical terms during *malokartin'e* and positioning it in readiness for the moment when strictures would finally be eased.

This innovative form of film adaptation began not with the silver screen but with the small screen. As part of the bid to expand Soviet television in March 1951, the Council of Ministers directed the Ministry of Cinema to collaborate with the Committee of Radio Information (Komitet radioinformatsii) that oversaw the television industry and carry out "experimental filming" of live performances for two television programs using cinema-grade film stock.[66] Nine months later, the results were a filmed musical concert and the first *fil'm-spektakl'*: Alexander Ostrovskii's *Truth Is Good, but Happiness Is Better* (*Pravda—khorosho, a schast'e luchshe*, Alekseev, 1952) performed by the Malyi Theatre ensemble at the Gor'kii film studio. The film adaptation was deemed to be of such good quality that the head of the Committee of Radio Information, Puzin, recommended to Malenkov that the 139-minute television program be screened in cinemas. By mid-January 1952, it was, and a new genre was born in world cinema.[67]

In its first year, this new type of film accounted for half of the output of the Soviet feature film industry and an even greater proportion of its profit margins,

66. Anderson and Maksimenkov, *Kremlevskii kinoteatr*, 897. The *Fil'my-spektakli* reviewer Mikhail Beliavskii erroneously credits workers at the Central Television Studio with conceiving of the new type of film. Mikhail Beliavskii, "Vypolniaia pozhelaniia zritelei," *Sovetskoe iskusstvo*, January 5, 1952: 2. For more on the history of Soviet television, see Kristian Feigelson, *L'U.R.S.S. et sa télévision* (Paris: Institut national de l'audiovisuel, 1990); Kristin Roth-Ey, "Finding a Home for Television in the USSR, 1950–1970," *Slavic Review* 66, no. 2 (2007): 278–306; Kristin Roth-Ey, *Moscow Prime Time: How the Soviet Union Built the Media Empire That Lost the Cultural Cold War* (Ithaca, NY: Cornell University Press, 2011); A Rokhlin, *Istoriia otechestvennogo televideniia* (Moscow: Aspekt Press, 2008).

67. Anderson and Maksimenkov, *Kremlevskii kinoteatr*, 897. Although it was common to film scenes from theatrical productions and condensed versions of plays in early cinema, Soviet filmmakers were the first to record theatrical performances in their entirety. The British television channel ITV was next to do so, with its programs *ITV Play of the Week* debuting in 1955, and *Armchair Theatre* in 1956. For more on the relationship between theater and early cinema, see A. Nicholas Vardac, *Stage to Screen: Theatrical Method from Garrick to Griffith* (Cambridge, MA: Harvard University Press, 1949); Ben Brewster and Lea Jacobs, *Theatre to Cinema: Stage Pictorialism and the Early Feature Film* (Oxford: Oxford University Press, 2003).

which is precisely what it was intended to do. Following the successful premiere of the first two productions in January 1952, Bol'shakov had written to Malenkov to propose *fil'my-spektakli* as the means by which to recover from the dismal release rate of 1951 and fulfill a demanding profit plan for 1952. He requested permission to produce ten more. Interestingly, the Minister of Cinema did not offer any account of expected profits, as he had done when pushing for the release of trophy films a few years earlier. Instead, he focused his argument on cost-effectiveness, explaining that filmed theater required neither the sewing of costumes nor the building of sets and would not impede existing filming plans in the studios or distract the Ministry of Cinema since they could be overseen by the Committee of Radio Information. Puzin had offered a more rigorous financial case for filmed theater in his report to Malenkov the previous month, prior to the cinema test screenings. He, too, focused on savings rather than profitability, underlining the fact that *Truth Is Good* required only nineteen days to film at a cost of a mere 403,000 rubles. This point was reiterated by Kruzhkov and Sazonov in their report to Malenkov a few weeks later, with the added detail that the average feature film was budgeted for 7 to 8 million rubles. Although not mentioned in these early exchanges on the new undertaking, *fil'my-spektakli* also skirted the costly film censorship process. This is because filming only took place for theatrical performances that were being staged at the time and had already been censored by Glavlit, which scrutinized the theater as closely as the Ministry of Cinema did film. This meant that filmed theater was not only the cheapest form of Soviet postwar cinema (even more so than trophy films) but also the quickest: the ten productions for which Bol'shakov sought approval in January 1952 had all premiered by the following December, doubling the number of Soviet feature films screened that year and taking the sixth, seventh, and eighth ranks at the box office, behind four *Tarzan* trophy films and one Soviet-made Stalin epic—a strong start for the new form of cinema.[68]

Indeed, despite its initial ties to television, Soviet filmed theater was fundamentally cinematic in nature.[69] The earliest planning discussions for *fil'my-spektakli* charged filmmakers with creating a viewing experience that surpassed live theater

68. RGASPI 17/133/383/110-111. In practice, several *spektakli* filmmakers supplemented the materials provided by the theaters, for instance, developing cinema sets for both *The Break-Up* (*Razlom*) and *The Living Corpse* (*Zhivoi trup*), hiring extras for the former as well, and incorporating new props (such as a live horse!) in *Liubov' Iarovaia*. I. Manevich, "Spektakl' na ekrane," *Iskusstvo kino*, no. 7 (1953): 97; "Novyi fil'm-spektakl'," *Sovetskoe iskusstvo*, June 21, 1952: 3; Anderson and Maksimenkov, *Kremlevskii kinoteatr*, 897, 902. For an account of the stages in theatrical censorship, see Joshua Wilson, "The Enigmas and Facts of a Social Experiment: A Reconsideration of Soviet Era Dramatic Texts 1920–1980" MA thesis, Idaho State University, 2003), 30–37.

69. The success of the *fil'my-spektakli* inspired an even more streamlined version of the venture during the early summer of 1952, which involved filming plays in situ without any cinematic adaptations. The results were artistically and technically far poorer that cinema grade *fil'my-spektakli* and were screened only on television in the USSR. These "poor cousins," and not the cinematically

spectatorship, reworking the play to take full advantage of the artistic possibilities of film. Pieces were occasionally edited for length, but most often their adaptation centered on the development of a technical shooting script, outlining the camera angles, shots, and movements. These started out quite modest in their ambitions, with axial cuts, shot-reverse-shot, cutaway and reaction shots, and close-ups directing the viewers' attention by typical cinematic means and granting access to the kinds of details about people and props that would have been inaccessible to theater audiences. The cinematization of the theatrical performance steadily became more sophisticated, however, as stage layouts were reorganized, transition scenes inserted, and animated wipes and documentary footage incorporated. The cinematography made use of panning and tracking shots to augment the action onstage, flash cutting to intensify the pace, and dolly movements to zoom in on the actors and heighten the emotion. As a result, the camera in *fil'my-spektakli* frequently took on a dynamic, almost personalized perspective that contrasted with the fixed midshot that predominated in late Stalin-era features, and instead anticipated the psychological camera of the Thaw era.

As a form of cinema, filmed theater served in two critical capacities for the benefit of the Soviet film industry, the first being as a preserve of thematic and generic diversity. *Fil'my-spektakli* revived the popular revolutionary war genre with hits like *The Breakup* (*Razlom*, Bogoliubov and Muzykant, 1952) and *Liubov' Iarovaia* and brought melodrama back to center stage with the likes of Richard Sheridan's *The School for Scandal* (*Shkola zloslviia*, Room, 1952) and Lev Tolstoy's *The Living Corpse* (*Zhivoi trup*, Vengerov, 1952).[70] *Fil'my-spektakli* also reintroduced themes long absent from Soviet production, including divorce, alcoholism, infidelity, and suicide.[71] These themes feature prominently in *The Living Corpse*, for instance, wherein the sympathetic protagonist Fedor Protasov perpetrates all four. No other postwar cinematic protagonist committed such acts; even the existence of a character who leaves his wife was enough to strike a script from the 1950 production plan.[72] The thematic diversity of filmed theater stemmed largely from the prioritization of classic plays for filming and the

filmed features, are what Kenez describes somewhat dismissively in his discussion of postwar filmed theater. Kenez, *Cinema and Soviet Society*, 210.

70. In an insightful reading of a handful of late 1930s examples, Anna Toropova highlights the way in which film adaptations of classic pre-Soviet theater kept the struggling genre alive before the war—a torch that I would argue *fil'my-spektakli* subsequently took up. See Toropova, *Feeling Revolution*, 174–87.

71. A distinction should be made here between de facto and intentional infidelity. Mistakenly believing her husband to be dead, Avdot'ia in *The Return of Vasilii Bortnikov* unknowingly commits infidelity, but she immediately ends the relationship upon her husband's reappearance (although the married couple's reconciliation requires the full length of the film to come to fruition). Significantly, Pudovkin's sensitive film followed after the key *fil'm-spektakl'* to deal with infidelity, *The Living Corpse*.

72. RGASPI 17/132/427/117-119.

inclusion of several foreign pieces. Of the thirteen *spektakli* produced under Stalin, 23 percent were set during the revolutionary or Soviet period, 15 percent were penned by foreign playwrights and set abroad, and the remaining 62 percent dealt with the imperial era. This distribution of settings was not representative of the contemporary theatrical repertoire, which was heavily oriented toward contemporary Soviet postwar life due to the persecutions of the Zhdanovshchina and anticosmopolitanism campaigns. Yet, apparently audiences preferred the classics, which were also well suited to expanding the cultural legacy of Soviet theater, since they featured the masters of the Soviet stage in their most well-known roles and offered the potential for greater appeal to audiences abroad.[73]

Filmed theater also served as a training ground for young and underemployed filmmakers and actors. One of the most damaging implications of the masterpieces policy was the immediate dismissal of cadres from the industry and the subsequent necessity for still others to abandon feature film production due to the subsequent lack of opportunities. Documentary film production absorbed some of these professionals, but by no means all. The sudden doubling of projects in production—even if each lasted for only a few weeks—provided a much-needed forum in which marginalized filmmakers might hone their skills, not to mention a welcome paycheck. Filmed theater launched the careers of young directors like Vladimir Vengerov and revitalized others that had been stalled by *malokartin'e*, as with Tat'iana Lukashevich, Iurii Muzykant, and Ian Frid. It renewed the on-screen presence of actors like Igor' Il'inskii of *Volga-Volga* (Aleksandrov, 1938) fame and instigated the film debuts of some who would go on to become cinematic gems, like stage actor Vladimir Zel'din, who continued to appear on screen until 2015, when he completed his last production at the age of one hundred. In short, filming theater provided a lifeline for filmmakers both in front of and behind the camera during the worst of the production slowdown.

Expanded Cinema

In addition to the diversification of types of films screened in Soviet cinemas, the worst of the film famine saw the expansion of the industry into new spheres both at home and abroad. In its most literal form, this expansion manifested as a series of coproductions between the major Soviet studios and fledgling national studios in Belarus and the Baltic republics, which as often as not involved the

73. Liencourt, "Le théâtre, le pouvoir et le spectateur soviétiques," 192; RGASPI 17/133/383/111. *Spektakli* were dubbed in Hungary, the German Democratic Republic, and China, and were screened in Poland, Bulgaria, and Czechoslovakia in Russian. "Sovetskie fil'my-spektakli na zarubezhnykh ekranakh," *Sovetskoe iskusstvo*, May 16, 1953: 1.

replacement of local personnel with filmmakers and apparatchiks from Moscow and Leningrad. These coproductions, discussed in greater detail in chapter 2, were relatively few in number, though, and are more symbolic of the impetus toward Soviet cinematic expansion than evidence of its realization. Instead, Soviet cinema exhibited quantifiable growth on the domestic front by means of the small screen and the rise of television, while audiences beyond the borders were reached via the efforts of the agency for film export, Soveksportfil'm (All-Union Association for the Export and Import of Films, or Vsesoiuznoe ob"edinenie po eksportu i importu fil'mov).[74] Together, these two undertakings were responsible for raising the annual viewership of Soviet films by half a billion and more, though these gains came at a hefty cost. Expansion was first and foremost politically motivated, undertaken to meet ideological goals in the context of the Cold War, as opposed to managing cost-effectiveness or forecasting profits. This was done, in the first case, to support a fledgling new technology and, in the second, to exploit and even create platforms for Soviet propagandization abroad, in pursuit of hearts and minds (or at least scoring points against Hollywood), rather than currency.

Films on the Small Screen

From its inaugural peacetime broadcast in December 1945, Soviet television relied heavily on cinematic output for its content. Newsreels, chronicles, and documentaries filled scheduled airtime, alongside a steady flow of feature films, well-turned classics and contemporary releases alike. During 1949–51 for instance, prewar productions *Lenin in October* (*Lenin v oktiabre*, Romm, 1937), *Lenin in 1918* (*Lenin v 1918 godu*, Romm, 1939), *The Great Citizen* (*Velikii grazhdanin*, Ermler, 1938), and *Member of the Government* (aka *The Great Beginning* or *Chlen pravitel'stva*, Zarkhi and Kheifits, 1939) aired alongside postwar pieces *The Red Necktie* (*Krasnyi galstuk*, Sauts and Sukhobokov, 1948), *The Third Strike* (*Tretii udar*, Savchenko, 1948), *Meeting on the Elba* (*Vstrecha na El'be*, Aleksandrov, 1949), and *Miners of the Don* (*Donetskie shakhtery*, Lukov, 1951).[75] The films were aired at no cost to either the incipient television stations of Moscow and Leningrad or the Committee of Radio Information, which oversaw television programming.[76]

74. In 1945, Soveksportfil'm succeeded Soiuzintorgkino (1933–45), which had itself succeeded Sovkino (1924–33).
75. Feigelson, *L'U.R.S.S. et sa télévision*, 44, 49.
76. The Ministry of Cinema was also required to share production equipment with the committee. Aleksandr Deriabin and P. V. Fionov, eds., *Letopis' rossiiskogo kino, 1946–1965* (Moscow: Kanon+, 2010), 176.

In March 1951, a Sovmin resolution formalized television's exploitation of cin-
ema production, requiring that all films be screened on television within ten
days of their premiere in cinemas. According to estimates by Glavkinoprokat
director Bobrov, this ruling translated into a loss of a quarter million cinema
viewers in Moscow alone that year.[77] Surprisingly, Bobrov does not call atten-
tion to the loss of ticket sales implicated in his estimate. Instead, his complaint
to Bol'shakov is framed in purely bureaucratic terms: Glavkinoprokat did not
receive credit (and the attendant subsidies) for home viewings, thus casting into
jeopardy its ability to balance the annual budget. It was apparently of no con-
cern to the director in charge of cinema promotion and distribution that films
were being screened for free. Bobrov's report could therefore be read as evidence
of the underdevelopment of profit-oriented thinking that persisted in the film
industry, in favor of an emphasis on budget keeping instead. Yet, it is equally
indicative of the director's tact in a situation where the political benefits of sac-
rificing film profits were clear. Television did, after all, broaden the circulation
of ideologically vital films, delivering "cinema for the masses" on a whole new
level. Even more important, television was key in the technological competition
with the West. Efforts in developing the new technology were proving notewor-
thy and warranted support—or at least only the most strategically phrased
critiques—from apparatchiks like Bobrov. Reduced ticket sales were a small price
to pay for a potential victory in the ongoing Cold War technology race.[78]

Films on Foreign Screens

As with the domestic small screen, foreign screens of all sizes and locales be-
came a hotly contested arena of Cold War cultural competition in these years.
Efforts to capture foreign audiences intensified during *malokartin'e* so that, by
1950, Soviet films were screening in fifty-two nations around the globe—and by
no means to empty seats. In 1949 alone, Soviet films attracted 430 million for-
eign viewers. These impressive turnouts did not translate into high profit mar-
gins, however, as only 100 million rubles were garnered from screenings that
year. Clearly, foreign spectators were not being charged at the standard 6-ruble
rate per adult film ticket. Even more interesting is that this figure actually over-
fulfilled the Ministry of Cinema's projection of foreign earnings by nearly
70 percent, indicating that film screenings abroad were not undertaken as a

77. Deriabin and Fionov, 182–83.
78. Station upgrades in 1949 established the Soviet Union as the leading broadcasting nation,
while engineers had developed large-screen models for public viewing measuring 1 by 1.2 meters
as early as 1941, giving the USSR a technological edge over the United States. Rokhlin, *Istoriia
otechestvennogo televideniia*, 123.

profit-making venture.[79] Rather than opening up new markets, Soveksportfil'm's primary task was simply to broaden access to new audiences. Films were reprocessed to accommodate a range of languages and cultures, supplied with a full complement of bespoke promotional material, and at times screened in facilities rented or even purchased by Soveksportfil'm—all to get Soviet films seen.[80]

According to Bol'shakov's reports and press releases, film export was a resounding success. The statistics are certainly impressive. The Minister tracked attendance figures in each nation to which Soviet films were exported, itemizing statistics for individual politically significant films like *The Fall of Berlin*.[81] The ever-growing tally of countries importing Soviet films was followed with anticipation, as were the variety and numbers of copies of films made available to each.[82] Prompting particular celebration was the start of 8mm and 16mm film distribution abroad in 1948–49. This was a boon to Soviet cinema both in under-cinematized socialist nations, where significant numbers of narrow-gauge film projectors were still in use, and even more promisingly in Western nations where narrow-gauge films screened by clubs and societies were exempt from censorship. The entire Soviet supply of *uzkoplenochnye*, or narrow-gauge film stock, and a great deal of film restoration and duplication expenditure was dedicated to this purpose in 1949. The result was the release of eighty-four Soviet films in France alone that year. Because these films were distributed through Friendship Societies, Workers' Parties, and other "progressive social organizations" with connections to the All-Union Society for Cultural Relations with Foreign Countries, or Vsesoiuznoe obshchestvo kul'turnykh sviazei s zagranitsei (VOKS), they could be screened in nations with which Soveksportfil'm did not yet hold an agreement, thereby broadening the reach of Soviet cinema even further.[83] It was thus with a victorious flourish that Bol'shakov enthused in a 1950 publication that, if before the war Soviet film was seen by millions of viewers abroad, and during the war,

79. RGASPI 17/125/373, 469, 576, 638, 639; 17/132/88, 90, 250, 251, 429; 17/133/386; Deriabin and Fionov, *Letopis' rossiiskogo kino*, 84.

80. In terms of the provision of promotional material, English was an exception: Britain would not screen the films (RGASPI 17/125/639/36) while subtitling was preferred in the United States (J. Krukones, "The Unspooling of Artkino: Soviet Film Distribution in America, 1940–1975," *Historical Journal of Film, Radio and Television* 29, no. 1 (2009): 110) even though Soviet research indicated that, in general, attendance at dubbed Soviet films was two to three times higher than at subtitled films (RGASPI 17/132/429/6). With regard to measures taken to ensure Soviet films were screened, a key example would be from Vienna, where Soveksportfil'm rented six theaters (RGASPI 17/125/639/36). The agency went to even greater lengths in China, supplying projectors and facilitating the use of Soviet films in the education system. See Tina Mai Chen, "Film and Gender in Sino-Soviet Cultural Exchange, 1949–1969," in *China Learns from the Soviet Union, 1949–Present*, ed. Thomas P. Bernstein and Hua-Yu Li (Lanham, MD: Rowman and Littlefield, 2010), 423–24.

81. RGASPI 17/132/429/4; 17/133/386/83-107.

82. This figure rose from 47 in 1948, to 48 in 1949, to 52 by mid-1950. RGASPI 17/125/639/35-55; 17/132/429/4, 29.

83. RGASPI 17/132/88/94-98; 17/132/429/6.

by tens of millions, then in the postwar period it would be seen by hundreds of millions.[84] He was quite right.

Achievements in multiplying Soviet cinema viewership were framed not simply as gains secured for Soviet films but more specifically as losses for Hollywood and "capitalist film." The cinemas of the world were cast as the houses and buildings of wartime Stalingrad, as each small victory was conveyed in triumphant reports, underlining the "unflinching" growth of interest in Soviet film among the masses in capitalist nations.[85] In the most successful cases, audience numbers relative to a nation's population were also provided to emphasize the permeation of Soviet cinema into foreign societies.[86] Meanwhile, the occasional defeat was mourned with equal aplomb, such as the lingering influence of Hollywood and German UFA films among Finnish audiences. These reports provide a picture of the ideological battle in which the Ministry of Cinema perceived itself to be involved: combating the immoral cinema of Hollywood, on the one hand, and the unreality of the German "Factory of Dreams," on the other.[87]

The strategy underpinning Soviet film export went beyond simply supplying and promoting films abroad. It also sought to ensure the relevance of exported films to foreign audiences—capitalist, socialist, and newly Soviet alike. The precise purpose varied in relation to each group, from propagandizing, to modeling, to integration, but many of the strategies remained the same. For instance, the Ministry of Cinema commissioned detailed reception studies for every nation in which Soviet films were distributed, providing clues as to audience composition and preferences, as well as challenges to increased attendance—measures that were not taken for domestic audiences, incidentally.[88] Foreign press reviews were monitored, as was the turnout to individual films in nations of particular interest, such as the Soviet Zone of Occupied Germany, later East Germany.[89] Films were cut with specific nations in mind, creating not simply generic capitalist and socialist versions but Japanese, French, Chinese, and other bespoke renditions.[90] Feature and documentary films intended for, and often coproduced

84. RGASPI 17/132/250/96.
85. RGASPI 17/132/429/5.
86. RGASPI 17/132/429/4-5; 17/125/639/189.
87. RGASPI 19/125/576/30.
88. RGASPI 17/125/639/37-54.
89. RGASPI 17/125/639/63; 17/125/576/29-46.
90. RGASPI 17/133/386/167. This is not to say that they were necessarily successful in appealing to the targeted foreign audience, however. For instance, the distribution of war films in the Soviet Zone of Occupied Germany ceased fairly early on, partly due to the antimilitarization stance of the Potsdam Agreement, which sought to demilitarize German society and culture, but also because of the inappropriate response of German audiences (particularly the youth) to these war films. It was common to hear laughter during the battle scenes, while audiences frequently failed to distinguish the (Soviet) heroes and the (German) villains. Press releases attempted to rebrand war films as simply historical films with an ultimately antiwar message, but this tactic failed. The exceptions were *The Battle of Stalingrad* and *The Fall of Berlin*, which were screened to much fanfare as part of the

with, new socialist and Soviet republics were commissioned, and permission granted to use the Barrandov studios.[91] One such coproduction with the Lithuanian SSR Ministry of Cinema, *Dawn over the Neman* (*Nad Nemanom rassvet/ Ausra prie Nemuno*, Faintsimmer, 1953), managed to combine an attack on the Roman Catholic church and the antipopular character of the Lithuanian bourgeoisie with a paean to collective farming. Although the success of these efforts to tailor exported films and coproductions to suit specific audiences is debatable, the intent was clear: cinema remained "the most important of the arts," as Lenin reportedly said, in pursuing the consolidation and expansion of the Soviet project.

It is practically a truism among literary dissidents to observe, often nostalgically, that the intensive literary censorship of the Soviet period made for more creative, better-quality writing, and it is not unusual for scholars to echo the sentiment. Such a claim has never been intimated in relation to cinema. Yet perhaps it should be. After all, despite the unprecedented constraints imposed on cinema production after the war, the years 1945 through 1953 did not see the death of Soviet film. Instead, the industry in these years weathered radical policy reversals and untold interference to develop new types of cinema and expand the reach of Soviet films, actively pursuing every avenue of potential development despite the risk and uncertainty this involved. Even at the worst of times, the industry persisted in taking small but important steps toward innovation, both technological and artistic, thereby positioning Soviet filmmaking for explosive renewal once genuine reform was possible. What kinds of films it made in the meantime, though, in the midst of all these practical, ideological, creative, and economic challenges, is the focus of the remainder of this book. And although my purpose in reviving this period of cinema is to argue for the fascinating nature of no few number of these films, I will leave it to the reader, in the final instance, to determine whether or not they warrant any regard for the way in which they navigated the constraints outlined here in this chapter.

concerted effort to promote the Stalin cult in East Germany. Lars Karl, "Screening the Occupier as Liberator: Soviet War Films in the SBZ and GDR, 1945–1965," in *Cinema in Service of the State: Perspectives on Film Culture in the GDR and Czechoslovakia, 1945–1960*, ed. Lars Karl and Pavel Skopal (New York: Berghahn Books, 2015), 345–46.

91. RGASPI 17/132/250/1-4; 17/125/638/5; 17/132/90/57-58.

THE GREAT PATRIOTIC WAR
ON SCREEN

According to Khrushchev, late Stalin-era war films were sickening. Dedicated to "praising Stalin as a military genius," they "surround[ed] Stalin with glory, contrary to the facts and contrary to historical truth."[1] This is an accurate description—but only of three out of the thirty-eight war films released in this period. The remaining thirty-five films tell a somewhat different story, as this chapter will reveal.[2]

1. Nikita Khrushchev, "Speech to 20th Congress of the C.P.S.U.," Nikita Khrushchev Reference Archive, 1956, https://www.marxists.org/archive/khrushchev/1956/02/24.htm.

2. The three films that Khrushchev defines accurately with this description are the artistic documentaries *The Third Strike* (*Tretii udar*, Savchenko, 1948), *The Battle of Stalingrad* (*Stalingradskaia bitva*, Petrov, 1949), and *The Fall of Berlin* (*Padenie Berlina*, Chiaureli, 1950). *The Vow* (*Kliatva*, Chiaureli, 1946) may also be considered an early gesture toward the new artistic documentary genre and is Stalin-centric. (I have not counted it among my tally of war films, however, since it covers the much broader period of 1924–45.) The remaining thirty-five war films, in order of release and with box office standing noted where applicable, are as follows: *Four Hearts* (*Serdtsa chetyrekh*, Iudin, 1945, box office ranking 5), *The Invasion* (*Nashestvie*, Room, 1945), *Duel* (*Poedinok*, Legoshin, 1945, 6), *Ivan Nikulin: Russian Sailor* (*Ivan Nikulin Russkii matros*, Savchenko, 1945), *Girl No. 217* (*Chelovek No. 217*, Romm, 1945, 7), *Dark Is the Night* (*Odnazhdy noch'iu*, Barnet, 1945), *It Happened in the Donbas* (*Eto bylo v Donbasse*, Lukov, 1945), *Days and Nights* (*Dni i nochi*, Stolper, 1945), *The Unvanquished* (*Nopokorennye*, also known as *The Taras Family*, Donskoi, 1945), *The Great Turning Point* (*Velikii perelom*, Ermler, 1946), *The Liberated Earth* (*Osvobozhdennaia zemlia*, Medvedkin, 1946), *Zigmund Kolosovskii* (Dmokhovsky and Navrotsky, 1946, 9), *Naval Battalion* (*Morskoi batal'on*, Minkin and Faintsimmer, 1946), *The Sky Slow-Mover* (*Nebesnyi tikhokhod*, also known as *Heavenly Slug* and *Celestial Sloth*, Timoshenko, 1946, 2), *A Noisy Household* (*Bespokoinoe khoziaistvo*, also known as *Trouble Business*, Zharov, 1946, 8), *Sons* (*Synov'ia*, Ivanov, 1946, 5), *Sinegoriia* (Garin, 1946), *Son of the Regiment* (*Syn polka*, Pronin, 1946, 7), *In the Mountains of Yugoslavia* (*V gorakh Iugoslavii*, Room, 1946), *The Nameless Island* (*Ostrov Bezymiannyi*, Bergunker and Egorov, 1946), *The Sleepless Road* (*Doroga bez sna*, Iarmatov, 1947), *The Scout's Feat* (*Podvig razvedchika*, also known as *Secret Agent*, Barnet, 1947, 1), *Marite* (Stroeva, 1947), *Story of the "Neistov"* (*Povest' o "Neistovom"*, Babochkin, 1947), *For Those Who Are at Sea* (*Za tekh, koto v more*, Faintsimmer, 1948, 6), *Private Alexander Matrosov*

War films were the most popular type of Soviet-made feature to screen during 1945–50, after which point their production ceased until after Stalin's death. They account for over a third of all feature film releases during these years, with nearly half of them ranking at the box office—an achievement unmatched by any other category of film. Audiences flocked to see victory played out on screen, ensuring that war films held the top spot in terms of ticket sales four years running, and secured half of the annual top-five rankings for the first six years of peacetime. Clearly, late Stalin-era war films did not make everyone sick.[3]

The majority of war films harbor only relatively weak connections to Stalin and his cult of personality. They are, however, very much concerned with political and ideological orthodoxy. More specifically, war films were shaped by two priorities: first, the need to redefine the war narrative through a more stringently Soviet lens. As Stephen Hutchings notes, films made during the war itself had "locate[d] the source of the moral authority motivating their brave heroes, in the eternal Russian soul rather than in a (potentially) transient political ideology," that is, Marxist-Leninism or Stalinism.[4] The task for the film industry after the war was to relocate it to the firm grounding of Stalinist ideology. This was not the Stalinism of the 1930s, though, or even simply a more grandiose version of it. Instead—and this is the second consideration that defined war films—it was a Stalinism that sought to rectify the politically undesirable legacies of the war and the way in which it was won. Late Stalin-era war films engaged in developing a distinctly *postwar* iteration of Stalinism.

Central to this task was the search for a suitable positive hero: a figure who could address the pressing question of who won the war and how, while simultaneously promoting the authority of the state and celebrating the pivotal role

(*Riadovoi Aleksandr Matrosov*, Lukov, 1948), *Victorious Return* (*Vozvrashchenie s pobedoi*, Ivanov, 1948), *Life in the Citadel* (*Zhizn' v tsitadeli*, Rappaport, 1948), *The Young Guard* (*Molodaia gvardiia*, Gerasimov, 1948, 1), *Story of a Real Man* (*Povest' o nastoiashchem cheloveke*, Stolper, 1948, 2), *Meeting on the Elba* (*Vstrecha na El'be*, Aleksandrov, 1949, 1), *Konstantin Zaslonov* (Faintsimmer and Korsh-Sablin, 1949), *Secret Mission* (*Sekretnaia missiia*, Romm, 1950, 4), *The Brave Ones* (*Smelye liudi*, also known as *The Horsemen*, Iudin, 1950, 1), *Far from Moscow* (*Daleko ot Moskvy*, Stolper, 1950). Please note that Macheret's catalog erroneously dates the release of *The Great Turning Point* to January 1945 rather than 1946.

3. There were 110 feature films released during 1945–50, excluding concerts, with the 38 war films accounting for 35 percent. The first-ranked war films were *The Scout's Feat* in 1947, *The Young Guard* in 1948, *Meeting on the Elba* in 1949 (which takes place during the final day of Berlin's capture and the early days of the postwar period), and *The Brave Ones* in 1950. After 1950, war films were replaced by rural films that followed the efforts of demobilized soldiers to rebuild collective farming after the war (see chapter 6). All box office statistics derived from Zemlianukhin and Segida, *Domashniaia sinemateka*; Sergei Kudriavtsev, "Otechestvennyi fil'my v sovetskom kinoprokate," *Kinanet LiveJournal*, accessed February 4, 2014, https://kinanet.livejournal.com/14172.html#cutid1.

4. Stephen Hutchings, "Ada/Opting the Son: War and the Authentication of Power in Soviet Screen Versions of Children's Literature," in *Film Adaptations of Literature in Russia and the Soviet Union, 1917–2001: Screening the Word*, ed. Stephen Hutchings and Anat Vernitski (London: Routledge, 2004), 34.

of the Soviet public in that victory. As the linchpin of socialist realism and its master plot, the positive hero was vital to defining the Stalinized war narrative. What was needed was a hero who reflected the newly attained maturity of the victorious Soviet people, while yet discarding the independent initiative and apolitical motivation of the protagonist of wartime media. This was a delicate balance to strike, and one that the positive hero of the 1930s could not achieve, as evidenced by the rarity of this figure and the traditional master plot in late Stalin-era war films. Instead, socialist realism required a new heroic focal point and trajectory, and war films took the lead in pioneering them.

As Khrushchev intimated, a handful of films simply credit Stalin with victory and forgo the need for a character arc or master plot. But most approach the attribution of victory in a less cultic manner, so that several refrains weave through cinema's ode to victory alongside the bombastic chorus of "Stalin!" Specifically, war films foreground the roles of the military command system, the Soviet Great Family, and the patriot in disguise—each representing a distinctive expression of the positive hero. Each also coincides with a specific type of war film. Narratives promoting the military institution itself as the hero culminated in the infamous artistic documentaries (*khudozhestvennye-dokumental'nye fil'my*) or battle epics and adopt a monumental, historicizing approach to their depiction of victory. Dramas that heroize the protagonist as a son and brother of the Great Family concentrate on victory as a social achievement, spawning from the superior unity and integration of the Soviet Union. Finally, the new genre of spy thrillers proposed the most innovative take on victory as a feat of heroic deception, positing a redefinition of the positive hero that departed radically from 1930s characterizations. This chapter explores each of these three types of war film and the iterations of the positive hero they present, unpacking how war films sought to establish not only the narrative of recent victory but also the image of heroism at the heart of Soviet postwar culture.

Monumental War Films and the Institutionalization of Heroism

The most notorious new genre of film to emerge after the war was the artistic documentary: that monumental treatment of the battlefront film that put on display the epic nature of Soviet military exploits. Numbering three in total, these films mark the cinematic epitome of the Stalin cult (see chapters 4 and 5). Yet they are much more than this. While they certainly do place Stalin front and center, there is more to their revision of the narrative of victory than their exaggerated claims regarding the leader. The artistic documentaries institutionalize

and historicize the war narrative, abstracting the positive hero from an individual who is representative of the system, to the military command structure itself. As a result, these monumental war films redefined the kind of story that could be told about the war during Stalin's final years. As a product of more than simply the personality cult, the artistic documentary genre provides valuable insight into the demands placed on the cinema industry during the early years of peace.

A telling case study to explore both of these themes—what the monumental approach to the war narrative looked like and why it came about—is provided by the three films made during these years that are dedicated to the Battle of Stalingrad, the origin point of Soviet victory in the Great Patriotic War. The first of these, *Days and Nights* (*Dni i nochi*, Stolper, 1945), was filmed in 1944 and adheres to what had become the typical melodramatic mode of battlefront storytelling during the war. *The Great Turning Point* (*Velikii perelom*, Ermler, 1946) was filmed the following year and represents the earliest attempt at a grander and more historical treatment of the war, reminiscent of the historical-revolutionary films of the mid-1930s. Finally, *The Battle of Stalingrad* (*Stalingradskaia bitva*, Petrov, released on Stalin's seventieth birthday in 1949) was the inaugural artistic documentary, although production delays meant it was the second to premiere.

The most striking distinction between these films is the scale of the story they tell. From the close-up of *Days and Nights*, with its focus on Captain Saburov and his battalion as they struggle to hold a handful of ruins in the heart of Stalingrad; to the long shot of *The Great Turning Point* and its showcasing of Colonel General Murav'ev's cartographically derived perspective of the battlefield from beyond the city limits; to *The Battle of Stalingrad*'s panoramic view of the entire front from the distant height of Stalin's Kremlin office—the framing of each film gradually moves from intimate microcosm to grandiose macrocosm.

Concurrent with this expansion of scale is the increased preeminence of historicity over the pathos of storytelling. The evocative melodrama is replaced by the painstaking docudrama. Fridrikh Ermler's film marks the halfway point between these two extremes. It fictionalizes the officers it follows, while taking inspiration from documented events and well-known historic episodes, such as the sacrifice of Matvei Putilov in 1942, who inspired the scene wherein Minutka, Murav'ev's driver, restores a severed communications line by clamping it together in his teeth, even as he succumbs to enemy fire.[5] Although received warmly as a much needed step in the right direction, *The Great Turning Point* was nevertheless criticized for having obscured historical details such as battle and officer

5. Elena Baraban, "The Battle of Stalingrad in Soviet Films," in *Fighting Words and Images*, ed. Elena Baraban, Stephan Jaeger, and Adam Muller (Toronto: University of Toronto Press, 2012), 245.

names, precise locations and dates.[6] A greater degree of historical accuracy and transparency was called for.[7] Hence Petrov's determination to pioneer a new approach to war cinema—nothing short of a new genre of feature film.[8]

Such a venture called for a new methodology, starting with the development of the screenplay. While typical war films drew on the work of war correspondents, novelists, and poets such as Konstantin Simonov, as Stolper did for *Days and Nights*, the monumental war film required a more direct approach. Ermler and screenwriter Boris Chirskov had taken a step in this direction with their fact-finding mission to interview officers at the Stalingrad front in 1944 when preparing *The Great Turning Point*.[9] But the artistic documentary went further, mobilizing a battalion of military consultants and frontline veterans, reams of classified documents, and wartime newsreel footage as its source base. In the case of *The Battle of Stalingrad*, screenwriter Nikolai Virta was tasked with incorporating "genuine" speech from sound-film recordings of Stalingrad veterans and other witnesses, possibly in order to avoid the criticism directed at *The Great Turning Point* for its unrealistic dialogue. The cast studied these same recordings in order to mimic the gestures, expressions, and diction of specific veterans, while the makeup artist A. Anjan drew on an extensive collection of photographs to help perfect the actors' embodiment of the "heroes of Stalingrad."[10] Despite its blatant idealization of Stalin and his role, the artistic documentary nevertheless aspired to historical accuracy, making for an intriguing paradox at the heart of the genre.[11]

One of the effects of the shift in source base and genre is a change in tone, reinforcing the move away from melodrama toward a more heavily "factual" narrative. This is most readily apparent in the way that the three films handle Stalin's famous proclamation on November 7, 1942 (the twenty-fifth anniversary

6. See Lenfilm Artistic Council discussions reprinted in Petr Bagrov and Vera Kuznetsova, eds., "Iz stenogrammy obsuzhdeniia khudozhestvennym sovetom 'Lenfil'ma' fil'ma 'General armii' [Velikii perelom], 24 November 1945," *Kinovedcheskie zapiski* 72 (2005), http://www.kinozapiski.ru/ru/article/sendvalues/455/.

7. Judith Devlin, "The End of the War in Stalinist Film and Legend," in *The Fiction of History*, ed. Alexander Lyon Macfie (Oxford: Routledge, 2014), 107–8.

8. Vladimir Petrov, "Kontury novogo zhanra," *Iskusstvo kino*, no. 4 (1947): 5–7.

9. Denise Youngblood, *Russian War Films: On the Cinema Front, 1914–2005* (Lawrence: University Press of Kansas, 2007), 85.

10. Petrov, "Kontury novogo zhanra," 5, 7; Liudmila Pogozheva, "Dialog v stsenarii i fil'me," *Iskusstvo kino*, no. 2 (1947): 21.

11. For more on the depth of research involved in developing artistic documentaries, see Elena V. Baraban, "Filming a Stalinist War Epic in Ukraine: Ihor Savchenko's *The Third Strike*," *Canadian Slavonic Papers* 56, no. 1–2 (2014): 17–41. Adding to the intrigue of the core paradox of the artistic documentary genre is the fact that the Artistic Council and military consultants critiqued the overemphasis on Stalin during the production of *The Battle of Stalingrad* and *The Third Strike* and required that it be tempered with greater focus on ordinary heroes and other members of the Politburo. That the final products are still so Stalin-centric makes one wonder just how outlandish the original takes were! See Devlin, "End of the War," 110.

of the October Revolution), that soon there would be "celebrations in our streets." What is used as an encouragement to the beleaguered soldiers in *Days and Nights* is wielded as a chastisement in *The Great Turning Point* when Murav'ev calls his subordinate Krivenko to a higher standard of self-discipline. Meanwhile, *The Battle of Stalingrad* reveals the context of the statement's origins, showing that shortly before its pronouncement, Stalin had unveiled plans for the Soviet counteroffensive that would eventually lead to the city's liberation. His was not a statement of wishful thinking but an informed prediction grounded in classified information, accessible only to the chosen few. From inspirational to instructive, to plain Stalinist rationality—this is the trajectory of cinema's presentation of the Battle of Stalingrad as well.

The move away from drama toward historicity required the promotion of the protagonist up the ranks of the military hierarchy so as to accommodate a more expansive view of the battlefront. From officer on the ground, to midranking officer just beyond the battle zone, to top-ranking officials in the Kremlin and frontline headquarters, the protagonists move further and further from the relatable, *tipichnyi*, or typical, positive hero of wartime cinema, and nearer to the embodiment of the entire system itself. In this sense, heroism becomes institutionalized over the course of these films. That is to say, the Soviet system—and specifically the military command structure—replaces the individual and even the collective soldier as the hero of the Great Patriotic War. While Captain Saburov is the picture of intrepid heroism in 1945, going above and beyond the strict implementation of orders to engage that gray area of action taken in accordance with his best judgment, in Ermler's 1946 film, Colonel General Murav'ev reprimands Lieutenant General Krivenko for deviating from protocol. Indeed, *The Great Turning Point* demonstrates repeatedly that heroism equates to perfect subordination to the needs of the military command, whether this means receiving news of the death of one's wife unblinkingly (Murav'ev) or sitting through a tedious meeting while slowly bleeding to death without complaint (the matured Krivenko). What is more, it establishes the notion that Stalin's leadership is conveyed directly through the military hierarchy, since Murav'ev receives his frontline assignment from Stalin personally, who also supplies him with a detailed plan. Submission to martial strictures sees its fulfillment in *The Battle of Stalingrad*, where the attentive implementation of Stalin's word is the primary form of heroism expressed on screen.

The distinctions between these three films can be linked back to a single core concern: producing a feature suited to conveying the historical and ideological gravity of the battle, and the Soviet war effort more generally. The urgency to strike a monumental note was intensified by the fact that the battle films were developed in a discursive vacuum, that is, in the absence of any party-sanctioned publication

establishing the official history of the war. By 1946, even the (relatively paltry) publication of veterans' memoirs ceased, leaving filmmakers and screenwriters to do what writers, historians, and memoirists could not, and determine the official war narrative.[12] This presented a rare opportunity for cinema to step into the role of "master medium" from its usual position lower down the artistic hierarchy, where it served primarily as a reinforcement to literature and fine art.[13] With the artistic documentaries, cinema set the agenda. That filmmakers took this responsibility seriously is clear in the number of deliberate citations they make on screen to historic source material: providing the text of telegrams; lingering on expansive detailed maps; and incorporating wartime media into their storytelling, from newsreel footage to radio broadcasts by *Govorit Moskva* (*Moscow Speaks*). Cinema was quite pointedly "writing the book" on the war. *The Battle of Stalingrad* makes the claim even more explicit by opening with a close-up of a weighty, yet nonexistent, tome titled *Annals of the Great Patriotic War: Stalingrad*, literally presenting the two-part film in place of a written publication. Indeed, after its approval by Stalin, the film was quite literally treated as the authoritative text on the battle, its screenplay disseminated to Glavlit editors, who consulted it when censoring publications that made mention of the battle.[14] Signs of official approval for this and similar productions in their venture to establish the official war narrative also lay in the eye-watering budgets assigned to them, and the access they were granted to Soviet tanks and captured German war matériel (and prisoners!), as well as other military resources for the battle reenactments.[15] The implications were clear: feature film had become the official narrator of the war.

Even before it became evident that this narrative-setting task would fall to cinema, the industry was already anticipating the need to develop a grander approach to the war. In other words, the impetus for the epic turn in war films was not strictly a top-down affair, nor was it developed solely in service of the Stalin cult.[16] In early 1944, discussions were taking place within the film industry

12. Geoffrey Hosking, "The Second World War and Russian National Consciousness," *Past & Present*, no. 175 (2002): 186.

13. Jan Plamper, *The Stalin Cult: A Study in the Alchemy of Power* (New Haven, CT: Yale University Press, 2012), xv.

14. Kenez credits all artistic documentaries with such an opening device, but *The Battle of Stalingrad* is actually the only one to do this. Kenez, *Cinema and Soviet Society*, 228. On the use of the film's screenplay as a reference text, see Boris Zaks, "Censorship at the Editorial Desk," in *The Red Pencil: Artists, Scholars and Censors in the USSR*, ed. Marianna Tax Chodlin and Maurice Friedberg (Winchester, MA: Unwin Hyman, 1989), 157.

15. Baraban, "Filming a Stalinist War Epic in Ukraine," 30.

16. That the idea did not originate with the top leadership is not at all surprising given what Belodubrovskaya has established regarding the development process of production plans: rather than imposing assignments on directors, the plans tended instead to ratify projects conceived by studios and favored directors. Though seeming ironclad, the centralized production plan system masked a deceptive degree of latitude for established figures in the industry. See Belodubrovskaya, *Not According to Plan*, 52–89.

regarding the need for cinema to provide a fitting monument to Soviet military achievements. One such voice belonged to Sergei Vasil'ev, director of Lenfilm, who mere weeks after the return of his studio to Leningrad, proposed the development of a feature that would reflect the full historical scale of victory.[17] The fruit of this call was *The Great Turning Point*, which Ermler and Chirskov had already begun to prepare. Yet Vasil'ev's motivations were not purely commemorative. In the same document, he also stressed the need for Lenfilm to be cautious not to develop a reputation as a Leningrad-centric studio, revealing a sensitivity to the rift already developing between the formerly besieged city and the Kremlin that housed the ultimate cinematic authority. A major production dedicated to victory at Stalingrad was a wise move by the studio head. This early step in cinema's journey to become the definitive medium of the war narrative was thus spurred by a mix of priorities.

The development of the artistic documentary was also indebted to the global cinematic context. That is, Soviet cinema was presented the opportunity to "write the book" for foreign audiences as well as the domestic one. Not only was the Soviet film industry remarkably functional throughout the war, unlike in other occupied territories, but it was also preoccupied with producing war films. This was something that Hollywood (and UFA in Nazi Germany) was more reluctant to embrace, prioritizing escapist fare instead. What is more, Soviet film officials posited that, if film trends following the First World War were any indication, what meager war film production Hollywood was supporting could be expected to cease altogether with the end of the conflict. After all, it had taken American studios eight years to "dare to approach" the Great War, as one Lenfilm discussion phrased it, implying that a similar delay was anticipated following the current conflict.[18] The time was ripe to flood the market with distinctly Soviet narratives of the Second World War, capturing the imaginations of audiences near and far.

The race was on by 1944. In May, Bol'shakov reported to Molotov that the cinema committee was keeping a close eye on British and American efforts to prepare versions of their films tailored to European audiences, but he also pointed out that Soviet efforts were ahead of the curve. Through the Sovkino agency in London, they were set to dub ten documentaries and features in up to four languages (Italian, Norwegian, French, and Czech), with three French adaptations ready to go and eight more being subtitled for distribution in Northern Africa.

17. Reprinted in Petr Bagrov and Vera Kuznetsova, eds., "Ob"iasnitel'naia zapiska k proektu tematicheskogo plana studii 'Lenfil'm' na 1945–1946 gody," *Kinovedcheskie zapiski* 72 (2005), http://www.kinozapiski.ru/ru/article/sendvalues/454/.

18. Bagrov and Kuznetsova, "Iz stenogrammy obsuzhdeniia khudozhestvennym sovetom 'Lenfil'ma' fil'ma 'General armii.'"

Meanwhile, at home, no fewer than sixteen titles were being prepared in Polish, Serbian, Romanian, Czech, and Hungarian versions.[19] This was one competition Bol'shakov was determined to win.

Three kinds of war films were marked for export, the first being bespoke titles that targeted viewers in a specific nation, as exemplified in the case of war films developed for distribution in Poland. An exchange of letters dating from August 1944 between Bol'shakov and Colonel General Nikolai Bulganin, stationed in Poland, reveals this agenda. The officer wrote to inform the cinema industry that there were no films being made in Poland, leaving a captive audience for Soviet films. Bol'shakov replied immediately, informing him that they were already on the case, preparing not one but two films for release to Polish audiences in the new year. He also committed to commissioning a third film, to be written by a Polish author.[20] The second type of war film suited to foreign export was the comedy, like *Four Hearts* (see chapter 1), that displayed the jolly human face of the Red Army and could serve as a corrective to any negative "rumors." But the third and ultimately most desirable type of film was the grand historical account of the war—the artistic documentaries with their pretensions to factuality. As Solov'ev explained in his lengthy paean to the new genre, it was the means by which Soviet cinema would provide the people of the world with the truth about the Second World War, which other nations sought to bury.[21] Typical melodramatic war films like *Days and Nights* were deemed too small-scale and unsuitable for distribution abroad.[22] The Grand Prix win for *The Great Turning Point* at the inaugural Cannes Film Festival in the autumn of 1946 only confirmed this critical conjecture, augmenting the appeal of large-scale productions and sweeping historical pictures. Films could even be edited with specific national audiences in mind, as with *The Fall of Berlin*, which enjoyed German, British, Chinese, and even Japanese variations among its many adaptations.[23]

In the context of urgency for an official narrative that could be readily exported, battle epics became a focus of the 1946–47 production plan and its comprehensive overhaul in the spring and summer of 1946.[24] Even so, the advent of the artistic documentary did not spell the end of diverse war narratives but instead represented only one strain of postwar Stalinism. Yet another pivotal theme was also introduced into the revised production plan that summer. This one took

19. Fomin, *Kino na voine*, 634–35.

20. Fomin, 623–24. Only one of the films was completed and screened in 1946 as *Zigmund Kolosovskii*. The other film underway in 1944 belonged to Vladimir Petrov, who landed on his feet when it was presumably dropped and subsequently directed *The Battle of Stalingrad*.

21. A. Solov'ev, "Puti razvitiia novogo zhanra," *Iskusstvo kino*, no. 4 (1949): 20.

22. Baraban, "Battle of Stalingrad in Soviet Films," 244.

23. RGASPI 17/132/429/40-43 and 17/133/386/167; Gosfilmofond, file 1652 (*The Fall of Berlin*).

24. Anderson and Maksimenkov, *Kremlevskii kinoteatr*, 732–37; Artizov and Naumov, *Vlast' i khudozhestvennaia intelligentsiia*, 556–57.

a more personal approach to connecting with Soviet and foreign audiences, namely, through the metaphor of family.

Dramas of the Great Soviet Family and the Heroic Son

The Great Patriotic War was an attack on the Soviet family. When the Germans stormed the borders of the USSR, they invaded not only a geopolitical entity but also a state and society united in political kinship. By the mid-1930s, the concept of the Great Family, or *bol'shaia sem'ia*, had developed into a central myth of the Soviet system. Though it was by no means a new idea, the image of the nation as a body of children (usually sons, specifically), united in brotherhood and growing in maturity under the guidance of a leader-father, took on deep significance during the Stalin era. It provided the basis for socialist realism and its master plot, and undergirded the Stalin cult, legitimizing the leader's representation as Wise Father Stalin (see chapter 4).[25] The Great Family served as the framework through which official discourse interpreted sociopolitical relationships within the Soviet Union and ultimately, after the war, across the socialist world.

The war assaulted this familial framework, unsettling both the bonds and the balances of the mythic social model. The months and years of occupation pitted brother against brother and son against father, orphaning countless citizen-children while simultaneously offering the opportunity for adoption into a different family—the fascist one. It also pitted the small, nuclear family against the Great Family in the contest for first place in the hearts and minds of Soviet combatants, for whom defense of their families (or vengeance on their behalf) was a primary motivator. Meanwhile, the wartime addition of new republics to the USSR and the birth of new socialist neighbors intensified the urgency of the Great Family analogy as a tool for integrating new members into the Soviet sphere. In short, shoring up the bonds of the Great Family was a crucial task in the months and years following victory.

Cinema played a key role in recentering the Great Family in the war narrative and adapting it to the postwar context so that it might remain a foundational myth. To this end, dramas about the war explore three main themes in relation to the Great Family. The first of these is its capacity to reintegrate the traumatized individual into the Soviet order, which plays out in films like *Son of the Regiment* (*Syn polka*, Pronin, 1946) and *Story of a Real Man* (*Povest' o nastoiashchem cheloveke*, Stolper, 1948), with their rare depictions of war trauma.

25. Clark, *Soviet Novel*, 115–17.

The second theme concerns the relationship between the small family and the Great Family, and the necessity of purifying the former for the sake of the latter—particularly in newly socialist lands, as in the Lenfilm-Riga studios coproduction *Sons* (*Synov'ia*, also known as *The Road Home*, Ivanov, 1946). Finally, a significant proportion of war films focus on the bonds of brotherhood enjoyed within the socialist sphere, especially between ethnic partisan groups and Soviet forces, casting the defeat of fascism as a family effort. Across all these films, the positive hero is envisioned first and foremost as a son of the Great Family. At times, he is a son who has been alienated by the traumas of war and must be enfolded once again into the Soviet household; at others, he is a foreign son anticipating adoption into the socialist kindred. In all cases, it is the Red Army that serves as the mentor figure—the mature brother or even father—lending Soviet power a familial face as it welcomes sons home. This emphasis on kinship dominates the depiction of the war against fascism beyond the famous battles, on the fringes of the contentious corridor between Stalingrad and Berlin, and makes for a compelling counterpoint to the command-centered view of the war effort propagated by the battle epics.

Trauma and Healing in the Red Army Family

War trauma was not a topic for open discussion in the Soviet Union. Support programs were plagued by underfunding and the persistent stigma surrounding those who sought help with mental health, limiting the effectiveness of state initiatives to address trauma. Meanwhile, the development of psychological treatment was severely hobbled by a materialist approach to diagnosis, which only acknowledged war-related mental illness and psychological trauma when tied to observable physical wounds, particularly damage to the head.[26] But where the hands of medical professionals were tied, those of Soviet writers were released to engage with the weighty legacy of four long and brutal years of violence, fear, and uncertainty—at least for a time. As Anna Krylova has shown, it was the writers who stepped into the role of "healers of wounded souls," using their prose to delve into and soothe the psychological wounds of the victors.[27] And given that roughly

26. Robert Dale, "'No Longer Normal': Traumatized Red Army Veterans in Post-war Leningrad," in *Traumatic Memories of the Second World War and After*, ed. Peter Leese and Jason Crouthamel (New York: Palgrave Macmillan, 2016), 119–41; Robert Dale, *Demobilized Veterans in Late Stalinist Leningrad: Soldiers to Civilians* (London: Bloomsbury Academic, 2015), 100–122; Benjamin Zajicek, "Scientific Psychiatry in Stalin's Soviet Union: The Politics of Modern Medicine and the Struggle to Define 'Pavlovian' Psychiatry, 1939–1953" (PhD dissertation, University of Chicago, 2009), 169–85; Catherine Merridale, "The Collective Mind: Trauma and Shell-Shock in Twentieth-Century Russia," *Journal of Contemporary History* 35, no. 1 (2000): 39–55.

27. Anna Krylova, "'Healers of Wounded Souls': The Crisis of Private Life in Soviet Literature, 1944–1946," *Journal of Modern History* 73, no. 2 (2001): 307–31.

half of war film productions were literary adaptations, cinema too came to be implicated in this therapeutic project, albeit in a markedly limited capacity.

Soviet cinema's engagement with the theme of trauma looked very different from that of other national cinemas after the war. Around the world, from Italy to Japan, Poland to the United States, and East to West Germany, filmmakers' quest to convey and, to varying degrees, remedy war trauma produced some of the most aesthetically and technically innovative cinema of the late 1940s and 1950s. Building on the experimentation of the 1920s and often influenced by German expressionism, postwar directors like Roberto Rossellini, Akira Kurosawa, Andrej Wajda, Fred Zinnemann, Gerhard Lamprecht, and Wolfgang Staudte led a small but significant contingent of world cinema in reckoning with the scars left by the Second World War. But the devices and techniques most frequently employed in this cinema of trauma to convey the psychological woundedness of the male protagonist—flashbacks, surrealist dream sequences, fantastical narrative elements; camera tilts, extreme close-ups, and audiovisual dissonance—were untenable to postwar socialist realism. Such strategies were the very definition of formalism. As such, they were antithetical to the Soviet state's cultural priorities of restoring Stalinist orthodoxy.

Instead of stylistics and technique, postwar Soviet cinema drew directly on its literary base and used metaphor to explore the soldier's internal world. As contemporary Soviet critic I. Grinberg noted, postwar writers had a tendency "to switch their narratives from the analysis of inner psychological transformations to descriptions of nature," using landscape to map out the positive hero's character arc.[28] This practice was readily adaptable to cinema, with the result that the visual language of landscape in late Stalin-era cinema became a vital means "for conveying and expressing man's inner world, that is, the journey of the human soul," according to film scholar Evgenii Margolit.[29]

In the popular war films *Son of the Regiment* and *Story of a Real Man*, this journey sees the protagonists travel from the forest of alienation and chaos, to the orderly and distinctly Soviet spaces of Red Square on parade and blue skies filled with planes flying in formation. The forested starting point of the two postwar films is familiar from the cinema of socialist construction in the 1930s. But

28. Quoted in Krylova, 320.
29. Evgenii Margolit, "Landscape, with Hero," in *Springtime for Soviet Cinema: Re/Viewing the 1960s*, ed. Alexander Prokhorov, trans. Dawn Seckler (Pittsburgh: Russian Film Symposium, 2001), 34. The metaphoric use of landscape shots was not new to the postwar period, with spatial and natural metaphors being key to 1920s and 1930s films relating to the construction of socialism, as Emma Widdis has shown. Emma Widdis, *Visions of a New Land: Soviet Film from the Revolution to the Second World War* (New Haven, CT: Yale University Press, 2003). But their use took on a subjective significance in the era of strict censorship and antiformalism, when other means of expressing the hero's inner world were tightly controlled. Unlike 1930s positive heroes, postwar heroes do not dream, for instance. There are no masquerades or carnivals, and cinematography is relatively subdued.

the similarity is only superficial. Instead of the airy forest alive with natural bounty, the forest of these two war films is a darkened space untouched by sunlight and terrorized by war: a broken, abandoned landscape, desolate and full of death, as evidenced by the corpses, abandoned artillery, and charred stumps that bestrew its expanse. This tormented woodland locates the positive hero's starting point not in the energetic potential of spontaneity but rather in the exhausted brokenness of trauma.

The forest is not only a mirror for the hero's trauma but also the site of his suffering. This plays out in *Story of a Real Man* for a remarkable eighteen minutes, accounting for the first 20 percent of the film. The screen is filled with trees as the sound of an aerial dogfight rings out, followed by a mighty crash. Cutting through the trees, the camera discovers the wounded body of a pilot. Aleksei Meres'ev has survived the fall, but his life is not yet saved. He sets out to return to civilization, at first limping and counting his steps aloud, even keeping up with entries in his flight log. But gradually these markers of humanity peter away, as Aleksei loses the will to articulate his existence in either spoken or written form. Exhaustion forces his devolution from bipedal to quadrupedal motion, and soon Aleksei must resort to dragging himself and eventually, in desperation, rolling. Throughout his journey, Aleksei is reduced from Soviet pilot, master of the skies and technology, to hunter-gatherer (and sometimes prey), scavenging for sustenance; then to hungry animal, his once clean-shaven face obscured by lengthening beard and hair as he crawls through the snow; and ultimately to a state of primordial chaos as his loss of all but the most basic powers of movement swirl the heavens and earth into a dizzying jumble of visual information. All this time, the forest is shrouded in a heavy silence that extends to the understated musical score, as a mere three or four notes resound at a time. The howling of the wind (which Aleksei later describes as "terrifying, terrifying") and occasional wild beast mark this as a landscape that has forgotten the existence of humanity. Such restrained sound design is highly unconventional in Stalin-era cinema and serves to intensify the sense of Aleksei's isolation in a landscape seemingly unreached by the order and structure of Soviet sound.[30]

Unreached, that is, until Aleksei recognizes the sound of Soviet planes overhead and, soon thereafter, two Russian-speaking boys whispering nearby. "Svoi" (mine), he whispers to himself in response to both sonic encounters, his face brightening at the recognition of Soviet sounds. The Russian word *svoi* can equally

30. Stalin-era sound film instead favors scores that provide a continuous wall of sound, thought to aid in guiding viewers into the appropriate emotional response to the images on screen. The prevalence of silence in the opening sequence of *Story of a Real Man* was also a point of debate among the members of the Artistic Council. In the end, Stolper's enthusiasm for the "magnificent sound things" that composed it prevailed, and the soundtrack remained dominated by sonic ellipses. See Gosfilmofond file 1755 (*Story of a Real Man*), Artistic Council discussion minutes, September 10, 1948.

FIGURE 2.1. Aleksei Meres'ev, man of the forest. *Story of a Real Man* (Stolper, 1948).

be translated as "mine" or "yours" (or even "his/hers/theirs"), meaning that it is possible that his second statement of *svoi* could be a faltering attempt to announce to the boys that he is theirs, one of their own. So considerable is Aleksei's transformation from Soviet man to wild creature that he is capable of no more than a word or two at a time, spoken in a hoarse whisper and unconvincingly at that (figure 2.1).

When he replies to the boys' hail, repeating weakly that he is "Russkii, Russkii letchik" (Russian, Russian pilot), they refuse to believe his self-identification, insisting he is German. They cannot recognize in this creature anything of shared identity and effectively reject the claim to relationship he makes with his initial declaration of "Svoi!" His time in the forest may have come to an end, but his journey to reclaim his Soviet identity has only just begun.

In contrast, the forested opening sequence in *Son of the Regiment* does not depict the unfolding of Vania's trauma but rather its culminating effect on the boy. Vania's forest is haunted by disorienting fog and monstrous mud holes that suck down the bodies of men and machinery alike, leaving their half-digested remains sticking out at disconcerting angles (figure 2.2).

FIGURE 2.2. Vania's forest, haunted by war. *Son of the Regiment* (Pronin, 1946).

The eerie stillness is palpable and compels the three Soviet soldiers creeping cautiously through the treed wasteland to keep their hushed murmuring to a minimum. Their movements speak of vigilance and rising tension (amplified by the agitated strings of the musical score), as if they are in enemy territory. It is in this unwelcoming space that they find the feral boy curled up in a hole, sleeping (figure 2.3). According to the novella, he has been living like this for two years—a fact conveyed in the film through his ragged appearance and animalistic reaction to the soldiers, scuttling away from their torchlight and shrieking mightily.

He is easily subdued by the lead soldier, who clamps his hand over Vania's mouth, but the boy's aggression is slow to dissipate, even after the Red Army man announces with a grin, "Svoi!" In the world of the forest, alienated from human company, *svoi* has had little meaning for Vania, and understanding dawns across his face only with painful sluggishness. It takes some convincing, but as Vania considers each of the men's smiling faces in turn, he finally responds with a faint smile of his own and agrees, "Nashi" ("ours," but implying more specifically, "our Soviet soldiers").[31]

31. Hutchings also highlights this term but considers it in relation to the implied contrast with *chuzhoi*, or other, alien. See Hutchings, "Ada/Opting the Son," 40.

FIGURE 2.3. Vania, son of the forest. *Son of the Regiment* (Pronin, 1946).

In both films, the acceptance of the protagonist as *svoi/nashi*—as belonging among Soviets—serves as the marker for his reentry into Soviet society. His reintegration into Sovietness, however, is a more prolonged affair and constitutes the bulk of each film. That is to say, although he may respond to the language of *svoi/ nashi*, he does not yet act the part of the true Soviet man. To this end, the master plot in these films contains an important adaptation, as loss of identity is added to the typical array of physical challenges that the positive hero must overcome.

Aleksei and Vania both struggle to perceive their Soviet identity upon first leaving the forest. In *Story of a Real Man*, this is conveyed through Aleksei's sudden disappearance from the screen. For the first twenty-five minutes of the film, actor Pavel Kadochnikov dominates nearly every shot, often filling the screen with his expressive face. But once Aleksei has undergone surgery to amputate his gangrenous legs, the camera's love affair with Kadochnikov comes to an end after one last, lingering midshot of his haggard, stunned profile, eyes staring fixedly into empty space. With this, the camera shifts its attention from the catatonic pilot to the lively bevy of recuperating men who share his ward. All the activity and energy of the large, sunny room centers on Semen Petrovich, regimental commissar and indomitable source of wisdom, encouragement, humor, and song. Among the soldiers, Aleksei alone is unresponsive to Semen Petrovich's fatherly mien.

Meanwhile, Vania may not disappear from the screen, but he is eager to disappear from the company of the Red Army scouts who seem bent on adopting him into their regiment. After eating his fill at their makeshift table, he accepts a few supplies and makes to depart, only to be roped back in with the offer of tea. The soldiers then prevail upon him to accompany them to their base. The boy accedes, but when the men fall asleep during the nighttime pilgrimage, Vania slips from the cart and escapes back into the woods. He has a hard time leaving its shelter and, once rescued a second time, has to be tied by the wrist to one of the soldiers in a type of forced kinship to prevent his fleeing again.

For the two protagonists, the journey from forest to squadron and parade ground takes them along the "path of resubjectification," as Kaganovsky explains in her analysis of Polevoi's novel—a conceptualization used by Zimovets as well in his discussion of Kataev's novella.[32] Both Aleksei and Vania must learn to perceive and reclaim their Soviet identity, that is, a sense of self that is bounded and defined by the collective and integrated into the authoritative structures of Soviet society.[33] Aiding them along this path is the Great Family of the Red Army. It is their brothers-in-arms who first rescue the heroes and pull them from the forest—practically by force, in Vania's case. In fact, it is the martial brother who first recognizes the hero as unequivocally Soviet and in need of rescue—for while the boys who find Aleksei take a great deal of convincing to concede that he is not German, the pilot's fellow airman realizes who he is almost immediately and flies him to the hospital. The brotherhood of the Red Army hospital and the regiment provide a warm welcome to Aleksei and Vania, full of lighthearted teasing that gradually chips away at the dour seriousness with which the trauma of the forest has enveloped them. For Vania, it is also his adoptive brothers who wash away the physical imprint of the forest, scrubbing him from top to tail, trimming his hair and dressing him in a diminutive uniform and greatcoat, enabling him to look the part of a Soviet soldier.

In this family, however, the focus is on the father figure, and it is he who ultimately restores the broken protagonist to Soviet wholeness.[34] In *Story of a Real Man*, it takes nearly a quarter of the film for the depressed, self-pitying pilot to

32. Lilya Kaganovsky, *How the Soviet Man Was Unmade: Cultural Fantasy and Male Subjectivity under Stalin* (Pittsburgh: University of Pittsburgh Press, 2008), 127; Sergei Zimovets, "Son of the Regiment," in *Socialist Realism without Shores*, ed. Thomas Lahusen and Evgeny Dobrenko, trans. John Henriksen (Durham, NC: Duke University Press, 1997), 191–202.

33. In contrast to Hutchings, who argues that Vania's subjectivity is left out of the film adaptation, I maintain that both *Son of the Regiment* and *Story of a Real Man* retain a degree of the subjectivity apparent in their literary source material, thanks largely to the metaphoric function of landscape in the films.

34. The motherly/sisterly nurse-comrades of Polevoi's novel are noticeably absent from the film adaptation, as female characters are reduced to props rather than active agents in Aleksei's journey to wholeness.

FIGURE 2.4. Aleksei Meres'ev, Soviet pilot. *Story of a Real Man* (Stolper, 1948).

finally respond to the gentle prodding of Semen Petrovich, calling him back to his identity as a Soviet (figure 2.4).

The commissar provides him with a news article about Karpovich, the First World War era pilot who recovered from the loss of a leg to fly again. As Aleksei reads it aloud with growing animation, he begins to put two and two together to equal five, as the First Five Year Plan slogan goes: if a tsarist subject could achieve that much, then surely he, a Soviet person, could fly without any legs at all. Semen Petrovich's death in the next scene solidifies Aleksei's determination, and his training montage commences, culminating twenty minutes later in his departure for the airfields at the front.[35]

In Vania's case, his resubjectification means overcoming not only his feral state but also his peasant upbringing in order to step into his full identity as a Soviet cadet on the cusp of manhood. The transformation is triggered by a reprimand from his captain and father figure, Dmitrii Petrovich Enakiev, who tells a

35. Being without a father figure during the most physically taxing stage of his development, Aleksei also calls on a secondary father figure, chief surgeon Vasilii Vasil'evich, for his strong shoulders of support when taking his first steps on the new protheses. The casting for this role is significant: the doctor is played by Aleksei Dikii, who, prior to his turn in Stolper's film, starred in *The Third Strike* as none other than the Wise Father himself, Stalin. With his aid, Aleksei returns to the skies.

preening Vania, "I see artillery insignia [*pushki*] and shoulder straps, but I don't see a soldier here." Clothes do not a Soviet soldier make. Vania's protests are met with a pointed question—"Is that how a soldier behaves toward his commander?"—referring to Vania's lackadaisical lounging as he delivered his report and his peasant bearing, addressing his superior officer as *diadenka* (a familiar form of the term "uncle") with a traditional bow and identifying himself as Pastushok ("Little Shepherd," a nickname given to him by the scouts). "Stand at attention!" snaps Enakiev curtly. "Dismissed! And enter again." Vania realizes the importance of this test and upon his return follows military protocol to a T, proving that he can speak the language of the Soviet soldier in both word and gesture. A smart salute replaces the bow as *krasnoarmeits* (Red Army soldier) Solntsev addresses his commanding officer with proper military title and delivers his report in a squeaky imitation of a soldier's bark. Despite this display of military discipline, the question remains, is Vania simply playing at being a soldier and a Soviet man?

The true test comes minutes later as Vania contemplates a photograph his commander has left with him while he attends to another matter. In it is pictured a happy family: the captain with his wife and son, who is just a little younger than Vania. As Vania hunches over the image in his hands, his shoulders slump, his chin dropping and brows knitting. His lips begin to tremble as if he is on the verge of tears. Does the photograph remind him of his own lost parents, or reflect back to him his desire to be a boy with a father rather than an orphan adopted by a regiment? It is impossible to know. What is clear, though, is that in this moment Vania makes the decision to leave the peasant boy Pastushok behind him for good and become *krasnoarmeits* Solntsev in earnest. When Enakiev returns, addressing him as Vaniusha and placing a comforting hand on his shoulder, implicitly extending to him the opportunity to remain a boy playing at soldiery, Vania instead shakes off his childhood and jumps up with a salute and a firm "Yes, sir, Comrade Captain!" No tears fall as the boy accepts his orders and steps beyond the father-child relationship of the pseudo–small family that Enakiev offers, and into the adulthood of sonship in the Great Family of the Red Army. A portrait of Stalin, illuminated by a sunbeam, smiles in the background. The once feral boy is now a worthy son of the USSR.

In both *Story of a Real Man* and *Son of the Regiment*, it is the Red Army that provides the context for the traumatized heroes' return to Sovietness and reintegration into the Soviet order. In this sense, the Red Army serves as the Great Family for these heroes, surrounding them with brothers and providing them with father figures. It is a family that is compassionate but firm, not allowing the heroes to revert to self-pity or remain hidden in the forests of their alienation and woundedness. It demands of them more than the mere appearance of restored Sovietness, which comes with a haircut and bath, clean clothes, and

FIGURE 2.5. Vania, Soviet and true son of the regiment (note the bust of Stalin on the pedestal in the background) (Pronin, 1946).

some food, and on to the point where their sense of Soviet identity is reinvigorated as well (figure 2.5).

In this way, through the metaphors of landscape and Great Family, traces of the work done by Soviet writers-turned-therapists were translated onto the screen. Soviet cinema may have maintained the taboo on direct reference to trauma, and eschewed the aesthetic explorations seen in world cinema, but it nevertheless acknowledged the male soldier's need for healing and sought, in some small way, to model it.

Of Families Great and Small

At the same time as it demonstrated the importance of the Great Family, postwar cinema also set about clearly defining the role of the *malen'kaia sem'ia*, or small family, in Soviet society. The Great Family metaphor had never been intended to replace the nuclear family—its proliferation during the mid-1930s was accompanied by attendant measures to strengthen the small family, most notably in the Constitution of 1936. After all, the traditional family, with its generational hierarchy and division of gender roles, reinforced and legitimated what

were essentially the same dynamics at play in the metaphoric All-Union family, with its emphasis on male bonds and vertical as opposed to horizontal relations. Yet, the metaphor did rely on *dis*placing the small family—on subordinating it to the needs and priorities of the Great Family. Political kinship outweighed blood relation, as celebrated in official discourse through exemplars like child informer Pavlik Morozov, who was lauded for "exposing" his father as a kulak. The message was plain: when loyalties were tested, all true sons and daughters must choose the Great Family over the birth family.[36]

This hierarchy of loyalties was challenged during the war. From the outset, wartime cultural production emphasized the essential role of the small family in motivating Soviet combatants. This was both a spontaneous response from cultural producers on a grassroots level (like artist Irakli Toidze's resurrection of the *Rodina mat'* or Motherland figure for his famous poster in June 1941) and, increasingly, an officially sanctioned strategy, whether as a mobilization tactic or simply a concession to reality.[37] Wartime media routinely depicted the soldier and partisan as defending the USSR for the sake of their own family members: the mother, sweetheart, or sibling left behind on the home front; the father, brother, or childhood friend killed in action; the husband, wife, or child slaughtered by the occupiers. Judging by the content of wartime cultural production, as well as accounts from veterans, defense of the small family and vengeance on its behalf were sentiments far more resonant than defense of Father Stalin or the sanctity of brotherly union within the Soviet Socialist Republics.[38] This was problematic from an official perspective, since it threatened to upend the hierarchy between the Great Family and the small family. Further to this, the discourse of the Great Family was as yet unestablished in the new lands added to the USSR during the war. Given this context, the theme of small family and Great Family prevalent in war films set in the Baltic states takes on considerable significance.

No such film was more popular than Ivanov's *Sons*, centering on two Latvian brothers who side with differing national families through the course of the war. Valdemar serves with the German SS, while Ianis, after escaping transport as a forced laborer, eventually joins the partisans. Their parents, who support Ianis, share their cottage with Ianis's wife, Ilga, and the little daughter Ianis has yet to meet. It goes without saying that the family and wider community disown

36. Clark, *The Soviet Novel*, 115; Catriona Kelly, *Comrade Pavlik: The Rise and Fall of a Soviet Boy Hero* (London: Granta, 2006).

37. Brooks, "Pravda Goes to War"; Richard Stites, "Soviet Russian Wartime Culture," in *The People's War: Responses to World War II in the Soviet Union*, ed. Robert Thurston and Bernd Bonwetsch (Urbana: University of Illinois Press, 2000), 171–84.

38. Brooks, "Pravda Goes to War"; Svetlana Alexievich, *The Unwomanly Face of War*, trans. Richard Pevear and Larissa Volokhonsky, repr. (London: Penguin Classics, 2017); Merridale, "Collective Mind"; Stites, "Soviet Russian Wartime Culture."

Valdemar, who is ultimately shot in the back and killed by his own commanding officer for no good reason other than to demonstrate the depravity of the Fascist Family that destroys its own sons. Meanwhile, at the climax of his character arc, Ianis faithfully chooses to put aside his strong personal desire to return home—which inspired his courageous escape from German captivity not once but twice—for the sake of aiding the partisans in their support of the advancing Red Army. His heroism lies in this act of renunciation, forgoing reunion with his wife and child in order to facilitate the arrival of the Soviet brother. After helping a Red Army officer to capture the German commander, he rips into the enemy officer for failing to address the Soviet with sufficient respect. Ianis is at his most passionate when demonstrating his own subordination to the Soviet liberator. Ianis's reward for prioritizing the needs of the Soviet Great Family over his yearning for his own family is a joyous reunion with a reconstituted family that reinscribes him as husband, son, and father. His own father simply nods silently in what may be tacit acknowledgment that Ianis, having proved his political acumen, now heads the family. In this way, the small family in *Sons* is aligned under the Great Soviet Family, thanks to the initiative of a Latvian partisan.

At the heart of the contrast between the two sons is their understanding of what constitutes love for the people. Ianis grasps what his brother cannot—that love for Latvia equates to support for the partisans and the Red Army. From the opening lines of dialogue, Ianis's deep affection for his homeland is clear: when asked what he sees from the cattle car window, he replies to his fellow prisoner, "Dom. Svoi dom" (Home. My home), even though there is no house in sight. His friend does not understand, but Ianis, as a true son of Latvia, recognizes that the fields and lakes he sees are his home, though they be many miles from the cottage where his family awaits his return. Valdemar, on the other hand, cannot perceive that he is betraying his people by persisting in his commitment to his SS commission. His mother lays it out for him plainly, challenging him for choosing "strangers over your own kind, peaceful people" (*svoi dobryi mirnyi narod*) and telling him that it is not too late for him to turn back. But Valdemar continues to insist on fulfilling his martial commitment.

Herein lies the greatest surprise of the film: Valdemar possesses redeeming qualities. He is not a purely villainous collaborator but rather an immature and misguided man who nevertheless maintains a certain sense of honor. He is committed to his duty as a soldier, as he explains repeatedly, yet also walks a fine line to protect those he cares about. When given the opportunity to inform on his love interest, Milda, or discipline his parents, he declines, instead protecting them from persecution by his commanding officer. He arrests, lies to, and manipulates his brother Ianis, telling him his wife and child have been executed, but he does so to persuade Ianis not to storm the German headquarters, thus saving

his brother's life—and his own too, of course, by association. He is self-centered and prone to whining, and lacks political understanding, but he is not completely blackhearted. Even so, Valdemar ultimately wears the wrong uniform, and as such he cannot participate in the new Latvia. This was a timely message to audiences who might otherwise be tempted to view postwar society—with its mix of former collaborators, the politically disengaged, former partisans and spies, and the "liberator" Soviet presence—in shades of gray rather than decisive black and white, and so fail to excise unwanted elements from their midst. People like Valdemar were not eligible for adoption into the Great Soviet Family.

In addition to modeling the correct relationship between the small family and the Great Family, and reinforcing the need for rigorous purification of its membership, *Sons* also models Latvia's place in the Soviet Family. It is in this regard that the composition of Ianis's family is significant, for it is overwhelmingly feminine. His father is the picture of spontaneity, as he instinctively sympathizes with the partisans and Soviets, yet he remains a bit of a blowhard and is ineffectual as the head of the household. He recognizes the evil of a son in German uniform but voices his protest with sarcastic shouts and inarticulate splutters. Instead, it is his wife who is the source of maturity in their home, calmly appealing to her younger son's idealistic nature, which the Germans have twisted. It is her words and not his father's accusations that give Valdemar pause, though ultimately he resists changing his ways. Like her mother-in-law, Ilga is similarly calm—unwavering in her trust in her husband and commitment to resisting the Germans, even when threatened at gunpoint. Her heart is true, as revealed in the love song she sings for Ianis. Meanwhile, the family's daughter is introduced from the first shot as a very feminine, domestically oriented little girl, humming a lullaby to her dolly while washing its tiny clothes. She is in training to be a Mother Heroine. This feminization of the Latvian partisan's family speaks to the relationship of the new republics to the Soviet Union and its Wise Father Stalin. While there are sons to be adopted from among the Baltic peoples, the primary role of Latvia is feminine: bringing to the Union the wisdom of a mother, the welcome of a wife, and the domestic service of a daughter. Latvia plays a supporting role in the male-oriented model of the Great Family.

It is plain to see why *Sons* was considered a politically significant film by the regime. In fact, it was the "seriousness of the political theme" that secured its release when the aesthetically minded members of the nascent Artistic Council called for it to be shelved on the grounds of its poor script, deplorable acting, terrible dialogue and songs, and "some [degree of] softness in the unmasking of the fascists" (possibly a reference to Valdemar's less than purely villainous characterization and anticlimactic death). Bol'shakov rejected the request, dismissing the complaints of Romm, Pudovkin, Pyr'ev, Dikii, Sergei Gerasimov, and

others as unimportant, emphasizing instead that "we need to release films, and it will go over very well in the Baltic region, I feel." Perhaps what he really meant was that it would go over well with his superiors that such a film was released in the Baltic republics. In the end, it traveled far beyond the western reaches of the USSR, to Romania, East Germany, and even distant Korea, exporting the message of the primacy of the Great Family half the world around.[39]

Extending the Great Family

A whole raft of similar films followed in the wake of *Sons* during 1946–48—films depicting and defining the war in regions and states newly joined with the USSR, either as Soviet republics or as socialist states in their own right. These included *In the Mountains of Yugoslavia* (*V gorakh Iugoslavii*, Room, 1946) by Mosfilm, filmed on location in Yugoslavia; *Marite* (*Maryte*, Stroeva, 1947), filmed in Lithuania by Mosfilm, with local collaboration; *Victorious Return* (*Vosvrashchenie s pobedoi*, Ivanov, 1948), credited to Riga Film Studio but with the involvement of Lenfilm personnel; *Life in the Citadel* (*Elu tsitadellis/Zhizn' v tsitadeli*, Rappaport, 1948), filmed in Estonia by Lenfilm with local participation; and *The Secret Brigade* (*Konstantin Zaslonov*, Faintsimmer and Korsh-Sablin, 1949), by Belarusfilm and Lenfilm. Additional war films were planned for Latvia, Poland, and Czechoslovakia, though they did not come to fruition.[40] These films were produced in keeping with the revised feature film production plan that was approved in June 1946, a mere fortnight after the release of *Sons*, making that film a test case of sorts, whether intentionally or not. Like *Sons*, these war films focus on the stories of partisans and Soviet sympathizers in German-occupied East Europe. *Life in the Citadel* is essentially a baroque version of *Sons*, featuring not just two sons but a daughter, a nephew, and a housekeeper's son as well, split in their loyalties to the Soviets and the fascists and vying for the support of the bourgeois head of household, Professor Miilas. The other films center more fully on the partisans themselves, celebrating the courage and sacrifice of Yugoslavian, Belorussian, Latvian, and Lithuanian heroes and even featuring—in the case of *Marite*—the kind of strong female lead that dominated Soviet screens in 1943–44. As with *Sons*, each of these films underlines the role of the Red Army in lib-

39. RGASPI 17/125/468/84-85; Gosfilmofond, file 2473 (*Sons*).
40. Lithuanian Film Studio was not founded until 1956, while Tallinnfilm was founded in 1944, but spent the first ten years of its existence as a documentary studio. Irina Novikova, "Baltic Cinemas—Flashbacks in/out of the House," in *Via Transversa: Lost Cinema of the Former Eastern Bloc*, ed. Eva Näripea and Andreas Trossek (Tallinn: Estonian Academy of Arts, 2008), 255; Eva Näripea, "A View from the Periphery: Spatial Discourse of the Soviet Estonian Feature Film: The 1940s and 1950s," in *Via Transversa: Lost Cinema of the Former Eastern Bloc*, ed. Eva Näripea and Andreas Trossek (Tallinn: Estonian Academy of Arts, 2008), 195–96; Fomin, *Kino na voine*, 623–24; Anderson and Maksimenkov, *Kremlevskii kinoteatr*, 732–37.

erating the region and facilitating the partisans' dearest wish: the establishment of socialist governance in their land. The people's will is socialism, and the Red Army answers the cry of the people, welcoming them into the family.

These regional war films were effectively an exercise in state building and consolidation. They were commissioned within weeks of outlining plans for the battle epic films that would define the core narrative of the war and were an important supplement to them, linking each region and nationality to the big-budget account of the advancing Red Army. In this sense, they were rather like spin-offs or side stories in a major film franchise. They sought to align new republics and the entire socialist sphere with the Soviet narrative of the war as well as, implicitly, the Soviet account of their socialist rebirth from the crucible of war. This vital cultural-political work had already begun during the waning months of the conflict, as seen with the 1944 example of the three war films intended for Polish audiences. Throughout its march westward, the Red Army advanced with films in hand, wielding cinema as a tool of ideological expansion and integration. Once in Germany, the Soviet administration was the first to reopen cinemas, even founding a dubbing studio within a month of arriving in Berlin. As a result, the USSR released more feature films in Germany than any other occupying force during 1945.[41] The subsequent prioritization of regional war film production was therefore essentially the postwar continuation of a Soviet wartime occupation strategy.

The revised production plan that mandated these regional war films also outlined how they were to be made: through strategic partnerships between central studios, Lenfilm and Mosfilm, and regional studios in Tallinn and Vilnius, adding to the partnership already pioneered by *Sons* with Riga Film Studio. Like *Sons*, these films were to be coproductions. In a continuation of the prewar cultural policy of establishing a film studio in each republic, the reconstitution and Sovietization of film studios in Latvia, Lithuania, and Estonia were pursued with some urgency in the early postwar years. The foundations of prewar Baltic cinema had been all but destroyed—physically, in the case of equipment, and metaphorically, due to the mass exodus of filmmakers fleeing either the profession or the country itself as the region fell under Soviet and German occupation. In order to rebuild, Moscow committed considerable funds and assigned delegations of filmmakers to implement the Soviet approach to feature film production in the new republics. In this way, these regional war films not only employ the Great Family metaphor but, as coproductions, also embody it.

41. David Bathrick, "From Soviet Zone to Volksdemokratie: The Politics of Film Culture in the GDR, 1945–1960," in *Cinema in Service of the State: Perspectives on Film Culture in the GDR and Czechoslovakia, 1945–1960*, ed. Lars Karl and Pavel Skopal (New York: Berghahn Books, 2015), 18; Karl, "Screening the Occupier as Liberator"; Thaisy, *La politique cinématographique de la France en Allemagne occupée*, 105.

The kind of partnership that resulted is telling of the family dynamic in the sphere of cinema. Indeed, the label "coproduction" was rather more aspirational than reflective of a genuine partnership. In the case of *Sons*, for instance, Riga Film Studio was technically not even instituted until 1948, two years after the film's release, meaning that the opening credits naming the film a coproduction are somewhat misleading. But, more important, the team from Lenfilm constituted nearly the entire crew and acting ensemble, with Latvians serving only as script consultant (Arvids Grigulis), co-lyricist (Ianis Rainis), and, in a rather meaningful casting decision, the Latvian Red Army soldier and fiancé to Milda, Artur (Zanis Katlaps). In short, the Soviet fathers of filmmaking produced this film, and Latvia was implicated only in the equivalent of a nonspeaking role, providing the setting and inspiration for the story. This was to be the general pattern of coproductions until well after Stalin's death, as the partnership between established and fledgling studios mirrored the central dynamic of socialist realism, pairing the as yet immature son, Latvian/Estonian/Lithuanian cinema, with the political mentor and father figure of Lenfilm/Mosfilm. Some productions allowed for greater involvement by local actors, as with Vera Stroeva's *Marite* and Gerbert Rappaport's *Life in the Citadel*, which were originally filmed in Lithuanian and Estonian, respectively. Secondary technicians (for example, second directors, cinematographers, and sound engineers) were occasionally drawn from regional talent as well, though for the most part regional studios were staffed by Soviets trained at VGIK in Moscow or the institutes in Leningrad. The goal may have been to create cinema that was "national in form and socialist in content," but generally it was ethnic Russians and Ukrainians who oversaw the injection of Baltic representation into Soviet cinema—at least during the late Stalin era. It was not until well into the Thaw, and after proving themselves as good little brothers for over a decade, that anything like the beginnings of a regional or national cinema was able to emerge in the Baltic republics.

In sum, the prevalence of the Great Family metaphor in late Stalin-era war films was no mere default to cliché but rather a necessity. It was a social, political, and ideological imperative in the midst of postwar demobilization, the expansion of the USSR, and the inception of a socialist sphere of influence. In aesthetic terms, it was deployed with varying degrees of success, but it did produce, in the films examined here, a certain degree of nuance in the characters of three heroes and one villain as they trod (or fell away from) the fraught path of Soviet sonship. But it was not only Soviet sons who received a revitalized heroic image in late Stalin-era war films; the women and daughters of the USSR gained one as well, forged at the crossroads of the last war and the next.

The Rise and Fall of the Heroic Spy

From the ashes of the Great Patriotic War arose yet another global conflict. This subsequent war inflected the emerging official narrative of recent history in both obvious and more subtle ways. Predictably, films made during the early Cold War sought to undermine the integrity of the wartime Allies as they morphed into the enemies of the postwar era. Alongside the battle epics, thrillers like *Meeting on the Elba* (*Vstrecha na El'be*, Aleksandrov, 1949) and *Secret Mission* (*Sekretnaia missiia*, Romm, 1950) highlighted the nefarious wartime dealings of the British or Americans and their attempts to negotiate a separate peace with Germany, arrange favorable trade deals, or otherwise disadvantage Soviet forces in the race to victory. Such revisionism was critical for legitimizing the anti-Western campaigns and xenophobic resolutions that defined the late 1940s. It also served as justification to keep the war-weary Soviet public on a constant war footing rather than demobilizing culture and permitting the kind of liberalizing reform that many anticipated would come with victory. Instead of the defeat of capitalism and imperialism, the Great Patriotic War was defined as a prelude to the *real* struggle that was only just beginning. Conspiracy-centric film plots were in this sense a reversion to type, reviving the rhetoric of the 1920s and 1930s that warned Soviet audiences to expect capitalist assault. Accusations in postwar films against American and British leaders and businessmen for scheming against the Soviet Union made for a familiar refrain indeed. In this sense, the Cold War element in the plots of these war films was part of the broader process of reasserting Stalinist orthodoxy and the norms of prewar official discourse.

The conspiracy plots may be the most blatant expression of Cold War revisionism in postwar cinema, but they are not the most significant. Far more fascinating was the impact of the Cold War on the positive hero. As a struggle waged largely through cultural competition and espionage, the Cold War gave rise to a distinctive new heroic form: the Soviet spy. He—and, more often, she—was a replacement for the now ideologically defunct wartime hero: the courageous partisan motivated by love for the Motherland or the resourceful Red Army soldier. Whereas the battle epics depersonalized heroism and displaced it onto the military command system, spy thrillers instead directed it onto the shoulders of undercover intelligence officers and partisan-spies. Rather than confronting the enemy openly, these Soviet agents were able to assimilate an alien culture and manipulate the enemy for the benefit of the socialist cause.

Espionage was a popular theme both for filmmakers and for the viewing public. Among the thirty-eight war films released from 1945 to 1950, eight (or one in five) featured the theme of intelligence prominently. Five of these were spy

thrillers, with main plots revolving around wartime espionage: *Duel* (*Poedinok*, also known as *Military Secret*, Legoshin, 1945), *Zigmund Kolosovskii* (Dmokhovsky and Navrotsky, 1946), *The Scout's Feat* (*Podvig razvedchika*, also known as *Secret Agent*, Barnet, 1947), *Meeting on the Elba*, and *Secret Mission*. Two more films, dedicated to partisan warfare, also reserved lead roles for spies: *The Young Guard* (*Molodaia gvardiia*, Gerasimov, 1948) and *The Brave Ones* (*Smelye liudi*, also known as *The Horsemen*, Iudin, 1950). One final partisan film, *Sons*, featured a partisan-spy in a supporting role. These espionage-themed films were greeted with enthusiasm, all eight ranking at the box office and half of them holding the top spot from 1947 to 1950. The most popular war films were the ones that featured spies in lead roles, while nearly half of the war films to rank at the box office depicted their covert deeds.

Granted, espionage was by no means a new theme. As Peter Kenez discusses, spymania had pervaded prewar Soviet culture and informed socialist realism from its earliest days. Things only intensified with the outbreak of the war, as the entire population was encouraged to go about the business of unmasking increasingly well-disguised foreign interlopers, such as the seemingly model soldier who was suspiciously unable to recognize Stalin's baby picture in the short film *In the Sentry Box* (*V storozhevoi budke*, Antadze and Dzjaliashvili, 1941).[42] However, these spies were invariably villainous—they were enemy spies, either foreign agents themselves or in the pay of capitalist powers. This spy figure was the mirror opposite of the positive hero, who was in fact tasked with exposing spies and hidden enemies. Up until 1945, films of every genre presented a clear message: villains wear masks, and heroes tear them off.[43]

Postwar cinema turned this pattern on its head. Of the war films with spies in lead roles, five star *Soviet* spies—that is, Soviets who wear masks and hide their true identity.[44] This is an innovation. In these films, it is the Germans who wear their uniforms openly, while the Soviets don various disguises, sometimes even SS uniforms, as with Masha Glukhova and Nikolai Dement'ev (aliases Marta Shirke and Kurt Iunius) in *Secret Mission*. Rather than tearing off masks, the primary goal of the Soviet spy is to keep the disguise intact and the veil

42. Peter Kenez, "Black and White: The War on Film," in *Culture and Entertainment in Wartime Russia*, ed. Richard Stites (Bloomington: Indiana University Press, 1995), 169.

43. Not only adventure and detective films but also comedies and dramas incorporated this critical plot point: sometimes as the central focus, as in Ermler's chilling *Peasants* (*Krest'iane*, 1935) and Pyr'ev's *The Party Card* (*Partiinyi bilet*, also known as *Anna*, 1936) where the enemy is in fact the protagonist's own lover; and at other times as a means of establishing the protagonist's promising potential, as in the comedy *Girl with Character* (*Devushka s kharakterom*, Iudin, 1939), where exposing the foe is all in a morning's work for Katia Ivanova, who rousts an enemy on her way to catch the train. For more on the vital project of heroic unmasking, see Fitzpatrick, *Tear Off the Masks!*

44. Rather than Soviet spies, *Duel* and *Meeting on the Elba* instead star Soviet intelligence officers concerned with unmasking enemy spies. They remain in uniform practically at all times, and at no point adopt disguises.

firmly in place. Such a delusive positive hero could only arise in a Cold War context where duplicity and the double identity of the secret agent were valorized as patriotic.

The duality of the Soviet spy not only risked coloring the positive hero with shades that previously had been reserved for the antagonist but also compromised the protagonist's developmental arc. Political maturation, after all, hinged on unmasking not only the enemy but also the self, in a quest for fully integrated Soviet personhood. The New Soviet Person was to be the same in public as in private, purged of any characteristics that might warrant concealment. To this end, socialist realism collapsed the subjective and objective self into a single unified image of a hero essentially lacking a personal life, or at least one whose personal life was lived publicly. The unified identity of the positive hero was conceived as an antidote to "the accursed legacy of 'fractured consciousness,'" as director Leonid Trauberg phrased it, that had plagued the protagonists of the 1920s and early 1930s.[45] The Soviet spy unsettles this composure and reintroduces the potential for fracture in the protagonist's identity, redefining heroism as the ability to maintain opposing private and public selves.[46]

In order to avert the implicit cognitive dissonance of the heroic Soviet spy figure, the films go to great lengths to demonstrate the genuineness of their protagonists' Soviet nature. They incorporate a surfeit of details demonstrating the multitude ways in which the secret agents are tied to the Soviet state, its culture, and its people. In fact, it is often through these ties alone that the Soviet spies are defined, as most of them lack a character arc. Instead of the journey from spontaneity to consciousness or from good to better (see chapter 6), these Cold War positive heroes are defined by their static, unchanging state of connectedness to the homeland. Since this relationship stands in for the master plot in most of these films, it is worth taking a little time to explore its representation on screen.

Soviet spies feature as the positive hero in five war films. The first of these is *Zigmund Kolosovskii*, wherein the eponymous Polish hero draws on what must be a walk-in-sized closet of costumes and disguises in order to assassinate German officers and rescue Polish patriots, preparing the way for the liberating Red Army. The next to be released was *The Scout's Feat*, which follows secret agent Aleksei Fedotov as he poses as Swiss industrialist Heinrich Ekhert in occupied

45. Ian Christie and Richard Taylor, eds., *The Film Factory: Russian and Soviet Cinema in Documents 1896–1939* (London: Routledge, 1994), 353. See also John Haynes, *New Soviet Man: Gender and Masculinity in Stalinist Soviet Cinema* (Manchester: Manchester University Press, 2003), 46.

46. Toropova locates the ability of postwar thrillers to genuinely thrill audiences in this very duality, which erased "the binary *svoi/chuzhoi*," or self/other, and introduced the possibility of "the foreigner within" (*Feeling Revolution*, 110–11). For more on the affective power of Stalin-era thrillers, see chapter 3 of Toropova, *Feeling Revolution*.

Vinnitsa. There, he uncovers a double agent among the partisans and kidnaps General von Kühn (played by the film's director), delivering him and his briefcase full of secrets to Moscow (inspired by true events!).[47] Meanwhile, Gerasimov's two-part masterpiece *The Young Guard* features among the ensemble cast the partisan-spy Liuba Shevtsova, who woos the German occupiers for the sake of sabotaging their rule. Next to be screened was *Secret Mission*, starring secret agent Masha, who pays with her life to uncover the machinations of the British and Americans in the final weeks of the war. The last film to feature espionage was *The Brave Ones*, whose female lead, Nadia Voronova, seeks to employ her superior German-language skills to serve as a spy for the partisans.[48] Though markedly divergent in their degree of professional training, age, and ethnic origin, these five heroes have one thing in common: their commitment to Soviet socialism, which is expressed politically, culturally, and socially.

On the political front, most of the films feature a type of commissioning scene to officially sanction the heroes and their duplicitous undertakings. Both of the professional spies—Aleksei in *The Scout's Feat* and Masha in *Secret Mission*—benefit from briefing scenes with a commanding officer, while partisan-spy Liuba, whose training at the NKVD school was interrupted by the invasion, undergoes three distinct commissioning rites in *The Young Guard* (see chapter 3). For both Liuba and Nadia from *The Brave Ones*, official approval is also signaled through their roles as messengers linking the local party representative in hiding with the partisans under occupation in town. The male lead in *The Brave Ones*, Vasia, also implies that the party leader's on-screen approval of Nadia's grandfather as a partisan activist extends to Nadia as well.

Amid this web of connectedness with Soviet officialdom, the one exception is Zigmund. As an escaped Polish officer, he is not privy to approval by a Red Army commander or local party leader, although he does eventually encounter the vaguely Lenin-like head of the Polish resistance, Ludwig K., who greets him as an equal. Instead, Zigmund's strongest ties to the Soviet Union are cultural (and ideological)—as they must be, considering that wartime Poland was not yet officially allied with the USSR. Unlike the protagonists of the other espionage films, Zigmund is one of the rare war film protagonists to follow a traditional master plot, and so he begins his agitational activities spontaneously. He

47. For more on Barnet and this film, see Julian Graffy, "Boris Barnet," in *A Companion to Russian Cinema*, ed. Birgit Beumers (Chichester: John Wiley and Sons, 2016), 509–32; Bernard Eisenschitz, "A Fickle Man, or Portrait of Boris Barnet as a Soviet Director," in *Inside the Film Factory: New Approaches to Russian and Soviet Cinema*, ed. Richard Taylor and Ian Christie (London: Routledge, 1991), 151–64.

48. Iudin's film was also the last war film of the Stalin era, although it began life as a Soviet cowboy comedy instead! For more on the fascinating production history of this unusual film, see Belodubrovskaya, *Not According to Plan*, 195–203.

is initially motivated by revenge for the death of his boyhood friend and gradually adopts instead the language of Slavic brotherhood and partnership between Russians (meaning the advancing Red Army) and Poles as the ideal for which he resists the Germans. His final act is to lead an impassioned crowd in a cheer conflating Russians, Poles, and the (Polish) homeland, wishing all three long life. This closing cry perfectly captures Soviet cinema's assumption of equivalency between Soviet and Slavic identities during the early Cold War. To be truly Russian, Ukrainian, Latvian, Polish, and so on was to be socialist and Soviet in sympathy, if not also citizenship. Zigmund aligns himself with this view as proof of his political maturation at the close of the film.

More generally, spy films use music, literature, and veiled references to the homeland (*rodnaia strana* or *rodina*) to convey the protagonists' rootedness in Soviet—and often specifically Russian—culture. For instance, Zigmund and his partner Stanislav, armed with an accordion, use folk music to communicate during their missions. In *The Young Guard*, Liuba's love for Russian folk song and dance is established before she is shown performing in German, the implication being that her first love is her true love. So deep is the connection between true identity and music that the enemy mastermind in *The Scout's Feat* tests his own agent's ability to respond appropriately to Russian music before sending him off to infiltrate the Soviet underground. For Nadia in *The Brave Ones*, it is the poetry of Vladimir Mayakovsky and the literature of Tolstoy that frame her understanding of the world and equip her for her future clandestine endeavors: she studies German because of the poet (she explains to her grandfather that English is an easier language but German requires strength, which leads to greatness, according to Mayakovsky) and discerns the true natures of the film's villain (Beletskii) and the hero (Vasia) because of a scene from Tolstoy's short story "After the Ball." Meanwhile, the professional spies prove their own poetic and literary inclinations by the manner in which they reference the homeland. For Masha, it is the dreamy look in her eyes and the softening of her clipped tones that reveal where her heart lies—so much so that an American pilot (sympathetic to the Soviets) realizes that she is not German not because she frees him from captivity but because of her softened demeanor when gesturing in an easterly direction. For Aleksei, it is the clever allusions in his speech that reveal his loyalties, as with his famed toast: when leading a roomful of fascist officers to drink "to victory," he waits until they have drained their glasses before clarifying, "to our victory," and drinking alone. He also incorporates a reference to Slavic craft in what remains in Russia today the most well-known code phrase of the Cold War era: "Do you have a Slavic wardrobe for sale?" ("U vas prodaetsia slavianskii shkaf?"). So it is that through music, literature, and shrouded speech these spies reiterate their Sovietness even while dressed as enemies.

Most telling of their true loyalties, however, are the protagonists' familial and social ties to the USSR. Aleksei begins and ends his story in the loving arms of his wife, with the closing scene and last line of dialogue repeating the opening scene, emphasizing his constancy. He will always return home literally and symbolically: he may flirt in the line of duty, but his wife holds his heart. The fact that she remains unnamed indicates that Aleksei's wife is more a sign of his integration into Soviet society than a particularly ardent source of romantic motivation. For Masha, it is a son entering fifth grade and a mother who await her return. Yet Masha is equally committed to "our people" (*nashi liudi*), referring to her fellow agents in the secret service. In fact, her parting note asks that her handler Nikolai embrace their colleagues for her, implying that it is the Great Family consisting of colleagues and comrades, and not just the personal family, that motivates her daring deeds. For Nadia's part, her undercover work provides a means to maintain contact with her grandfather. Both Zigmund and Liuba lack any substantial familial (or romantic) ties—Zigmund because the film neglects to develop his character, and Liuba because the Young Guard are themselves a type of big Soviet family.

In spite of such thorough attestations to the upstanding character of the Soviet spy—not to mention the figure's popularity at the box office—the new protagonist did not last. Instead, after 1950, the masked hero went on hiatus until a triumphal return in 1968. The downfall of the Soviet spy was not an issue of popular appeal, as Soviet audiences seemed to be waiting impatiently for the figure's return, if explosive box office results are any indication.[49] Instead, the problem was conceptual: the secret agent needed to be believable and expressive in both roles, as supposed enemy and loyal Soviet. Aleksei and Liuba achieve this with aplomb, but subsequent depictions of the new hero abandon such duality, editing out the character's agency, depth, and, most of all, any potential for inner conflict. The result makes for the ultimate disappearing act as the Soviet spy vanishes before the viewer's very eyes. A closer look at Aleksei and Liuba, Masha and Nadia reveals how exactly the spy's disappearance played out.

49. The return of the Soviet undercover agent in 1968 was most decisive: three Soviet spy film series took seven of the top eight box office spots, averaging over fifty-five million ticket sales each, compared with an average of thirty-one million for the Stalin-era Soviet spy films (which was an impressive figure at the time). More specifically, the four parts of the multifilm series *The Shield and the Sword* (*Shchit i mech*, Basov, also released on television) took first, second, seventh, and eighth spots; the two installments of *Strong with Spirit* (*Sil'nye dukhom*, Georgiev) held third and fourth spots; and *The Road to Saturn* (*Put' v Saturn*, Azarov) took sixth place. All three series centered on male Soviet spies who infiltrate the German military during the Great Patriotic War. Each part of *The Shield and the Sword* circulated in just under 2,000 copies, while the remaining films boasted just under 1,700 copies apiece. These figures are comparable to those for *The Young Guard*, but *Secret Mission* and *The Brave Ones* enjoyed slightly more copies at 2,021 and 2,125, respectively. *The Scout's Feat* is the exception among all these films, attaining its twenty-two million viewers with only 1,069 copies in distribution. These statistics imply that Soviet Cold War audiences were waiting eagerly for the heroic spy to return to the screen.

Initially, the Soviet spy consisted of two equally convincing personas, but with the network of ties to Sovietness highlighting which of them was genuine. Though acting under orders, the spy operated with a marked degree of individual agency. Aleksei is the embodiment of this dashing expression of heroism. He goes above and beyond his commission to secure General Kühn's briefcase and overfulfills the plan in grand style by delivering the general himself to Moscow and almost incidentally rooting out an enemy agent along the way. Aleksei enjoys the most screen time of any Soviet spy, enabling him to showcase his enemy persona at work (managing his business) and at leisure (socializing with the German military and industrial elite), while revealing his Soviet self, dressed in worker's attire, to the partisans. The characterization of Liuba, despite her sharing the screen with a large cast, is fleshed out even more than that of Aleksei. She is depicted in a wider range of situations as both her collaborator and patriot selves: maintaining her cover in public among the enemy, in private with her landlady, and on stage before a mixed audience; and sharing her true self with family, friends, and mentors (see chapter 3). She also pushes the envelope with regard to her activities as a spy—and herein lies the most potentially problematic aspect of her undercover identity. Liuba actively, albeit chastely, seduces the enemy. Although historically warranted—the "honey trap" has long since been a core tactic in espionage—Liuba's actions are doubly risky in the context of postwar Soviet culture. First, they cast her in the same light as the villainesses of wartime cinema, where flirtatious behavior was the outward sign of a traitorous heart. Second, her use of her sexuality to overcome the enemy ran contrary to the redefinition of female heroism unfolding in Soviet society after the war. Beginning with the Family Law of 1944, the state was making considerable efforts to direct women's patriotic energies toward reproduction, heroizing motherhood in place of deeds of derring-do. This shift was reinforced shortly after Victory Day, as awards to women combatants and other expressions of official recognition for their service came to a grinding halt. In this context, Liuba's femme fatale, though patriotic, disrupted the postwar revival of traditional (maternal) femininity.

Secret Mission and *The Brave Ones* walk the Soviet spy figure back from this perilous precipice and constrain the new hero to the point of nonexistence. Beginning with *Secret Mission*, Masha could not be further from Aleksei's or Liuba's dynamic extrovert if she tried. She spends much of the film either absent or blending into the background. Though Elena Kuzmina received top billing as Masha, she was in reality a supporting actress, with the focus lying instead with the American, British, and German conspirators. The heroine who exposes their dastardly deeds has, by the closing minutes of the film, been all but forgotten.[50]

50. Though Masha's handler Nikolai returns to Moscow, he does not convey her hugs to their comrades as she requested in her final note, let alone interact with her mourning family. Instead,

FIGURE 2.6. Masha as Marta, spy in action. *Secret Mission* (Romm, 1950).

As a result of her limited screen time, Masha's two personas are barely developed (figures 2.6 and 2.7).[51]

Her German self, Marta, is so stiff and obvious in its artifice that it is a wonder she succeeds in deceiving anyone. In contrast to Liuba, she abstains from any application of feminine wiles. But her refusal to play the game of flirtatious double entendres with an SS Oberführer comes at a cost, as it arouses his suspicions against her, leading to the car chase that ends her life. For Masha, it is better to die pure (*chistaia*), like a good Soviet woman, than compromise her morals in order to maintain the cover of Germanness. Masha serves as a mere cypher for the indomitability of the Soviet state, before dying a needless death.

the finale focuses on Churchill, the nefarious American businessmen, and their ongoing plots to launch a new war against the USSR.

51. The one reviewer to comment on the duality required of the heroine tactfully noted that "the viewer would like to know more about Masha. He would like to see her true face more often—the face of a good Soviet woman," before criticizing the filmmakers for failing to give Kuzmina the scope to develop her heroine properly. Liudmila Pogozheva, "Missiia, perestavshaia byt' secretnoi," *Iskusstvo kino*, no. 5 (1950): 15.

FIGURE 2.7. Masha smiles! A rare moment as her Soviet self, shared with fellow spy Nikolai. *Secret Mission* (Romm, 1950).

The Brave Ones carries this type of on-screen erasure to its culmination with Nadia. She is barred from fulfilling her potential as either a spy for the partisans or a lead character in the film. Although she is tipped as an important protagonist in the opening minutes of *The Brave Ones*, with a generous introduction scene establishing her academic abilities, dedication to sacrificial labor, and irrepressibly cheerful attitude, she is gradually sidelined from the plot as the film progresses. Nadia herself laments this situation in an almost self-reflexive bit of scripting, complaining that she wanted to be assigned to a mission and play a more active role in the partisan resistance, but instead she is stuck in admin, translating intercepted German post. Apart from this and one sentence spoken to deflect a couple of flirtatious fascists, Nadia is not permitted to put her linguistic skills or womanly charms to work for the Soviet cause. Much like Masha's purity, Nadia's upstanding character undermines her success as a spy, as the villainous Beletskii does not even consider that she could be anything other than a loyal Soviet and orders her arrest immediately upon spotting her in town. Though promised interrogation and thus the opportunity

to prove her loyalty at least, Nadia appears untouched in her next scene as she and a trainload of women are rescued by Vasia. Nadia has all the makings of a significant player in the partisan cause, but in reality her role in *The Brave Ones* is abortive, making her the spy who never was.[52]

The Soviet spy was clearly a casualty of the postwar reversion to traditional gender politics, given the preponderance of women protagonists who filled the role.[53] (The same was true in literature, although, for once, the pen followed the precedent of the camera, so that the revisions and shifting storylines that spelled the end of the young female spy appeared in print only after they premiered on screen.)[54] It is no coincidence that Zigmund and Aleksei live, while Liuba is exposed and executed, Masha commits suicide, and Nadia undergoes the metaphoric death of replacement by a horse—in both the plot and the heart of the male lead, as the wild stallion Buian ultimately saves the day. Tellingly, when Soviet spies do eventually return to the screen beginning in 1968, they are invariably male.

Yet it was not only shifting gender ideals that consigned the deceptive positive hero to the shelf. The overriding atmosphere of *beskonfliktnost'* (conflictlessness) that permeated late Stalin-era cultural production was equally detrimental. In essence, this approach concentrated on outworking the implications of Soviet victory for the master plot of socialist realism. The resultant narrative claimed that the defeat of fascism, as the ultimate expression of capitalist imperialism, established the superiority of Soviet socialism, settling all vestiges of ideological conflict within the victorious state and promoting Soviet society to a more politically mature stage of development. As such, the USSR was no longer plagued by domestic conflict between alien elements and enlightened socialists. Class warfare was over. The result was that in this era of political enlightenment, the only possible remaining conflict was between "the good and the better," as it was commonly phrased, and no longer between good and bad. Granted, these sentiments were not articulated as a comprehensive theory or official directive, nor were they even conceptualized explicitly. But this did not prevent them from permeating cultural production and having a deleterious effect on Soviet cinema.

The harmonious standards of *beskonfliktnost'*—as this narrative was eventually labeled by its detractors—made for exceedingly dull plots. In his analysis of

52. It is not even clear that she "gets the guy" in the end. Instead of a wedding or other domestic scene establishing her romantic relationship with Vasia, the epilogue is devoted to showcasing his bond with a new horse, the colt of Buian, his beloved wild stallion. Poor Nadia is sidelined completely. Who can compete with a racehorse?

53. It is worth noting that in both *Meeting on the Elba* and *Duel*, which track male Soviet officers as they uncover enemy spies, the undercover agents are all women: American CIA operative Janet Sherwood in the former, and the German fake mother-daughter team in the latter. Even in foreign lands, it seems that the spies are predominantly women.

54. Xenia Gasiorowska, *Women in Soviet Fiction, 1917–64* (Madison: University of Wisconsin Press, 1968), 166–69.

Cold War thrillers, Evgeny Dobrenko uses a mathematical metaphor to express the effects of *beskonfliktnost'* in stripping away all tension from the plot of what should have been the most suspenseful genre of film, dubbing them "equations without unknowns." By resolving the battle between "good" and "bad" ideological elements in Soviet society, the approach of *beskonfliktnost'* circumvented the possibility for uncertainty in narratives about the contemporary USSR.[55] Without unknowns, mystery and thrill are impossible.

Beskonfliktnost' stripped the vitality not only from the postwar master plot but also from the positive hero. Just as screenwriters edited away any plot device that posed a genuine threat to the ascendancy of socialism, so too did they refine the positive hero into a figure of instinctive maturity, whose challenges were invariably external and not internal (see chapter 6). Such a context was fundamentally unwelcoming for a hero who moonlighted as a villain and was therefore at risk of internal tensions. The spy's duality introduced the potential for conflict of the sort no longer palatable in the era of "the good versus the better," no matter how finely dressed it might be in patriotic colors. This is why Masha's German persona is so very flat and undeveloped, and why Nadia could not even be permitted to conceive a German self.

Paradoxically, it was the peculiar postwar context that gave rise to the spy as a figure of Soviet heroism, yet also required its demise. It was an artificial death— an unnecessary sacrifice to the ideological hubris of *beskonfliktnost'* and Mother Heroines, and as pointless as Masha's suicidal car crash in *Secret Mission*. But it was also an exciting experiment on the part of filmmakers, testing waters that, alas, would not warm significantly until after Stalin's death. Once they did, and the Soviet spy eventually returned to delight Soviet audiences, he became arguably the most popular positive hero of Soviet cinema. Yet his early beginnings, and his feminine roots, have often been forgotten, with *Seventeen Moments of Spring*'s Maxim Isaev (*Semnadtsat' mgnovenii vesny*, Lioznova, 1973)—better known by his cover name, Otto von Stierlitz—even gaining credit for Aleksei's clever code phrase. Does the film have a Slavic spy? In the late Stalin era, such a thing proved impossible.

After 1950, war films were no longer included in Stalin-era production plans, and as a result, the final cinematic word on the war belonged largely to the battle epics and their Stalinized official narrative of events, which reached their apogee

55. Granted, Dobrenko does not reference *beskonfliktnost'* explicitly, but the tendencies and narrative practices that he discusses are the fruit of this approach. Dobrenko, "Late Stalinist Cinema and the Cold War." His analysis focuses on a different corpus of films than this discussion, although it does also include *Secret Mission*.

in early 1950. Nevertheless, this is but a single, albeit rather bombastic, word in the postwar cinematic discourse on war. In reality, Soviet victory in the Great Patriotic War was attributable to a great deal more than simply the genius of Stalin, and contrary to popular assumption, this reality was in fact reflected in the full range of popular postwar films dedicated to the battles, soldiers, and spies so pivotal to the triumph of the USSR.

Filmmakers did not simply produce narratives of the war that served as uncritical extensions of the Stalin cult but rather engaged with the pressing search for a positive hero and character arc fit for the new era of Soviet development—albeit cautiously. Caught between the overbearing shadow of the Stalin cult films, on the one hand, and the radical transformation of the hero and plot in Thaw-era war films, on the other, it is no wonder that the early postwar experiments in war cinema have gone unnoticed. Yet they remain there, preserved in celluloid, or rather nowadays in lines of zeros and ones and available to stream on YouTube. They reveal that war films responded not simply to the petulant demands of the cult of personality to prioritize Stalin's military genius but more so to the needs for social integration in the wake of trauma and dramatic political upheaval within the USSR and the emergent socialist sphere; for firming up the foundational metaphors of a multinational, multiethnic state; for recognizing the contribution of forces other than the Red Army, be they foreign or undercover, while yet folding them in under the authority of the Soviet state; and for giving the Soviet people their due while yet maintaining the sanctity of Stalin's leadership.

By no means did Soviet cinema necessarily succeed in these undertakings, yet its attempts to do so marked the war films of these years. Rather than martial odes to Stalin, these war films constitute a medley of sorts thanks to their differing visions of heroism—one that is largely harmonious but occasionally fractures into dissonance. The result has made for several unexpectedly intriguing works. This chapter has highlighted a few of them, and the following chapter is dedicated to yet another, though it turns away from issues of characterization and plot, toward instead a question of technique as it explores the literal and metaphoric uses of sound in the most popular of all late Stalin-era war films, Sergei Gerasimov's *The Young Guard*.

LISTENING TO *THE YOUNG GUARD*

Stalingrad may have been the most popular battle in terms of film production, but it was not the battle that inspired record-breaking numbers of Soviet film-goers to part with their rubles and kopeks. This honor rested instead with the much smaller-scale but no less defiant struggle on the outskirts of the Ukrainian mining town of Krasnodon, where a handful of young Soviets resisted a villainous occupying force to the point of losing their lives in a gruesome mass execution. These youths were the historic Young Guard immortalized in Aleksandr Fadeev's Stalin Prize–winning novel and brought to life on the big screen by Sergei Gerasimov in his two-part film *The Young Guard* (*Molodaia gvardiia*, 1948). At over seventy-nine million combined ticket sales for the two parts, *The Young Guard* drew the largest crowds of the late Stalin period for a domestic production, while part I even gave *Tarzan the Ape Man*, the most popular foreign film of the decade, a run for its money. In short, it was a blockbuster.

The Young Guard is an intriguing film not simply because of its popularity but due also to its nature as a film caught at the crossroads, both conforming to and circumventing the Stalinization of the war narrative that was well underway by 1948 with the development of the epic battle films. It is a film crafted amid multiple heated controversies: over the novel that formed its basis, the score that brought it to life, and the broader issue of "alien" cultural influence in the early Cold War USSR. Gerasimov's film is an ideal example of postwar censorship in action, since the plot, characters, and even score were redesigned in accordance with the emerging Stalinist orthodoxy. Yet, it is far more than the sum of these ideologically refined parts. Rather than reducing war to a matter of enlightened

leadership, military strategy, and heroic sacrifice, *The Young Guard* depicts the Great Patriotic War as a clash of cultures, with Krasnodon as a battlefield wherein cultural expression—particularly *voiced* and *sounded* expression—is the primary means of contestation between the Soviet Union and Germany. More specifically, Gerasimov's production highlights the significance of silence, sound, and song in the context of war through the way in which it engages with the score, sound engineering, and diegetic music. This approach renders Gerasimov's film exceptional in both form and content.

The notion that song and score boast considerable semantic meaning in Soviet cinematic depictions of war is by no means revelatory.[1] The melancholy ballad taken up in four-part harmony by the regiment, the ethnic motifs representing the diversity of the Soviet fighting forces, even the monopoly of the Red Army on melodious cries of "Ura!"—all are familiar components of the Soviet war film. Enemies too are coded musically, with off-key brass marches more often than not cueing the advent of Third Reich forces and jazzy numbers announcing the suspect American allies in the films of the 1940s. Postwar cinema expanded the repertoire of sonic signifiers even further, incorporating folk music into the triumphal scores of battle epics such as *The Third Strike*, *The Battle of Stalingrad*, and *The Fall of Berlin* and suspense dramas like *Meeting on the Elbe*.[2] While *The Young Guard* builds on these sounded associations, it moves far beyond them, transforming this smattering of tropes into a symbolic language sufficiently coherent and comprehensive to form the basis of the film's plot. That is to say, instead of following the classic socialist realist master plot charting the positive heroes' dialectical development, Gerasimov's film is structured around transformations in the sound design: in the changing meaning of silence and sound as the occupation progresses, and in how the young protagonists interact with silence, sound, and song as their resistance gains momentum. In this sense, it is the soundtrack that provides the master plot. The result is a unique conceptualization of the war as a cultural battle rather than a military or political one.

As told through the film's sonic elements, the tale of the Young Guard follows a double arc. The first arc, completed in part I of the film, centers on silence and its reappropriation by the young heroes. As such, the first film traces the transformation of silence from a sign of submission to German aggression into a tool of patriotic Soviet resistance. The second arc, the preoccupation of part II of *The Young Guard*, focuses on sound and the reassertion of Soviet sounds over the Germanic. This arc unfolds as the protagonists begin to vocalize Soviet culture

1. David C. Gillespie, "The Sounds of Music: Soundtrack and Song in Soviet Film," *Slavic Review* 62, no. 3 (2003): 490.

2. Tatiana Egorova, *Soviet Film Music* (New York: Routledge, 2014), 129–31.

and identity through such things as ideological speechmaking, addressing Germans in Russian, and most powerfully through cultural performance, be it poetic recitation, traditional Ukrainian and Russian dance, or folk song. At first, the Young Guard undertake these acts of speech and song privately, within their own circle. But they soon graduate to the public sphere, using Soviet sound first as a tool of distraction and ultimately as a statement of open defiance. As a result of such sonically centered plotting, the major conflict of *The Young Guard* is displaced from the battleground to the soundscape. This marks a reversal of the usual relationship between the oral and visual in Soviet cinema, where sound is used to add emotional depth to the images in order to help steer their impact on and interpretation by audiences.[3] Instead, the images of *The Young Guard* render more comprehensible the meaning of sound in the war as a cultural struggle against the occupiers.

Although *The Young Guard* is a product of exhaustive ideological correction, with Gerasimov's adaptation transforming the novel's ode to youthful initiative and sacrifice into a textbook case of the foresight and leadership of the party, it nevertheless remains an unusually creative work for the period. At final viewing, it bears less in common with the saber-rattling of the Stain-era war epic than the more nuanced fare of the Cold War era of cultural competition under Khrushchev. With this in mind, let us listen again to this film, leaning in to catch the subtler sounds of conflict that score and soar far beyond its conventionally Stalinist imagery.

Adaptation and Censorship

First, a little about the origins and production of this Stalinist blockbuster. By the time *The Young Guard* made it onto Soviet screens in October 1948, the tale of the youthful resistance movement was already a cultural phenomenon.[4] Its first literary iteration was published as a serial in the journal *Znamia* (*The Banner*) over several months in 1945 before it was released in a single volume in December to much acclaim. Fadeev, who was considered a politically reliable figure, had been commissioned by the Komsomol to write the novel, which he based largely on documentary evidence that he supplemented with "poetic license" when it came to character development, the relationships within the group, and most controversially in later

3. Kevin Bartig, "Kinomuzyka: Theorizing Soviet Film Music in the 1930s," in *Sound, Speech, Music in Soviet and Post-Soviet Cinema*, ed. Lilya Kaganovsky and Masha Salazkina (Bloomington: Indiana University Press, 2014), 182.

4. Historian Juliane Fürst describes it as the Harry Potter of its day—an apt comparison! Fürst, *Stalin's Last Generation*, 142.

years, the identity of the collaborator who betrayed the youths to their deadly fate.[5] The tale struck a chord, particularly with Soviet youth, and flew off the bookstore shelves at an astonishing rate. Library waiting lists ran into the hundreds, and impatient would-be readers resorted to begging, borrowing, and stealing in order not to miss out on this literary sensation. Tens of thousands of readers participated in public discussions, and enthused youths established their own Young Guard organizations in schools across the Union.[6] Needless to say, the film adaptation of Fadeev's novel was highly anticipated by Soviet audiences.

It was also of keen interest to the regime, but for somewhat different reasons. The novel was initially celebrated and awarded the Stalin Prize First Class in 1946, and its author promoted to chairman of the Writers' Union. But in late November 1947, it fell afoul of officialdom during the re-Stalinization process embodied by the *Zhdanovshchina*. Heavy criticism by Agitprop's official organ, *Kul'tura i zhizn'* (*Culture and Life*), for the theatrical adaptations of *The Young Guard* were quickly extended to Fadeev's novel itself as editorials in *Pravda* and *Literaturnaia gazeta* (*Literary Gazette*) denounced its depiction of chaos and panic instigated by the German advance, its failure to reveal the leading role of the party in organizing an orderly evacuation of the Krasnodon region, and the portrayal of the youth movement as functioning virtually independently of party input.[7] Interestingly, the abrupt repudiation of the novel occurred just ten days after part I of the film was previewed and discussed by the Artistic Council, lending credence to writer and memoirist Ilya Ehrenburg's claim that it was the film adaptation that called Stalin's attention to the features of Fadeev's story subsequently defamed in the press.[8] Either way, the brouhaha over *The Young Guard* in late 1947 meant that the film adaptation became a very public test case for developing the corrected, politically usable version of this vital wartime narrative.

It also meant that Gerasimov had to go back to the drawing board. The director had crafted his cousin-in-law Fadeev's novel into a play to help train his acting and directorial students at VGIK. They performed it in February 1947 at the Theatre of the Film Actor in Moscow before an audience of cinema industry notables (including Minister of Cinema Ivan Bol'shakov), whereupon the deci-

5. Harold Swayze, *Political Control of Literature in the USSR, 1946–1959* (Cambridge, MA: Harvard University Press, 1962), 46; Maksim Kazyuchits, "Sergei Gerasimov's *The Young Guard*: Artistic Method and the Conflict of Discourses of History and Power," *Studies in Russian and Soviet Cinema* 13, no. 2 (2019): 163.

6. Fürst, *Stalin's Last Generation*, 141–42, 153.

7. Swayze, *Political Control of Literature in the USSR*, 43.

8. Gosfilmofond, file 1306 (*The Young Guard*), "Obsuzhdenie, 20 Nov 1947"; Fürst, *Stalin's Last Generation*, 156.

sion was made to develop it for the big screen.[9] Filming proceeded apace until it was halted so jarringly in the fallout from the novel's public censure. After extensive reshoots and editing over the coming months, part I finally met with Artistic Council approval in late July 1948 and was even commended for "achieving a correct resolution of the theme of the party's leadership of the struggle of the Soviet underground against the Hitlerite occupiers."[10] Gerasimov passed the test and provided a viable retelling of the story suited to the emerging Stalinized account of the war—at least in part I.

Part II, however, fell short of the mark. In the same report that lauded the revised first installment, the Artistic Council condemned the second for its gloomy preoccupation with the suffering and death of the protagonists, which was deemed to overshadow their accomplishments. Gerasimov was charged with reworking the film under the implicit directive to leave much more of the heroes' hardships to the imagination so as not to dilute the message of victory. The final version certainly bears the telltale signs of abrupt transitions and truncated scenes typical of hasty reediting, but it was enough to earn the reluctant recommendation of the Artistic Council for the film's licensing a fortnight later.

Dmitry Shostakovich's score for the film traced a similar path of ups and downs. He was an ideal composer for *The Young Guard*, being incredibly popular among Soviet youth at the time and having already begun work on an operatic treatment of the story. Gerasimov was enthusiastic about Shostakovich's involvement, praising his score for the first part of the film during the November 1947 Artistic Council discussions and likening it excitedly to a "free voice pouring from the throat of the cinematic frame." The score for the second half of the film, however, was lambasted for "exacerbating the mood of depression" in the final scenes and was singled out for correction. Shostakovich had fallen into disfavor during the film's production, so that by the time part II was under review, he numbered among the so-called formalist composers castigated in the February 1948 resolution "On the Opera *'The Great Friendship,'*" his repertoire rendered off-limits for public performance.[11]

In light of this blacklisting, Shostakovich's work on such an ideologically significant production as *The Young Guard* no doubt took on new consequence for the composer, and not only as a means to pay the bills. Though generally dismissive of film scoring by this point in his career, Shostakovich did concede that

9. For a fascinating study of *The Young Guard* in light of the role of Gerasimov and his wife, Makarova, as trailblazing pedagogues at VGIK, see Kazyuchits, "Sergei Gerasimov's *The Young Guard*."

10. RGASPI 17/132/90/39.

11. Swayze, *Political Control of Literature in the USSR*, 44; Levon Hakobian, *Music of the Soviet Era: 1917–1991* (Abingdon, Oxon: Routledge, 2017), 174. Gosfilmofond, file 1306 (*The Young Guard*), "Obsuzhdenie, 20 Nov 1947"; RGASPI 17/132/90/40.

it was a "political seminar" for composers, and he may have realized that it could provide a potential route back into official favor.[12] By mid-August, the amended score was completed and deemed "successful," helping to secure the film's release and arguably earning Shostakovich the invitation from Stalin to represent the USSR abroad that he leveraged into a revocation of the ban against himself and his "formalist" colleagues.[13] At the very least, the score "set him firmly on the path of recovery," in much the same way as the film brought the tale of *The Young Guard* back into the realm of official approval, as attested by the avalanche of awards granted to the film's cast and crew.[14]

In many ways, the account of *The Young Guard*'s adaptation and censorship for the screen follows a familiar trajectory given the context of the Zhdanovshchina. Spontaneous partisan activity is subsumed under the leadership of the party; the Red Army is suddenly more active and orderly than ever before; and any hints of loss, trauma, or the cost of individual sacrifice are drowned out by the overwhelming emphasis on Soviet victory with not one but three montage sequences featuring bombastic war front footage. Yet, it is this seemingly typical Stalinization of *The Young Guard* that makes its unusually nuanced and richly layered use of sound all the more striking, beginning from the very moment war comes to Krasnodon.

12. Laurel Fay, *Shostakovich: A Life* (New York: Oxford University Press, 1999), 171.

13. RGASPI 17/132/90/42. The turnaround for this transformation was less than a fortnight, between July 31 and August 13, 1948, and no doubt helped secure the Artistic Council members' recommendation for the film's release despite their continued ire at the tragic ending (see RGASPI 17/132/90/40, 42). The revisions may well have been worth it for Shostakovich personally as well, considering that the motif from the youth's death march reappears in several of the composer's later works, including the First Cello Concerto (1959) and the "most confessional of Shostakovich's works," his autobiographical Eighth String Quartet (1960). Solomon Volkov and Antonina W. Bouis, *Shostakovich and Stalin: The Extraordinary Relationship between the Great Composer and the Brutal Dictator* (New York: Knopf, 2004), 268, 272; John Riley, *Dmitri Shostakovich: A Life in Film* (London: I. B. Tauris, 2005), 64.

14. Marina Frolova-Walker, *Stalin's Music Prize: Soviet Culture and Politics* (New Haven, CT: Yale University Press, 2016), 231. Following record-breaking ticket sales, a concerted promotion campaign by a delighted Komsomol leadership, and the award of a Stalin Prize First Class (1949), the key creative figures behind *The Young Guard*—Fadeev, Gerasimov, and Shostakovich—were sent to New York City as representatives of the USSR at the Cultural and Scientific Conference for World Peace in March 1949. Reluctant to travel so far when he was ill and still officially in disfavor with the regime, Shostakovich initially refused the commission. Stalin then intervened directly, phoning the composer to "request" his participation, whereupon the formalist pointed out that his work, along with that of a handful of others, was currently banned in the USSR. The next day, a doctor was sent to Shostakovich and the ban on formalist composers was lifted. Several days later, *The Young Guard* team was in New York City, alongside the dynamic duo behind the postwar Stalin epics, director Mikhail Chiaureli and screenwriter Petr Pavlenko, whose next project, *The Fall of Berlin*, Shostakovich was also due to score. Fay, *Shostakovich*, 172; Terry Klefstad, "Shostakovich and the Peace Conference," *Music and Politics* 6, no. 2 (Summer 2012): 1–21. Why Shostakovich was singled out by Molotov and then Stalin to serve as a delegate for this conference is unknown, but it is likely that his "successes" in scoring ideologically significant films at least helped to prepare the way.

Arc One: From Submissive to Appropriated Silence

The arrival of the Germans on Soviet soil is seldom depicted in postwar film. One exception would be *The Fall of Berlin*, wherein the protagonists witness the initial advent of the enemy by air and motorbike. Yet even there, the hero Alesha passes out after a brief montage of destruction, only to awaken three convenient months later, having been evacuated to safety beyond occupied territory. Instead, late Stalin-era war films tend to either join the conflict already underway (or, better yet, once the tide has turned in favor of the Red Army) or avoid picturing the actual invasion. For postwar cinema, the German invasion is either established fact or shocking report, but in either case it is not something that warrants illustration.

Gerasimov discards this unspoken convention decisively in *The Young Guard*, treating the invasion of Krasnodon in an extended sequence that accounts for almost 8 percent of the first installment's total running time. It is masterfully done. The nearly six and a half minutes combine the usual array of wide-angle and medium shots with deep focus, high-angle shots, and a swooping crane shot, crowned by a two-minute long take that sees the camera suddenly dislodged from a stable long shot and take off into an extended, disorienting tracking shot that constantly shifts its focus between confused villagers and crowing victors as if itself in a state of bewilderment. But it is not only the visual artistry of this sequence that is so remarkable; more so, it is the accompanying soundtrack, which Gerasimov uses to convey the complete subjugation of Krasnodon to German authority. This is done not in the more predictable manner of *The Fall of Berlin*, where the violent noise of war overwhelms a village with the explosive percussion of bombs and gunfire, although it is true that the arrival of the German forces to the region surrounding Krasnodon is broadcasted in such a manner. Instead, the occupation of the town itself is underscored through a far more metaphoric use of sound, as the bustling German soundtrack drowns out the sounds of daily life.

From the very outset of this sequence, the film underscores the significance of sound. Marked by an intertitle, it begins with babushka Vera Vasil'evna noisily chopping wood, then cuts to the comfortable silence of an interior shot where her daughter Elena Koshevaia, played by Gerasimov's wife, Tamara Makarova, sits contemplating a photograph of herself and her son Oleg—a picture of the happy life granted to Soviets. Vera disrupts this quietude when she rushes in, distraught, to proclaim the coming of the Germans. The immediate cut to an exterior shot is accompanied by the tinny strains of a brass band giving jaunty proof to Vera's announcement, echoed now by a winded Sergei Tiulenin, hastening to give warning. For the audience and many, if not all, of the people living

here on the outskirts of Krasnodon, the enemy is heard long before he is seen. And once he is, it is his voice and his noise that dominate.

Apart from a hurried exchange between two future Young Guards, the townspeople remain silent throughout the invasion: both the men being rounded up and the women who watch. The Germans monopolize the ability to create sound as their assertive shouting seems to consume all the air. Exclamations, directives, and questions spoken in (noticeably fluent) German fill the soundtrack, which is unusual since Germans in Soviet war films tend to speak heavily accented Russian with only a smattering of German words tossed in for flavor. The effect for the viewer is to re-create at least an echo of the confusion of the wartime experience of occupation. The ascendancy of the German language is underlined by the sign in Gothic script that an officer carries and will no doubt soon install over the new local German headquarters. These sounds released by the Germans disrupt regular life in Krasnodon and displace its inhabitants to the position of mute observers. In what could be seen as an attempt to counter this effect and reassert the humble routine of daily chores, one woman tries to fill her buckets at the well, only to have them snatched by raucous, shirtless German soldiers who toss the pails' contents with celebratory whoops. She watches aghast as a rumbling truck full of singing soldiers with accordion accompaniment set the wet soldiers to singing and dancing. It seems to be their song as much as their dance that stuns her into silence (figure 3.1).

The sonic assault of the occupying force reaches its climax with the piercing brass march that presages the arrival of the motorcade bearing General von Ventsel. As he steps out of the vehicle to survey his new dominion, the ensemble responsible for the boisterous serenade becomes visible on a flatbed in the background, and Shostakovich's frenetic score becomes diegetic: just one more weapon in the arsenal of Germanic reverberation reshaping Krasnodon. The combined rumble of the truck's engine and resonance of the brass band is so forceful that it threatens to drown out the German officers themselves as they greet one another. The Soviets are speechless in the face of this solid wall of foreign sound. The German invasion both silences the people and alienates them in their own community.

There is no bloodshed or physical violence in these scenes of German takeover. Gunfire is reserved for a chicken destined for the soup pot, and shouts, to express celebration or give instruction. The true battle of this invasion and subsequent occupation resides in the cacophony of the German troops, the relentlessness of the German language, spoken and sung, and the conquering clamor of the brass band. These are the forces that usurp Krasnodon.

The silence of the subdued Soviets is broken only momentarily at the end of the sequence by Vera, who, presumably cued by the revving of the truck and

FIGURE 3.1. A wall of sound: the German invasion of Krasnodon. *The Young Guard* (Gerasimov, 1948).

thudding of her own axe (surrendered earlier to the Germans), protests indignantly at the razing of the picket fence and felling of the alder saplings in her front yard. She is the only one to utter a sound directly against the Germans during the invasion. That she does so in protest against an act of such salient allegorical meaning as breaching the borders of her home and felling the young trees in her care is no coincidence. (She, for one, will not stand quietly by as the youth of her nation is cut down to satisfy German whims.) But her outcry only amplifies the otherwise unbroken silence of her neighbors and calls attention to the overall muteness of the Soviet response to invasion. Both the Germans and her own daughter ignore Vera's exclamation, and it is clear that a new balance of power has been established in Krasnodon.

This pattern of sonic subjugation by the Germans plays out repeatedly in the coming days and weeks, beginning that very evening on the hills overlooking the town. Here, the young protagonists and other residents gather on their way back home after a failed attempt to flee across the river to safety. Expanding the occupation of the town's streets and homes to the hills and fields surrounding it, a Wehrmacht motorcade pulls up to where the group is gathered. The commanding officer jumps out and launches into a shrill monologue as he orders people

stripped of their boots and other belongings, strikes an exultant pose for a photographer, and sings and dances a giddy little jig. Again, the people are silent in the face of this onslaught of German noise. But this time, the quality of the silence has begun to shift: the young faces are neither stunned nor bewildered as were their older counterparts in town; instead, their expressions are circumspect, as if holding their peace while weighing the excitable officer and his antics. This moment is the first step toward a shift in the meaning of silence in the film.

The redefinition of the people's silence from a sign of submission to a tool of defiance continues shortly after, while a group of German soldiers carouses drunkenly at the Os'mukhins' house. Their off-key singing of "Stenka Razin" (adapted to claim the Volga for Germany) and bellicose *sieg heil*–ing are shown to be disturbing Volodia Os'mukhin, who lies bedridden as his mother and sister tend him worriedly.[15] The domineering wave of German clangor is oppressing happy Soviet families. All this racket provides the perfect cover, however, for anti-German action. Nearby, Sergei Tiulenin (Serezha) and Valeriia Borts (Valia) reunite at an attic window, quietly observing the foe just as they had done the Germans' arrival a short time earlier. The scene is re-created almost shot for shot from the invasion sequence, when the two first met and were helpless to do aught but watch and listen from the school window as their neighbors were rounded up. This time, the young people's silence serves a martial purpose. Serezha, adjuring Valia to keep quiet, stealthily pitches a pair of Molotov cocktails at a German-occupied building, igniting shouts of panic along with the flames. Gerasimov's echoing of the earlier scene here emphasizes the transition of silence from a symptom of the powerless, as during the invasion, into a weapon wielded by those determined to take action against the oppressor.

Once founded, the Young Guard continue to use silence to their advantage, carrying out acts of retribution and sabotage on tiptoe while the enemy is consumed with his own conversing and merrymaking. In two key sequences, a collaborator is hanged and dozens of comrades freed from German imprisonment after a guard is felled, all to the tune of silence (figure 3.2).

The Young Guard weaponize what was initially a sign of submission. In so doing, they reclaim their agency as loyal Soviets and take up the role of operatives of the underground. It is no coincidence that in the closing moments of the first film, the silence of the Young Guard is paralleled by that of the party representatives responsible for organizing the region's resistance movement. Shots of the two groups standing quietly at attention around a radio thrumming with the opening theme of the news broadcast *Govorit Moskva* are intercut with one another, not only construing the close connection between the youths and

15. Riley, *Dmitri Shostakovich*, 63.

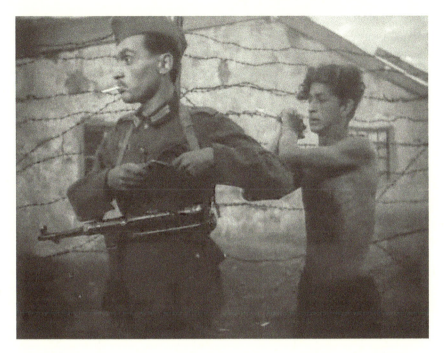

FIGURE 3.2. Death comes on tiptoe. *The Young Guard* (Gerasimov, 1948).

their adult mentors (that is, between partisan and party) but also demonstrating the appositeness of silence as a patriotic act.

Arc Two: Vocalizing Sovietness

Despite the successes of the Young Guard's quiet resistance, a cultural war cannot be won through silence alone. Instead, victory must also involve the reassertion of patriotic sound. The first film foreshadows this necessity in Part I. The two scenes in which Oleg and then Liuba Shevtsova first encounter the invaders foreshadow the need for a dynamic, audible response to follow on from patriotic silence. In these scenes, each young hero reacts to the German soldiers initially with a frosty silence that conveys a sense of mature self-possession, in contrast to the juvenile japery or sleazy fawning of the unwanted German houseguests. Maintaining a mute response becomes impossible, however, as the enemies persist in trying to engage the protagonists. For Oleg, a responsible and cultured Marxist-Leninist, this is because the German soldier's increasingly disrespectful behavior (including damaging several books) can no longer be left unchallenged. For Liuba, who has been formally commissioned with infiltrating

the Wehrmacht to gather vital intelligence, deceiving the Germans requires communicating with them and winning their trust. And so both Oleg and Liuba ultimately break their silence and address the Germans directly, either in defiance (Oleg) or duplicity (Liuba). These two uses for Soviet sound model the approach adopted by the Young Guard as a whole in the second part of the film.

The close of the first film signals the need to shift from silent to sounded warfare, setting up part II and its sounded arc. As the *Govorit Moskva* theme rises from the radios of loyal Soviets young and old, Shostakovich's score stirs to life and the shot cuts to a train crossing a bridge, observed by the partisans just as it explodes magnificently (and repeatedly, for effect), toppling the train into the river below. A frenetic montage keeps time with the triumphant orchestration, intercutting shots of partisan leader Andrei Val'ko machine-gunning wildly (and seemingly rather fruitlessly, given that he is so far from the conflagration), and train cars combusting spontaneously, shredding apart, leaping into the air, and otherwise defying the laws of both physics and continuity editing.[16] The whole sequence is punctuated visually and audibly by repeated munitions blasts as even the water itself explodes in trumpeting plumes like a musical fountain. This closing montage, beginning with the shots of the Young Guard and regional party leader Ivan Protsenko et alia standing in tribute before their radios, was added following the first round of criticism by the Ministry of Cinema's Artistic Council in 1947. It was intended to highlight the ties between the youths gathered in Krasnodon, the regional party organization, the front, and the voice of authority at the center, and also to end the first installment of the film on a more resounding note.[17] The sound of (edited) victory is very loud indeed.

The Dance Party: Reclaiming Song and Dance

Part II of the film sees the young protagonists gradually advance toward just such a resonant victory of their own. This is not to say that the Young Guard have hitherto been completely silent in their activities. Rather, their enunciation of Soviet ideology and identity simply remained largely private in part I. These confidential utterances of Sovietness culminate in a pivotal sequence early in part II of the film, as the protagonists gather on the eve of November 7 in honor of the twenty-fifth anniversary of the October Revolution. The ensuing celebration marks the climax of clandestine expressions of Sovietness and lays the groundwork for taking such performances public. It is a critical moment in the film. As

16. For instance, two cars apparently make it to the grassy banks of the river, where they roll down and crush a group of Germans. How on earth either the men or the train cars made it to dry land for their fatal fellowship is unclear.

17. Kazyuchits, "Sergei Gerasimov's *The Young Guard*," 165; RGASPI 17/132/90/38.

with the equally significant invasion sequence, the celebration sequence commands a considerable proportion of the second film: a full ten minutes, or nearly 10 percent of the running time. This scene consists of two distinct phases, each marking an important step in the replacement of silence with patriotic sound as the primary weapon in the Young Guard's arsenal.[18]

The first of these phases presents the more formal aspect of the evening's festivities, which begin with a degree of solemnity as Oleg offers an effortful toast to the Revolution. The youths hush one another to keep their responses subdued. A visceral reminder of the seriousness of the situation immediately follows in the form of a furious knock at the door, whereupon several German officers enter the kitchen next door and carry off much of the food prepared for the gathering, seemingly oblivious to the fact that there was a great deal more sustenance at the ready than would be warranted on an average evening by the small Koshevoi family. The Young Guard hold their collective breath on the other side of the kitchen door, once again forced into silence by the occupiers' presence. How easily silence can become a sign of submission once again and not the powerful tool of resistance the Young Guard would otherwise have it be. But all is well, the Germans leave, and Ul'iana Gromova (Ul'ia) soon presses forward in commemorating the historic day with a sober recitation from Mikhail Lermontov's "Demon."

Both the enforced silence and the formality of this opening chapter of the party sequence encapsulate the dynamics between the Young Guard and sound up to this point in the film. Oleg's toast and Ul'ia's verse recall the official air and performative language that have characterized the Young Guard's activities together to date, beginning with the ritualized oath-swearing ceremony that founded the group and continuing through the two subsequent party-style meetings held during the first film. These official gatherings were complete with an order of business, motions proposed and carried, and minute-taking, and addressed such issues as action plans, inducting new members, and passing judgment on behalf of the Soviet state, with the verdict subsequently delivered as if in a court of law during the youths' execution of the collaborator. The celebration of November 7 begins in the same room as these earlier proceedings, filmed using the same mise-en-scène, and therefore drawing a clear connection to the group's previous assemblies. These activities, aping the procedures and voice of the party, had served to maintain a type of covert Soviet order for the youth in Krasnodon in the midst of the occupation. The Germans may have taken over the party building for their headquarters, but the Soviet state of the Young Guard

18. In contrast, the celebration in no way served as a turning point in Fadeev's novel, where it was a much smaller affair and neither transformed into a reclamation of cultural performance nor inspired the ploy to use a cultural show as cover for an anti-German operation.

had Oleg's dining room. From here, they went out into the quiet corners of the occupied town to furtively mete out Soviet justice. Such was the extent of the Young Guard's Soviet practice to date: secretive, formal, and ritualistic.

The second phase of the party sees the expansion of the protagonists' rather formal enunciations of Sovietness into the less ceremonious realm of song and dance. This marks an important shift in the tone of the Young Guard's activities—from bureaucratic ritual to expressions of popular culture—which is signaled in the way it comes about.[19] Just as Ul'ia's grave recital peaks in grandeur as she slowly rises from her seat and the camera steadily inches into a midshot, Serezha interrupts with a wisecrack, and the room erupts in laughter. It is the first genuine burst of hilarity that has been voiced since the invasion. With it, the mood of constraint inspired by the enemy's presence in town (and reinforced by his recent intrusion) seems to shatter, and the youths abandon their attempts to quieten their celebration. Instead, at Liuba's behest they leave the meeting room behind for the music room next door and let loose in an unbridled display of musical revelry. With this, they step out of the routine of secret Soviet practice and speech established so far, and toward a more overt performance of Sovietness. They begin at first by dancing a waltz to a Slavic melody performed by a trio of boys on guitars and a balalaika, whereupon Baba Vera admonishes them for "dancing foreign" and leads them in "our Gopak," a traditional Ukrainian dance. Oleg joins with bouncing energy and wildly flopping hair, before Liuba takes the lead with a Russian dance. Though a rug is rolled out to muffle the feverish tapping of her footwork, no further effort is made to hush the joyous renaissance of the sounds of Soviet celebration (figure 3.3).

With this, the Young Guard's articulation of Sovietness extends beyond the bureaucratic forms of official culture dominant in the first film, to the lively display of folk culture that Soviet nationalities policies of the 1930s ostensibly encouraged and socialist realism of the postwar era certainly extolled.

This noisome celebration does more to counter the repressive occupancy of the enemy than any number of secret meetings and ritualistic protocols. This is because in seizing the prerogative to carry out an evening of traditional Russian and Ukrainian entertainment in honor of the event that birthed the USSR, the Young Guard take back the realm of cultural performance that hitherto has belonged solely to the Germans in Krasnodon. As we have seen, Gerasimov's account of the invasion involved the German mastery of the soundscape in large part specifically through music and singing, in addition to the rest of the commotion. In the intervening scenes, the Germans alone continued to enjoy music.

19. This is not, however, to imply that popular culture is opposed to formal or official culture, since Soviet popular culture as depicted in state-approved cinema like *The Young Guard* is itself "official."

FIGURE 3.3. Liuba dancing Soviet. *The Young Guard* (Gerasimov, 1948).

By filling the diegetic soundtrack for the first time with Russian melodies, the dance party of the Young Guard lays claim to one of the most vital of the enemy's weapons for Soviet use. What is more, it also inspires Oleg to propose forming a cultural club—one that facilitates the move of Soviet cultural performance from a private back room to a public stage. It is in this transition that the youths' song and dance transform from a type of defense mechanism to maintain Soviet identity within the safety of their inner circle, into an offensive strategy for engaging and disarming the enemy. After the party, the Young Guard cloak their activities no longer in silence, but rather in assertive sound.

The Concert: Deceptive Soviet Sound

Now armed with the power of song and dance, the young heroes seize the soundscape of Krasnodon in what the Artistic Council considered to be the most successful sequence of *The Young Guard*: the concert scene.[20] In it, the newly founded cultural club puts on a performance for the Germans under the guidance of the Young Guard, who use it as cover for an arson attack against the labor

20. RGASPI 17/132/90/39.

exchange building, where the enemy has been processing townspeople for transport to Germany as slave labor. In this way, the protagonists mobilize sound as a tool of distraction and deception in their campaign to protect friends and neighbors from exploitation. The fifteen-minute sequence weaves together two unrelated episodes from Fadeev's novel in a manner that infuses not only the scene but also the film as a whole with greater ideological heft. It is this scene, as redefined by Gerasimov and executed by sound engineer Nikolai Pisarev, that makes the developmental arc of the film and its unique representation of warfare possible. This is achieved primarily through two specific features of the sequence: the sound design and Liuba's performance. Together, these two elements present warfare as a cultural struggle while also identifying what is necessary for victory in such a conflict. In the course of this quarter hour, the concert's German audience is reduced to mere listeners as the Young Guard take back control of both sound and its perception in their boldest offensive yet.

In terms of montage, the concert scene is constructed of continual cross-cutting between two parallel arenas. In the first, inside the concert hall, shots of the Soviet performers alternate with those of the German audience seated before them and the Young Guard watching both stage and stalls from the wings. In the second, outdoors, Liuba keeps a lookout as Serezha overpowers a guard and sets several incendiaries alight inside the labor exchange building, while Ul'ia watches over their escape, ready to assist by distracting wary guards with a gunshot fired into the ground. The intercutting of these two ternary dramas of action and observation heightens the tension of the sequence by doubling the stakes: will the Young Guard onstage succeed in captivating (and thus preoccupying) the treacherous audience? Will the Young Guard outside succeed in foiling the guards and fulfilling their plans of sabotage? In both minidramas, near disaster is overcome through quick action, and the Young Guard emerge triumphant. Liuba provides the narrative thread tying together the two halves of the action, as she transitions seamlessly from assisting in the sabotage to starring onstage. But it is the sound design that truly unifies the scene and renders it easily legible despite the complexity of the visual storytelling.

Throughout the entire sequence, whether indoors or out and regardless of the shot's point of view, the soundtrack belongs to the concert hall stage. Accommodation is made in the volume of the soundtrack depending on the shot's location and to ensure that dialogue among the members of the Young Guard is decipherable. But all other sound is subsumed to the recital indoors. The effect is to emphasize the significance of the concert, and also to convey the extent to which it is the Young Guard who are now ascendant in Krasnodon. For instance, when a performance in the hall first elicits applause, the approbation accompanies an exterior shot of Serezha returning into view after having dispatched a

German guard. The juxtaposition of indoor sound and outdoor action means that the officers in the hall are unknowingly applauding the defeat of one of their own. On the one occasion when the sound of the concert is interrupted, it is done so by the Young Guard themselves, as Ul'ia fires the gun to distract the guards. In other words, the youths are in control of what is heard, which in turn determines what is perceived by the Germans. As the building goes up in flames, and even when it explodes and the German guards finally arrive on the scene, the only noise conveyed in the sound design is clapping from inside the hall, where the officers have been singing along with Liuba's performance. The applause is confirmation of the Soviet dominion established in the town that evening and is made all the more potent by the audience's lack of awareness.

This resonant victory is underscored by the closing montage of the sequence, which mirrors the finale of part I, but this time with the Young Guard taking a more active role. Shots of Liuba's triumphant display are intercut with the blazing building outside, the dancing flames echoing her swirling skirts. This visual metaphor is followed by shots of Protsenko, Val'ko, and the partisans battling on the front (and dying, in Val'ko's case). On the soundtrack, the closing crescendo of Liuba's song and responsive cacophony of clapping harmonize into an exultant flourish as the orchestral score blooms into life, punctuated by battlefront explosions. The concussive reports instigated by the partisans are impressive, but the applause provoked by Liuba and the Young Guard that night in Krasnodon is just as powerful a melody of conquest. As if to underline this connection, the concert sequence closes with an intertitle proclaiming the coming of the "historic days of the defeat of German forces at Stalingrad," and their retreat westward, passing Krasnodon. This evening of song, dance, and arson has been the Young Guard's personal Stalingrad.

Of equal, if not even greater, significance as the sound design in this critical sequence is Liuba's stint onstage and the numbers she performs. Unlike the literary versions of *The Young Guard*, the cinematic adaptation sees Liuba present two foreign pieces for her set: a Spanish dance, complete with clacking castanets, and a crowd-pleasing cabaret-style tune sung in German with a can-can accompaniment. The performance is rather risqué, and not just because Liuba reveals more leg to the invaders than can be comfortably permitted for Soviet eyes (though blocking is used to obstruct the camera's view of the more scandalous of skirt flounces). The inclusion of foreign compositions and choreography was also risky in a political sense, considering the campaigns of cultural purging pursued by the regime after the war. What is more, official concern over the "ideological corruption of youth" that had taken place during the German occupation, particularly in Ukraine, would likely have spelled close scrutiny for Gerasimov's film given its content and intended audience as a Soiuzdetfilm

production.[21] The result was worth the gamble, though, for not only did Liuba's choice of performance pass censorial scrutiny without remark but it also substantially enriches the concert sequence and the victory it represents.

More specifically, Liuba's foreign set list renders the Young Guard's success that evening both more believable and ultimately more potent. With regard to the first point, the plausibility of the Germans' obliviousness to the conflagration raging outside relies on their being convincingly preoccupied by what is happening on the stage before them. Initially, the Young Guard struggle to captivate them with offerings of traditional melodies and folk songs. The Germans are disengaged and restless, scoffing when Ivan Turkenich serenades the Russian Volga—a river the officers had claimed for Germany in their own song earlier in the film. Ivan's quick switch into the familiar toe tapper "The Peddlers" fares better and inspires the first round of mild applause, while the subsequent *tsyganskii romans* (gypsy-style song and dance) elicits greater approval, perhaps due to its exotic flavor.[22] It is not until Liuba takes the stage, however, that the spectators are completely absorbed in the Soviet performance. And this is arguably precisely because Liuba's performance does not present as being Soviet. From the moment she sweeps in, the audience is engaged, eagerly ogling her dancing form and singing along with the German lyrics as they trip from her lips. Liuba's physical attractiveness certainly plays a part in their delight, with her relatively revealing evening attire and Aryan coloring making a compelling contrast to the dour-faced boys in peasant shirts who preceded her onstage. So too do the months she has spent wooing the occupiers with ready giggles and conversation, inspiring them to call for her to take the stage long before her set. (Little do they know she is out of earshot outside, acting as accomplice to murder and arson.) In short, Liuba provides entertainment suited to German tastes (figure 3.4).

The impact of Liuba's set list goes beyond sex appeal to cultural appeal, a much more evocative issue for regimes invested in social engineering like Nazi Germany and the Soviet Union. Liuba's act appears to concede the cultural ascendancy of Germany and its so-called dream factory, the cinema industry. This is because her repertoire would have been perfectly at home on the soundstages of UFA, the central Nazi-era film studio. Liuba is essentially playing the Soviet Marika Rökk or Zarah Leander, leading ladies of German wartime cinema. Like Liuba, both stars sang in heavily accented German, being of Hungarian and Swedish origin, respectively. They were also skilled dancers, with their films incorporating energetic onstage performances. In fact, Leander even slinks through a Spanish dance as she sings in *Back Then* (*Damals*, Hansen, 1943), while Rökk kicks up a superlative

21. Fürst, *Stalin's Last Generation*, 143.
22. This piece, "Korobeiniki," is better known to modern Western audiences as the "Tetris song."

FIGURE 3.4. Liuba dancing Nazi. *The Young Guard* (Gerasimov, 1948).

can-can in time with her vocals in *The Woman of My Dreams* (*Die Frau meiner Träume*, Jacoby, 1944).[23] Carried out in a similar style, from costuming to the choice of song and choreography, Liuba's set is a grand gesture toward cultural assimilation, albeit a deceptive one. It is the culmination of her efforts in posing as a Germanophile, and the fact that her disingenuity goes undetected marks her greatest achievement as a spy. Rather than simply a seductress, Liuba's performance establishes her as a cultural chameleon, capable of adopting the enemy's ways— however bourgeois and degenerate—and wielding them in service of the Soviet cause.

In so doing, Liuba's set redefines the nature of the Young Guard's victory, transforming the destruction of the labor exchange building from a mere act of martial resistance typical of partisans in wartime cinema into a conquest redolent

23. Rökk's film *Die Frau meiner Träume* was one of the first trophy films to be released in the USSR when it screened in the autumn of 1946 as *Devushka moei mechty*, while *Damals* was among the last, premiering as *Kto vinovat* in 1955, though Leander's film *Das Herz der Königin* (Froelich, 1940) was released five days after the first part of *The Young Guard*, in 1948, as *Doroga na eshafot*. In an interesting aside, it turns out that Rökk was a Soviet spy during her time as a Nazi film star, while Leander declined to socialize with members of the Nazi regime, paralleling Liuba's own anti-German agenda. This would not have been known at the time of the film's production, however, and is but one of those happy coincidences that make historical research so very rewarding.

of the Cold War context of the film's production. This is because it evokes the so-called culture war that typified the contest between the former wartime allies, and the particular expression of this competition that had been playing out on cinema screens across the Soviet Union since late 1946: trophy films (see chapter 1). These Sovietized releases of Hollywood and Nazi-era German films played a key role in Soviet postwar cultural policy. Contrary to impressions fostered by the metaphor of the iron curtain, the Soviet strategy in the emerging Cold War was not a matter of complete isolationism. Instead, the regime held in tension the impetus toward cultural orthodoxy, on the one hand, and the appropriation of foreign cultural influences, on the other. Such hybridity in cultural policy was already familiar by the postwar period, which saw the reinvigoration of the ongoing campaign to catch up to and overtake the West. This goal necessitated a degree of interaction between the USSR and its Western competitors as each vied to prove itself the true heir to the scientific reasoning and humanist ideals of the Enlightenment and the classical civilizations that inspired it. As a "struggle of ideas," the Cold War facilitated a renewal of the strategies of cultural appropriation that influenced Soviet diplomatic and domestic policy through the late 1920s and early 1930s, albeit in a closely controlled manner. It was to this end that trophy films were used, as well as foreign periodicals and literature.[24]

Liuba's performance draws on this Cold War strategy of cultural warfare, mobilizing the soft power of song and dance to confound the enemy. She embodies the rejuvenated "Great Appropriation," as Clark terms it, by not simply adopting but in fact appropriating Western culture. This is demonstrated first in the concert hall scene, where she uses Western performance styles to disarm and deceive, but even more authoritatively during her subsequent arrest and imprisonment. For when the Germans arrive to take Liuba in for interrogation, she scrambles to pack—what? Not her copy of Stalin's *Short Course* or a volume of Mayakovsky's verse, but her Spanish castanets. These castanets are ready to hand for the first confrontation in the prison cell when, after screaming to attract the guard, Liuba launches them at him like deadly projectiles. When the guards return later, Liuba stomps toward them in an aggressive iteration of the prowling Spanish tap dance she executed earlier onstage. She is confrontational, powerful, menacing. In her final hours Liuba does not abandon the foreign culture she had donned like a

24. Vladimir Pechatnov, "Exercise in Frustration: Soviet Foreign Propaganda in the Early Cold War, 1945–47," *Cold War History* 1, no. 2 (2001): 5; Clark, *Moscow, the Fourth Rome*; Michael David-Fox, *Showcasing the Great Experiment: Cultural Diplomacy and Western Visitors to the Soviet Union, 1921–1941* (New York: Oxford University Press, 2012). For more on trophy films and their uses during the Cold War, see Knight, "Enemy Films on Soviet Screens." For foreign periodicals, see Pechatnov, "Exercise in Frustration"; and for foreign literature, see Samantha Sherry, *Discourses of Regulation and Resistance: Censoring Translation in the Stalin and Khrushchev Era Soviet Union* (Edinburgh: Edinburgh University Press, 2015).

disguise, but rather owns it and weaponizes it, using elements of Western culture in her final assault against the alien presence in her hometown.

As Clark has shown, however, cultural appropriation could be a fraught venture, and this was no less true for a positive hero like Liuba than for the intelligentsia of the 1930s or the Ministry of Cinema and other officials in releasing trophy films. To this end, great care is taken in the film to establish Liuba's patriotic credentials, as discussed in chapter 2. Moments after her appearance on screen, she is formally tasked by the Krasnodon region party leader Protsenko to play the spy on the grounds of her training at the NKVD school, Komsomol activities, and facility with German language and performance arts. Her assignment is then reiterated by family friend and partisan leader Val'ko, representative of the older generation of Civil War heroes. But it is not until after she has helped to found the Young Guard, thereby securing the implicit affirmation of her peers as well, that Liuba unleashes her charm offensive against the German officers. The legitimacy of Liuba's behavior is proved three times before she adopts her collaborator persona. What is more, she is not shown to perform for the Germans prior to the concert scene, and instead only sings and dances alone or with her comrades, and always in Russian. Liuba's triple commissioning and cultural purity cast her as uniquely suited to appropriate Western culture and deceive the Germans while herself remaining uncompromised. Not everyone is cut out to be a cultural warrior, but Liuba Shevtsova is one of them—using song to reclaim Krasnodon, and even turning a prison cell into a stage owned by the Young Guard.

Imprisoned: Defiant Soviet Sound

The contrast in purpose behind Liuba's two performances—first in the concert hall and then in the prison cell—highlights the final stage of development in the film's arc of vocalizing Sovietness, namely, the transition of song from an instrument of deception to one of bold defiance. This plays out in the final scenes of the film, as the heroes are imprisoned and executed with songs on their lips. Their wielding of melody in these moments represents the pinnacle of their resistance, now expressed directly and unequivocally. This is also the sequence wherein the score reaches its peak sonically, ideologically, and creatively. As a result, the sound design of the film's finale brings together the dual sonic arcs of the two-part film into resonant resolution of the diegetic and nondiegetic sound.

Rather than cowing them, the Young Guard's imprisonment after the concert inspires the most radical act of cultural resistance yet seen from the plucky protagonists: impassioned, unquenchable, defiant song. It is this undisguised sound that embodies the sacrificial heroism that the film promises from the outset. Ul'ia, weakened by torture, determinedly initiates the Ukrainian folk song

"Watching the Sky and Thinking a Thought" and, after a moment's hesitation, is joined by the girls cradling her broken form. The lyrics, drawn from a poem by Mykhailo Petrenko, provide a fitting euphony for the doomed youths, expressing a longing to forsake the earth and fly to the heavens, escaping a life of hardship and alienation since childhood—an orphan's life.[25] As the song fills the cell, it reaches through the prison walls, where it lifts the spirits of the adult women partisans long since held captive, and resonates more deeply as men's voices join in harmony. The guards cannot quell the impromptu concert as it amplifies and blends smoothly into a second song, a patriotic Soviet-era melody that pervades the entire detainment complex with its strong marching rhythm, reverberating as far as the interrogation room in which the Young Guard are processed for execution. Ul'ia's song becomes the most unconstrained and widespread act of defiance witnessed in Krasnodon, unifying young and old, men and women, those who may yet live and those being sentenced to their deaths.

As if to emphasize the newly asserted authority of the Young Guard over song, the score likewise reaches its greatest impact as the heroes make their final stand. Shostakovich's "Death of the Heroes," reworked at the behest of censors, combines an appropriate gravity with the soaring scope of an ode to produce a composition that balances the tragic and the optimistic in true socialist realist fashion. The death march begins softly as the Young Guard are led, bound and beaten (but not defeated), to the mines where the adult partisans had perished before them. Searchlights illuminate their severe expressions and tattered appearance. The orchestration builds cleanly and firmly as the youths step with dignity into line, invoking their stance when swearing the oath of the Young Guard so many months ago. They are silent with a ferocity that makes it plain that they did not break under the abuse that has taken place off-screen (having been edited out). The score speaks for them in their silence, expressing their defiant refusal to waste so powerful an instrument as their voices on the fascists. The score climaxes and fades back into silence as Oleg steps apart from the group and stares down a Soviet collaborator, before launching into his final speech of dedication to the cause, addressed not to the foe but to his comrades. They then respond in kind as he leads them in singing the "Internationale," the socialist revolutionary anthem. They are building on the momentum of the earlier defiant melodies, crowning the two songs performed in the prison with a third, to create a musical trilogy that showcases the union of national folk culture, militant Soviet modernity, and global socialist revolution.

25. This well-known piece was chosen for the film adaptation rather than specified in the novel. It went on to a prestigious "career" after the film as one of the titles performed at Stalin's seventieth birthday in 1949 and was among the first songs to be sung in outer space in 1962. "Divlius' ia na nebo, ta y dumku gadaio . . . ," *Vikipediia*, January 17, 2021, https://w.wiki/j9i.

In addition to its palpable historic significance, the "Internationale" also contains a more immediate message for the executioners currently aiming their rifles. For this was the song that had marshaled the dying breaths of the partisans shot by the Wehrmacht soon after their arrival, in the first part of the film— the execution that was meant to destroy the resistance in Krasnodon, but which in reality galvanized Oleg into establishing the Young Guard. This song serves as a melodic baton within the film that is passed from one generation of Soviet patriots to the next, from the veterans of the Civil War to the new heroes of the Great Patriotic War. The message to the diegetic audience of enemy officers is clear: they may pull the trigger again and again, but they are powerless against the idealism and dedication that unify every Soviet regardless of age or gender (figure 3.5).

Meanwhile, the message to the nondiegetic audience is equally clear: it is now your turn, postwar generation, to take up this melody and all it represents; honor the memory of those who last sung it, and be ready. In this climactic scene, appropriated silence (as they approach the mine), vocalized Sovietness (Oleg's final speech), and defiant song (the "Internationale") come together as the Young Guard make the ultimate sacrifice. When their song is cut off abruptly,

FIGURE 3.5. With their final breaths, they sing as one. *The Young Guard* (Gerasimov, 1948).

Shostakovich's final piece, the aptly titled "Apotheosis," bridges the cut between the youths' valiant last stand and the third and final montage of Soviet military victory that brings the film to a close in the postwar present. Protsenko, now flanked by ranks of Pioneers, Valia, and other Krasnodon survivors, dedicates a memorial to the youths and commands the closing military salute by an honor guard. The film ends with flags, gunfire, and the firm pronouncement of the names of the dead as the weighty score resolves against a blackened screen.

This chapter has presented *The Young Guard* as an exceptional film. But it may just as well be defined as extraordinary. The story of the film's censorship and its own censoring of the tale of the youthful heroes is incredibly ordinary for the late Stalin period: it follows precisely the trajectory one expects of a film of the *malokartin'e* period and confirms the predominance of the editor's red pencil in the film production process. Yet Gerasimov's film is also highly unusual in its powerful use of silence and sound to tell the story of war in a subtler and richer way than Stalinist orthodoxy allowed for. Although not exactly experimental in its use of sound, it is certainly creative, imbuing the soundscape with greater meaning than is to be heard in other films of the time. *The Young Guard* is also remarkable for the role it played in training up a new guard of young filmmakers and actors—careers that would come into their own during the Thaw era and beyond, giving rise to some of the most iconic Soviet films and television series. Gerasimov's use of his students both before and behind the camera for what was the most eagerly anticipated film of the postwar years demonstrates his bold commitment to overcoming the stagnation that dominated the postwar film industry. And so *The Young Guard* helped to keep the Soviet film industry alive both creatively and practically at a time when it was needed most.

THE STALIN CULT ON SCREEN

During the Great Patriotic War, the unthinkable happened: Joseph Stalin faded from Soviet visual culture. While the occurrence of his name in *Pravda* waxed and waned with the tides of military victory and defeat, the face of the leader graced newsprint and posters only rarely, while his embodiment disappeared from feature films.[1] There was, after all, an inherent risk in linking the image of Stalin with the calls to defend, protect, and liberate that dominated wartime visual media, as it could imply an admission of failure on his part to have safeguarded the nation. In Stalin's place, imagery of families, villages, "heroic" cities, and *Rodina mat'*, or the Motherland—entities suited to playing the role of victim—proliferated, galvanizing efforts for a defensive war. This changed dramatically once the nature of the conflict shifted to a more offensive effort and victory was assured in late 1944. Stalin's portrait swiftly reconquered visual media to serve as the focal point of a rapidly expanding postwar personality cult. By his seventieth birthday celebrations in December 1949, the image of the aging leader permeated the visual landscape of the Soviet Union.

1. In fact, two film productions that featured Stalin as a lead character were shelved during the early months of the war, *The First Cavalry* (*Pervaia konnaia*, Dzigan) in 1941 and *The Defense of Tsaritsyn Part II* (*Oborona Tsaritsyna*, Vasil'ev and Vasil'ev), in 1942, although Part I did screen that year. For more on Stalin's disappearing act from visual culture, see Victoria Bonnell, *Iconography of Power: Soviet Political Posters under Lenin and Stalin* (Berkeley: University of California Press, 1999), 252; Plamper, *Stalin Cult*, 53–56, 62; John Barber, "The Image of Stalin in Soviet Propaganda and Public Opinion during World War 2," in *World War 2 and the Soviet People*, ed. Carol Garrard and John Gordon Garrard (Basingstoke: Macmillan, 1993), 38–49.

As if to make up for lost time, postwar depictions of Stalin proved bolder in their claims to authority and more pervasive in their distribution than those of the prewar cult. Posters and portraits were reproduced in runs of hundreds of thousands, papering the Soviet Union with the leader's placid visage while his inspirational presence and words were shown on the silver screen to be shaping not just Soviet but also world history. Facets of Stalin's image introduced by the 1930s cult were developed more fully, and new ones were added. This was particularly noticeable of Stalin's portrayal in feature films. Cinema attested as never before to the leader's paternal care for his people and indeed all progressive peoples, his strategic brilliance and military genius, and, most consequentially, his right to rule alone, based on his own merits and no longer reliant for legitimacy on his identity as Lenin's heir. Though barely half as many films featured Stalin as a character after the war as before, it was nevertheless during the postwar period that Stalin's cinematic presence apotheosized into omnipresence, reaching beyond the films in which he appeared as a character.

Scholarship has long since noted the dramatic expansion of the Stalin cult after the war and the pivotal role of cinema in its proliferation. Indeed, the personality cult films have garnered more attention than all other postwar films combined. Foundational work has been done on the individual Stalin films, with Richard Taylor and Denise Youngblood providing in-depth analyses of plots and dialogue (particularly helpful during the many decades that these films were not accessible in the West), and Judith Devlin and Elena Baraban delving into the production histories of several features. Meanwhile, Hans Günther's discussion of *The Vow* initiated the vital thematic work of locating cinematic imagery in relation to the cult more broadly, followed by Jan Plamper's monograph, which places cinema within the art history of the cult. Most recently, Evgeny Dobrenko continued this task in his examination of *The Vow* as an exemplar of the way in which socialist realism, as expressed in cinema, graduated under late Stalinism from the use of metaphors and allegories to metonymy and synecdoche in its promotion of the Stalin cult. Dobrenko shows how postwar cinema began to build political myths directly and explicitly, rather than using the more implicit, oblique means adopted by earlier films.[2]

2. Richard Taylor, *Film Propaganda: Soviet Russia and Nazi Germany*, 2nd ed. (London: I. B. Tauris, 1998); Youngblood, *Russian War Films*; Devlin, "End of the War"; Baraban, "Filming a Stalinist War Epic in Ukraine"; Hans Günther, "Wise Father Stalin and His Family in Soviet Cinema," in *Socialist Realism without Shores*, ed. Thomas Lahusen and Evgeny Dobrenko (Durham, NC: Duke University Press, 1997), 178–90; Plamper, *Stalin Cult*; Dobrenko, *Late Stalinism*, 112–25. Devlin's full body of work on the cult explores a range of other visual and written media, as well as Stalin's early film image; see Judith Devlin, "Visualizing Political Language in the Stalin Cult: The Georgian Art Exhibition at the Tretyakov Gallery," in *Political Languages in the Age of Extremes*, ed. Willibald Steinmetz (Oxford: Oxford University Press, 2011), 83–102; Judith Devlin, "The Iconography of Power: Stalin and His Images," in *Power in History: From Medieval Ireland to the Post-modern*

This chapter benefits from these studies, building in particular on the comparative, contextualizing approach of the latter few and applying it to the full complement of Stalin cult films. In so doing, it seeks to apply Oksana Bulgakowa's insight into Soviet historical political films of the 1930s, which she argues should be approached as a single, continuous (if evolving) text, given the attentive manner in which such films were conceived and censored. The same was true of the cult films, with screenplays and even productions at times being coordinated.[3] This chapter therefore analyzes each Stalin film in relation to the others and to the visual landscape of the cult as a whole, while also examining how that landscape was embodied on screen. In so doing, the chapter refines our understanding of the role of cinema in the apotheosis of the leader, while also identifying what rendered the cinematic expression of Stalin distinctive.

Joseph Stalin, Film Star

The character of Joseph Stalin made his feature film debut in 1937, in the inaugural title of the historical-revolutionary genre, Mikhail Romm's *Lenin in October* (*Lenin v Oktiabre*).[4] In it, and across the seven films of this type that followed over the next five years, Stalin was depicted consistently as Lenin's most dedicated follower, confidant, and natural heir. Though significant in its claims, this was but a supporting role for Stalin that limited his cinematic interlocutors to cameos and bit parts.[5] All this changed after the war. In 1946, following a nearly four-year

World, ed. Anthony McElligott et al. (Dublin: Irish Academic Press, 2011), 231–58; Judith Devlin, "A Case Study in Censorship: Stalin's Early Film Image," in *Central and Eastern European Media under Dictatorial Rule and in the Early Cold War*, ed. Olaf Mertelsmann (Frankfurt am Main: Peter Lang, 2011), 27–48; Judith Devlin, "Stalin's Death and Afterlife," in *Death, Burial and the Afterlife: 1*, ed. Phillip Cottrel and Wolfgang Marx (Dublin: Carysfort Press, 2014), 65–88.

3. Bulgakowa, "Kollektive Tagträume/Collective Daydreaming," 263. Baraban's work on *The Third Strike*, which brings to light the close coordination between Savchenko's film and the other Stalin cult film in production at the time, *The Battle of Stalingrad*, renders Bulgakowa's argument all the more compelling.

4. More precisely, *Lenin in October* marked the first *live-action* feature film representation of Stalin. He was also drawn into an animated dream sequence three years earlier, in Fridrikh Ermler's *The Peasants* (*Krest'iane*, 1934). See Petr Bagrov, "Ermler, Stalin, and Animation: On the Film *The Peasants* (1934)," trans. Vladimir Padunov, *KinoKultura* 15 (2007), http://www.kinokultura.com/2007/15-bagrov.shtml.

5. There were two exceptions to this pattern: *The Great Dawn* (*Velikoe zarevo*, aka *They Wanted Peace*, Chiaureli, 1938), which is generally considered the inaugural Stalin cult film, and *The Defense of Tsaritsyn Part I* (*Oborona Tsaritsyna*, Vasil'ev and Vasil'ev, 1942), which casts Stalin as an action hero in times of war (Part II apparently ran too far with this, however, and was shelved). The following list provides the percentage of screen time afforded to Stalin in feature films released up to and during the Great Patriotic War, albeit with one important caveat: these films were all de-Stalinized following Khrushchev's speech to the Twentieth Party Congress in 1956, meaning that Stalin was largely cut from the footage. Restored versions of the films have been consulted wherever available, but not in the cases denoted with an asterisk. It is also possible that versions identified as being restored are nevertheless incomplete since the lengths of even these versions do not align with the film lengths listed in

hiatus, the character of Stalin returned to feature films as a star, eclipsing his pre-war performance and that of his mentor Lenin. As he stepped into the limelight afforded a leading man, Stalin was revealed as the embodiment of the archetypes of Father, Visionary Leader, and Military Genius gifted with seemingly divine prescience.[6] No longer reliant on his special relationship with Lenin for legitimacy, the Stalin of postwar cinema became a Lone Leader, unique and unaccompanied as he directed the nation. In this way, the cinefication of Stalin, which had begun as a means of affirming his distinction as Lenin's heir, became after 1946 the most vivid means of locating his right to rule in his own apotheosized form. This transformation took place over five films that together developed his role as the head of the Great Family (the particular focus of Chiaureli's three films), demonstrated his visionary leadership, and established his military credentials (the main concern of the battle epics). Together, these three themes formed the new bases of Stalin's authority in cinema's postwar expression of the personality cult. Each of these representations of Stalin—as more than Lenin's Heir, Wise Father, Visionary Leader, and Military Genius—is explored in turn over the coming pages.

Although it was an industry-wide undertaking, the primary architect of Stalin's revitalized image in postwar film was Mikhail Chiaureli. The Georgian director was responsible for three of the five major postwar Stalin epics: *The Vow* (*Kliatva*, 1946), *The Fall of Berlin* (*Padenie Berlina*, 1950), and *The Unforgettable Year 1919* (*Nezabyvaemyi 1919 god*, 1952).[7] Curiously, Chiaureli's earliest films did not presage a career in cultivating the personality cult or consolidating the

Macheret's catalog and other sources. *Lenin in October*, 1.6 percent; *The Man with the Gun* (*Chelovek s ruzhem*, Iutkevich, 1938), 5.4 percent; *The Great Dawn*, 30.5 percent; *The Vyborg Side* (*Vyborgskaia storona*, Kozintsev and Trauberg, 1939), 0.9 percent; *Lenin in 1918* (*Lenin v 1918 godu*, Romm, 1939), 8.9 percent; *Iakov Sverdlov* (Iutkevich, 1940), *0 percent; *The Siberians* (*Sibiriaki*, Kuleshov, 1940), 6.2 percent; *Valerii Chkalov* (Kalatozov, 1941), 9.3 percent; *The Defense of Tsaritsyn Part I*, 36.8 percent; *Aleksandr Parkhomenko* (Lukov, 1942), 1.9 percent; *His Name Is Zukhe- Bator* (*Ego zovut Sukhe-Bator*, Zarkhi and Kheifits, 1942), *0 percent. For a complete list of Stalin appearances in feature films during the leader's lifetime, including shelved projects and those from which Stalin scenes were excised before release, see the appendix in Bagrov.

6. After the war, Stalin featured in eight films and accounted for the percentage of screen time noted in the list that follows. These films were of course also de-Stalinized, with only the two most dramatically shortened films (indicated with asterisks) having been partially restored so far. It is safe to assume that Stalin's presence accounted for a higher proportion of screentime in the original releases than indicated here: *The Vow*, 25.9 percent; *Private Alexander Matrosov*, 0 percent (not yet restored); *The Third Strike*, 15.1 percent; *The Battle of Stalingrad I & II*, 30.9 percent; *The Fall of Berlin I & II**, 18.1 percent; *Miners of the Don**, 2.1 percent; *The Unforgettable Year 1919 I & II*, 26.4 percent; *Dzhambul* (Dzigan, 1952), 0 percent (not yet restored). Of these eight films, three presented Stalin in cameo-like sequences rather than incorporating him into the main narrative of the film. A clear shift toward leading roles for Stalin had taken place.

7. The final Stalin epic to bear Chiaureli's name (along with those of Gerasimov, Aleksandrov, and a few others), is *The Great Farewell* (*Velikoe proshchanie*, also known as *Great Mourning*, 1953), the documentary dedicated to Stalin's funeral. This production—and its abundance of unused footage—is revisited in Sergei Loznitsa's *State Funeral* (2019).

rather constrained genre of artistic documentaries. Instead, productions such as *Saba* (1929), a morality play about the evils of consuming alcohol, and *Out of the Way!* (*Khabarda*, 1931), a satire mocking petit bourgeois values, demonstrated an inventive and almost playful approach to narrative film and what Peter Kenez has called "a highly individual, even idiosyncratic talent."[8] In fact, *Out of the Way!* even earned Chiaureli the accusation of formalism—a designation generally considered a badge of honor in histories of Soviet cinema, but a dangerous one at the time, being a euphemism for heretical bourgeois leanings. In 1934, Chiaureli's trajectory turned onto what might be called a more radiant path as Georgian party leader Lavrentii Beriia introduced him to a certain other powerful Georgian in a private Kremlin screening of Chiaureli's film *The Last Masquerade* (*Poslednii maskarad*, 1934). On the strength of Stalin's approval of the film and Beriia's patronage, Chiaureli was invited to participate in a closed screenplay-writing competition celebrating the twentieth anniversary of the Revolution.[9] The result was *The Great Dawn* (*Velikoe zarevo*, also known as *They Wanted Peace*, 1938), the director's first film to feature Stalin as a character.

The film also marked Stalin's first breakout role as a fully developed supporting character, enjoying screen time practically on par with Lenin, though it did not start out this way. Originally, Chiaureli stuck to his tried-and-tested method of exploring a corner of the Revolution as it played out against nationalists and Mensheviks in Georgia, with Stalin not appearing until rather late in the screenplay, where he was identified simply as "the Caucasian" standing by Lenin's side. Over the course of three rewrites, Chiaureli was steered toward relocating the revolutionary action from the Caucasus to Petrograd and bolstering the roles of the two leaders.[10] Despite the added screen time, in the final version Stalin's characterization followed the established precedent and remained centered on his relationship with Lenin. Whether identifying an opportunity or inspired to concentrate on a preeminent subject of his day, Chiaureli had found his calling: the cinematization of Stalin's biography. He called for cinema artists to develop more literary, personalized films about the leader and immediately set about doing so himself, developing a follow-up to *The Great Dawn* that would take Stalin into the post-Lenin period and cast him as "the Lenin of today," as the slogan went.[11] Though delayed by the war, this project eventually played across the

8. Kenez, *Cinema and Soviet Society*, 230.
9. Devlin, "End of the War," 108.
10. Devlin, "Case Study in Censorship," 37–38.
11. Devlin, "End of the War," 108. David-Fox notes that Stalin himself has been credited with devising the formulation that "Stalin is the Lenin of today," which was then passed on to Henri Barbusse and first appeared in print in his biography of Stalin published in 1935. By 1939, it had become a popular saying within the party as Anastas Mikoian published an article by this title in *Pravda* in honor of the leader's sixtieth birthday. David-Fox, *Showcasing the Great Experiment*, 232. See also Henri Barbusse, *Stalin: A New World Seen through One Man*, trans. Vyvyan Holland (London: John

nation's screens as *The Vow* (1946), the film that established the postwar conceptualization of a Stalin that had surpassed Lenin.

The Vow juxtaposes the lives of Stalin and the Petrov family of Stalingrad, tracing their interactions at key moments in the history of the Stalinist state. The Petrovs constitute a composite of "types": adult sons who represent Soviet workers and the technical intelligentsia together building socialism (or in this case, a tractor factory); a Komsomol-aged daughter who dedicates her life to political agitation and dies at the hands of wreckers; a father who likewise dies, albeit at the hands of kulaks on the eve of collectivization; and, most significantly, a mother who embodies "all the best features of Russian women," as Chiaureli explains. "The hero of the film was the family," he continues, "[which] reflected the aspirations and dreams of our entire people."[12] Stalin interacts with the heroic family (or, more specifically, with its matriarch) across three phases of Soviet history, from the immediate aftermath of Lenin's death, to the era of the first Five Year Plan, and ultimately the Great Patriotic War. The Petrovs provide a picture of how the Soviet people navigated these three periods, while Stalin's plotline reveals what was happening in the heart and mind of the great leader as he sought to direct the path forward to Communism. Chiaureli's goal was to forge a narrative in which Stalin did not simply appear episodically but rather was shown to develop as a character.[13] He succeeded in doing so particularly with regard to Stalin's characterization as Father and Visionary Leader not only in this film but also in the two that followed: *The Fall of Berlin* and *The Unforgettable Year 1919*. Taken together, Chiaureli's trilogy of films form a character arc for Stalin that sees him grow from legitimate successor to Lenin into an omniscient and omnipresent leader without parallel.

More Than Lenin's Heir: Stalin, the Lenin of Today

In order to achieve this visible development of the leader as a character, however, Stalin had first to be loosed from the restrictive framing that had hitherto dominated his cinematic representation as Lenin's Heir. This was undertaken in *The Vow*, which begins with the familiar composition—depicting Stalin as the chief of all mourners after Lenin's death—but extends it into the most radical claim of the interchangeability of Stalin and Lenin to be found in Stalinist cinema. The process begins half an hour into the film, during the eponymous oath

Lane the Bodley Head, 1935), 290; Anastas Mikoian, "Stalin—eto Lenin segodnia," *Pravda*, December 21, 1939: 6. This slogan later appeared in Stalin's official *Short Biography* in 1947, which the leader edited himself.
 12. Mikhail Chiaureli, "Voploshchenie obraza velikogo vozhdia," *Iskusstvo kino*, no. 1 (1947): 10.
 13. Chiaureli, 10.

FIGURE 4.1. Varvara Mikhailovna commissions Stalin as the new Lenin. *The Vow* (Chiaureli, 1946).

scene. Although it takes place in a crowded Red Square, the scene was inspired by Stalin's historical speech to the Congress of Soviets at the Bol'shoi Theatre on January 30, 1924, in which, speaking on behalf of all party members, he made six ritual vows to Comrade Lenin, committing the party to honor and fulfill Lenin's vision for the Soviet Union and world communism.[14] The film places recent widow Varvara Mikhailovna, the Petrov family matriarch, in the audience. She has made the perilous wintertime journey from Tsaritsyn (soon to be renamed Stalingrad) bearing a letter for Lenin that was penned by her late husband, Stepan, in order to expose a group of exploitative kulaks. The letter cost Stepan his life and tragically, by the time Varvara is able to complete the trek in his stead, its intended recipient has also died. But as she listens to Stalin's speech, Varvara Mikhailovna experiences a revelation: Stalin is the new Lenin, and placing the precious envelope in his hands would fulfill her quest. As she presses forward to deliver the epistle, holding it aloft like an icon during a holy day procession, the masses seem to realize her intention and part before her (figure 4.1).

14. Joseph Stalin, "On the Death of Lenin," Marxist Internet Archive, January 30, 1924, https:// www.marxists.org/reference/archive/stalin/works/1924/01/30.htm.

This tacit approval of the widow's conflation of Stalin and Lenin is Stalinist cinema's first and only depiction of a public response to Stalin's claim to be Lenin's Heir. Once accepted by the Soviet people on screen in this momentous scene, the claim needed no repetition in cinema. A clichéd claim had transformed into established fact—Stalin is today's Lenin—and a turning point in the representation of Stalin in film had been reached.

Instead of establishing equivalency between the leaders of past and present, however, the popular acceptance of Stalin's leadership in the vow scene subtly demoted Lenin as Stalin became not so much his equal as his replacement and one better equipped to lead "today." This is first signaled in *The Vow* at the end of Stalin's speech, as Lenin rises again in the form of a giant profile on a red flag. Lenin is resurrected symbolically to take up his new position *behind* Stalin, who presumably directs the appearing and disappearing of his mentor, now rendered two-dimensional and ultimately manipulable on his bed of red silk (figure 4.2). What should mark the incontrovertible preeminence of Lenin in reality confirms his superfluity.

The shift in Lenin's positioning vis-à-vis Stalin is confirmed upon Lenin's return "in the flesh," as it were, several years later in Chiaureli's final Stalin epic, the revolutionary war film *The Unforgettable Year 1919*. Like *The Vow*, and

FIGURE 4.2. Lenin rises again, to back his heir. *The Vow* (Chiaureli, 1946).

indeed also Chiaureli's intervening production, *The Fall of Berlin*, this artistic documentary interweaves a grand historical narrative centered on Stalin (how he saves Petrograd from counterrevolutionaries and foreign interventionists in 1919) with a plotline following the lives of "typical" Soviets, in this case, a young couple dedicated to the Bolshevik cause. In it, Lenin is a shadow of his former self, commanding a mere quarter of the screen time allotted to Stalin. Even his physical presence is weakened. He seems unable to stand alone, leaning heavily on Mikhail Kalinin and entrusting to Stalin the safeguarding of Petrograd, himself, and all hope for the Revolution.

In contrast, Stalin has never been so capable as in 1919. He swings heroically from an armored train, skims across the Neva in a speedboat, directs a battleship, and holds court among the soldiers positioned in the forest, winning their hearts as he feasts, fights, and celebrates with them. Stalin's commission to lead the defense of Petrograd is less a charge and more an endorsement of the man of quiet confidence who already knows what to do—as confirmed by the angelic choir that serenades him as Lenin reads aloud the resolution transferring him authority on the Petrograd front. The symbolism of the communication link between the two leaders is inverted with respect to the historical-revolutionary films of the 1930s, where Stalin's authority on the front derived from regular telephone, telegraph, and postal communication with Lenin. Rather than tracing the impact of Lenin's words on Stalin's leadership, *The Unforgettable Year 1919* illustrates the influence of Stalin's words on Lenin and Kalinin, who read his telegram with visible gratitude. By the end of the film, Lenin is so indebted to Stalin that he cannot even speak during the ceremony at which he and Kalinin honor Stalin with the Order of the Red Banner. Lenin simply beams and shakes his protégé's hand in speechless wonderment, leaving the final words of the film to Stalin. The explanatory intertitle that follows the oath scene (set in 1924) of Chiaureli's earlier film retroactively becomes true for Lenin in 1919 as well: "The vow of Stalin has become a symbol of faith for the whole people [including Lenin], the curriculum of their lives." By showing Lenin to be indebted to Stalin, Chiaureli's final Stalin film depicts a leader who eclipses his teacher in life and not just in death.[15]

15. Iutkevich's *Light over Russia* (*Svet nad Rossiei*) was dedicated to GOELRO, Lenin's electrification campaign of the 1920s, and granted a more robust role for Lenin, who featured in over a third of the film's running time (whereas Stalin appeared for less than half that). It was shelved mere days before its planned release in 1947. The Revolution and Lenin years were avoided by filmmakers after this, not returning to the big screen until Chiaureli's epic in 1952 and subsequently in the filmed theatrical performances of *The Break-Up* (*Razlom*, Bogoliubov and Muzykant, 1952) and *Liubov' Iarovaia* (Frid, 1953). Complaints about the dearth of revolutionary films were a given in discussions of the film industry both in print and behind closed doors, yet filmmakers had very good reasons for avoiding the period.

Wise Father Stalin

Chiaureli's illustration of Stalin as "the Lenin of today"—even when that today occurs in 1919—cleared the way to explore facets of Stalin's characterization beyond that of Heir. Perhaps the most well-developed of these was the archetype of Father, the development of which the director traced through all three of his films. The figuration of Wise Father Stalin was already familiar to audiences by the time *The Vow* premiered, having been instigated in 1935, when Stalin was first pictured in *Pravda* accompanied by a child, and gaining even greater momentum in 1937, when he was promoted to Father of adult children as well in works of visual culture.[16] This image had been slow to infiltrate cinema, however. While Lenin's Heir had appeared in eight films before the war, Father Stalin manifested in only two, as a fairy godfather to a group of children in young Val'ia's dream sequence in *The Siberians* (*Sibiriaki*, Kuleshov, 1940) and as a paternal source of inspiration and direction to the record-breaking pilot in *Valerii Chkalov* (Kalatozov, 1941).[17] Fatherly engagement with the Soviet people was instead primarily the preserve of Lenin in prewar cinema. Romm's *Lenin in October* and *Lenin in 1918* conveyed Lenin's paternal side most fully, providing him with young worker-revolutionary Vasilii and his wife, Natal'ia, to mentor through both films, as well as little orphaned Natasha to take under his wing in the second production. The promotional poster for *Lenin in 1918* emphasized his fatherly nature by using a retouched still of the leader helping the little girl with her drawing. By this visual definition, Lenin in 1918 was the protector of the fatherless and nurturer of their potential. By the end of the film, however, Natasha gains a second father, as Stalin returns to Lenin in Petrograd and receives the little girl into his arms, hinting at the Father Stalin who would one day raise the "healthy child" birthed by Lenin and the October Revolution.[18]

The Vow transfers the paternal role decisively to Stalin by showing the precise historical moment when he took on the fatherly mantle of his predecessor. As before, the transfer occurs during the climactic oath scene in Red Square. Arriving only after Lenin's death, Varvara Mikhailovna finds herself without recourse for the defense of her fatherless family, which the letter would doubtless have elicited from the beloved Lenin. This changes in the moment Stalin accepts

16. Jan Plamper, "Georgian Koba or Soviet 'Father of Peoples'? The Stalin Cult and Ethnicity," in *The Leader Cult in Communist Dictatorships: Stalin and the Eastern Bloc*, ed. Balázs Apor et al. (London: Palgrave Macmillan, 2004), 131; Anita Pisch, *The Personality Cult of Stalin in Soviet Posters, 1929–1953: Archetypes, Inventions and Fabrications* (Acton, ACT: ANU Press, 2016), 255.
17. Although more a documentary than a feature film, Vertov's *Lullaby* (*Kolybel'naia*, 1937) develops the image of Father Stalin more fully. See Günther, "Wise Father Stalin."
18. Lenin in Ann Bone, trans., *The Bolsheviks and the October Revolution: Minutes of the Central Committee of the Russian Social-Democratic Labour Party (Bolsheviks) August 1917–February 1918* (London: Pluto Press, 1974), 174.

the letter—marked by blood and a bullet hole—on Lenin's behalf. With this one gesture of acceptance, Stalin steps into the role of ersatz father to the Petrov family and, through them, also to the entire nation as it suffers under the kulak yoke. Stalin receives the paternal commission from both Lenin and the Stepan Petrovs of society—the fathers who could not protect and nurture their families without support from the leader. From this moment onward, Stalin recognizes Varvara Mikhailovna time and again in a crowd and takes her aside to share a few words of wisdom about what is to come for their nation. His confidences steel her—and, through her, the Petrov family (and Soviet society)—to sacrifice for his vision of an industrialized, victorious Soviet land. The effect, as Hans Günther observes, is to "grow to monumental allegorical proportions" the characterization of Stalin as the head of not just the party or state but of the Great Family.[19]

Stalin's promotion to Fatherhood over the nation in postwar cinema required overstepping not only Lenin's claim to the role but also the claim of the other parent, the Mother or *Rodina mat'* (literally, Motherland Mother). *Rodina mat'* represented the reconceptualization of the traditional Mother Russia figure (*Rossiia-matushka*) that rose to prominence immediately on the outbreak of war in 1941. Although elided by official discourse during the 1920s in favor of a Revolutionary Fatherland, the feminine notion of homeland returned in mid-1934 as Stalin began to use the term *rodina* (motherland) to refer to the Soviet Union rather than simply the land of one's birth (which historically could be quite narrowly defined).[20] Within weeks of the German invasion, the *rodina* gained a body and a title in one of the most memorable posters of the war, Irakli Toidze's *The Motherland Calls* (*Rodina mat' zovet*, June 1941). Released initially in a run of 5,000 in late June, by October a staggering 200,000 additional copies were printed, with another 100,000 in 1943.[21] The strong, matronly reenvisioning of the younger, more ornamental tsarist-era Mother Russia quickly became

19. Günther, "Wise Father Stalin," 185.

20. Günther, 178; Elena Baraban, "The Return of Mother Russia: Representations of Women in Soviet Wartime Cinema," *Aspasia* 4, no. 1 (2010): 122; Bonnell, *Iconography of Power*, 72; David Brandenberger, *Propaganda State in Crisis: Soviet Ideology, Indoctrination, and Terror under Stalin, 1927–1941* (New Haven, CT: Yale University Press, 2011), 101.

21. Robert Logan, *The Great Patriotic War: A Collection of World War II Soviet Propaganda Posters* (Guelph: University of Guelph Library, 1984), 33; Unattributed, "'The Motherland Is Calling Us!': What's behind Famous WWII Poster?," Agenda.ge, May 9, 2015, https://www.agenda.ge/en/news/2015/1016. During *perestroika*, Tamara Toidze, the artist's wife, popularized an account of her own role in inspiring the poster. Apparently, with the announcement of the war, she burst into her husband's studio to share the news, striking a dramatic pose, which he told her to hold while he sketched. For the sake of comparison, Dmitri Moor's equally iconic "Ty chem pomog frontu?" was printed in 1941 in a run of two thousand, while another very early war release, Sheglov and Avvakumov's "Zavoevanii Oktiabria ne otdadim," was printed in a run of ten thousand. See entries for individual posters at the website of Klaus Waschik, Nina Baburina, and Konstantin Kharin, "Real'nost' utopii: Iskusstvo russkogo plakata," 2001, http://www.russianposter.ru.

iconic.[22] Soon, *Rodina mat'* was seen in posters across the nation fulfilling several of Stalin's iconographic roles: floating above lines of determined Red Army soldiers, her face set against the fascist menace; cradling children, protecting their happy childhoods; and lending her name as a battle cry. Toidze's revived feminine leader also appeared on screen, embodied most notably by the partisan leader Comrade P. (Praskov'ia Luk'ianova) in *She Defends the Motherland* (*Ona zashchishchaet rodinu*, Ermler, 1943), who protects her village with fierce capability, and defiant matrons Marfa Safonova from *In the Name of the Motherland* (*Vo imia rodiny*, Pudovkin and Vasil'ev, 1943) and Fedos'ia in *Rainbow* (*Raduga*, Donskoi, 1944), both played by Elena Tiapkina, who encapsulated the steeliness of a mother offended on behalf of all mothers by the heartlessness of German sons. In these films, the Motherland figure leads partisans and villagers, inspiring them and, through her forceful speeches, forbidding and requiring certain behaviors of them with the authority of a policy maker who enjoys the backing of the state. She is active, self-motivated, and intimidating. She is a leader, and as such, the coincidence of this Motherland figure with Stalin on his reappearance in Soviet visual culture required careful navigation.

After the war, the corporeal expression of the *rodina* was given form by widows Varvara Mikhailovna in *The Vow* and Varvara Vasil'evna in *The Village Teacher* (*Sel'skaia uchitel'nitsa*, Donskoi, 1947), a drama following the life of the titular heroine from before the Revolution to the Cold War. Vera Maretskaia reprises her role as the symbolic *Rodina mat'* (first played in Ermler's wartime film) and bears an uncanny resemblance to Toidze's figure, even fading into the *Rodina mat'* of the poster at one point during an artful scene transition. Both films retain a considerable degree of independence for their matronly cyphers in pursuing their ideals. Yet, this autonomy is tempered by a dependence on Stalin personally (in *The Vow*) or the Soviet system more generally (in *The Village Teacher*) to achieve their potential. As Günther observes, Varvara Mikhailovna's growth and status in *The Vow* are contingent on the increasing attention Stalin pays to her throughout the film.[23] Similarly, while the country schoolteacher Varvara Vasil'evna is not personally associated with Stalin, her goals and methods anticipate those of the Soviet state, requiring Soviet power—and specifically its Stalinist iteration—in order to be fulfilled. Although the film traces Varvara's life as a teacher from before the Great War, it is not until the 1930s and 1940s that her classroom grows into a large school and her students graduate as productive members of society. Varvara's *Rodina mat'* is free to pursue her dreams

22. Karen Petrone, "Motherland Calling? National Symbols and the Mobilization for War," in *Picturing Russia: Explorations in Visual Culture*, ed. Valerie A. Kivelson and Joan Neuberger (New Haven, CT: Yale University Press, 2008), 197.
23. Günther, "Wise Father Stalin," 185.

and reap the fruit of her labor only in Stalin's USSR, meaning that her positive qualities actually highlight the beneficial character of the Stalinist state.[24]

The *Rodina mat'* of postwar cinema may still sacrifice her children (or students), but she no longer leads or directs them. That role is fulfilled by Stalin alone, as a single parent. This is a development distinctive from the 1930s expression of the Father archetype, which grew in significance in tandem with the accentuation of the "feminine, maternal element" in Soviet mythology.[25] *The Vow* subverts this symmetry by taking the relationship between the Motherland and Father to its furthest logical extreme in a symbolic "Holy Wedding" as Stalin honors Varvara Mikhailovna in the final scene of the film—the scene traditionally reserved for weddings.[26] Stalin and Varvara walk toward one another, meeting in the center of the Georgievskii Hall of the Grand Kremlin Palace with its golden chandeliers, arched high ceiling, and ornate Corinthian columns. He wears his full military dress uniform, complete with epaulettes and a chestful of medals in what is his only such formal appearance in feature film, while she wears a sparklingly white embroidered shawl over her plain attire. She has aged markedly during the war, while he remains dapper with the barest touch of gray above his temples. He thanks her in the name of the Motherland, bending to kiss her hand. Stalin's gallant humility before her is so perfectly executed as to reverse its effect. Rather than subordinating him in the relationship, his humbleness intensifies his mastery of their dynamic, a point that is underlined when he addresses her on behalf of the Motherland that she is meant to represent and so gives voice to the *rodina* before Varvara herself can utter a word. Stalin absorbs the Motherland into his own image as Wise Father in the very moment she reaches the peak of her symbolic significance.

The Village Teacher completes this process of iconographic subjugation by demoting *Rodina mat'* from the image of a wartime leader to that of a postwar daughter. This is achieved by underlining Varvara Vasil'evna's reliance on Stalin for the fulfillment of her purpose and potential, while denying her an encounter with him: she learns of and "accepts" her Order of Lenin from the radio announcer rather than the leader of the USSR. After this point, *rodina* is but a

24. This priority of Stalin as the leader of not just the state but also the *rodina* was underlined further in a spate of posters and films that attributed the fertility of Soviet agriculture to Stalin's canalization program and other state-initiated farming strategies. See, for example, *The Return of Vasilii Bortnikov* (*Vozvrashchenie Vasiliia Bortnikova*, Pudovkin, 1953) for the benefits of Stalin's canalization and collective farm amalgamation campaigns, and *Bountiful Summer* (*Shchedroe leto*, Barnet, 1951) for the superiority of the green conveyor method of maintaining dairy cows (that is, allowing them to graze and milking them in the field rather than housing them in barns). The *rodina* is not productive on its own, but instead depends on Soviet power and the insight of the leader to fulfill its potential, much like Varvara Vasil'evna.

25. Günther, "Wise Father Stalin," 179.

26. Günther, 185.

word on the lips of patriotic young people in films depicting the war and contemporary Soviet society, or a sweep of fertile landscape, rendered even more bountiful by Stalin's canalization program or collective farm amalgamation policies in the rural comedies. Having found her fulfillment in Stalin's Father figure, *Rodina mat'* metamorphoses from anthropomorphic into lexical and georgic representations, leaving the scene clear for a single Father.

After this point, Stalin's Great Family consists solely of sons and daughters. The most memorable of these are the young couples played by Boris Andreev and Marina Kovaleva in *The Fall of Berlin* and *The Unforgettable Year 1919*, who provide Stalin with his own Vasilii and Natal'ia, the couple mentored by Lenin in Romm's films. Although Chiaureli's two films do not share a cast of characters or chronological link—the first is concerned with Stalin's exploits during the Great Patriotic War, while the second, during the revolutionary war—they nevertheless create a unified story of the deepening intimacy of the leader's relationship with his people. The tale begins conventionally enough in *The Fall of Berlin*, with Stalin and his mandate to build socialism inspiring the fatherless steelworker Aleksei (Alesha) Ivanov to achieve remarkable feats in the foundry. Alesha, whose birthdate of October 25, 1917, marks him as a true son of the Revolution, is an ideal representative of the new society forged under Soviet power and is rewarded for his achievements with the opportunity to meet Stalin. He stumbles and stutters his way through the encounter as the leader receives him magnanimously, correcting him with the patience of a seasoned mentor. Their exchange moves beyond the usual clichés, however, when Alesha pours out his heart to Stalin, explaining his secret love for schoolteacher Natasha Rumiantseva and his hopelessness over winning her heart. Here Stalin proves that he is interested in the happiness of his people not only in economic, political, and social terms but also on a personal, romantic level as he counsels the young man in how to woo his lady love with poetry and sincerity. Alesha puts the advice into action, and once the German invaders (who rudely interrupt the courtship) have been dealt with, the lovers share their first kiss under the approving eye of Stalin. Significantly, although both Alesha and Natasha search for one another during the war, it is only when prioritizing their pursuit of the leader—joining the crowds that greet his (fictional) arrival in Berlin and maneuvering to the front row—that they are reunited with each other.[27] Their eyes lock only within the scope of Stalin's gaze. When Natasha approaches Stalin moments later to thank him "for everything you've done for our people, *for us*," she is crediting him not only for victory in war but also as the author of their romantic bliss.

The Unforgettable Year 1919 picks up the relational narrative from this point, with the young couple played by Andreev and Kovaleva now named Vladimir

27. Günther, 186–87.

Shibaev and Katia Danilova. They are committed in their love for one another and, once the interventionist counterrevolutionary forces have been routed by Stalin, are finally free to marry at the end of the film. The wedding scene sees Stalin assert his fatherhood in a subtle yet pointed way that speaks of his intensified familial bond with his people. He arrives just as the marriage celebrations (of which he was unaware) get underway and protests good-humoredly, "A wedding without me?!" The silence that follows the crowd's initial burst of laughter belies the levity of his observation and is broken only by Volodia's nervous chuckle and repentant hangdog expression as he acknowledges through his body language that he neglected to invite the most important guest—the symbolic father of the bride. The leader accepts the apology implicit in Volodia's bearing and steals the spotlight with a wedding speech to rouse the dead, prompting the guests to send up a cheer for Stalin more impassioned than any lavished on the newlyweds. With this speech, Stalin confirms his leadership role but also his patriarchal authority as the one to grant approval for the espousal of the young lovers.

Stalin's involvement in consecrating the matrimonial happiness of Volodia and Katia is particularly significant in this film given the characterization of Lenin in what is the party founder's only appearance in postwar Stalin era cinema. In sharp contrast to *Lenin in 1918*, by the time of *The Unforgettable Year 1919*, Lenin is isolated from the people in his Smol'nyi office, unable to form meaningful bonds with anyone outside the party leadership (quite the contrast to the Lenin of 1918 portrayed in Romm's 1939 film). In the course of Chiaureli's postwar trilogy, Stalin usurped Lenin's trope as the friend and father of common people and extended it to become the patron of romance and marriage. In *The Vow*, Lenin could not step into the role of patriarch for the Petrov family because he was physically unable. But in *The Unforgettable Year 1919*, he has simply become too isolated while orchestrating the revolutionary war to participate in the lives of his people, unlike Stalin in *The Fall of Berlin*, who is able to remain the Wise Father invested in his people's personal happiness even while choreographing the war effort.

In this way, Chiaureli's films fashion a grandiose image of Stalin as Father—one who is always available, even when the great Lenin is not. The implication is that Stalin has not only succeeded but also superseded Lenin as Father to the Soviet people. Indeed, just as the Motherland was transmuted into a daughter in Stalin's Great Family, Lenin too practically becomes a son in *The Unforgettable 1919*, in that he is so doddery and dependent that he seems to have entered the "second childishness" described by Shakespeare.[28] Lenin is unable to interact with the world on his own and must depend on the steadying hand and directive word

28. Jacques in *As You Like It*, act 2, scene 7.

of another as Kalinin's arm leads him to the call of Stalin's voice. Significantly, it is Stalin's voice that closes all three of Chiaureli's films, silencing first the Motherland figure of Varvara Mikhailovna in *The Vow*, then that of true son Alesha Ivanov, whom he ignores in the closing moments of *The Fall of Berlin*, and finally, Lenin himself in *The Unforgettable Year 1919*.

Visionary Leader, Lone Leader

Stalin likewise surpasses Lenin with regard to his vision in leadership. *The Vow* reveals that Stalin possesses the unique ability to identify the potential inherent in technology, natural resources, and people themselves. For instance, Stalin is able to envision the revolutionary significance of the tractor while other party leaders, including Molotov, merely look on in mild befuddlement. (He also diagnoses a mechanical problem and determines its resolution solely through the power of his discerning ear.) Stalin is able to visualize the precise layout of a new manufacturing center in all its transformative industrial might where expert surveyors see only an insignificant field. Particularly telling is the contrast between Stalin's two daydream sequences, which bookend the oath scene and so take place immediately before and after Stalin's transition from Lenin's Heir to Visionary Leader. In the first daydream, Stalin is seated in his office shortly after Lenin's death, sketching his beloved mentor from memory when he succumbs to a reverie conveyed on screen by overlaying archival footage of Lenin in the top corner. The effect creates a thought bubble just in front of Stalin's head, with Lenin's face replacing the desk lamp. For twenty seconds, Lenin is once again Stalin's light (figure 4.3).

By the second daydream, set during the first Five Year Plan, Stalin no longer needs Lenin to illuminate the way: the heir can now see it for himself. Rather than remembering the past imbued with Lenin, Stalin now looks to the future. He sees a Soviet land transfigured by fleets of tractors akin to the one he is inspecting as he enters the reverie. This time, the daydream footage is underlaid across the entire frame so that Stalin remains in sharp focus as four successive waves of machinery crest in the background around him, filling the frame. "This is Lenin's dream," Stalin explains, meaning that Stalin shares his mentor's vision of the world re-created by a hundred thousand tractors (figure 4.4).[29]

But Stalin also moves beyond Lenin's insight by taking practical steps to realize the new world, declaring his unwavering support for the development of

29. This is a reference to Stalin's 1929 speech commemorating the Revolution, where he quotes Lenin's anticipation of the day when they would be able to supply one hundred thousand tractors to the countryside. See Joseph Stalin, "A Year of Great Change: On the Occasion of the Twelfth Anniversary of the October Revolution," in *Works*, vol. 12 (Moscow: Foreign Languages Publishing House, 1954), 124–41.

FIGURE 4.3. Stalin's thoughts are only of Lenin. *The Vow* (Chiaureli, 1946).

FIGURE 4.4. Stalin shares Lenin's vision. *The Vow* (Chiaureli, 1946).

tractor technology and mapping the layout of the Stalingrad tractor factory. With the second reverie, Stalin's gaze is no longer *on* Lenin; it is now that *of* Lenin and is in fact sharper, since Stalin combines vision with action to bring the future into tangible being. In this way, Stalin is depicted as seeing what others cannot—not even Lenin. Stalin steps into the role of Visionary Leader based on his own merits, without recourse to his relationship with his predecessor. Stalin alone can direct the processes that will realize the anticipated Soviet future.

With this, Chiaureli sets a new tone for cinematic representations of Stalin, positing him personally (rather than Stalinism) as the lens through which history must be understood. In a creative application of Marx's theory of historical development, *The Vow* presents Stalin as the embodiment of the dialectic that drives Soviet history forward from Lenin's death. Stalin is shown to draw together the past (Lenin) and the future (transformed rural and industrial landscapes), while he also serves as the meeting point between reality and socialist reality, that is, reality in its revolutionary development or the elusively imminent future. It is in Stalin's understanding that a tractor prototype transforms into a fleet of tractors, an empty field develops into a progressive industrial city, and a besieged army translates into victory against the fascists. He pulls visions of the future into today. In so doing, the Stalin of Chiaureli's film shapes history, taking key decisions and speaking into the lives of his people—industrialists, politicians, and peasants alike; he makes sense of history, giving meaning to life and death. *The Vow* transformed the cinematic enunciation of Stalin's relationship to power. No longer haunted by Lenin's specter, Stalin was now himself a visionary, Lone Leader unrivaled in war and peace.

Military Genius

Stalin's singularity is honed further in the crucible of war in three battle epics released in time for his seventieth birthday celebration: *The Third Strike*, depicting the liberation of Crimea through Soviet (and emphatically not Ukrainian) efforts; *The Battle of Stalingrad* (*Stalingradskaia bitva*, Petrov, 1949), or what may be more aptly titled "How Stalin Saved His City"; and Chiaureli's *The Fall of Berlin*. The films were intended as merely the opening salvo in a barrage of artistic documentaries outlining the decisive battles of 1944 known collectively as "Stalin's Ten Blows." According to Grigorii Mar'iamov, Bol'shakov's assistant, Stalin dictated the idea to the Minister of Cinema, although it is also the case that requests had been received for more films about Stalin.[30] Regardless, the

30. Mar'iamov, *Kremlevskii tsenzor*, 105. One such request for more Stalin films, from V. I. Vitkovich, has been reprinted in Anderson and Maksimenkov, *Kremlevskii kinoteatr*, 716–17. For his part, Chiaureli had been petitioning for permission to film a Stalin biopic since the late 1930s.

battle epics certainly served as an apologia for the many epithets granted to Stalin during the war, from the officially bestowed titles of Hero of the Soviet Union and Generalissimo, to the monikers popularized in the media, including "genius strategist of our time" and "architect of victory." The battle epics built on the conceptual momentum of *The Vow* to refine the notions of Stalin's visionary and solitary leadership into the prescience of a Military Genius who alone (and unaided) was the originator of Soviet triumph.

The topic of Stalin's military acumen was by no means an innovation of the postwar period. The personality cult had already become concerned with gilding his revolutionary war record by the late 1930s. This was done through exaggeration, theft (stealing accomplishments from Trotsky's biography, such as founding the Red Army), and tactful reframing of his absence from key victories as evidence of his dedication to the most difficult (and less renown) areas of the front.[31] Several projects were in the works to enshrine Stalin's military career onto celluloid when the Germans invaded in June 1941, but only one escaped the shelf: the first instalment of the Vasil'evs' *The Defense of Tsaritsyn* (*Oborona Tsaritsyna*, also known as *Fortress on the Volga*, 1942). In it, the leader's vision and strategic superiority are on display as he spots talent and promotes its bearers, and as he listens patiently to the aged military brass before instructing them in explicitly *revolutionary* tactics (as opposed to, it is implied, the tactics of imperialist war-making).[32] The Great Patriotic War battle films build on these characteristics of Stalin and extend them to a point approaching divinity.

The first of the battle epics in development (though second to be released), *The Battle of Stalingrad*, opens with a display of Stalin's preternatural sight. Using the film layering technique reminiscent of *The Vow*, Stalin is shown to see the front lines quite literally—complete with burning fields; columns of advancing Germans, tanks, and horses; and the shadows of the Wehrmacht flying overhead—when considering a map of Stalingrad and the surrounding region. Throughout each of the films, his office table is draped in oversized maps that the leader caresses gently with pencil-bearing hand or magnified eye. His visionary sight and attendant strategic understanding of these maps are so robust as to negate the need for additional input. He requires only confirmation from messengers and the reports they bear, not information, though he deigns to receive them

31. Pisch, *The Personality Cult of Stalin in Soviet Posters*, 301–3.

32. In the shelved projects, we see incidents of personal bravery: in *The First Cavalry*, Stalin remains in the train car headquarters on the front, strategizing diligently over his maps, despite a rain of gunfire befalling the windows and walls; in the second part of *The Defense of Tsaritsyn*, his heroism extends so far as to lead an assault on foot in the city streets and venture into the middle of a raging cavalry charge to stand on a hill and strike an inspirational pose while marveling that this is "a people who can do wonders."

nonetheless (as well as input from experienced military advisers).[33] For instance, in Savchenko's *The Third Strike* he greets communiqués with a patient "yes, yes, yes, I know, I know" in a tone implying that he *already* knows since his superior skills of reasoning had led him to conclude what the envoy now merely substantiates with his top secret frontline reports. By *The Fall of Berlin*, Stalin's foresight has so sharpened that he corrects those who bring him reports and schools the marshals in what it takes to win a war. In one particularly memorable sequence early in the conflict, Marshal Georgii Zhukov requests 150 tanks to mount a counteroffensive, to which Stalin responds, "150 you say? Take only eighteen machines. Plus armor shells. They are excellent weapons." "Marvelous weapons!" echoes Molotov, and with that the matter is closed. Later, as Stalin coordinates the marshals for the final battle, he again corrects Zhukov's assessment of what is needed to execute the assault, this time telling him to commit over 20 percent *more* armaments than he had estimated. When considered together like this, these two incidents indicate that Stalin's military genius may not even be so much about tactics and strategy as the ability to speak authoritatively. As Zhukov presumably learns, if Stalin says that eighteen tanks will be sufficient, they are.

Stalin's military genius derives largely from his innate wisdom and vision, but also from his work ethic. *The Battle of Stalingrad* reveals that the leader devotes his nights to studying the details of offensive and defensive strategy, such as antitank ditch construction or Kutuzov's maneuvers against Napoleon, rather than pursuing the comforts of home and sleep. He apparently needs only a late-night cigarette or a spot of choral folk music on the radio to feel rejuvenated. Stalin possesses an incomparable command of the details—*all* details, from the numbers of tanks, shells, and guns on a particular portion of the front, to matters of personnel—and is able to interpret this information properly and translate it into successful strategy. He carries the vision of victory.[34]

The battle epics corroborate Stalin's reputation as a successful military strategist, a genius and visionary. But they also demonstrate that every successful maneuver of the war emanated from Stalin personally. During the planning stage, it is always and *only* Stalin's hands that sketch out the necessary maneuvers of

33. Marshal Aleksandr Vasilevskii was among these consultants in the film and did double duty in real life as an adviser on Savchenko's *The Third Strike*. See Baraban, "Filming a Stalinist War Epic in Ukraine," 24, 29–30.

34. According to Hugh Lunghi, the British interpreter to Winston Churchill who observed Stalin during the "Big Three" Conferences of the Second World War, this is actually an accurate picture of the Soviet leader, who made a point of devouring, retaining, and sharing detailed technical data without recourse to notes. Hugh Lunghi, "Reminiscences of the Big Three" (paper presented at the conference "The Cold War and Its Legacy," Churchill College, Cambridge, UK, November 18, 2007). An abridged version of the talk has been published as Hugh Lunghi, "Reminiscences of the Big Three," in *Out of the Cold: The Cold War and Its Legacy*, ed. Michael R. Fitzgerald and Allen Packwood (London: Bloomsbury Academic, 2013), 16–19.

defense and attack as the marshals look on, the only coherent sound escaping their lips being the slow puff of breath that bespeaks unabashed awe. Through the power of montage, Stalin also dominates the implementation of these plans on the battlefield. Assault sequences are intercut, particularly in *The Battle of Stalingrad* and *The Third Strike*, with shots of Stalin in the Kremlin, usually with telephone receiver in hand or dictating commands through a telegraph officer. He is the master puppeteer pulling on telephone lines and wire cables like the strings of a marionette, directing his marshals and their men in the field. Through communications technology, Stalin is there on the front, conducting the explosive concussions of antiaircraft guns and the waves of tanks cresting the landscape. The instruments that had extended authority to Stalin in 1930s historical-revolutionary cinema by connecting him to Lenin are redeployed in the postwar artistic documentaries as means to convey his own unrivaled authority across the breadth of the Soviet Union. The lines of communication are now only ever one-way: *from* and never *to* Stalin. He is the source of his own military genius.

Together, Stalin's Three Blows, as these films might be termed, present him to be the embodiment of the full range of meanings implicit in what was possibly his most ubiquitous title: *vozhd'*, or leader. This term originally signified military leadership and was used metaphorically of political leaders only after the October Revolution.[35] In a sense, then, the war and its commemoration afforded Stalin the opportunity to fulfill the destiny embedded in his title, to render metaphor into reality, albeit if only with the collusion of the Soviet film industry.

Stalin's Apotheosis

In developing Stalin's paternal, visionary, and military characterization and fashioning him into a Lone Leader, cinema took his representation beyond the bounds of Marxist materialism into the realm of godhood. The leader's apotheosis is achieved in film through the tools and techniques of wardrobe, lighting, camera angle, soundtrack, and framing. A standout example can be found in the final scene of *The Fall of Berlin* as Stalin—shot from below to emphasize his towering authority and elevated perspective, bathed in sunlight and dressed in purest white recalling the biblical description of the returning Messiah—descends from the heavens (albeit via airplane rather than a white horse) onto the tarmac of the Berlin airfield to the roaring cheers of people from every nation and tongue. The imagery is not what one could call subtle, and as such has garnered frequent attention in scholarly analyses of Stalin's image in the personality cult generally, and the

35. Pisch, *The Personality Cult of Stalin in Soviet Posters*, 306.

postwar Stalin films particularly.[36] Yet, cinema's deification of Stalin was not limited to his portrayal on screen. Films demonstrated both explicitly and implicitly that Stalin's presence extended far beyond his physical body, or more precisely, the bodies of actors Mikhail Gelovani and Aleksei Dikii, who played the leader after the war. It is to this theme of how cinema conveyed the leader's spiritual presence that we now turn.

Stalin's Omnipresence

Stalin's omnipresence is declared outright by General Vasilii Chuikov in *The Fall of Berlin*. As outrageous as such a claim may seem at first, by the time Chiaureli's paean to the war leader was released in 1950, it was actually the (pseudo-)logical outworking of an ongoing conversation about Stalin's wisdom pursued in the first two Stalin war films. There is a high degree of dialogue between the three epics, which is not surprising given that they follow on from one another chronologically, share a common cast of characters, and use mostly the same actors, with the notable exception of Mikhail Gelovani, who replaces Aleksei Dikii as Stalin in the final film. What is more, the directors and screenwriters of the first two installments were specifically instructed to coordinate their efforts to guarantee consistency from one project to the next.[37] As a result, by considering these three films together as a single text, we can trace the cinematic development of Stalin's omnipresence from inception to explicit enunciation.

It all begins with Stalin's prescience as depicted in *The Third Strike* with his aforementioned assurance when receiving a report that, yes, he already knows. *The Battle of Stalingrad*, released just over a year later, then follows as Chuikov, struggling on the Stalingrad front, encounters firsthand the full extent of Stalin's foresight. In a pivotal scene, deflated in the face of overwhelming German forces and poor communication lines, the general sighs, "If only Comrade Stalin knew!" As the scene fades to black, his adviser responds reassuringly, "He knows." What

36. In discussions of *The Fall of Berlin* alone, Stalin is likened to an icon, a god, God, and the Prince of Peace. Taylor, *Film Propaganda*, 119–21; Kenez, *Cinema and Soviet Society*, 232; Maya Turovskaya, "Soviet Films of the Cold War," in *Stalinism and Soviet Cinema*, ed. Derek Spring and Richard Taylor (New York: Routledge, 1993), 138; Youngblood, *Russian War Films*, 98; Günther, "Wise Father Stalin," 187–88; David Caute, *The Dancer Defects: The Struggle for Cultural Supremacy during the Cold War* (Oxford: Oxford University Press, 2003), 145; Richard Stites, *Russian Popular Culture: Entertainment and Society since 1900* (Cambridge: Cambridge University Press, 1992), 120; Youngblood, *Russian War Films*, 101.

37. Baraban, "Filming a Stalinist War Epic in Ukraine," 28. Baraban argues that the need to work within the framework established for *The Battle of Stalingrad* by the less artistic Vladimir Petrov (even though his project was not as far along in development at the time) constrained Igor Savchenko's stylistics in *The Third Strike* and prevented the creation of what otherwise had the potential to be a landmark film for Ukrainian cinema.

comes next proves the truth of this conciliatory remark and provides the response to the implicit question secreted in Chuikov's comment: Where is Stalin? The next scene opens with the sound of the Kremlin bells chiming the midnight hour as Stalin arrives at his office, retrieves the Stalingrad file from his secretary, and immediately orders Rodintsev's Thirteenth Guard Division to be diverted to Chuikov's aid since, he explains into the telephone receiver, "It is very difficult for them there." The implication is that Stalin supplies Chuikov's needs just as the general himself first articulates them. Stalin's unrivaled understanding collapses the distance between the leader in the Kremlin and his general on the front and indeed every soldier fighting for the Motherland.

This effect of the montage was noted by one viewer, V. I. Krylov, a war invalid, who identifies the juxtaposition of these two scenes as the pivotal moment of the film. The leader may be "far away in Moscow," he concedes, yet the next scene proves that ultimately "Stalin is near. He is here, right alongside you, Commander! Right alongside you, soldier!" Krylov explains that Chuikov's lament was not in vain: "Yes, [Stalin] heard. Yes, he sees. He feels and knows it. The people and Stalin are inseparable."[38] Krylov's interpretation of these scenes reads like a catechism—a statement of faith in an omniscient and consequently omnipresent leader. Stalin is ever present because he is all-knowing. By the end of the battle for Stalingrad (as depicted in the next film, *The Fall of Berlin*), Chuikov has learned this lesson for himself. "Stalin is always with us," he intones, face beaming as he imparts this revelation to the as yet uninitiated Alesha Ivanov and his Ukrainian comrade.

The question remains as to how broadly "we" might be defined here, and whether "always" applied as much off the battlefield as on. The answer is found in films depicting postwar Soviet reality and the reintegration of veterans into everyday life, which make it clear that Alesha and his friend did indeed carry the lesson of Stalin's omnipresence with them into life after demobilization. Although films devoted to everyday postwar life are primarily the concern of chapters 6 and 7 in this book, it is worth considering them here briefly for the ways in which they extend the critical claim of Stalin's apotheosis beyond the front and moments of crisis—and, crucially, beyond the films that featured Stalin in the credits—and into the homes and workplaces of the postwar USSR and its sphere of influence.

38. It is unclear to whom the veteran addressed his correspondence. It reads like an amateur film review rather than a letter to the editor, but whether or not it was commissioned, and who received and transcribed it, is unclear. V. I. Krylov, "O dostoprimechatel'nosti kinofil'ma 'Stalingradskaia bitva,'" n.d., Gosfilmofond, file 2304 (*The Battle of Stalingrad*), document 23/753, page 2.

Stalin's Mediated Presence

Films set in the postwar USSR that do not feature Stalin among the cast of characters nevertheless usually intimate his presence on the screen in other ways. The most obvious of these is through set decor and the incorporation of objects from the cult of personality into the living, leisure, and work spaces of the protagonists. In particular, portraits of Stalin appear across the entire landscape of cinematic reality, mediating his presence through canvas and paper, paint and ink wherever good Soviet citizens and positive heroes congregate. He can be spotted in homes, as in *Bountiful Summer* (*Shchedroe leto*, Barnet, 1951) where the two male protagonists share their houses with their mothers and numerous portraits and history paintings of Stalin festooned with fine linen like a family portrait or icon; and also in public celebrations, fronting the truck that bears the award-winning harvest, spearheading a celebratory march, or overseeing a well-earned community feast.[39] The likeness of the leader is almost always presented as high art, being framed often in gilt but at the very least in flowers. His portrait was not positioned in mundane public places where it could be glimpsed in passing. Instead, the placement of Stalin's portrait was purposeful, and its existence, framed into permanence.[40]

Such attentive presentation veered at times toward reverence, lending the leader's portrait an iconic quality. This effect is emphasized conspicuously in *The Fall of Berlin*, as film historians have noted. Early in the film, a joyous Natasha delivers an agitational speech to the young people, underlining the happy lives they have gained under Stalin. Gazing down on her from a gargantuan gilt frame (centered in the shot, while Natasha is off to the side) is a portrait of Stalin. It is to this sacred image that she addresses her words of gratitude. "There are tears of happiness in her eyes as she looks at the icon," explains Peter Kenez, noting that "she speaks with religious ecstasy."[41] Significantly, it is Natasha the reverent devotee and not Alesha the diligent worker who, at the end of the film, is rewarded with permission to approach the apotheosized Stalin and kiss him

39. The treatment of a picture of Stalin as if it were a family portrait or icon was no mere cinematic invention but was in fact common at the time in Soviet households. Devlin, "Iconography of Power," 248–49. For more on the image of Stalin as icon, see Pisch, *The Personality Cult of Stalin in Soviet Posters*, 350–72. For examples of Stalin's presence via portrait, see *Bountiful Summer* and particularly *Miners of the Don*, where the portrait was so prominent in the main feast scene (there are two) as to warrant the excision of every shot in which it was visible as part of the de-Stalinizing impetus under Khrushchev.

40. That is, apart from a slipup in *Bountiful Summer* that apparently was not caught by censors, wherein a portrait of Stalin in the collective farm meeting room is replaced by one of Khrushchev, then party leader in Ukraine where the film was set, only to reappear in later scenes. Oops.

41. Kenez, *Cinema and Soviet Society*, 232.

"like an icon."[42] The effect is to create a cinescape in which Stalin's face is central, and his gaze ubiquitous and enlivened in a manner anticipated by the poet and lyricist Vasilii Lebedev-Kumach in his 1937 tribute to the discerning powers of Stalin's printed and painted eye:

> And so—everywhere. In the workshops, in the mines
> In the Red Army, the kindergarten
> He is watching
> You look at his portrait and it's as if he knows
> Your work—and weighs it
> You've worked badly—his brows lower
> But when you've worked well, he smiles in his moustache.[43]

Only now, in 1950, it is not work that Stalin weighs with his brows and rewards with a twitch of his moustache, but reverence.

In addition to incorporating the artistic trappings of the cult of personality, a number of films also convey Stalin's presence in the absence of both two- and three-dimensional representations of his likeness. These films mobilize set design to imply Stalin's spiritual presence into the lives of hardworking local leaders in the cinematic version of what personality cult expert Jan Plamper has termed Stalin's "presence-in-absence." Plamper explains that as the leader made fewer and fewer public appearances after the war, even forgoing revolutionary celebrations in Red Square, he came to be conveyed indirectly much more frequently in the art of the cult, as images highlighted the effect he had on others rather than depicting his appearance itself. To this end, paintings show soldiers leaning in toward a radio to listen to his voice or children skipping with joy having just seen him from a distance. At party meetings in Poland, the custom developed of leaving a chair vacant in his honor, prepared to welcome the Soviet leader should he appear.[44] When the purview is expanded to include film, we can see this same dynamic observed by Plamper played out on screen as well, specifically with regard to the arrangement of office furniture, which took on symbolic significance over the course of several films in the early 1950s. What may at first appear to be a mere coincidence in set design

42. Taylor, *Film Propaganda*, 121. Alesha's sidelining in this sequence of worship was something that some viewers took great exception to, as will be discussed in chapter 5.

43. Quoted in Davies, *Popular Opinion in Stalin's Russia*, 152. For the original, see Vasilii Lebedev-Kumach, "Ego portret," *Pravda*, December 5, 1937: 1.

44. Plamper, *Stalin Cult*, 59, 114, 264n94. The paintings discussed by Plamper are Pavel Sokolov-Skalia's *The Young Guard (Soviet Resistance in Krasnodon)* (*Krasnodontsy*, aka *The Voice of the Leader*, 1948), and Dmitrii Mochal'skii's *After the Demonstration (They Saw Stalin)* (*Posle demonstratsii [Oni videli Stalina]*, 1949).

was honed into a sign of Stalin's presence in the offices of local leaders across the USSR and beyond.

Offices and headquarters had been a favorite setting in Soviet cinema practically since its inception. From Bolshevik headquarters at the Smol'nyi in Petrograd and later the seat of the government (Sovnarkom) in Moscow, to local party branches in films set in agricultural and industrial spaces, the Soviet office was most often the physical location of legitimate authority in a film.[45] Meetings were held here, speeches given, and decisions made. Despite this consistency of function, the offices themselves were arranged with anything but uniformity, instead embracing heterogeneity in their furnishings and use of space. This diversity disappeared after 1950, rendering the Soviet office symbolic not only in its function but also in its composition in film. The office and desk of the leader, following a few consistent repetitions, became a clear indicator of the correctness and worth (or lack thereof) of a local official or leader in industry and agriculture.

The change came with the release of Mikhail Chiaureli's *The Fall of Berlin* in January 1950. The film replicated Stalin's personal office in the Kremlin exactly, thanks to Chiaureli's specially granted access to the original.[46] Never before had the seat of Soviet power been so fully and faithfully depicted. It proved a watershed, after which the positive figure of leadership always worked in a private office arranged like that of Stalin, with the desk in the back right-hand corner, the desk chair between it and the wall, and a portrait of Stalin or Lenin hanging above; two chairs on the opposite side of the desk; a long table placed perpendicular to the desk and draped in a plain colored tablecloth with chairs along both sides; and windows along the right-hand wall, with one next to the desk (figures 4.5 and 4.6).[47]

The only significant distinction was the width of the office: Stalin's was broader, meaning his set of meeting tables was not directly in front of his desk. The local leader also sat at a desk where Stalin himself would feel at home: papers, books, and ephemera to the right when seated; ink bottles along the top center; telephone and Lenin lamp to the left. This lamp boasted an entire mythology of its own: it was lit each night whether or not Stalin was in the office so that it might be seen to

45. See, for instance, *Lenin in October* and *Lenin in 1918*, and Pyr'ev's films *The Party Card* (aka *Anna*; *Partiinyi bilet*, 1936), *The Rich Bride* (*Bogataia nevesta*, 1938), and *The Tractor Drivers* (*Traktoristy*, 1939).

46. Anderson and Maksimenkov, *Kremlevskii kinoteatr*, 812.

47. In contrast, communal offices, such as that of Petr Sereda in *Bountiful Summer*, did not follow these arrangements since doing so would be impossible in a space shared by several professionals. Instead, the new symbol was limited to leaders who were of sufficient authority to warrant a private office space, such as local party leaders, district collective farm managers, and industry heads. Nevertheless, even those who did not enjoy private offices arranged their desktops in a manner suited to Stalin, such as Tutarinov's secretary in *Cavalier of the Golden Star* and the eponymous Tat'iana Kazakova in *The Country Doctor*.

shine from the Kremlin window "as a symbol of Stalin's constant vigilance and diligence."[48] Within a few films, the Stalin-inspired office arrangement attained the universality and uniformity characteristic of signification, featuring in *Conspiracy of the Doomed* (*Zagovor obrechennykh*, Kalatozov, 1950), *Far from Moscow* (*Daleko ot Moskvy*, Stolper, 1950), *Cavalier of the Golden Star* (aka *Dream of a Cossack*; *Kavaler Zolotoi zvezdy*, Raizman, 1951), and even *Country Doctor* (*Sel'skii vrach*, Gerasimov, 1952), where it was applied to a domestic setting. This reiteration of Stalin's office decor, and specifically the consistent placement of the Lenin lamp not only on the left side of the desk but also next to a window, as it was in the Kremlin, expanded the scope of the leader's diligence beyond the capitol to every branch of Soviet administration and even into the homes of distant villages.

Crucially, this arrangement only occurred in the workspaces of *legitimate* local leaders—those who were properly Stalinist in their approach to wielding authority—and not in those of weak or corrupt leaders. For instance, the office walls of lackadaisical collective farm chairman Musii Antonovich in *Bountiful Summer* are noticeably bare, underlining his failure to take his position seriously. In *Cavalier of the Golden Star,* Regional Committee Secretary Pavel Kondrat'ev is unable to manage the lower-ranked chairman of the Executive Committee Fedor Khokhlakov, who impedes the protagonist Sergei Tutarinov in his plan to construct an electricity station for the collective farm. Manifesting his indecisiveness as a leader, Kondrat'ev's office is a parody of Stalin's, with all the right elements located in the wrong places: the desk is angled near the door instead of square and at the opposite end of the room, and is at the foot rather than the head of the long table, with the framed portrait of Lenin placed midway along the room rather than near the desk. Similarly, Khristina Padera, the corrupt minister of foodstuffs and Marshall Plan supporter in *Conspiracy of the Doomed*, sits at a desk on the left side of her office, in the center. Although her lamp is on the left, her telephone sits jauntily on the right, and rather than useful materials such as ink bottles and paperwork, her desk is littered with bourgeois objets d'art. When the popularly elected, Soviet-sympathizing Agricultural Union representative, Kosta Varra, arrives at this den of political iniquity to displace Padera, he conspicuously purges the desktop, removing the bourgeois touches, dusting the work space with a handkerchief as if to dispel the germs of American capitalism, and placing the telephone on the left side of the desk with a victorious flourish. No doubt a complete office redecoration will be necessary, but for now, Varra is ready to work in a manner worthy of Stalin. True leaders, wielding legitimate authority, became recognizable not only by their words and deeds but also by their personal work environment, the arrangement of which coincided

48. Pisch, *The Personality Cult of Stalin in Soviet Posters*, 209.

FIGURE 4.5. Stalin's desk in the Kremlin. *The Fall of Berlin* (Chiaureli, 1950).

with the leader's preferences. In this way, Stalin can be said to be present even in films where his interlocutors do not feature on the cast list.

Cinematic Stalin and Soviet Visual Culture

For the most part up to this point, I have analyzed the cinematic representation of Stalin as if it developed in artistic isolation. In reality, film was but one medium in a broad landscape of visual media mobilized by the cult of personality. What is more, it operated within an aesthetic structured on reiteration and intertextuality.[49] In other words, the cinematic image of Stalin was the product of a dialogue between existing representations of the leader popularized in posters, paintings, and photo-

49. This is a dominant theme in scholarship on the aesthetic, for instance, in foundational works on literature: Clark, *Soviet Novel*; Régine Robin, *Socialist Realism: An Impossible Aesthetic* (Stanford, CA: Stanford University Press, 1992). But for key works that illuminate the lesser-known practices of specifically visual intertextuality, see Leah Dickerman, "Camera Obscura: Socialist Realism in the Shadow of Photography," *October*, no. 93 (2000): 138–53; Susan Corbesero, "History, Myth, and Memory: A Biography of a Stalin Portrait," *Russian History* 38, no. 1 (2011): 58–84; Bulgakowa, "Kollektive Tagträume/Collective Daydreaming."

FIGURE 4.6. A good leader's desk (Regional Secretary Boichenko). *Cavalier of the Golden Star* (Raizman, 1951).

graphs, on the one hand, and filmmakers—including the actors who played the leader, the directors, and cinematographers—on the other. In fact, the reliance of film on other visual media for guidance in representing Stalin is so marked that familiar compositions from the cult of personality showed up not only on the walls in the background but also in the very framing of the films' shots. Though examples can be found throughout the postwar Stalin films, nowhere is the influence of preexisting portraits of Stalin more striking than in *The Fall of Berlin*, one of the best case studies for the visual intertextuality of postwar Soviet cinema.

Chiaureli's epic features eight sequences that center on Stalin. Each one of these makes visual reference to at least one well-known photograph, painting, or poster of the leader—often all three, since photographs provided the basis for virtually all portraits, paintings, and posters of the General Secretary, whose image was carefully curated by his private office and occasionally himself personally.[50] This was a practice typical of socialist realist visual culture more generally but was

50. See https://claire-knight.com for the full range of film stills, posters, portraits, and photographs referenced in this discussion. Devlin, "Visualizing Political Language," 83; Devlin, "Iconography of Power," 234, 236. This use of photography as the model for visual works was a feature not only of the personality cult but of socialist realism more generally. See also Dickerman, "Camera Obscura."

particularly noticeable in relation to images of the leader. This only intensified after the war when fresh photographs of Stalin were few and far between. Instead, old images were retouched and transformed into new compositions as Stalin was given a few streaks of gray at his temples and a change of clothing, with his postwar uniform of tan or white replacing his nondescript prewar garb. Cinema also participated in this copying and editing of existing depictions of Stalin.

Most of the Stalin scenes in *The Fall of Berlin* open with an establishing shot dominated by Gelovani as the leader, usually posed and framed in a way that would have been familiar to viewers from other visual media, especially official portraits. Stalin is never in the process of speaking in these moments, or in fact in the process of doing anything, and only begins to take action once the camera has fully absorbed his image. For example, the first Stalin scene finds him playing the gardener—a role he was partial to—and holding a pose reminiscent of the 1936 poster that popularized his Gardener-Father image, "Thank you beloved Stalin for our happy childhood!" ("Spasibo liubimomu Stalinu za schastlivoe detstvo," V. I. Govorkov, 1936).[51] While in the poster he is surrounded in his garden by excited children, in the film he is still awaiting the arrival of the happy child, Alesha, who is coming to thank him. The shot also mirrors F. S. Shurpin's Stalin Prize–winning *The Morning of Our Motherland* (1948) that was already being celebrated and lithographed during the production of Chiaureli's film. In it, the leader dressed in white gazes out over the fields of the bountiful garden that is the Soviet Motherland, holding his hands in the manner adopted by Gelovani in this introductory shot.

The second Stalin scene, set in his Kremlin office during the war, features a prolonged establishing shot that re-creates exactly Stalin's 1942 official wartime photographic portrait: a half-length of the leader sporting his plain brown military uniform, viewed in profile facing right. This same pose and framing are repeated midway through the fourth scene during the Yalta Conference, where it marks a dramatic turning point, and again at the end of Stalin's fifth scene. Stalin's uniform is updated, however, to the version with epaulettes that he sported after January 1943, while his hair is streaked with gray.[52] Similarly, Stalin's official 1945 photographic portrait—which served as the basis of the most widely reproduced painted portrait of the personality cult, Laktionov's triumphant 1949 rendering of Stalin as generalissimo—likewise makes an appearance in the fi-

51. Devlin, "Visualizing Political Language," 98.

52. As the official image of the war leader, this composition was extremely popular in postwar posters as well, such as P. S. Golub's "Beneath the banner of Lenin, beneath the leadership of Stalin, forward to a new victory!" ("Pod znamenem Lenina, pod voditel'stvom Stalina, vpered, k novym pobedam!," 1945), V. G. Pravdin's "To work so that Comrade Stalin says thank you" ("Rabotat' tak chtoby tovarishch Stalin spasibo skazal," 1949), and V. Koretskii's "Beloved Stalin Is the People's Happiness" ("Liubimyi Stalin schast'e narodnoe," 1949, reprinted in 1950).

nal frames of the film, a sequence so replete with restaged portraiture that it is impossible to catalog every visual reference. Meanwhile, Stalin's third scene opens with a pose cribbed from *Joseph Vissarionovich Stalin at the Kremlin* (*Iosif Vissarionovich Stalin v Kremle*), a 1948 full-length study of the leader in profile painted by portraitist to the Soviet elite, Dmitrii A. Nalbandian (and reprinted in *Ogonek* in 1949), right down to the cigarette in Stalin's hand (he was usually depicted on screen with a pipe).[53] The shot also recalls Konstantin Kitayka's painting *Stalin at the Military Air Show* (1949). It is possible that the artists used the same reference photo for their works, and that it was familiar to the film-makers as well. This same composition recurs in the seventh and briefest Stalin scene, where the leader instructs the Politburo.

It was not only the salient establishing shots that re-created familiar compositions of the leader, nor was it solely his official portraits that defined Stalin on screen, however. Among the wealth of diverse examples, two types of shot stand out for their dialogue with ostensibly candid photographs of the leader fulfilling his duties. The first are depictions of Stalin seated at a table or desk in his Kremlin office. In the film, the entire sixth Stalin scene consists of such shots, first at a table, then at his desk, with Gelovani reproducing Stalin's posture and gestures from a series of photographs dating from the 1930s and 1940s. These photographs had been immortalized in numerous posters and paintings by the time *The Fall of Berlin* was in production, so it is possible that Chiaureli and cinematographer Kosmatov used them as a model for shooting this pivotal scene.[54]

The most significant composition in *The Fall of Berlin* to bear a meaningful visual history is the infamous "god-making" shot of Stalin emerging from the airplane at the Berlin airfield. In this low-angle shot, the white-clad leader is radiant as he waves to the crowd from atop a mobile staircase next to the plane that has recently descended from the heavens. This shot has been highlighted by film scholars as "the unsurpassed apogee of [Stalinist] monumentalism" marking "the descent of God the peace-maker to Earth," the "Prince of Peace" who is greeted with "adulation [that] reaches religious proportions . . . as if he

53. Nalbandian completed more than one work under this title. The one echoed so precisely in the film was reprinted in *Sovetskoe iskusstvo* in 1948; see N. V. Voronov, "Predystoriia stroitel'stva semi Moskovskikh vysotok," Iz istorii Moskovskikh Stalinskikh vystok, 2000, http://retrofonoteka .ru/skyscrapers/moscow_skyscrapers.htm.

54. The earliest photograph that I am aware of dates from 1935, "Stalin in his Kremlin study" (Getty images). It inspired V. I. Govorkov's poster, "From the Kremlin, Stalin is concerned for each one of us" ("O kazhdom iz nas zabotitsia Stalin v Kremle," 1940), and at least two follow-up photos of an older Stalin working at his desk. These later poses provided the basis for the poster "It is our good fortune . . ." (1948), by L. G. Petrov (reprinted in Anita Pisch, *The Personality Cult of Stalin in Soviet Posters*, 418), and an unattributed painting that now hangs in the Stalin Museum at Gori (Getty images). What is more, the image of the leader at work at his desk became rather a standard for Communist leaders in the 1950s, with Mao having his own painted portrait done in this manner, and Tito, a photographic one.

were the living God." If *The Fall of Berlin* represents the height of "Stalinist pi-ety" and "the apotheosis of Stalin's cult of Stalin," this shot is the epitome of that deification.[55] Yet, it is by no means innovative, but is instead a faithful re-creation of one of the most famous photographs of Stalin from the postwar period: his greeting of the Moscow Victory Parade on June 24, 1945, from atop Lenin's Mau-soleum.[56] This image was translated into a widely disseminated poster in 1948, "Glory to our great people!—J. Stalin" ("Slava nashemu velikomu narodu!—I. Stalin") by N. Petrov and M. Abramov, before gracing the closing sequence of *The Fall of Berlin*.[57] It is worth noting that the 1945 photograph was itself de-rivative, being the most recent in a long line of such low-angle shots of Stalin waving to crowds from the Mausoleum that were produced almost annually throughout the 1930s, most often during the November 7 revolutionary cele-brations. *The Fall of Berlin*'s god-making shot is therefore the culmination of a tradition of images presenting Stalin's elevation above Lenin (literally as well as figuratively from his position above his mentor's resting place) and the Soviet people, be they gathered at Red Square or a fictional Berlin airfield.

The sense of deliberate visual citation created by the precise manner in which the Stalin scenes are framed and shot is only heightened by the acting style of Mikhail Gelovani. By 1949, Gelovani was a veteran Stalin impersonator, having first played "the Caucasian" in Chiaureli's prewar *The Great Dawn*, and again after the war in *The Vow*. Gelovani prepared for the role by studying intensively every form of media that captured the likeness and habits of the leader, from gramophone recordings to documentary footage, paintings to photographs. When filming *The Great Dawn*, the actor watched his own daily rushes and was not content with any shots wherein he could recognize himself, requesting re-shoots until all that could be seen was Stalin. His approach was consequently monumental: it primarily involved posing.[58]

55. Günther, "Wise Father Stalin," 188; Taylor, *Film Propaganda*, 100, 120; Youngblood, *Russian War Films*, 101; Caute, *Dancer Defects*, 145; Kenez, *Cinema and Soviet Society*, 234.

56. Reprinted in *Krasnoarmeiskaia gazeta*, no. 1 (July 1945).

57. Incidentally, it is the cinematic iteration of the famous pose—recognizable by Stalin's removal of his hat to better reveal his beaming visage to the jubilant crowd—that was further immortalized as a full-length statue of Stalin in East Germany. A photo of this statue, dated March 4, 1954, is held in the Bundesarchiv collection but is also available on Wikimedia Commons at https://commons.wikimedia.org/wiki/File:Bundesarchiv_Bild_183-23647-0005,_Riesa,_Stalindenkmal.jpg (accessed June 28, 2019).

58. Aron Bernshtein, *Mikhail Gelovani* (Moscow: Kinotsentr, 1991). Another postwar Stalin actor, Aleksei Dikii, likewise considered the role to be that not of a man but of a "granite monu-ment" (*granitnyi pamiatnik*) and, according to Mar'iamov, begged to be released from playing Stalin with the argument that it would take too long to prepare, meaning he could not possibly do justice to the role. Perhaps he had heard of Gelovani's rigorous study regimen. Equally, perhaps he remembered all too well the labor camp in which he had languished during the late 1930s before being rehabilitated at the start of the war. See Mar'iamov, *Kremlevskii tsenzor*, 105.

In *The Fall of Berlin*, Gelovani's Stalin is very still, never raising his arms apart from a few stiff waves in the final scene. He does not turn; he rotates. He does not point; he indicates. He does not stride or even walk; he glides unhurriedly. Even when lighting a match—his most dynamic gesture in two and a half hours of film—the motion is so slow that it is a wonder the match catches light. Nor does Stalin multitask. For instance, during a discussion as to resourcing an offensive, he moves from one point in the room to another, stops, then bestows his wisdom in simple, direct pronouncements; he opens a notebook, reads, closes it, then replies to a question. He never ventures far from the camera and rarely does anything as forceful as walking out of the frame. Instead, the Stalin of *The Fall of Berlin* is contained and constrained by the camera's field of vision, his movements paradoxically still, just as a poster image is fixed within its borders. Kosmatov's cinematography collaborates closely with Gelovani, defaulting almost invariably to a static midshot when filming the architect of victory. The combination of Gelovani's restraint and the formal, ponderous camerawork minimizes the sense of movement in the Stalin scenes, drawing the cinematic image closer to its photographic, printed, and painted source material. The unusual degree of stillness attributed to photographs of the leader is certainly mirrored here in his cinematic embodiment.[59]

It is impossible to know how intentional the translation of still images into live action was on the part of the filmmakers, though they would certainly have been very well acquainted with the key images of the personality cult. Regardless, it is worth considering why Stalin's cinematic representation coincides so closely in visual terms with preexisting cult works. Why re-create the Stalin of *Pravda* photographs, official portraits, and political posters so precisely? Doing so was of course the safe option in a climate of ever-tightening censorship and persistent cultural repression. After all, the trauma of the September 4, 1946, resolution lambasting the failures of the cinema industry was still fresh when work began on the Stalin battle epics. But following the models provided by photography and portraiture was not simply a matter of protecting against censure; it was also fundamental to the task of socialist realism to present reality in its revolutionary development. In the visual arts, this meant using photography as a basis for portrayals of Soviet life in order to create a consistent—if revolutionized—version of reality that remained tied clearly to historical reality, at least superficially. Meanwhile, celebrated artistic works like official portraits and prize-winning historic paintings provided the surest base from which to expand the world of socialist reality. By copying preexisting compositions,

59. Plamper, *Stalin Cult*, 39.

filmmakers re-created a reality that was already familiar to viewers, including censors. Presenting Stalin in a familiar way, holding familiar poses and framed in an established manner, impresses cinema's iteration of Stalin with an air of legitimacy, authority, and accuracy. In short, visual intertextuality fosters a sense of realism, artificial though it may have been.

Postwar cinema made some of the most extravagant claims about Stalin ever formulated under the auspices of the personality cult. As we have seen, the full potential of film was exploited after the war to present a wholly developed embodiment of the leader and his influence on the world through the films of genres new and old. With Chiaureli's films and the war epics, and the pervasive presence of the leader rendered through physical and "spiritual" mediation in comedies and dramas about contemporary Soviet life, cinema became what Jan Plamper refers to as the "master medium" of the Stalin cult. Yet its mastery lay not in pioneering any facet of Stalin's representation or even establishing iconic images of the leader. Instead, the role of film was consolidatory, drawing together depictions of Stalin from other media and concatenating them into an animated and accessible vision of an increasingly reclusive head of state. Cinema's mastery lay therefore in its sweeping scope, in terms of both its capacity to incorporate and consolidate every image of Stalin, and its unmatched distribution across the Soviet Union.

Yet these very strengths may well have been the undoing of cinema when it came to conveying a clear and authoritative definition of the leader and his relationship with the Soviet people. The next chapter will explore the limits of cinema's mastery in service to the personality cult as we consider viewer responses to that most Stalinist of films, *The Fall of Berlin*.

RESPONDING TO *THE FALL OF BERLIN*

According to one Soviet viewer, films that incorporated Stalin into their storylines did a great service to the public by providing an exciting opportunity to see the beloved leader. "After all," he explained, "not everyone is destined to see comrade Stalin [in person]!"[1] Stalin's turn as a lead character in postwar films was more than simply image promotion; it was also about facilitating encounter between the leader and his people. The question is, what did audiences make of such encounters? As we saw in the previous chapter, the films themselves modeled an array of proper responses to Stalin. Chiaureli's historic epics portrayed the child-like trust of the Soviet people in their Wise Father and their enthused support for his taking up Lenin's mantle to stand alone at the forefront of socialism. Even films not explicitly about Stalin depicted heroic Soviets who surrounded themselves with reminders of their inspirational leader to the point of channeling his presence even in the absence of portraits, busts, and banners quoting his wisdom. This was the reception to the Stalin cult perpetuated on screen, but what of reality? How did historical Soviet audiences respond to the postwar permutation of Stalin in film?

Reception is a challenging issue for Soviet cinema at the best of times, and even more so during the late Stalin period for which relatively little source material has survived. One exception is Chiaureli's *The Fall of Berlin*. The two-part ode to Stalin's victorious leadership of the war effort was so valued by the regime for its ideo-political and artistic significance that a sampling of viewers'

1. RGASPI 17/132/427/58, Svodka No. 15, by I. Kiriushkin and N. Kravtsova, April 5, 1950, letter 63.

letters was preserved in the party archives, while official reviews proliferated in the press beyond the normal rate. As a result, *The Fall of Berlin* boasts the broadest pool of sources relevant to film reception in the postwar Stalin years. The film constitutes not simply a convenient case study, however. It is also an ideal one for exploring audience interaction with the personality cult in its final years. Intended as Mosfilm studio's seventieth birthday gift to Stalin and considered by scholars to perpetrate the most blatant deification of the leader, *The Fall of Berlin* presents the clearest depiction of the postwar incarnation of Stalin as the apotheosized Wise Father, Military Genius, and Visionary Leader who no longer needs the presence of Lenin or the Politburo to shore up his leadership.[2] Contemporary reviews and viewers' letters provide the opportunity to decipher whether and in what ways these facets of the Stalin cult resonated with postwar audiences.

These two pools of sources are not without their complexities. The ten published reviews under consideration here were penned by professional film critics, public figures, and—rather unusually for the period—"average" Soviets and were printed in the news dailies *Pravda* and *Izvestiia* and in the art and cinema journals *Sovetskoe iskusstvo* and *Iskusstvo kino*. In light of the severe limitations on coverage of cinema in the press after 1947, ten reviews comprise a larger than average sampling for a postwar film. The inclusion of assessments by everyday Soviets, though common in the 1920s and 1930s, was also a rare occurrence after the war and indicates concerted efforts to popularize the film.

The archival collection of viewers' letters is equally diverse. *The Fall of Berlin* was required viewing for most students and workers, and it is from these demographics, as opposed to apparatchiks, that the majority of the sixty-three letter writers hailed, being teachers, engineers, factory workers, pensioners, students, and soldiers. Most were men, with only six letters from writers with feminized last names.[3] They addressed themselves from every corner of the Soviet Union to the editor of *Pravda* in letters that ranged from a few sentences to several pages in length. The correspondence has unfortunately not been preserved in its original form but was transcribed and compiled into a forty-two-page document by I. Kiriushkin and N. Kravtsova of *Pravda*'s letters department in 1950.[4] This compilation made its way to Kruzhkov of Agitprop and Sazonov of the Central

2. Taylor, *Film Propaganda*, 100, 119–21; Kenez, *Cinema and Soviet Society*, 232; Devlin, "End of the War," 113; Turovskaya, "Soviet Films of the Cold War," 138; Youngblood, *Russian War Films*, 98, 101; Günther, "Wise Father Stalin," 187–88; Caute, *Dancer Defects*, 145; Stites, *Russian Popular Culture*, 120.

3. There are a number of letters with Ukrainian, Georgian, and other non-Russian last names, meaning that the authors could be women.

4. RGASPI 17/132/427/17-58. The majority of these letters contain the standard opening and closing lines of Soviet letter writing and so were likely transcribed in their entirety, although it is possible that letters were "excerpted" as they were transcribed.

Committee's cinema department, who together summarized the critiques offered in the letters and excerpted key quotations for the attention of Central Committee secretary Mikhail Suslov.[5]

Of the sixty-three transcribed letters, only six (rather brief) letters were wholly positive in their assessment of the film. The remaining fifty-seven offered up critical analyses, styling themselves as correctives to the film and its published reviews, which supposedly failed to inform readers of the film's faults.[6] In this sense, the letter writers demonstrated a strong sense of agency as they engaged in the creative process—or more specifically the editing process—outlining cuts, improvements to makeup, and rewrites that would address the film's shortcomings. These suggestions were not simply hypothetical. Instead, letters conveyed the expectation that the film could be reedited for rerelease, or at the very least corrected before it was distributed abroad and foreign viewers were led astray by its errors.

Both groups of sources were filtered in some way by the authorities: the reviews, by editors; and the letters, by the *Pravda* letters department and party functionaries. They were all doubtlessly shaped by self-censorship as well, whether consciously or not, since both sets of sources were written for an official audience. The authors of published reviews bore the added burden of providing a model to Soviet readers of how to interpret *The Fall of Berlin*, while the letter writers needed to justify their overwhelmingly critical assessments of the film. These conditions complicate our consideration of authorial intent and the engagement with official discourse apparent in the sources. But they also render even more telling what is written and what is printed: Which criticisms survive the censor's pencil, be it held by an editor or the writer him- or herself? What misconceptions, misinterpretations, and oversights make it to print or into the post? Which themes and figures dominate the discussion and which are underrepresented? These types of questions can draw considerable insight from even the most complex of sources.

Interrogating the reviews and letters pertaining to *The Fall of Berlin* in this way uncovers a surprising degree of agency among the authors when it comes to defining whom they perceived to be the two main characters of the film, namely,

5. RGASPI 17/132/427/59-61. Kruzhkov and a colleague from Agitprop, V. Pereslavtsev, had done the same already for letters sent to the editor of *Kul'tura i zhizn'* (referenced in RGASPI 17/132/427/15), which unfortunately have not been preserved.

6. Of course, there is no way of knowing how representative the preserved examples are of either all letters received or viewer responses in general. It is possible that correspondents with a critical view were more likely to put pen to paper—a purely praiseworthy epistle seems a bit of a wasted effort, after all. Alternately, it is possible that critical letters were considered to warrant passing along to higher authorities, hence their preservation in the party archives. Regardless of how typical they were, these transcriptions at least provide valuable insight into the kinds of things that viewers were interested in concerning the film.

Stalin and the Soviet people. The *vozhd'* and *narod* (leader and people) evoked in these sources are radically distinct from the images propounded by the film itself of Stalin as the Lone Leader who is Wise Father to naive children. Instead, a different leader emerges among viewer responses: one who is not alone but is instead defined by his partnership with and reliance on the matured Soviet people, who in turn are typified as adult children who have attained political consciousness and consolidated their positive heroism through the course of the war. In this way, official and popular reception of *The Fall of Berlin* reached beyond the traditional cult imagery of the film, and its prewar formulation of the positive hero and master plot, to engage with the postwar search for a new positive hero, while also redefining the leader himself along the way. That reviewers and letter writers were able to do so speaks to the persistent multivalence of Stalin cult imagery in spite of tightened censorship, which allowed enough space for Soviet audiences to read a Stalin of their own choosing into the "Ultimate Stalin Film."[7]

An Extradiegetic Leader: Stalin of the People

The most striking feature of the written reception to *The Fall of Berlin* is its redefinition of the leader, who transforms from the apotheosized figure on screen into someone who is defined, according to viewers, by his relationship with the Soviet people. This formulation of the leader, which we might term "Stalin of the People," is evident in both the published reviews and archived letters from viewers, but it is depicted with differing accents depending on the type of source. Published reviews convey the new figuration through positive means, by lauding the unity and interdependence of the leader and the people, while keeping the emphasis on Stalin. In contrast, archived letters advocate the new representation of the *vozhd'* through negative means, by critiquing the film for using outmoded, imbalanced terms to define the exchange between leader and people instead of celebrating their mutual reliance. In so doing, these letters shift the focus away from Stalin and onto the Soviet people. For this reason, it is helpful to analyze the two types of sources separately with regard to their figuration of the leader.

While both the published reviews and the unpublished letters distinguish between the historic Stalin and the "image of Stalin" created by Mikhail Gelovani for the camera, reviews give far greater attention to both Stalins than do the let-

7. Promotional tagline used by International Historical Films, *The Fall of Berlin* (*Padenie Berlina*, Mikhail Chiaureli, Mosfilm, 1950).

ters, with each published piece referencing positively the historical Stalin and often also Gelovani's character. However, most such references take the form of perfunctory stock phrases rather than extended odes to his image or detailed exposition on his character. In fact, film scenes that develop Stalin beyond the standard platitudes escape remark by reviewers. For instance, reviews ignore the film's allusions to Stalin's spiritual presence on the battlefield, expressed most directly in Chuikov's assertion that "Stalin is always with us!"—a significant claim concerning Stalin's wartime leadership. They also overlook Natasha Rumiantseva's overwhelming devotion to the leader, displayed most memorably at the close of her speech in the concert hall with her impassioned cry of "Long live Stalin, who has brought us into a great and happy life!" One review even denies that Stalin is the object of Natasha's ardor, describing her instead as "selflessly loving the Motherland and [deriving her] inner strength from this love."[8]

This last example highlights a dominant trend among reviews, which, rather than being straightforward paeans of praise for Stalin, tend to discuss him in relation to the Soviet people, denying him as the focal point of his own characterization. Reviews define the relationship between the leader and the people using both traditional Stalinist terms and a specifically postwar conceptualization of the unity between the *vozhd'* and *narod*. The first formulation, familiar from the 1930s cult of personality, presents Stalin as the wise leader, teacher, and father, with the people as loving followers, pupils, and children. This representation is conveyed in the reviews by stock phrases praising "the calm, wise foresight" "of the master teacher and leader Iosif Vissarionovich Stalin,"[9] and is evident in *The Fall of Berlin* itself in the interaction between the leader and Aleksei Ivanov and Natasha, who find in Stalin their inspiration and, in Alesha's case, instruction for all matters of life, from labor to love. This paradigm presents an unequal relationship, with Stalin in a dominant position and the Soviet people in perpetual debt to him as beneficiaries of his great insight and gift of happiness.[10]

The second, more pervasive definition of the relationship between *vozhd'* and *narod* in the reviews, however, emphasizes the unity between Stalin and the Soviet people. Three reviews specify this unity as the main theme of *The Fall of Berlin*, while the remainder incorporate it into their discussions of the film.[11] In this

8. Aleksandra Iablochkina, "Vo imia mira i schast'ia narodov," *Sovetskoe iskusstvo*, February 11, 1950. Iablochkina was an accomplished stage actress who enjoyed a prolific career with the Malyi Theatre that predated the Revolution.

9. Iablochkina; Vladimir Shcherbina, "Fil'm o velikoi pobede," *Pravda*, January 25, 1950: 3.

10. Ssorin-Chaikov, "On Heterochrony."

11. Liudmila Pogozheva, "Padenie Berlina," *Iskusstvo kino*, no. 1 (1950): 10–14; Shcherbina, "Fil'm o velikoi pobede," 3; Aleksei Mares'ev, "Velichestvennyi obraz vozhdia," *Pravda*, January 25, 1950: 3. Pogozheva and Shcherbina were professional critics, while Mares'ev was the Hero of the Soviet Union celebrated in Polevoi's novel and Stolper's film *Story of a Real Man* (see chapter 2).

rendering, the interaction is closer to a partnership as Stalin put "his steadfast faith in the Soviet people, in their heroism," their strength, power, and reason.[12] Rather than continually responding to their leader out of indebtedness, the people have proved their worth and elicited a response from Stalin. This marks a significant development in the representation of the leader who is now implicated in a two-way faith relationship with the Soviet people.

When it comes to the viewers' letters, the theme of "the great unity of the people and leader" is likewise prevalent, as writers echo the notion that the leader derives "his greatness and wisdom from his deep, inseparable connection with the people, with its interests, aspirations and hopes."[13] The persistence of these ideas in the letters is significant given their otherwise limited engagement with Stalin. Only thirteen letters dwell, even briefly, on the leader, and these tend to concentrate on his representation in the film rather than the historical Stalin. Gelovani's Stalin is celebrated and denigrated in equal measure: he is deemed to be both an exact embodiment of the leader, successfully erasing the line between reality and cinema, and a shoddy one, monotonous and inert in his movements and detached in his mien, spoiling the ending of the film with his excessive posing.[14] Positive assessments are usually found at the very outset or close of the letter, as if fulfilling a formality, and almost always provide the context for fierce critique of other aspects of the film, thereby softening the critical blow. For instance, E. P. Drozdov concludes his letter by noting the "exceptional power of Gelovani's performance—the viewer forgets that Stalin's role is played by an actor," before complaining in the next clause that "the other members of the government are depicted much worse."[15]

Letters that are critical of the film's image of Stalin tend to be more detailed and engage more closely with the platitudes and principles of the Stalin cult. In this way, they underscore the dissonances that the cult had come to contain by the postwar period, as new metaphors and emphases in meaning were layered atop one another over the years. Three examples stand out for their rejection of Stalin's characterization in the film, which the writers perceive to contradict the basic principles established by the personality cult. The first is a reading of Natasha's speech that highlights the tension inherent in the Stalin cult between the tropes of indebtedness to the leader and the leader's personal modesty. B. V. Ustintsev accuses the filmmakers of "unfairly attributing to Stalin a dictatorial

12. L. Kolchin, "Vysokokhudozhestvennyi fil'm," *Pravda*, January 25, 1950: 3; Shcherbina, "Fil'm o velikoi pobede," 3. Kolchin was a Red Army captain.

13. RGASPI 17/132/427/30, letter 26; 17/132/427/47, letter 50.

14. RGASPI 17/132/427/21, 23, 28, 37, 43, 58 (letters 9, 13, 22, 38, 45, 63), contrasted with RGASPI 17/132/427/18, 23, 47 (letters 1, 14, 50).

15. RGASPI 17/132/427/21, letter 9.

attitude" in this scene by implying that the leader sought the kind of vehement gratitude Natasha expresses on behalf of the Soviet people for their happy up-bringing. Such fervency was, according to Ustintsev, in direct contradiction to the humility and charisma for which "our leader is known to all progressive humanity, not least of all to we Soviet people." Rather than seeking personal recognition, insists the filmgoer, Stalin always emphasized that it was the party or the people together who were responsible for Soviet achievements.[16]

A. A. Kotomkin likewise rejects what he considers to be Stalin's dictatorial bearing in several scenes shared with members of the Politburo where the leader is shown to make decisions without consulting his colleagues.[17] Kotomkin's complaint—and seven others like it that protest the film's pale, mute, colorless, distorted, inactive caricatures of Molotov, Kalinin, Voroshilov, et alia—foregrounds the antipathy between, on the one hand, the notions of collective leadership and Stalin's modesty (mainstays of the cult since its inception) and, on the other, the intensified postwar emphasis on Stalin's authority to lead alone.[18]

The most straightforward yet nevertheless poetic critique of the film's image of Stalin is P. E. Zaichenko's scathing indictment of the allegorical scene in which Stalin first appears, pottering in his garden as a heavenly chorus serenades him and the sun kisses his upturned face: "Look at these stunted trees, uncrowned and nearly leafless twigs, either thrust or driven into the virgin soil of a forest glade overgrown with an unruly carpet of grass. Where do the filmmakers see such a 'garden'? Such a garden does not testify to an industrious gardener. The negligence in this scene not only reduces the artistic embodiment of the idea that it is necessary to raise people in the manner of a careful gardener, but even discredits it."[19] Rather than following the direction of the camera's gaze and focusing on the leader, here depicted as God in his Eden, Zaichenko concentrates on God's object, the garden itself, and finds it to be so inadequate as to negate the gardener's deity and delegitimize the well-established visual metaphor of Stalin as the nation's gardener, cultivating the Soviet people for the new world of his creation.[20] Zaichenko's call for greater attention in depicting the garden also resonates with the primary preoccupation of the reviews and letters, which is the film's portrayal of the Soviet people, the fruit of Stalin's garden, rather than the gardener himself. Despite redefining the gardener in similar terms,

16. RGASPI 17/132/427/35, letter 34.
17. RGASPI 17/132/427/55, letter 59.
18. RGASPI 17/132/427/18, 19, 26, 30, 34, 39, 43, letters 1, 7, 18, 24, 31, 39, 46.
19. RGASPI 17/132/427/30, letter 26.
20. For more on the arboreal and other nature-based metaphors used in the Stalin cult, see chapter 3 of Pisch, *The Personality Cult of Stalin in Soviet Posters.*

the two types of sources examine the fruit of his garden in distinctive ways, as we shall see next.

A New Positive Hero: Stalin's Grown-Up Children

As with the image of the leader, the representation of his costar, the positive hero, in written responses to the film is likewise rooted more in the context of the film than in *The Fall of Berlin* itself. For its part, Chiaureli's epic avoids the theme that otherwise preoccupied war films: the search for a postwar formulation of Soviet heroism. Instead, Stalin's presence provides the focal point, displacing the ostensible protagonist, Alesha Ivanov, from the spotlight and holding him captive to a resolutely prewar figuration of the positive hero. To this end, the film adopts the 1930s master plot of spontaneity to consciousness for Alesha, taking him from a condition of rather painful immaturity to a more mature state through the trials of war, so that he can stand before Stalin once again at the end of the film in a more dignified—if yet utterly mute and slightly pathetic—manner. According to socialist realist conventions, and specifically the principle of *tipichnost'*, or typicality, the positive hero is the embodiment of the Soviet people. In this sense, the film consigns the Soviet people to the fate of Sisyphus, destined to repeat the prewar maturation arc over and over again, never quite grasping heroism fully even after Great Patriotic victory. Granted, Natasha also represents the Soviet people in *The Fall of Berlin*, yet she is even more limited than Alesha in that she is denied a development arc of any kind and instead simply models a single facet of the Soviet people: their gratitude. Rather than growth, Natasha's narrative is one of fulfillment. During her speech at the outset of the film, Natasha is defined according to her dream of one day thanking Stalin; in the final scene, she enacts that dream, but even this resolution is facilitated by circumstances (he comes to the nation where she has been held captive) rather than by her own agency (she boasts no achievements that might earn her access to his presence). In terms of the characterization and arc of the positive hero, therefore, *The Fall of Berlin* had nothing new to offer the aesthetic and could have been made before the war for all it conveys about the positive hero and therefore the Soviet people.

What is fascinating about the written responses to the film, however, is that they reject this retrogressive dimension of the film altogether. Reviews do so implicitly, celebrating instead an extradiegetic version of the heroic Soviet people as mature, adult children to Stalin's Wise Father, while the letters do so explicitly, challenging the filmmakers outright for their flawed representation of the

hero as childish and immature. The result is that the viewers themselves correct the outdated positive hero and master plot of *The Fall of Berlin*, postulating a vision of heroism suited to the postwar context.

Published Reviews and a Soviet People Partnered with the Leader

Beginning with the reviews, the Soviet people represent the most fully developed character in officially sanctioned responses to *The Fall of Berlin*. According to critics and other published commentators, it is the Soviet people who provide the theme and purpose of the film. This assertion originated with prerelease publicity as Minister of Cinema Bol'shakov described the artistic documentary as a "film about simple Soviet people under the leadership of Stalin."[21] The cinema critic A. Solov'ev went even further in his discussion of the shooting script, denying Stalin any mention: "While developing the theme of the battle for Berlin strategically, the authors also reveal the theme of the people deeply, clearly and intelligibly, with all the necessary details. The heroes in whom this theme is developed do not appear in the script merely incidentally, in the intervals between battles or during fights. They are the subject at all times, driving the plot."[22]

Once the film was screened, reviewers only expanded on these assertions. Vladimir Shcherbina, a *Pravda* literary critic whose lengthy article features the most enthused pronouncements of Stalin's greatness, declares that *The Fall of Berlin* is "the most remarkable example . . . of excellent films recounting the exploits of the Soviet people." It is "a story of two beautiful young Soviet people," depicting the "joyful atmosphere of the peaceful labor of the Soviet people," the "strength of the humble Soviet people," and "the triumph of the socialist country and her outstanding people"—alongside the "greatness of Stalin" of course.[23] Similarly, the *Iskusstvo kino* critic Liudmila Pogozheva writes that with *The Fall of Berlin*, Chiaureli and screenwriter Petr Pavlenko created a work "of enormous ideo-political significance, that shows with great artistic force the fate of the Soviet person intertwined with the fate of the Motherland, with life and the struggle of all the people."[24] She continues by pointing out that this film, along with Chiaureli's earlier Stalin epic, *The Vow*, illustrates the intimacy of Stalin and the people in the same manner as does Mayakovsky's poem dedicated to the relationship between Lenin and the Bolshevik Party. This is a startling claim in light of the stanza she quotes in her review:

21. Ivan Bol'shakov, "Blizhaishie zadachi sovetskoi kinematografii," *Izvestiia*, July 14, 1948: 3.
22. Solov'ev, "Puti razvitiia novogo zhanra," 18.
23. Shcherbina, "Fil'm o velikoi pobede," 3.
24. Pogozheva, "Padenie Berlina," 11.

The party and Lenin—
 twin brothers,—
who is more
 precious to mother-history?
We say—Lenin,
 we mean—
 the party,
 we say—
 the party,
 we mean—
 Lenin.[25]

Here, Mayakovsky affirms the closeness of the leader and party, likening them to twins who are equal in historical significance. Pogozheva's application of this sentiment to *The Fall of Berlin* implies that Stalin and the people were joined in a relationship of parity, even interchangeability: when we say Stalin, we mean the Soviet people; and when we say the Soviet people, we mean Stalin.

According to reviews, the film's representation of the people accounted for its success: its standing as a masterpiece (*shedevr*), its "living truthfulness and emotional intensity," and its popularity with audiences.[26] Reviewers assert that the film was created for "us," claiming ownership over it on behalf of the Soviet audience through the frequent use of first-person plural. In this way, the reviews collapse the distinction between the cinematic and historical Soviet people. Only Shcherbina seems to have been aware of this melding of representation with reality, and heartily approved of it, explaining that *The Fall of Berlin* "was born of the deep need of the Soviet people to speak of their own life. . . . The voice of the people is heard in the film, the beat of its pure, courageous heart."[27]

The people who command such prominence in the reviews do not appear in the film itself. This is because the reviews' depiction of the people is not consistent with Alesha and Natasha, who embody the Soviet *narod* in the film. The two protagonists remain childlike and even childish in their dependence on Stalin for their happiness, and they are unable to find each other apart from the catalytic presence of Stalin. In contrast, the Soviet people of the reviews are needed by the leader as he places his faith in their strength, relies on them, and is inspired by them. This version of the leader also contrasts sharply with the Stalin of *The Fall of Berlin*, who does not rely on or seek inspiration from anyone but instead

25. Quoted in Pogozheva, 13.
26. A. Bratchikov, "Fil'm o liudiakh, vospitannykh Stalinym," *Pravda*, January 25, 1950: 3; Shcherbina, "Fil'm o velikoi pobede," 3; Antonina Barbotkina, "Glubokoe vpechatlenie," *Pravda*, January 25, 1950: 3.
27. Shcherbina, "Fil'm o velikoi pobede," 3.

remains alone in his greatness. In short, the *narod* and *vozhd'* described in the reviews are not diegetic but rather come from somewhere outside the film itself.

More specifically, the reviews' equation of the Soviet people and Stalin joined in a partnership of mutual recognition and trust seeped in from the broader visual context in which the film was screened. It came from the spheres of graphic art and painting wherein the idea of a *vozhd'* paired with the *narod*—a Stalin of the People—had come to dominate after the war. Although founded on the Wise Father figure of the prewar period, Stalin of the People was the product of two developments particular to postwar iconography. The first of these was a shift in the portrayal of the people with whom Stalin interacted, in what was the artistic equivalent of Stalin's sudden cinematic engagement with "everyday" Soviets like the Petrov family in *The Vow* and the young couples in Chiaureli's other films. In prewar political posters, Stalin was most often flanked by party cadres, Stakhanovites or other model workers, or a man and woman grasping hammer and sickle as representatives of the industrial and agricultural proletariat. Normally, the leader was disproportionately large and loomed over a sea of disembodied heads or shrunken figures belonging to the party membership or proletariat. His interaction with the Soviet people was one of dominance over the political and social elite of the USSR rather than engagement with the full breadth of the *narod*.

After the war, there was a shift in the visual discourse as Stalin was thronged instead by a mass of individuals who were differentiated according to age, ethnicity, and profession.[28] Gone was the emphasis on leading laborers, party members, and the proletariat. In its place was a modern Soviet Union constituting diverse nationalities and professions, from traditionally garbed peasants and herders to business-suited bureaucrats, with skilled workers filling the gaps in between. Stalin was now shown clearly to be in relationship with the Soviet people as a whole, in all their socioeconomic, educational, and ethnic diversity. What is more, the figures of Stalin and the people in postwar graphic art were most often proportional to one another, implying a more equitable dynamic.

The second postwar trend underpinning the notion of a Stalin of the People was the preponderance of poster captions and painting titles that linked the people with depictions of Stalin as the Lone Leader of the USSR. Despite being pictured alone in postwar compositions, freed of Lenin and the party, Stalin was inescapably paired with the entire *narod* through slogans declaring that while alone, he thought of, acted on behalf of, and hailed the great Soviet people. For instance, N. Petrov and M. Abramov's illustration from 1948 of a waving Stalin

28. Bonnell, *Iconography of Power*, 253.

in military dress was captioned "Glory to our great people! I. Stalin," while posters by V. S. Ivanov and others implied that the leader did everything from voting in party elections to annotating irrigation plans with "the people's happiness!" in mind. The people of these captions were no longer merely children or representatives of modernized agriculture and industry; they were now united with Stalin in greatness as their happiness preoccupied his waking thoughts. Images of Stalin surrounded by the people merged with those of Stalin on his own, as it was revealed that he was *not* in fact a solitary leader but was instead accompanied by the people at all times. Stalin had become a metonym for the Soviet people.

This representation of the leader resonated with Soviet audiences, as illustrated by the reviews of *The Fall of Berlin* and discussions in the press concerning the significance of Stalin in art. For example, the film critic Rostislav Iurenev celebrated postwar cinema for showing that the "images of the people and the leader are inextricably linked," even extending this revelatory accomplishment to every representation of Stalin: "Numerous works of literature and painting, sculpture and music, theater and cinema, embody the features of this image [of Stalin]. The ideological and educational value of these works is inestimable. They embody the ideas and accomplishments of the Soviet people, and the image of the great Stalin, thus helping the people to understand more fully the meaning and path of the construction of communism."[29]

As Sarah Davies demonstrates in her study of 1930s popular opinion and the Stalin cult, people tended to pick and choose from among the many elements of Stalin's public identity, preferring those that were of greatest personal relevance, while ignoring or downplaying others.[30] This same process was visible in the reviews for *The Fall of Berlin*, where Lenin's Heir appears but once, and Wise Father Stalin only occasionally through stock phrases; and although more visible than the other images, Stalin the Military Genius—a facet of his Lone Leader persona—was nevertheless outclassed by Stalin of the People, in spite of the war veteran credentials of several of the reviewers.[31] As Aleksei Dikii, who played Stalin in *The Battle of Stalingrad* and *The Third Strike*, intoned, "We know, of course, that the applause does not belong to us, the actors, but to the image of the leader, whom the spectators 'know.'"[32] In the case of reviewers of *The Fall of Berlin*, this "known" leader was specifically Stalin of the People.

29. Rostislav Iurenev, "Obraz velikogo vozhdia," *Iskusstvo kino*, 6 (1949), 8.
30. Sarah Davies, "The 'Cult' of the Vozhd': Representations in Letters from 1934–1941," *Russian History* 24, no. 1/2 (1997): 147; Davies, *Popular Opinion in Stalin's Russia*, 155.
31. Evgenii Gudz', "Proizvedenie, poniatnoe kazhdomu," *Pravda*, January 25, 1950: 3. Gudz', a student at the Suvorov Military College, states that "this film clearly shows what the great Lenin and his devoted friend and colleague comrade Stalin have done for our Motherland."
32. Aleksei Dikii, "Pochetnyi dolg sovetskikh khudozhnikov," *Iskusstvo kino*, no. 6 (1949): 11.

Archived Letters and the Demand for a Different Hero

While reviewers made their preference for this formulation of the *vozhd'-narod* relationship clear by privileging it in their articles, viewers' letters supported it indirectly by critiquing the film's *actual* representation of the relationship, which adopts the traditional asymmetrical father-child paradigm familiar from the prewar imagery of Wise Father Stalin. A minority do so by questioning the representation of Stalin, labeling him as dictatorial or negligent (as discussed earlier) or, in other words, as a grossly overbearing or failed version of the father figure. Added to these accusations is a letter insisting that "Comrade Stalin is not seen in this film." The author, engineer Dmitrii Priemskii, explained that Gelovani's portrait of the leader failed to capture the living Stalin, who is "near and great for each of us."[33] The film depicts the wrong Stalin, distant and alien, and entirely too much a Lone Leader.

The majority of the letters, however, aim their vitriol not at Stalin but at the Wise Father's subject, the childlike Aleksei Ivanov, who provides the film's "synonym for the millions of Russian, Soviet Ivanovs" who constituted the USSR.[34] Forty-four of the fifty-seven critical letters focus their sights squarely on Alesha, who is lambasted more fiercely than the German enemy. In fact, he has only a single, rather oblique defender in O. Nesterov of Sverdlovsk, who finds Boris Andreev to be "simply charming" in the role of Alesha.[35] The consensus instead deems the steelworker to be primitive, uncultured, uneducated, illiterate, impolite, rude, crude, and coarse, an alcoholic and "great hunter of vodka," silly, stupid, poorly raised, ill-bred, and ignorant of basic etiquette. "Even the peasants from the most dull corner of our Union . . . behave themselves more politely and with greater culture than this [supposedly] first-class worker," lament I. I. Belov and E. I. Shmal'ts of Tallin.[36] Viewers were ashamed of him and felt embarrassed because of him. "You sit in the cinema hall," explains senior sergeant V. L. Luzhetskii, "and redden because of the hero, the representation of a Soviet first-class person."[37] This was not a representative of the Soviet people: Alesha is not a product of Soviet society, of the current times, of steelworker training, or even of his own biography, which began on the auspicious October 25, 1917, and designated him a true son of the Revolution. Letter writers protest repeatedly that "our first-class youth are not like this!"; "there are no such people among

33. RGASPI 17/132/427/23-24, letter 14.
34. RGASPI 17/132/427/47, letter 50.
35. RGASPI 17/132/427/28, letter 22.
36. RGASPI 17/132/427/34, letter 32.
37. RGASPI 17/132/427/42, letter 44. See also RGASPI 17/132/427/26, 53, letters 17, 56.

us"; and "none among our people would conduct themselves so." As the film's embodiment of the Soviet people, Alesha creates a distorted, false, unrealistic image that was not simply erroneous but an example of outright slander against the Soviet people.[38]

The most heated censure of the steelworker focuses on the scene in which he meets with Stalin and the members of the Politburo, a scene that "hurts the eyes and ears," largely because of its attempts at humor that see Alesha as the butt of the jokes.[39] "How could it be that a scene depicting a meeting between the leader and a hero of labor is played comically? This is blasphemy!"[40] decries E. P. Mosiakina, a veteran of the Battle of Berlin. In reporting on the popular outcry against this scene, Kruzhkov and Sazonov observe that for viewers, "the fact that Aleksei hides behind the bushes, confuses the patronymic of comrade Stalin, behaves himself too cheekily at the reception, and requests help in dealing with his girlfriend, etc., vulgarizes the image of Aleksei, who is represented in the film as a leading Stakhanovite."[41] In short, viewers' letters dwell on the contradiction between Alesha's position in society and his level of culture. Such a leader in labor should be someone who has already been refined from raw material into finished product; someone literate and mature, a model of Soviet achievement rather than a bumbling man-child dependent on explicit instruction from the Wise Father in matters of culture, comportment, and even romance. Viewers express a sense that times have changed, that such a lack of development as that displayed by Aleksei Ivanov no longer existed in the Soviet Union—certainly not for an accomplished, skilled laborer. M. M. Smirnov, a middle-aged worker, expresses it this way: "Sure, 35 years ago I could not have given such a [critical] review of the film, but now you must excuse me! I have my opinion and will never agree with the representation of the first-class worker given in the film *The Fall of Berlin*. To present a first-class worker as such a backward, ill-bred fellow in the thirty-third year of Soviet power is a great mistake!"[42] Schoolteacher P. P. Ivanov develops this observation even further, explaining that "we are proud that we belong to a people of victors, a people who built communism, and we want to see on screen a real Soviet person."[43]

In contrasting the hardworking yet childish Alesha with "Soviet reality," the letter writers lay claim to a more mature definition of the contemporary Soviet people. This definition applied not only to middle-aged Soviets who had learned

38. RGASPI 17/132/427/34, 39, 33, 37, letters 32, 40, 30, 38.
39. RGASPI 17/132/427/26, letter 17.
40. RGASPI 17/132/427/30, letter 24.
41. RGASPI 17/132/427/15.
42. RGASPI 17/132/427/24-25, letter 42.
43. RGASPI 17/132/427/22, letter 11. See also RGASPI 17/132/427/58, letter 62, which states pointedly that "viewers request, in the future, to see the real life of the Soviet people."

the lessons of Soviet power but to young people like Alesha, who was only twenty-three years old when he met Stalin yet was raised under the red flag.[44] This mature definition of the people also necessitated a more dignified, adult interaction with the leader: rather than parent to toddling child, it demanded that of parent to adult child—one who had grown into a support, inspiration, and source of security for the elder. In other words, it necessitated a reciprocal relationship, akin to that embodied by Stalin of the People.

The most prominent examples of this popular reconceptualization are found in letters that suggest an alternate ending for the film. Two writers in particular take issue with the unidirectionality of praise in the final sequence, as ecstatic hordes from around the world greet Stalin on his arrival in Berlin. Alesha and his beloved Natasha reunite under Stalin's benign gaze, and Natasha asks permission to approach the leader to thank him for everything, kissing him on the shoulder—perhaps because of his towering height; perhaps as a throwback to the similar gesture of obeisance performed by serfs toward the serfholder—whereupon Stalin calls on the progressive peoples of the world to fight to maintain hard-won peace in these troubling times. The film closes by reinforcing the unequal relationship between leader and people, underlining the indebtedness of Soviets and indeed the world to comrade Stalin. And therein lay the error:

> Comrade Stalin does not recognize Aleksei and does not prompt him to approach. If this was reality, Iosif Vissarionovich, seeing Aleksei, would undoubtedly have called him to himself, congratulated him like an old acquaintance, and who knows, maybe embraced the hero-soldier and given him a fatherly kiss. Maybe the filmmakers need to think about this. It should have been that comrade Stalin and the steelworker-soldier Ivanov (embodying in the film our heroic working class) again meet warmly in the finale. It would have been good if Stalin thanked Ivanov, and through him, the entire people, all the soldiers of the Soviet Army, for their valiant, difficult military work. How marvelous this scene would have been, a well-deserved beautiful crowning film about our Great Victory.[45]

And again:

> The viewer is pleased for Aleksei Ivanov and applauds his bravery and thousands like him, applauds comrade Stalin for the fact that he flew to the courageous Soviet soldier. But it seems to me that the end of the

44. It even extends to children only recently born into the postwar era who, as viewers point out, were in fact more mature than Alesha. RGASPI 17/132/427/22, 58, letters 11, 63.
45. RGASPI 17/132/427/56, letter 59.

film was done a little incorrectly. In my opinion, it would have been very good if comrade Stalin, when he is thanked by Natasha, noticed his former steelworker acquaintance, now the valiant soldier Aleksei Ivanov, and grasped him by the hand and thanked him for the defeat of the German occupiers, because Ivanov was not only a celebrated steelworker, but also a brave soldier defending his Motherland. With such an ending, the screenwriter and director would have once more shown the great attention of the leader for each individual enlisted Soviet person. From this the soul of the Soviet person would have been raised even more.[46]

These two alternate endings emphasize that Stalin is in fact indebted to the people, particularly the soldiers, and that he owes them recognition for what they have done.[47] In disregard of the film's claim that Stalin was responsible for orchestrating victory single-handedly, these viewers insist that victory is the achievement of the people, who deserve requital from the leader. Instead of embracing the apotheosized Lone Leader presented in the film, these viewers of *The Fall of Berlin* promote a more relational version of the leader surrounded by capable, active colleagues and supported by a mature, cultured people to whom he is deeply indebted. This Stalin of the People derives his greatness, wisdom, and legitimacy from a population of accomplished adults with whom he enjoys a relationship of reciprocal trust and recognition.

Reinterpreting *The Fall of Berlin*

The appeal of this representation of Stalin was due greatly to timing. For an audience that had been engaged in total warfare throughout four long years, the notion of having served as Stalin's partners in victory was attractive and also rang true to personal experience. In waging and winning the Great Patriotic War, the Soviet population fulfilled the purpose for which the party-state had charged them to sacrifice and prepare since the first push to industrialize and collectivize rapidly in 1928: they defended socialism against imperialist attack. In answering the regime's call, the Soviet people proved themselves as reliable, trustworthy partners and no longer the politically and technologically illiterate

46. RGASPI 17/132/427/56, letter 60.
47. Incidentally, Chiaureli is partly to account for these viewers' expectation that Stalin would have recognized Alesha after all these years, since the director had Stalin do as much in his film *The Vow*, when the leader recognizes the widow Varvara Petrova twice, both times after several years have passed, and thanks her and, through her, the "millions of Soviet mothers" and their "outstanding sons" who won the war. Stalin does the same thing in Dzigan's *First Cavalry* (*Pervaia konnaia*), which, although it was shelved in 1941, is testament to the existence of some sort of a tradition around the leader's extraordinary attentiveness to his people.

children the party had set out to transform throughout the 1920s and 1930s. The ideological narrative of the 1930s fulfilled, many Soviets anticipated the beginning of a new era after the war, a new phase in the interaction between party-state and society—and a new phase that would involve a reconceptualized relationship with the leader.[48] The old trope of Wise Father was no longer sufficient, while the newer Lone Leader image did not resonate keenly.

Even before the war, though, Soviet audiences had demonstrated a preference for elements of the Stalin cult that pertained to his relationship with the people. Victoria Bonnell finds this to be the case in her examination of poster reviews dating from the 1930s, while the Tretiakov Gallery exhibition in honor of Stalin's sixtieth birthday in 1939 adopted the theme "Stalin and the People of the Soviet Country in the Visual Arts" as the best means by which to explore the life of the great leader.[49] The Stalin of the People formulation was also aligned with official party doctrine that, as David Brandenberger discusses, "had stated quite clearly since 1932 that leaders emerge from among the people." He points out, however, that "Soviet mass culture had rarely followed this directive and routinely characterized Stalin as playing a paternalistic role in relation to Soviet society."[50] Stalin of the People corrected this tendency, providing an ideologically warranted representation that appealed to the public.

It is therefore conceivable that audience members were looking for Stalin of the People on the screen. Letter writers who did not find him in Chiaureli's war epic were offended by what they saw instead: a Lone Leader unconscionably aloof from his colleagues who were mere background players, and an infantile rendering of the Soviet hero that testified to an unbalanced relationship between leader and people. But those who did see Stalin of the People in the film—including some letter writers and all the reviewers—celebrated the film as the depiction of unity and mutual trust between the leader and the people. The question is, how did they see this in the film? Certainly, they may have simply projected what they wished to see (or assumed they would see) onto the screen. Yet, there are also two specific features of the Stalin scenes in *The Fall of Berlin* that facilitate the interpolation of Stalin of the People into the film for those viewers who sought to find it there.

First is the precise framing of the Stalin scenes and particularly the establishing shots, which closely echo well-known socialist realist compositions, as discussed in chapter 4. Of the seven specific works embodied by Mikhail Gelovani and restaged by Chiaureli and cinematographer Leonid Kosmatov, the captions and titles of five

48. For more on popular expectations after the war, see Zubkova, *Russia after the War*.

49. Bonnell, *Iconography of Power*, 163, 167.

50. David Brandenberger, "Stalin as Symbol: A Case Study of the Personality Cult and Its Construction," in *Stalin: A New History*, ed. Sarah Davies and James Harris (Cambridge: Cambridge University Press, 2005), 261.

refer to the *narod*, "we" or the "country," despite their absence from the image. It is possible that, just as the people were present in these posters through the mediation of the word, so too were they present in the film's restaging of the posters, mediated by viewers conversant with postwar renderings of Stalin's relationship with the people, and possibly these posters and paintings specifically, given their broad distribution in the lead-up to Stalin's seventieth birthday celebrations that year.

Added to the particularity of the images themselves is the fact that they appeared during the film's only moments of silence. Silence was rare in postwar Stalin-era cinema largely because officials considered it risky to present images divorced from the directive influence of the word (written or spoken), or at the very least a musical score to cue the appropriate emotional response to the images. This concern was in accordance with the concept of inner speech developed by the literary critic Boris Eikhenbaum during the early years of Soviet cinema, which held that silence provides the viewer with an opportunity to process and respond to images unconsciously, developing his or her own explanation for what is pictured on screen.[51] Silence encourages internalized narration, meaning that the inclusion of sound was a way of curbing such interpretive opportunities. More recent scholarship echoes Eikhenbaum's early suppositions by underlining the heightened salience of sound, particularly dialogue, in shaping viewers' interpretations of audiovisual material, and positing that silence "return[s] the message of the images to the film's spectator."[52] Rather than absorbing meaning as given, silence facilitates reflection and interpretation among viewers, who are able to draw on ideas and iconography from beyond the film itself to invest cinematic images with meaning.

In the Soviet context, the visual landscape and discourses provided by socialist realism proved a rich resource for audiences' interpretations of cinema. In the case of *The Fall of Berlin*, the three silences occurring during Stalin scenes are augmented by a kind of visual silence. Three visual effects—the plainness of the mise-en-scène and set; the stillness of the cinematography with its static shots and ponderous pans; and the acting style of Gelovani with his proclivity for posing and slow movement—together conspire to mute the busyness that can otherwise result when capturing movement on film, particularly on harsh Agfa color film stock. Stalin's solitariness in these moments of silence is also signifi-

51. Katerina Clark, "Aural Hieroglyphics? Some Reflections on the Role of Sound in Recent Russian Films and Its Historical Context," in *Soviet Hieroglyphics: Visual Culture in Late Twentieth-Century Russia*, ed. Nancy Condee (Bloomington: Indiana University Press, 1995), 16; Boris Eikhenbaum, "Problems of Cine-Stylistics," in *The Poetics of Cinema*, ed. Richard Taylor, trans. Richard Sherwood (Oxford: RPT Publications, 1982), 11.

52. Michel Chion, *Audio-Vision: Sound on Screen*, trans. Claudia Gorbman (New York: Columbia University Press, 1994); Clark, "Aural Hieroglyphics?," 16. See https://claire-knight.com for the full range of film stills, posters, portraits, and photographs referenced in this discussion.

cant since, according to the time-honored cinematic convention, it is when alone that a character's true nature is most likely to be revealed. Viewers of *The Fall of Berlin* are invited to reflect on Stalin's image when the character is seemingly at his most authentic and when, incidentally, he is pictured in the same poses as posters and paintings that present a Stalin of the People. In this way, the framing of these silent, visually muted scenes creates the scope for viewers to read Stalin of the People into the film.

The architects and artists of the Stalin cult may well have striven "to create uniform and uniformly legible cult products—which they then expected to be read uniformly by the audience," as Plamper explains.[53] Yet the very means they employed to achieve this goal ultimately undermined their success, at least with regard to cinema. The re-creation of familiar artistic compositions on screen provided the viewers of *The Fall of Berlin* with access points to draw on the broader text of socialist realist visual culture when imputing meaning to the film's images. This wider canvas stretched across time as well as space, implicating "the entire sphere of the imaginary," as Dobrenko observes,[54] but this also means it incorporated the kinds of tensions and contradictions that accrue within such an expansive aesthetic system purely as a function of breadth and longevity. As a result, Stalin's singular ability to lead in *The Fall of Berlin* was thrown into conflict with his famed modesty and the principle of collective leadership; insistence on the childlike indebtedness of the Soviet people was confronted by the wartime narrative of their maturation through the trials of conflict and sacrifice; and Stalin's lone authorship of victory was challenged by the very notion of the Soviet people itself, defined as a unified mass of exceptional heroes (in the socialist realist tradition of *tipichnost'*), making it impossible not to credit them with victory. Instead of the Wise Father or Lone Leader, some viewers saw the outdated Heir of Lenin, or dreamed of a Stalin partnered with the people. Many of these tensions were rooted in the cult of Stalin itself, while others arose between the cult and other building blocks of socialist realism. Whatever the case, creative readings of *The Fall of Berlin* grew from these frictions, lending momentum to the popular conception of Stalin of the People.

This new identity theme was enunciated differently by published reviews and unsolicited letters. The reviews, as authorized expressions of opinion, kept the focus on Stalin but drew the Soviet people into the spotlight alongside him. They described a Stalin in mutually determining relationship with the Soviet people but did not challenge the imbalanced exchange that was depicted in the film

53. Plamper, *Stalin Cult*, 218.
54. Dobrenko, *Political Economy of Socialist Realism*, 6.

itself. In this way, the reviews' development of Stalin of the People remained consistent with the postwar project to recenter the leader in visual media following his muted visual presence during the war.

The letters, as the work of "everyday" Soviets, had no such constraints and instead focused on the other party in the equation. By rejecting Alesha, the childish child of Stalin, and painting an altogether more mature image of Soviets, the letters put the leader and the people on an equivalent footing: not equal, since Stalin was an individual and the people, a multitude, but equivalent in value and reciprocal in what they contributed to and required from the relationship. To justify this position, the letters used not reality but socialist realist principles to correct the mistaken relationship portrayed in *The Fall of Berlin*. Together, published and unpublished sources fleshed out an alternate rendering of the postwar leader but did so with tools provided by the discourse of the Stalin cult and socialist realism itself.

The popular development of this image of Stalin is not indicative of interpretive freedom under late Stalinism. Instead, it highlights the differing degrees of latitude claimed by writers of official and officially minded film reviews to favor particular themes and features from within the context of the state-mandated aesthetic while ignoring others altogether. The results of this picking and choosing are telling. Davies observes that in the 1930s, Soviet letter writers preferred the paternalistic Wise Father to more charismatic depictions of the leader, and in anticipating the next decade, she speculates that this may have changed after the war.[55] She is partially right: Wise Father Stalin was indeed supplanted, but by another relational rather than charismatic figuration of the *vozhd'*. If responses to the pinnacle of postwar cult production, *The Fall of Berlin*, are taken as representative of cult reception after the war, then—despite the heroics of Generalissimo Stalin—it was the image of a leader who was in relationship with the people that resonated most strongly with Soviet audiences. The difference was that after the war the people were perceived as having matured, no longer needing a Father who would teach them to walk and provide them with a happy childhood, but instead a partner who would lean on them as they supported one another. The implications of this shift for socialist realism were considerable, as we will see in the next chapter.

55. Davies, "'Cult' of the Vozhd'," 148.

RURAL LIFE ON SCREEN

When Nikita Khrushchev condemned Stalin's cult of personality during his Secret Speech to the Twentieth Party Congress in February 1956, he reserved special mention for the role of cinema in perpetuating Stalinist myths, naming war films like *The Fall of Berlin* as the worst culprits. But Khrushchev also highlighted a second, less obvious group of films for their complicity in the cult. He accused these films of creating a falsified picture of Soviet reality that he claimed Stalin himself believed, and which consequently rendered the Soviet leadership (including Khrushchev) impotent to deal with practical postwar challenges properly. The implication was that these particular films were even more damaging to the Soviet Union than were productions that purveyed a Stalinist account of victory or a spuriously grandiose image of the leader. These nefarious works of the cult were none other than rural films: comedies and dramas depicting life in the countryside that, according to Khrushchev, "dressed up and beautified the existing situation in agriculture."[1] It is such films that have since become inextricably linked with Khrushchev's notion of *lakirovka deistvitel'nosti*, or the

1. Khrushchev, "Speech to 20th Congress of the C.P.S.U." Ten of these rural comedies and dramas placed in the box office rankings, and as such are the primary focus of this chapter: *The Village Teacher* (*Sel'skaia uchitel'nitsa*, Donskoi, 1947), *Tale of a Siberian Land* (*Skazanie o zemle Sibirskoi*, also known as *Symphony of Life*, Pyr'ev, 1948), *The Distant Bride* (*Dalekaia nevesta*, also known as *Under Sunny Skies*, Ivanov-Barkov, 1948), *The Train Goes East* (*Poezd idet na vostok*, Raizman, 1948), *Cossacks of the Kuban*, *The Brave Ones*, *Cavalier of the Golden Star* (*Kavaler Zolotoi Zvezdy*, also known as *Dream of a Cossack*, Raizman, 1951), *Bountiful Summer* (*Shchedroe leto*, Barnet, 1951), *Miners of the Don*, and *The Return of Vasilii Bortnikov* (*Vozvrashchenie Vasiliia Bortnikova*, Pudovkin, 1953).

varnishing of reality, which he identified as a fundamental building block of the Stalin cult.

There was certainly a great deal about life in the rural USSR that could use a little varnishing in the postwar years. The Soviet writer Ales' Adamovich declaimed the period as "the most tragic time for the Soviet village, in terms of hopelessness and [the] outrage of every human sentiment."[2] These years witnessed the inauguration of a permanent trend of flight from the land that ultimately transformed the Soviet Union, playing a pivotal role in "the main event of twentieth-century Russian history [which] was not war, revolution, or even totalitarianism, but the end of the thousand-year history of Russian agrarian society, the violent death of the village."[3] The exodus was fueled not by a surfeit of rural labor brought on by agricultural mechanization (as anticipated by Bolshevik ideology) but by desperation and disillusionment following famine and the brutal recollectivization of agriculture after the war. Of course, neither tragedy nor violent death was visible in the collective farms (*kolkhozy*) and villages of contemporary Soviet feature films. Instead, the golden fields, forested foothills, and tidy village streets became the backdrop to cinema's bold refashioning of Soviet everyday reality.

Yet rather than simply plastering over reality with images of material abundance and joyous celebration, Soviet cinema developed an idealized image of rural life that corresponded to the postwar context. Specifically, rural cinema resolved three of the most politically and socially challenging legacies of the war: the memory of occupation, the physical destruction of the countryside, and the social upheaval of demobilization and the demographic crisis. The films mitigated these repercussions of the war by reclaiming formerly occupied lands for the Soviet people, rebuilding villages and embedding them into the metropole, and reintegrating veterans smoothly into rural society. Together, these three cinematic themes made for a bold statement as to the viability of the Soviet system, declaring the complete social, political, and economic recovery of the USSR following the destabilization of war.[4] This chapter explores each of these claims in turn.

In engaging with postwar reality, even if only to misrepresent it in specific ways, rural films were implicated in the crisis of postwar socialist realism and the demand for a new formulation of the positive hero. Beginning in 1950, rural

2. Quoted in Zubkova, *Russia after the War*, 148.

3. Dobrenko, *Political Economy of Socialist Realism*, 32. See also Jean Lévesque, "'Into the Grey Zone': Sham Peasants and the Limits of the Kolkhoz Order in the Post-war Russian Village, 1945–1953," in *Late Stalinist Russia: Society between Reconstruction and Reinvention*, ed. Juliane Fürst (London: Routledge, 2006), 116.

4. Due to the condition of rural screening facilities in the late Stalin period, these claims were made predominantly to urban audiences, who benefited from more numerous and better-quality cinemas.

films essentially replaced war films, both in the production lineup as war films were no longer commissioned in the annual plans, and at the box office, filling the gap left by the disappearance of the most popular category of domestic postwar production and wooing viewers by the millions. Usually promoted as comedies, the lighthearted dramas of life and labor in the countryside told the story of what happens next, after victory, as heroic soldiers returned home and transitioned to peacetime service. It was in telling such stories that a stable new cinematic image of the postwar positive hero ultimately emerged, alongside a new iteration of the master plot. In this way, rural films resolved the conundrum that arose at the heart of the official aesthetic in the wake of wartime victory, ushering in a new—albeit short-lived—era of socialist realist cinema.

Reclaiming the Land

Within days of the invasion of June 22, 1941, the agricultural heartland of the Soviet Union was captured by German forces. By September 1, a German civilian administration had been established to govern the former Ukrainian Soviet Socialist Republic, tethering the breadbasket of Europe to the Axis cause for over two and half years. The Black Earth region of the RSFSR and the North Caucasus were also occupied during much of 1942, with some areas escaping within a couple of months, and others taking six or eight, after the Red Army turned the tide with victory at Stalingrad in late 1942. As the German forces drew back, they imitated the retreating Red Army of 1941 and scorched the earth wherever possible, with the Ukrainian fields taking the brunt of the assault. Antitank trenches, land mines, and bomb craters further scarred the landscape in battle zones, particularly in the Black Earth region around Kursk, site of the largest tank battle in history. This legacy of occupation and physical destruction was the context for the depiction of the land and its relationship to the Soviet people that proliferated in postwar rural cinema, as films reclaimed these defiled landscapes for the Soviet nation.

By 1945, Soviet cinema had a long history of laying claim to land, particularly peripheral spaces.[5] The tundra and forests of the Far North and East were staked out in adventure films such as Gerasimov's *The Courageous Seven* (*Semero smelykh*, also known as *Seven Brave Men*, 1936), *City of Youth* (*Komsomol'sk*, 1938), and Dovzhenko's *Aerograd* (1935), while the rich soils and pasturelands of Ukraine and Southern Russia came under party influence in collectivization films, including Eisenstein's *The Old and the New* (*Staroe i novoe*, also known as *The General*

5. Emma Widdis, "'One Foot in the Air?' Landscape in the Soviet and Russian Road Movie," in *Cinema and Landscape*, ed. Graeme Harper and Jonathan Rayner (Bristol: Intellect Books, 2010), 78–79.

Line, 1929), Ermler's *Peasants* (*Krest'iane*, 1935), and collective farm comedies like Pyr'ev's *The Rich Bride* (*Bogataia nevesta*, also known as *The Country Bride*, 1937), *Tractor Drivers* (*Traktoristy*, 1939), and *Swineherd and Shepherd* (*Svinarka i pastukh*, also known as *They Met in Moscow*, 1941). The tradition of expressing state ownership through cinematic representation persisted and indeed flourished in the late Stalin period, as the proportion of films set in rural spaces inflated.[6] If the particular locations explored on screen were any indication, the distant peripheries and lands recently occupied by the German Wehrmacht and Reichskommissariat Ukraine were of specific interest to the Soviet regime after the war. Of the ten most popular rural films, those released during the 1940s were set in Siberia, with *The Distant Bride* in Turkmenistan, while those screened in 1950–51 were based in formerly occupied Eastern Ukraine and the North Caucasus. *The Return of Vasilii Bortnikov*, released in 1953, returned rural action to Siberia but with a newfound focus on the grain-producing collective farm more reminiscent of the Ukrainian *Bountiful Summer* than *Tale of a Siberian Land*.

These locations were not new to Soviet screens, having graced the growing network of cinemas in the 1930s as well. Yet the expression of the regime's ownership of the land and settlements in these familiar settings involved new methods after the war. Rather than dynamic panoramas and sequences demonstrating the mastery of nature, or the martial-like imagery of conquest pioneered in the 1930s to claim the landscape for Soviet sovereignty, terrain was rendered Soviet through stillness as postwar cinema developed more subtle means of linking the land to Soviet identity. The key element in this late Stalinist strategy of ownership was the landscape montage. Although dating practically from the inception of Soviet cinema, it was after the war that this type of sequence became the primary mode of representing landscapes in feature films, with each rural film boasting at least two landscape montages roughly thirty seconds in length. Consisting on average of six shots and exploring a single scenic theme (for example, fields of grain or a river), these montages did more than simply locate the action. Instead, they invited contemplation in the same manner as landscape painting.

The connection between the cinematic images and painted landscapes was rooted in their framing and composition. In place of the mobile pans and tracking shots common in prewar scenery (such as the opening sequence of *The Rich Bride* and the aerial shots of *Aerograd*), nature was framed in static medium shots in postwar montages.[7] This fixed framing stabilized the spectator, enhancing the illusion of a contained natural space that was presented to the viewer for his or her unhurried engagement, as with a painting on a gallery wall. What is more,

6. For instance, of the nine new feature films released in 1951, seven were set in rural areas, meaning the fields, forests, mountains, and coastlines beyond urban centers.

7. Widdis, "'One Foot in the Air?,'" 79.

the cinematic landscape montages invariably depicted "space freed from event-hood (e.g. war, expeditions, legends)," which is how the art historian Anne Cau-qelin defines the distinction between nature as landscape and nature as setting.[8] Although landscape montages were related to the plot—with sequences illustrating the coming of a storm in *Cavalier of the Golden Star* and *The Return of Vasilii Bortnikov*, for example—they did not depict action. Instead, they punctuated it. Occasionally, they even interrupted the plot, as with the penultimate feasting scene in *Cavalier of the Golden Star*, which is broken up by a sequence of shots picturing a sunset over fields of grain. These nature-focused interruptions create what Martin Lefebvre refers to as *temps morts* or "lulls in the story" that facilitate viewer engagement with the images as landscape rather than setting.[9]

The landscapes in rural films correspond specifically to postwar Soviet landscape painting. This is significant because the landscape painting of these years represented a marked departure from prewar artistic practice, which rejected traditional landscape art for its failure to demonstrate the transformative achievements of Soviet power. The war years witnessed a renaissance of natural landscapes that was tied to the general revival of patriotic, Russian nationalist themes in Soviet visual culture. After the war, the primary focus of the landscape painting genre turned permanently away from depictions of Soviet rural modernity to scenes of "unfiltered" or traditional rurality, complete with folk costumes, hand tools, and wooden spoons. Cultural geographer Mark Bassin associates this shift with the quest for stasis that characterized postwar socialist realism as it sought to cultivate a "sense of transcendence and eternity" in relation to the Soviet system.[10]

Cinematic landscape montages foster such impressions of timelessness even more effectively, as they are almost thoroughly bereft of humanity and its trappings.[11] These bucolic landscapes hearken back to the works of late nineteenth-century artists Isaak Levitan, Ivan Shishkin, and other Peredvizhniki (Wanderers), wherein the only hints of human existence were sown fields and haystacks.[12] Although revolutionary in the late nineteenth century, the works of the Peredvizhniki were considered to be Russian classics by the Soviet period. Because of this

8. Quoted in Martin Lefebvre, "Between Setting and Landscape in the Cinema," in *Landscape and Film*, ed. Martin Lefebvre (New York: Routledge, 2006), 22.

9. Lefebvre, 29.

10. Mark Bassin, "The Greening of Utopia: Nature, Social Vision, and Landscape Art in Stalinist Russia," in *Architectures of Russian Identity: 1500 to the Present*, ed. James Cracraft and Daniel Rowland (Ithaca, NY: Cornell University Press, 2003), 164, 167–68.

11. A few power lines feature in a landscape sequence in *Cavalier of the Golden Star*, which recounts the construction of an electric power station. But even here the presence of the power lines is surprisingly muted, as they are shown almost exclusively in the distant background, with the foreground devoted to the portraiture of ripened grain.

12. Bassin, "Greening of Utopia," 167; Sergei Kapterev, "Illusionary Spoils: Soviet Attitudes toward American Cinema during the Early Cold War," *Kritika: Explorations in Russian and Eurasian History* 10, no. 4 (2009): 800; Margolit, "Landscape, with Hero," 31.

association with classical Russian art, cinematic landscape montages enacted a distinct form of ownership over the land from that expressed through prewar scenes of the mastery of nature. Rather than basing their possessive claim on feats of transformation and conquest—a mode of dominance that requires constant innovation and intensification in order to maintain its relevance in a modernizing society—postwar ownership was rooted in an appeal to tradition and timelessness.[13] This strategy responded directly to challenges to Soviet possession of Ukraine and the North Caucasus during the 1940s that derived from alternative national and ethnic claims to these lands. Competing national narratives included those of the Third Reich, which staked out the area as German lebensraum, and Ukrainian nationalists agitating for an independent (non-Soviet), united Ukraine.[14] Even particular ethnic groups—including the Karachais, Kalmyks, Chechens, Ingushetians, Balkars, and Crimean Tatars—were perceived by the regime as a threat to Soviet sovereignty during the war and were deported to Siberia, Kazakhstan, Kyrgyzstan, and other distant areas as the Red Army reclaimed the Caucasus and Crimea.[15] By imbuing the Soviet representation of the land with an aura of agelessness, and drawing a straight line between prerevolutionary and Soviet landscapes, the scenic montages of postwar cinema cut through the complications posed by various national and ethnic narratives about the land that revived with the war.

These visual statements of eternal ownership were not without intimacy, however. In contrast to the cinema of the 1930s, postwar montages did not employ the aerial views and long shots reminiscent of tactical diagraming, preferring the midshot and often filling the foreground with flora.[16] Such framing creates the impression of proximity to the land, drawing the viewer into a contained and manageable stretch of nature. In addition to its more intimate composition, the scenic montage is also frequently tied to an individual protagonist, personalizing the landscape.[17] This is achieved in two ways: first, by indicating that the camera's gaze belongs to a specific character. For instance, a shimmering riverscape montage in *Cossacks of the Kuban* is prefaced by shots of Galina Peresvetova

13. On the conquest of nature, see Widdis, "'One Foot in the Air?,'" 79; Widdis, *Visions of a New Land*, 186. The appeal to tradition was reinforced by the postwar afterlife of *Rodina mat'*, as discussed in chapter 4, which subordinated the *rodina* to Soviet authority and Stalin personally.

14. Both the Bandera faction of the Organization of Ukrainian Nationalists (Orhanizatsiia Ukraïns'kykh Natsionalistiv [OUN]) and Ukrainian Insurgent Army (Ukraïns'ka povstans'ka armiia [UPA]) challenged the Soviet presence in Ukraine into the mid-1950s, when their underground activities were finally quashed. Zenon Kohut et al., *Historical Dictionary of Ukraine* (Lanham, MD: Scarecrow Press, 2013), 676.

15. Pavel Polian, *Against Their Will: The History and Geography of Forced Migrations in the USSR* (Budapest: Central European University Press, 2004), 140.

16. Lefebvre, "Between Setting and Landscape in the Cinema," 54.

17. Cf. Margolit, who argues that "landscape at this time . . . exists disconnected from the character" in cinema. Margolit, "Landscape, with Hero," 31; Paul Virilio, *War and Cinema: The Logistics of Perception* (London: Verso, 1989).

FIGURE 6.1. Petr Sereda's return to the land. *Bountiful Summer* (Barnet, 1951).

gazing into the distance and is accompanied by the collective farm chairwoman's bittersweet song, "As You Were, so You Have Remained" ("Kakim ty byl, takim ostalsia") which, although referring specifically to a romantic relationship, simultaneously reinforces the timelessness of the Soviet heroic claim to the land. Similarly, both Sergei Tutarinov and Petr Sereda are shown to be contemplating nature during lengthy landscape sequences in *Cavalier of the Golden Star* and *Bountiful Summer*. In both films, the montages anticipate the hero's encounter with his future sweetheart in the next scene, and the launch of his plans to transform the collective farm in the one after that. The nature sequence serves in this way as a final contemplative interval prior to the hero's entry into the fullness of life and responsibility as a local leader (figure 6.1).

Second, landscape montages serve as the metaphoric representation of a protagonist's emotions, expressing his or her inner life. In the romantic subplot of *The Return of Vasilii Bortnikov*, for example, Pavel's jubilation at Fros'ka's pledge to wait for him is conveyed through an exultant orchestral swirl and an abrupt cut to a shot of the nearby riverbank, which sparkles with the warm summertime glow of Magicolor film stock. Meanwhile, a more industrial landscape montage is used to convey Lida's state of inspiration in *Miners of the Don*. Here, the young heroine's enraptured revelation of her plans for higher education and

future labor to a lovesick Vasia is interpreted (and interrupted) by images of factories outlined darkly against a majestic sunset.

The subtlest articulations of inner life through landscape montage occur in Pudovkin's final film, *The Return of Vasilii Bortnikov*. In the first significant sequence, ten shots of melting snow and ice follow Vasilii's prolonged exchange with the local party cell secretary, who challenges him to return to himself and remember how to celebrate life. It is clear as he smiles and sings following this montage that Vasilii has undergone his own springtime thaw and has been reborn into the happy life of postwar Stalinism. His reformation continues (with nine more images of the melting landscape), so that even his estranged wife, Avdot'ia, notes the difference in him and tentatively seeks to reconnect. Vasilii rejects her, however, and leaves her alone by the riverbed, where her patience and perseverance in the face of private hardship is translated by the steadfast flow of the subsequent riverscape montage. Later, a masterful sequence combines both strategies of linking protagonist and landscape: on learning of the death of his father, Vasilii stares out over the fields of harvest when, after a few shots, a destructive rainstorm rolls in, violently pouring out the tears that the protagonist himself is unable to shed.[18] In this way, postwar landscape montages anticipate the psychological landscapes of Thaw-era cinema, which offered "a new sensory proximity between man and nature."[19] Late Stalin-era film therefore initiated the breakdown of the "implicitly collective" gaze of 1930s cinema toward nature, pointing to the possibility of engaging more personally with the mythic expanse of the Soviet countryside while yet retaining it as the domain of the Soviet hero.[20]

In sum, when compared with earlier films, late Stalin-era cinema continued to convey the regime's ownership of the countryside but did so by means that took into account the specific postwar context. Rather than a space to be conquered, tamed, and aligned with socialist modes of labor organization, Soviet rurality was depicted as just that: already Soviet, stripped of references to competing national narratives, and linked on an emotional level to Soviet heroes. As postwar cinema drew on prerevolutionary conceptualizations of the countryside conveyed by nineteenth-century landscape painting, it evoked the past, displacing Soviet rurality into a timelessness that circumvented any and all alternate claims to the land. At the same time, rural cinema also anticipated the future, rebuilding the villages planted in the midst of these eternal landscapes. Let us now turn to this theme, as we move from the spaces to the places of rural cinema.

18. This montage opens with a pan shot and incorporates a second pan partway through.
19. Widdis, "'One Foot in the Air?,'" 81.
20. Widdis, 79.

Rebuilding the Village

As with landscape, the representation of the rural settlement also underwent a fundamental transformation in postwar cinema, being characterized increasingly in the manner of the metropole. Villages were depicted both as established places—already constructed, collectivized, and populated—and as urban spaces, replete with the conveniences of city life. Unsurprisingly, historical reality offers quite a different picture. Rural settlements may have been established, but they were far from stable as an increasingly migratory rural population searched not so much for work as for work that actually paid. Immediately after the war, most collective farms had trouble sourcing the grain with which collective farm workers were remunerated for their labor, due in large part to increased taxes and requisition rates. In 1946, nearly 76 percent of collective farms across the USSR were unable to provide a full kilogram of grain per day to their workers, with nearly 8 percent offering no payment at all. This figure rose as high as 70 percent in some areas of the RSFSR, rendering the likelihood of payment worse in 1946 than during the direst agricultural year of the war. What began as a resurgence of seasonal migration patterns developed into permanent exodus after 1950. This meant that the urban-rural divide was indeed broached as hundreds of thousands, and eventually millions, of Soviets fled the countryside. Fueled by a mix of factors—disappointment at official resolutions strengthening the collective farm (in 1946 and 1948) rather than dissolving it as many had expected; famine in 1946–47 (in which 1.5 to 2 million people perished); the hope of better prospects in industrial employment with the Labor Reserves—rural emigration exacerbated the collective farm labor crisis that was unsolved by demobilization. Those remaining in the countryside worked fewer days for the collective farm, preferring instead to hire themselves out, work their private plots, or "lie about."[21]

State policies added to the disarray, as measures intended to bring agriculture back under centralized authority employed contradictory tactics and fostered population instability. Hundreds of individual collective farms and state farms were first dissolved and reestablished, then amalgamated, and at times transformed into brigades within the new farm. Agricultural labor organization was radically restructured in 1950, doing away with the wartime *zveno*, or link system of small, often family-based work units that were initially championed after the war, in favor of the far less popular large brigades. Meanwhile, hundreds of thousands of collective farm workers were exiled for poor labor performance

21. Zubkova, *Russia after the War*, 60; Lévesque, "'Into the Grey Zone,'" 116; Christopher Burton, "The Labour Region in Late Stalinist Population Dynamics," *Russian History* 36, no. 1 (2009): 135. See also John Channon, "Stalin and the Peasantry: Reassessing the Postwar Years, 1945–53," in *Politics, Society and Stalinism in the USSR*, ed. John Channon (London: Palgrave Macmillan, 1998), 191.

(of whom many were war invalids, youths, or the elderly), and still others were deported as kulaks or potential wartime collaborators. Significantly, postwar cinema engaged the recentralization process only indirectly, by treating the amalgamation of three collective farms in a subplot of *The Return of Vasilii Bortnikov*.[22]

Instead, cinema presented an already centralized rural sphere. It did so, first of all, by depicting rural locations as established places: sites where collectivization and socialist organization were already complete. The necessary infrastructure was in place, with protagonists arriving via rail (as in *Cavalier of the Golden Star*, *The Distant Bride*, *Bountiful Summer*, and of course *The Train Goes East*), while roads, fences, and sturdy housing and outbuildings defined the village limits—in sharp contrast to the temporary settlement in *Tractor Drivers* (1939), for instance, with its collection of caravans parked in the field.[23] Meanwhile, rendering the area specifically Soviet was the office of the local party representative, often a key site of action (as in *Cavalier of the Golden Star* and *The Brave Ones*), and the local Mashinno-traktornaia stantsiia (Machine-Tractor Station, or MTS), as in *The Return of Vasilii Bortnikov* and *The Train Goes East*. The presence of the party was also attested to by the party meetings and Komsomol activities sprinkled throughout the plot, as in *The Return of Vasilii Bortnikov* and *Bountiful Summer*. Such details implied the recentralization of village and collective farm life following the "rural autonomy of the war years."[24]

Rather than socialist construction, the rural settlement was shown to be in the process of Soviet perfection. This change in emphasis paralleled Soviet visual culture's abandonment of the rhetoric of socialist construction after the war and of reconstruction by 1947.[25] Works of socialist realism declared that the rural sphere was already the domain of socialism. The electric power stations, collective farm amalgamation, and new agricultural and mining techniques that motivated the plots of postwar rural cinema simply added to the productivity of already success-

22. Lazar Volin, "The Turn of the Screw in Soviet Agriculture," *Foreign Affairs* 30, no. 2 (1952): 277–88; Channon, "Stalin and the Peasantry," 189–91. There were approximately two million war invalids among the demobilized soldiers. See also Polian, *Against Their Will*, 164–71. Also overlooked is the intensive collectivization process unleashed on newly acquired territories in Western Ukraine, Bessarabia, the Baltics, and Western Belorussia. Faintsimmer's *Dawn over the Neman* (*Nad Nemanom rassvet*, 1953)—a coproduction between Lenfilm and the Lithuanian film studio—was the first feature film to address postwar collectivization, although several earlier documentary films tackled the subject.

23. The roads in these films are usually in good condition, with the one exception being found in front of the *chainaia* in *Tale of a Siberian Land*, which employs a large muddy pothole to comedic effect.

24. Channon, "Stalin and the Peasantry," 187.

25. Although a popular caption in political posters of 1944–46, the declaration "Vosstanovim!" (Let's restore/rebuild!) disappeared by 1947, while the theme faded from film scenarios following the official condemnation of Kozintsev and Trauberg's reconstruction film *Simple People* in September 1946, and returned only during the Thaw in films like Saltykov's *Chairman* (*Predsedatel'*, 1964).

ful Soviet communities.[26] In fact, of the ten box office hits examined here, three are devoted to celebrating existing rural achievements: *Cossacks of the Kuban*, which exults in the plentiful harvest; *The Distant Bride*, a paean to Turkmenistan's horse-breeding and carpet-weaving expertise; and *Tale of a Siberian Land*, which, although incorporating discussion of constructing a lumber mill and a brief, hazily filmed shot of a model of said mill, focuses on the spiritually restorative, inspirational qualities of the Siberian community and landscape.

The Periphery as Destination: *Girl with Character* (1939) versus *The Train Goes East* (1948)

Iulii Raizman's *The Train Goes East* provides a clear illustration of the postwar emphasis on the peripheral settlement as an established place, particularly when compared with prewar cinema. Raizman's comedic romp follows schoolteacher Zina Sokolova and naval marine Nikolai Lavrent'ev across the USSR as they head from Victory Day celebrations in Red Square to new lives in Vladivostok. It is essentially a tourist film, with a case of mistaken identity and ensuing romantic misunderstandings serving as the plot—much like the popular prewar film by Iudin, *Girl with Character* (*Devushka s kharakterom*, 1939). In fact, Raizman's film could be considered a sequel to Iudin's. Not only are the primary protagonists, Zina and Katia Ivanova, practically interchangeable in appearance, character, and story arc, but Raizman also picks up almost where Iudin leaves off: on a train filled with song, bound for the Far East. Despite the similarities in plot and characterization, the two comedies differ radically in their engagement with the rural setting in a manner that demands closer examination.

It is clear from the opening sequence that the eponymous *Girl with Character* is a true daughter of Siberia. Hailing from a tiny settlement in the forest, Katia Ivanova is a sable farmer who lives in a one-room wooden cabin with but a few touches of homely comfort. She is handy with a rifle, pursuing a villain from his hiding place in her loft through the woods and handing him over to Red Army soldiers practically as a matter of course as she heads off to catch the train. Despite producing such a heroine, Siberia is not the focus of the 1939 film and features only in the opening sequence. Few signs of civilization are visible in Iudin's sketch of the eastern taiga: instead of proper roads, there is a narrow track through the trees; instead of a train station, a lonely set of rails where the train happens to stop, no platform in sight; instead of a bustling settlement, an *izba*

26. The one exception to this definition is *The Village Teacher*, a film that covers the transformation of the revolutionary and socialist construction periods, before culminating in the "stability" of the postwar years.

(log house) or two and a richness of sable on which to practice one's political speeches, as Katia does with relish.

The film is oriented toward Moscow from the moment Katia boards the train, which hosts the heroine's induction into the labors and luxuries of urban living. Her stint as a waitress in the dining car, with all its little refinements, foreshadows Katia's involvement in the capital's consumer industry (as an assistant in a fur shop and a quality control agent for a gramophone record factory), while also facilitating the relationships that would shape her urban adventure. The countryside Katia has left behind is not even visible from the train windows. In fact, when a window persists in falling open in the dining car, both Katia and eventual love interest Sergei Berezkin spring immediately to close it, as if this infiltration from the outdoors threatens to destabilize the illusion of refined urban life maintained within the train car. There is nothing to see along the way; only Moscow is worth seeing. The film returns to the rural theme, however, in the final scene as Katia, Sergei, and Katia's city workmates set off for the Far East. According to their song, it is a land in need of socialist construction; and according to their demographic makeup, it is also in need of plenty of young women to help populate its barren expanse.

Apparently, this trainload from 1939 was successful on both counts—at least in the vision of the periphery presented by Raizman just under ten years later, which depicts the full extent of the settled, socialized countryside. As with Iudin's train, it is on the *I. V. Stalin* of *The Train Goes East* that the film becomes oriented toward the object of its gaze. This time, however, it is the periphery rather than the center that is of interest, as lush green landscapes fill the train windows. During a brief stop at a station along the way, Zina becomes so engaged with the joyous liveliness and delicious *bubliki* on offer in the rural market that she fails to rejoin the train before it leaves, hindering Nikolai as well. This marks the beginning of a sixty-minute tour across the RSFSR, as the irrepressible duo travel first by car, then by cargo plane, foot, ferry, horse and cart, and tractor as they race to catch up with the train. They wend their way from the bustling rural station to a thriving evacuated industrial complex (complete with its own brass band) that has settled permanently beyond the Urals, then on through the forest, along the river, and over the hill to a vibrant MTS outpost, making friends and pitching in with the labors of daily life along the way. Even when their plane crashes in the middle of the forest, they soon stumble across civilization again, or at least a rustic type willing to convey them to the local settlement. Through the protagonists' travels, the film fixes the tourist gaze on the countryside, engaging with nature and settlements alike as objects to be claimed and consumed by the urbanized visitors who stand in for the (primarily urban) film audience. The comedic adventure introduces the rural space not

merely as a roughly sketched starting point or raw material for great future deeds but as a thriving locale, dotted with stable industries and productive communities. Instead of facilitating rural development, the protagonists bear witness to its existing fulfillment. In this way, *The Train Goes East* discloses that heading east after the war does not mean leaving Soviet civilization behind but rather simply encountering it in a new context.

This case study also hints at the second major feature of postwar depictions of rurality, namely, the urbanity of the countryside and its integration into the urban center. No doubt inspired by official discourse that called for the breaking down of the urban-rural divide, cinema used urban attributes to characterize rural settlements. For example, rural films endowed the countryside with a population density comparable to that in the city. People flood the village streets, pack meeting rooms beyond capacity, and carpet the fields during harvest.[27] The most stunning display of the sheer mass of rural inhabitants is found in *Cavalier of the Golden Star* during the canal-digging sequence, where it is a wonder that work is even possible amid the deluge of humanity. Village avenues replicate not simply the bustling population of Moscow streets but also the range of services they offered. Along with the requisite official offices and meeting rooms, MTS outlets, agricultural outbuildings, and streetlights, rural settings boast cafés and clubs (*Tale of a Siberian Land*, *The Brave Ones*), cinemas (*Cossacks of the Kuban*), exhibitions (*Bountiful Summer*), markets (*Cossacks of the Kuban*, *The Train Goes East*), concert and dance halls (*The Village Teacher*, *Cossacks of the Kuban*, the village in *The Fall of Berlin*), and even a musical instrument store (*Cossacks of the Kuban*) and leisure facilities, such as fairgrounds complete with racetracks (*The Distant Bride*, *The Brave Ones*, *Cossacks of the Kuban*), and merry-go-rounds and swings (*Miners of the Don*, *The Distant Bride*, *The Train Goes East*). Even summertime road works—a more mundane feature of city life— were not unheard of in rural USSR (*The Country Doctor*). These features, along with the rail lines and constant stream of visits to and from the city, fashion the village space into an extension of the metropolis.

According to official rhetoric at the time, increasing the cultural level of the collective farm was key to overcoming the urban-rural divide.[28] To this end, song, dance, and references to Russian poetry and Soviet (political) literature continued to feature in rural films as they had done before the war. However, rural *kul'turnost'*, or culturedness, was also translated into film through the depiction of domestic

27. Only the winter evening lanes of Vasilii Bortnikov's village appear more sparsely populated; but even here, protagonists casually bump into one another repeatedly.
28. "Kul'tura kolkhoznoi derevni," *Pravda*, October 6, 1949: 1; Nikita Khrushchev, "Organizational-Economic Strengthening of the Collective Farms," *Current Digest of the Russian Press* 3, no. 7 (1951): 3–13.

space, as the cultured countryside was shown to begin quite literally in the home. The stark rustic cabins of films such as *The Courageous Seven* and mobile trailers of *Tractor Drivers* were replaced with cozy cottages decorated in the Stalinist bourgeois style that emerged in the late 1930s. In these homes, plaster and paintings adorned walls, floral bouquets beautified tables, and arboreal potted plants trimmed windowsills and sitting room corners, going so far in *Cavalier of the Golden Star* as to turn the Liubashevs' abode into a virtual botanical garden. Curtains and other forms of window dressing abound, particularly in Barnet's *Bountiful Summer*, where domestic interiors are punctuated liberally with drapery, including hefty door curtains and embroidered valences about the frames of paintings and portraits. The furnishings are plentiful—cushions, rugs, tea sets, dishware in display cabinets—as are the rooms in which they are housed. Such sights were by no means new to Soviet cinema in the postwar period, but they did achieve a newfound normalcy specifically in the rural setting during these years. Katia's rough-hewn, single room cabin in *Girl with Character* became a distant memory as rural dwellings were at last shown to be the equivalent of their urban counterparts.[29]

The Periphery as Center: *Alone* (1931) versus *The Village Teacher* (1947)

The periphery was not simply made to resemble the city and in this manner incorporated into the center; it also became its own center capable of attracting residents from the grip of the metropolis. Speaking to this development was the theme of return that dominated rural films of the period. One after the other, protagonists were shown returning to the village: Andrei Balashov and Natasha Malinina in *Tale of a Siberian Land*, Nikolai Lavrent'ev in *The Train Goes East*, Sergei Tutarinov and Semen Goncharenko in *Cavalier of the Golden Star*, Tat'iana Kazakova in *The Country Doctor*, Oksana Podpruzhenko and Petr Sereda in *Bountiful Summer*, Kerim in *The Distant Bride*, Dunia Bortnikova in *The Return of Vasilii Bortnikov*, and virtually the entire cast of *The Brave Ones*, which concerns the struggle of horse-trainers-turned-partisans to evict the Germans from

29. In her work on the visual range of Soviet cinema, Ekaterina Sal'nikova defines Stalin-era cinema as flattened, arguing that these films did not engage with texture or material detail in any significant manner. Sal'nikova notes that this disinterest in materiality was overcome in the cinema of the 1960s, but my findings suggest a much earlier starting point for the transition to more layered visuals. As discussed here, the domestic interior was far more textured in the postwar period, as were costumes—with patterned dresses, embroidered blouses, kerchiefs, and shawls dominating on-screen wardrobes—while landscape montages from the early 1950s rediscovered an interest in the types of natural materials (water, ice, grass, and mud) that Sal'nikova highlights as missing from monumentalist Stalin-era cinema. Ekaterina Sal'nikova, "Evolutsiia vizual'nogo riada v sovetskom kino, ot 1930-kh k 1980-m," in *Vizual'naia antropologiia: Rezhimy vidimosti pri sotsializme*, ed. Elena Iarskaia-Smirnova and Pavel Romanov (Moscow: Variant, TsSPGI, 2009), 339.

their North Caucasian town. Meanwhile, Vasilii Bortnikov's return is so central to the cinematic adaptation of Galina Nikolaeva's novel *Harvest* (*Zhatva*, 1950) that it warranted renaming the story. Star workers and innovative rural professionals still make the visit, familiar from 1930s cinema, to Moscow or another city to receive recognition, but they always return to the village.[30] Others are known to have returned, although their actual arrival is not shown, like Nazar Protsenko in *Bountiful Summer*, most of the male cast of *Miners of the Don*, and the lone woman veteran of these films, Nastia Gusenkova of *Tale of a Siberian Land*, while still others relocate permanently to a rural setting, including Zakhar in *The Distant Bride* (although he hails from the Don region originally), Natal'ia Dubko in *The Return of Vasilii Bortnikov*, and Varvara Vasil'evna Martynova in *The Village Teacher*. Significantly, the majority of these migrants are members of the rural intelligentsia—teacher, doctor, accountant, dairy manager, engineer, party men, and several horse trainers—or cultural intelligentsia: artist, composer, and singer. These are precisely the individuals whom the regime was hard-pressed to convince to take up rural assignments in reality. As Khrushchev lamented in a speech to the Moscow Communist Party in December 1950, young people were flocking to the cities to gain qualifications needed in their villages or collective farms, but then remaining in the city.[31] Early 1950s cinema attempted to correct this trend by casting the countryside in the role of the large city: as the locale that drew and retained the best and the brightest.

The metamorphosis of the peripheral settlement into the center is demonstrated strikingly in Donskoi's *The Village Teacher*, which follows the course first plotted by Trauberg and Kozintsev with *Alone* (*Odna*, 1931), but comes to a very different conclusion. Both films follow a newly trained schoolteacher assigned to establish a primary school in rural Siberia. Elena's tenure in the herding community of *Alone* is brief and intense, cut short by illness (brought on by exposure in a politically motivated act of self-sacrifice) and ending with a promise to return. Varvara Vasil'evna's turn as the titular village teacher in the fictional Siberian village of Shatry predates that of Elena by seventeen years, beginning in 1914, and spans her entire career, right up to 1947, the year of the film's release. Despite a shared premise, the films contrast strikingly in their depiction of the periphery.[32] Elena's Altai is exotic: peopled by ethnic Siberians, scored with instrumental screeches and wails, and peppered with images of arcane shamanist rites and a

30. *Tale of a Siberian Land*, *The Country Doctor*, and *The Return of Vasilii Bortnikov*.

31. Sal'nikova, "Evolutsiia vizual'nogo riada v sovetskom kino," 339. This phenomenon is confirmed by Burton, "Labour Region in Late Stalinist Population Dynamics."

32. Unfortunately, the scene depicting Elena's dangerous trek across the bleak landscape in the midst of a wintry tempest has been lost, depriving this book of a potentially interesting point of comparison with the more tamed landscape of Varvara's Siberia.

bleak landscape.[33] Varvara's Shatry is ethnically Russian, having been founded by exiles during the tsarist era, meaning that the only attribute distinguishing the young teacher as a *peterburzhenka* from the imperial capital rather than a *sibiriachka* from the wilds of the taiga is her lack of felt boots.

More significant is the contrast between the films' conceptualizations of the role of Siberia in the protagonists' lives: for Elena, it is a workplace, while for Varvara it becomes home. More specifically, in the earlier film, *Alone*, Siberian backwardness is the target of the young teacher's political consciousness as she attempts—with varying degrees of effectiveness—to whip the lazy chairman into shape, mentor a promising herder, oust the kulaks, and prevail against foreign capitalist conspirators, all while teaching the village children. The film focuses on Elena's political work, as does the young woman herself. Once having sacrificed her health in her efforts to perform her ideological duty, Elena is airlifted home to the capital, perhaps to survive and return, perhaps not. It is of little consequence, since she has already completed the task of bringing Soviet light to the dark periphery, which, subsequent to her laborious venture, remains a distant locale, separated from the center.

Unlike Elena, Varvara's return to Shatry is never in doubt whenever she departs for the city. This is because the mining town becomes her home. Donskoi prioritizes the personal plot—Varvara's personal life and her quest to fulfill her pedagogical ideals—above political work in *The Village Teacher*—so much so that, although Shatry is shown to have been transformed under Soviet power, the actual process of transformation is not depicted. Instead, it is implied through the addition of lessons on collectivization and Stalin to Varvara's curriculum. The personal orientation of the plot means that Varvara's connection to the village and its land and people is conveyed clearly. Her brief married life begins and ends in Shatry, as her fiancé first escapes to her there during the Revolution, marries her, is forced to leave, and ultimately returns during the Civil War only to die on Varvara's favorite knoll overlooking the valley. This spot later bears not only a commemorative plaque to her husband but also a living monument to Varvara herself: a magnificent school building. In her widow's solitude, the pupils of Shatry become Varvara's family; in her barrenness, they are her children, writing to her from the front during the Great Patriotic War, visiting her in her retirement after the war, and growing up to be just like her, as one graduand proclaims.

33. It is significant that Kozintsev and Trauberg chose to depict the Altai settlement in this manner given that the ethnic Russian population of the Altai region, known as Oirotskaia Avtonomnaia Oblast' during 1922–48, was considerably higher at 52 percent than the native Altai population (40.5 percent), according to the 1926 census. Tsentral'noe statisticheskoe upravlenie, Otdel perepisi, *Vsesoiuznaia perepis' naseleniia 1926 goda/Recensement de la population de l'U.R.S.S. 1926*, vol. 6 (Moscow: Izdanie TsSU Soiuza SSR, 1928), 188. (Note that the census misspells the name as Oiratskaia.)

Not only is Shatry the center of Varvara's personal life but it also transforms into the metaphoric center of the nation as it matures into a Soviet city to rival Varvara's tsarist hometown, St. Petersburg. Shatry does not replicate the appearance of the imperial administrative capital, but it does acquire its function in both Varvara's life (as her home) and the Soviet Union as a whole. Like the St. Petersburg of Varvara's youth, Soviet Shatry is a cultured educational center. Its primary educator, Varvara herself, is recognized across All-Union radio as a leading pedagogical heroine of the Soviet Union, as she is named ahead of Leningrad's leading educator when they are congratulated. Even more telling is the film's final scene, which mirrors the opening sequence set at the graduation ball for Varvara's cohort at the St. Petersburg school for young women. The parallelism between the opening and closing sequences implies that, by the end of the film, the mining village has replaced St. Petersburg, becoming the Soviet heir to the imperial city. The ball in Shatry is as cultured as the one in St. Petersburg, featuring well-dressed young men and women and skillfully performed music and dance. Yet it is also far more joyous, freed from the restrictive presence of an authoritarian schoolmistress and reveling instead in Soviet unity and friendship, and crucially, the recent military victory, as evidenced by the collections of medals decorating several of the dancers' chests. Most significant among all these details, however, is the repetition of a key conversation during the two ball scenes, shared in both by an aspiring teacher named Varen'ka and her mustachioed dance partner. At the first ball, Varvara Vasil'evna herself is the Varen'ka in question, sharing with her future husband her dreams of teaching children in remote Siberia; in the closing scene, a Soviet-raised Varen'ka tells her partner of her plans to leave Shatry for someplace "very distant" where she will teach children, just like Varvara Vasil'evna. Shatry is no longer the "very distant" place to which aspiring teachers migrate; it has become a city, an educational center, and most important, *the* center from which young men and women embark to the far reaches of the USSR, carrying the transformative light of Soviet socialism. In this way, Soviet Shatry replaces tsarist St. Petersburg as it transforms from periphery into center (figures 6.2 and 6.3).

When it came to depicting the places of rural USSR, postwar films demonstrated that not only was socialist construction achieved, but so too was peacetime reconstruction. The villages were already rebuilt and indeed were well along the path to perfection as established, modernized, and even urbanized locales. Paradoxically, in pursuing this idealized representation of rural Sovietness, cinema revived the traditional, prerevolutionary peasant understanding of the position of the village in the world, namely, as its very center. By creating a village so fully integrated into the Soviet urban sphere that it duplicated both the semblance and the function of the metropole, cinema created a modernized and Sovietized *mir* (meaning both "village" and "world"): a rural community that serves as a

FIGURE 6.2. Varvara Vasil'evna's graduation ball in St. Petersburg, 1914. *The Village Teacher* (Donskoi, 1947).

self-contained world and the center of its own universe, drawing inhabitants away from the city and into its embrace. It is to these new arrivals to the cinematic villages that we now turn.

Reintegrating Veterans

In addition to reclaiming the space and places of the countryside, postwar cinema also reclaimed specific populations by depicting them as fully integrated into Soviet rural society. For instance, subplots were populated by active young collective farm workers like Pavel and Fros'ka (*The Return of Vasilii Bortnikov*), in contrast to the failure of actual collective farms to recruit youth into membership.[34] Meanwhile, Cossack protagonists sang, danced, and labored out their loyalty to the state, dispelling any lingering doubts relating to wartime collaboration with the Germans and agitation for Ukrainian independence.[35] By far

34. Lévesque, "'Into the Grey Zone,'" 105–6.
35. For examples, see *Cossacks of the Kuban*, *The Distant Bride*, *The Brave Ones*, and *Cavalier of the Golden Star*. For a discussion of the representation of Cossacks and Ukrainians in general in

FIGURE 6.3. The graduation (and victory) ball for Varvara's school in Shatry, 1945. *The Village Teacher* (Donskoi, 1947).

the most prominent and politically significant display of reintegration, however, was that of the war veteran. A dominant theme in rural films, the cinematic rendering of demobilization provided a perfected narrative of what was in reality a problematic process. Rather than representing a potential challenge to the regime, the veteran on screen was absorbed smoothly and completely into the social and political structures approved by the state; rather than encountering the real-life burdens of trauma and poor health, official suspicion, imprisonment, and eventual abandonment by the regime, the cinematic veteran found his place easily in rural society.[36]

The choice of a rural setting for this narrative of seamless integration was apt. According to social historian Elena Zubkova, "the most prominent face of postwar society was that of the man in uniform, the veteran," but this was particularly the case in the countryside, to which roughly two-thirds of demobilized soldiers had

Soviet film, see Joshua First, *Ukrainian Cinema: Belonging and Identity during the Soviet Thaw* (London: Bloomsbury Academic, 2015).

36. Zubkova, *Russia after the War*, 63–64; Edele, "Soviet Veterans as an Entitlement Group." Edele points out that nearly all veterans' privileges were revoked by 1948. Even the symbolic support of the regime for those who had served was curtailed in late 1947 with the demotion of Victory Day to a regular work day.

returned by January 1947.[37] The collective farm was also the place that needed them most, as women outnumbered men nearly three to one on the eve of demobilization in 1945.[38] Encouraged by promises of economic opportunities for themselves and their families, and expectations of decollectivization, peasant soldiers returned home or joined villages in other regions—at least initially. When these assurances proved empty and veterans were faced instead with the poverty of rural life and a newly strengthened collective farm order, they began leaving. By the time demobilization was complete in 1948, with 8.5 million soldiers released into civilian life, the population of the rural USSR was in decline. Within five years, the number of able-bodied collective farm workers had decreased by 3.3 million.[39] Veterans' abandonment of the countryside not only intensified the rural labor shortage that lingered from wartime but also exacerbated the employment situation in the cities, where demobilized soldiers spilled over from low-level industrial jobs into "the army of beggars, small-time conmen, black marketeers, and criminals" that burgeoned after the war.[40] On screen, however, veterans returning or relocating to the village meet with no such difficulties in transitioning to collective farm life and are absorbed fully into its very fabric. Of the sixteen new arrivals to the village mentioned earlier, eleven were veterans, making the figure of the returned, reintegrated soldier a trope of rural cinema.

The veteran's adjustment to peacetime life in film unfolded on two levels, implicating both the public and private spheres. Veterans were reintegrated into public life as they slipped directly into leadership roles in the cinematic village, where their authority was respected with little hesitation. For instance, veterans Nazar Protsenko and Petr Sereda chair the collective farm and head up its production plan and finances in *Bountiful Summer*; Vasilii Bortnikov secures his previous position as chairman and founds the new Communist Party cell in his area in the film named for his return; Kerim resumes life as an established horse trainer in *The Distant Bride*; and Sergei Tutarinov and Semen Goncharenko command masses of laborers in the construction of a power station in *Cavalier of the Golden Star*. The ease of these veterans' incorporation into the hierarchy of rural labor was due largely to their specific demographic: on-screen veterans were invariably of the second generation of *frontoviki*, or frontline soldiers, meaning they were in their thirties and forties by the end of the war, when

37. Zubkova, *Russia after the War*, 22; Mark Edele, "Veterans and the Village: The Impact of Red Army Demobilization on Soviet Urbanization, 1945–1955," *Russian History* 36, no. 2 (2009): 164.

38. Zubkova, *Russia after the War*, 21.

39. Edele, "Veterans and the Village," 167–68, 172; Zubkova, *Russia after the War*, 66.

40. Burton, "Labour Region in Late Stalinist Population Dynamics," 128; Edele, "Veterans and the Village," 163.

the films pick up their story.[41] Unlike first-generation soldiers who joined up straight from school, second-generation *frontoviki* left jobs and careers for the front. After the war, they—or at least the officers among them—enjoyed the highest success rate in securing leading positions in the agricultural sector, particularly those who possessed prior experience in agriculture or specialized training. The average veteran was not so fortunate, however, while even those who did secure such placements did not always find that their leadership was valued by those under their authority.[42] Rural films therefore focused on a privileged group of veterans, while also inflating their successes. As a result, veterans on screen did not need to prove their credentials to the rural community but instead simply received their due as experienced leaders, transitioning smoothly into leadership roles in the public sphere.

These demobilized heroes integrated easily into the private sphere as well, by two means: symbolic adoption into the village family and romance. Rather conveniently (and contrary to historical trends), the majority of rural film protagonists were orphaned bachelors, rendering their assimilation via familial and amorous connections both apt and rather straightforward. Adoption often played out within the first moments of a former soldier's arrival in the village, as he was welcomed into a specific household. For instance, Petr Sereda is feted into the family with song and repast by his friend Nazar Protsenko and the latter's mother in *Bountiful Summer,* while Sergei Tutarinov is doted on in the homes of several parental figures in *Cavalier of the Golden Star* and frequently visits another household that he dearly wishes to join—home to a certain Irina. In *Tale of a Siberian Land*, Andrei Balashov lodges at a café-boardinghouse wherein the patrons interact as one big happy family, complete with a bossy mother (Kapitolina Kondrat'evna), goofy older brother (Iakov Burmak), and younger sister figure, Nasten'ka, who knew Andrei at the front. The *chainaia* is the closest thing the orphaned composer has to a family home, having abandoned his former ersatz father and sister in Moscow. Significantly, the hero's adoption as son and brother was more a plot point than a character arc in these films, established in a single scene rather than weaving throughout the story, as in the war films of a few years earlier. The ease with which these demobilized soldiers accept a place at the family table contrasts starkly with the more tempestuous process of resubjectification undergone by traumatized soldiers like Meres'ev and Vania as they struggle to find their place in the pseudofamily of the Red Army (see chapter 2).

41. Although specific ages were not mentioned in the films reviewed for this book, the actors playing the demobilized *frontoviki* averaged thirty-six years upon their film's release.
42. Edele, "Soviet Veterans as an Entitlement Group," 113–14.

In short, by the time he arrived at the village, all was well in the heart and mind of the former soldier—no resocialization was necessary.

While families may have welcomed the veteran to the village, it was romance that kept him there, ensuring his permanent settlement in the community. The Soviet countryside had long served as an oasis for romance on screen (specifically in rural comedies), even during the early years of socialist realism when the official aesthetic was wont to eschew romance or depict it as a distraction from the heroic quest for political consciousness.[43] After the war, the amorous tendencies of rural cinema blossomed more fully as romance was elevated and entwined with the main plot in both comedies and dramas.[44] The love plot routinely got its start in the scene prior to the main, leadership-centered plot and culminated just after the accomplishment of the main labor task of the film. In this sense, romance became part of the master plot itself—its crowning glory rather than an obstacle along the way. This turn to private life paralleled a similar development in postwar literature, where the positive hero's personal relationships became integral to his or her public life.[45] But whereas Soviet novels explored the positive hero's family life and role as parent and spouse, cinema concentrated specifically on romance as it unfolded prior to marriage and childbearing. In other words, cinematic romance focused on courtship, charting the course from first encounter to engagement or mutual understanding, with the culmination of the plot being a matter of timing rather than the resolution of a significant conflict. So central was the love plot to the rural film that most features boasted not one but two tales of romantic entanglement, engaging both the lead and supporting characters in matters of the heart.[46] Such a doubling of romance indicated the centrality of the capacity for romantic love to the characterization of the positive hero. This had particular implications for the demobilized soldier, since the ability to fall in love indicated his emotional reconnection to his humanity and the resolution of any lingering wartime trauma. In this sense, much like adoption, the romance plot was not so much a mechanism of

43. Clark, *Soviet Novel*, 206. Pyr'ev's prewar rural comedies *The Rich Bride* (*Bogataia nevesta*, 1938), *Tractor Drivers* (*Traktoristy*, 1939), and *Swineherd and Shepherd* (also known as *They Met in Moscow, Svinarkha i pastukh*, 1941) all feature significant love plots. For more on the love plot in (mostly prewar) Stalin-era cinema, see Tat'iana Dashkova, "Liubov' i byt v kinofil'makh 1930-nachala 1950-kh gg.," in *Istoriia strany/Istoriia kino*, ed. C. Sekirinskii (Moscow: Znak, 2004), 218–34.

44. For instance, in 1952 the Ministry of Cinema's Artistic Council advised A. Batrovii, the scenarist of *Tomorrow, the Ocean* (*Zavtra, okean*), that his script must be revised to contain more romance. "V khudozhestvennom sovete Ministerstva kinematografii SSSR," *Sovetskoe iskusstvo*, August 20, 1952: 4.

45. Clark, *Soviet Novel*, 204–6.

46. Of the eight films surveyed that boast more than two protagonists (and therefore have the capacity to accommodate a double romance), only *The Brave Ones* features a single romantic plot. The remaining seven popular rural films bring together two couples—albeit some more successfully than others. Among the less popular rural films, Gerasimov's *The Country Doctor* also follows a single romance plot.

reintegration, tracing a process of socialization for the demobilized hero, as a sign that he was already fully adjusted to peacetime from the moment he arrived in the village. He needed only the opportunity to demonstrate it.

Although predictable in terms of human interest, the focus of the romance plot specifically on courtship rather than married family life (as in literature) is surprising from an ideological perspective, since it represents a missed opportunity to directly support one of the regime's most pressing postwar agendas—pronatalism. After the war, the Soviet Union faced the most urgent demographic crisis of its existence, giving rise to sweeping legal, social, and economic reforms with the intent of increasing birth rates and strengthening the nuclear family.[47] A series of tax breaks and awards were even devised for women who bore multiple children, culminating in the title of Mother Heroine for ten or more births. Yet, there are no such large happy families on screen, where the focus remains on unmarried adults. In fact, there are nearly no children at all in rural films, with the exceptions being the students in Soiuzdetfilm's *The Village Teacher* and the fleeting appearance of Vasilii Bortnikov's two silent daughters. Granted, this may have been due in part to practical constraints: when Soiuzdetfilm was reorganized in 1947–48 to become Gor'kii film studio, its specialization in children's cinema was abandoned, which presumably constrained efforts to recruit and train child actors.[48] Yet even so, rural cinema was not harnessed in the pronatalist campaign with anything approaching its full potential. On screen, the Soviet countryside remained a showcase for the fecundity of the land only, and not its population.

Instead of validating the regime's pronatalist strategy directly, rural films aligned with the official agenda in a more oblique manner: by wiping the slate clean on the complex social problems implicated in the demographic crisis. The institutions of marriage and the *malen'kaia sem'ia*, or small, nuclear family, did not weather the war and immediate postwar period well. Wartime dalliances and the common practice of taking "front wives" (and the lesser-known phenomenon of what might be termed "home front husbands") meant that postwar reunions were not always such joyous occasions. Added to this, the revised Family Law of 1944 effectively encouraged men to engage in extramarital affairs to boost birth

47. Mie Nakachi, "Gender, Marriage, and Reproduction in the Postwar Soviet Union," in *Writing the Stalin Era: Sheila Fitzpatrick and Soviet Historiography*, ed. Golfo Alexopoulos, Julie Hessler, and Kiril Tomoff (New York: Palgrave Macmillan, 2011), 101–16.

48. Alexander Prokhorov, "Arresting Development: A Brief History of Soviet Cinema for Children and Adolescents," in *Russian Children's Literature and Culture*, ed. Marina Balina and Larissa Rudova (New York: Routledge, 2008), 140–41. For more on children's cinema in the USSR, see Birgit Beumers et al., eds., "Margarita Barskaia and the Emergence of Soviet Children's Cinema," trans. Jamie Miller and Birgit Beumers, *Studies in Russian and Soviet Cinema* 3, no. 2 (2009): 229–62, as well as the bibliography compiled by the Working Group for Study of Russian Children's Literature and Culture, at http://www.wgrclc.com/resources. The participation of child actors beyond Soiuzdetfilm productions has yet to be surveyed.

rates, protecting them from the financial and social consequences of their actions. For instance, the reforms denied unmarried mothers the right to petition for child support or even to name the father on the birth certificate (let alone through a patronymic), while divorce was made more difficult for women to initiate, should they wish to sever ties with a neglectful husband or formalize a wartime relationship.[49] These reforms strengthened the nuclear family on paper while weakening it in practice, as single parenthood became a common reality. In more tangible terms, it translated into an average annual rate of nearly 840,000 illegitimate births between 1946 and 1952.[50] Rural films avoided engaging with these social challenges by scarcely depicting wedded life, with married protagonists Varvara Vasil'evna (*The Village Teacher*) and Vasilii Bortnikov spending most of their time separated from their spouses (which is indicative in itself).

Films focused instead on eligible men of marriageable age—those without familial complications.[51] The result was a statistical impossibility, as each female protagonist attained the reward of a romantic partner by film's end. (Dunia Bortnikova even has two heroic husbands to choose from!) Such tidy resolution of course obfuscated the realities of high wartime fatality rates and the resulting gender imbalance on the collective farm. But it also "solved" the demographic crisis in a very particular way. By privileging the formation of new couples and, by implication, preparing the ground for new families, rural films idealized the fresh start as the way forward for Soviet society: ignore the past, relocate to the village, start over. This was the path to fulfillment in both labor and love. In this sense, although there may have been practically no married couples or children actually on screen, rural films were nevertheless pronatalist in orientation, opting to neglect—much like the regime itself—the complexity of the demographic crisis and the fallout from the policies intended to redress it.

In sum, the reintegration of demobilized men into rural society in these films "resolved" several of the most pressing social issues facing the Soviet regime after the war. The trope of the returned, reintegrated veteran ensured that it was the

49. O. M. Stone, "The New Fundamental Principles of Soviet Family Law and Their Social Background," *International and Comparative Law Quarterly* 18, no. 2 (1969): 394.

50. Zubkova, *Russia after the War*, 21.

51. The one exception to this pattern is the titular hero in *The Return of Vasilii Bortnikov*, who is already married with children. Rather than a fresh start, he and his wife Dunia—who, having believed him to be dead, has since taken up with another man—must work through their emotions (explored largely through the use of psychological landscapes and thaw imagery) and relationships (the second man is a decent fellow) in order to come together once again. Their relationship plays out much like a courtship plot, however (rather than a family drama), and intertwines with the leadership plot in the same manner as a more straightforward romance. It is worth noting that Pudovkin's film is exceptional in other regards as well, in terms of both its artistry (with some of the most mobile, poetic cinematography in late Stalin-era cinema) and its engagement with the taboo theme of infidelity. In these regards, *The Return of Vasilii Bortnikov* might be considered a precursor to the Thaw era.

able-bodied, well-adjusted mature officer who became the postwar image of the Great Patriotic War combatant, and not his frontline brother who struggled with trauma, injury, disability or unemployment—let alone his sister, who had likewise taken up arms only to be denigrated for her actions during peacetime.[52] The veteran hero of rural films embodied an impossibly perfected demobilization process and silenced discussion of all those who did not return—at least until Thaw-era cinema. He took up his assigned role of rebuilding the Soviet Union with ease, leading the collective farm into the next stage of technological development and sending a clear signal that the return of the soldiers to the village would *not*, in fact, spell the abolishment of collective farms but rather their strengthening.[53] Finally, the veteran was also positioned as a balm to the demographic crisis, restoring the gender balance in the village and engaging straightforwardly in the kinds of relationships that would one day see the landscape teeming with large, happy families. He was, in short, precisely the positive hero that the postwar Soviet Union needed.

The New Positive Hero and Master Plot

The new positive hero embodied by the veteran was more mature in his political sensibilities than the prewar protagonist. In socialist realist terms, he was already in a state of consciousness when his story began, eschewing the central dialectic that defined the classic master plot. The veteran's character arc was instead linear, concentrating on processes of refining rather than forging, honing rather than transforming, and above all, perfecting his leadership skills rather than undertaking great feats of physical strength that could earn him a leadership position. Instead of unmasking hidden enemies or foiling the efforts of wreckers and saboteurs, the veteran faced down bad weather, bureaucratic pedantry, and in his love life, issues of timing. None of these hurdles was dialectical in nature, and rather than initiating a new synthesis or greater depth of political enlightenment in the hero, they simply provided opportunities to confirm and hone his skills. In each case, the protagonist developed *as* a leader rather than *into* a leader. For example, among the collective farm chairmen, Vasilii Bortnikov learns to be more demonstrative and interactive with his workers, while Gordei Voron (*Cossacks of the Kuban*) concedes the importance of encouraging the personal happiness of his star workers; Nazar Protsenko learns to take the advice of others, while his

52. For more on the decidedly cold reception afforded women combatants after the war, see Alexievich, *Unwomanly Face of War*; Anna Krylova, *Soviet Women in Combat: A History of Violence on the Eastern Front* (Cambridge: Cambridge University Press, 2010).

53. Zubkova, *Russia after the War*, 61.

adviser Petr Sereda realizes that others are capable of pioneering useful ideas as well (*Bountiful Summer*); and finally, Sergei Tutarinov (*Cavalier of the Golden Star*) becomes proficient at navigating a multilayered administrative system, winning the respect of fellow leaders through his vision and persistence. Each case is a matter of conflict between "the good and the better" and a quest for the mastery of existing skills rather than political enlightenment.[54]

These changes in characterization and plotting were consistent with the specific biography of the veteran hero. As a former officer tempered by the flames of war, he genuinely was more mature in both years and experience, having already been proved a leader and a reliable representative of the regime. Yet, it was not only the demobilized officer who was depicted in such a manner in rural films. In fact, he was but one articulation of a more broadly expressed image of mature, masterful Soviet heroism that transcended age, gender, and service record, while also implicating protagonists whose narratives predated the war. In these films, female leads and young protagonists were just as mature as the war-tempered veteran, while their stories likewise centered on mastery rather than transformation. In other words, the mature positive hero and linear, nondialectical master plot reveal fundamental changes in the official aesthetic itself, and not simply the logical outworking of a specific character biography or periodization. It had taken five years of false starts and dead ends, but the newly won maturity of the victorious Soviet people was finally translated onto the screen through the mature protagonists and linear plots of these early 1950s rural films.

Having concentrated so far on male leads, let us now take a closer look at female protagonists and younger heroes to explore the full scope of what proved to be the most stable late Stalin-era iteration of the postwar positive hero and master plot. Relatively few rural films featured a woman in the lead role, but they did all reserve a prominent role for a female counterpart and love interest to the starring veteran, while subplots were dominated by women in supporting roles. Regardless of her precise billing in the hierarchy of the film's credits, however, the female positive hero was, like the male hero, a paragon of maturity from the moment she appeared on screen. The clearest example of equivalency between the two leads is found in *Cossacks of the Kuban* where, although not a veteran like Gordei Voron, Galina Peresvetova is nevertheless his equal in both accomplishment—being a collective farm chairwoman in her own right—and political acuity. If anything,

54. This is a reference to the late Stalin-era concept known pejoratively as *beskonfliktnost'*, or conflictlessness, which posited that since the enemies of socialism had been defeated in the Great Patriotic War, the only form of conflict remaining within the Soviet Union was one of mastery or refinement: "the good" versus "the better." (See the end of chapter 2 for a fuller discussion.) Mastery was of course also the watchword of the Second Five Year Plan (1932–37), though it did not make much of an impression on the official aesthetic at that time. Instead, it is the postwar period that can be termed the era of mastery in socialist realism.

she is the more mature of the two, expressed through the fact that her farm has an edge on Gordei's when it comes to the use of modern technology and accounting. No male veteran is needed to rescue her collective farm! In cases where the standing of the female protagonist was not as prestigious as that of her male coeval (as was more common), the women nevertheless began their stories as mature Soviets, with expertise and experience to their credit and a knack for inspiring and instructing others. For instance, in *The Return of Vasilii Bortnikov*, Dunia Bortnikova is already the head of a modern, productive dairy, but she travels to the city to further her scientific education, improving her capacity to innovate and lead her team well. Meanwhile, in *Bountiful Summer*, Vera Goroshko is already a leader of note when she sets out to modernize the local dairy and introduce a new education program for her milkmaids, breaking records as she progresses. Irina Liubasheva and Nadia Voronova in *Cavalier of the Golden Star* and *The Brave Ones* follow a similar trajectory, with Irina mimicking Dunia Bortnikova, adding to her expertise in goose herding by training also as a power station controller, and Nadia echoing Nat'alia Dubko's arc, as she puts her considerable education into service for the partisan cause. Each of these women has already proved to be an effective contributor to Soviet society, but each is also motivated by her Soviet ideals to improve in labor and leadership. For the female positive hero, political maturity was not bestowed by the war front but was earned in wartime agriculture and the subsequently revived peacetime economy. Her arc, like that of the male veteran, was devoid of conflict, with emphasis instead on her readiness to tackle practical questions—How to improve clover growth? How to raise milk production? What was causing the repeated tractor breakdowns?—as she seized every opportunity to pursue mastery.

The linear plot of mastery applied not only to characters who were mature in age, like the veteran and female lead, but also to young protagonists. This marks a significant departure from socialist realist literature where the dialectical plot persisted, albeit displaced onto the younger supporting characters who populated the subplots where they gradually came into political consciousness in traditional fashion.[55] In film, even young heroes—both leads and supporting characters— began their stories in a state of maturity and accomplishment. Among the subplots in *The Return of Vasilii Bortnikov*, for instance, young MTS recruit Fros'ka is a skilled tractor driver who seeks to extend her expertise to nighttime harvesting. Once she has proved she no longer needs the light of day to excel, Fros'ka vows to learn to operate the machinery used for digging irrigation canals as well, which will lead the MTS into a new era under Stalin's canalization program. At the same MTS, recently qualified engineer Nat'alia Dubko develops her deduction skills by

55. Clark, *Soviet Novel*, 202.

identifying the mechanical malfunction plaguing the tractor fleet and the worker responsible for it. She then subjects the hapless fellow to a stern lecture to ameliorate his "insufficient industrial culture," demonstrating the authoritative approach she has developed toward leadership. Both young women start out as established specialists and simply broaden their expertise through the course of the film.

The most dramatic examples, however, are cases in which a young central protagonist displays political consciousness beyond his or her years. Such cases throw into sharp relief the transformation of the hero and the master plot in these films, with Vasia Govorukhin of *The Brave Ones* and Varen'ka (later Varvara Vasil'evna Martynova) of *The Village Teacher* being the prime examples. Both leads first appear on screen as teenagers who, despite their tender years (and the anachronism in Varen'ka's case), are already fully formed new Soviet people. From the outset of the partisan film *The Brave Ones*, Vasia demonstrates his maturity as both a horse trainer—riding the "untrainable" wild horse Buian to multiple victories in prewar races—and a vigilant Soviet, recognizing that there is something untoward about the leading horse trainer Beletskii long before he is unmasked as a German spy. For her part, Varen'ka is likewise already an ideal Soviet teacher the first time she stands at the front of a classroom despite it being the tsarist period. This is indicated by her introductory lesson for new students, which is repeated word for word at various points throughout the film. The only thing that changes about this initiatory speech is the classroom in which it is delivered, the condition of which improves with the advent of Bolshevik, and subsequently Stalinist, power. Varen'ka's methods, goals, and phrasing are unchanged, implying that they were already aligned with Soviet pedagogy from the outset. What is more, Varen'ka does not undergo a political awakening but instead holds the correct (Soviet) ideals before the Revolution even takes place. This is affirmed by the fact that Varen'ka's approval of the Bolshevik revolutionary Lenin is contingent on his meeting her desire for peasant children to be granted access to higher education. She is not inspired by Bolshevism but rather supports the movement once her husband confirms that it resonates with her established personal convictions. In short, neither Vasia nor Varen'ka is transformed. Instead, the world around them changes until it is able to provide the circumstances in which the young protagonists can more fully outwork who they already are. For Vasia, this means becoming a partisan and hence a better rider and unmasker of enemies; for Varen'ka, it means becoming the teacher she always sought to be, unencumbered by the prejudices of the tsarist educational system. In both cases, the teenagers undergo a journey of mastery in their chosen professions rather than one of transformation.

These final examples demonstrate that it was the aesthetic itself that had changed by this point, specifically in terms of how it conceptualized Soviet her-

oism. In rural films, the newfound maturity of the positive hero was not restricted to those whose stories began after the war in the age of victory but instead was applied retroactively to all protagonists, regardless of when they were born. The classic formulation of the dialectical master plot had been replaced. In this way, rural films reflected back to postwar Soviet audiences the state of maturity and the call to mastery that now ostensibly defined their lives as Soviet citizens. As such, rural cinema provided a clearer and more fulsome response to the popular demand for new heroes (and a master plot to suit them) than literature, which confined the linear plot of mastery and mature characterization to main protagonists. In this sense, rural cinema was not simply popular but also populist in its engagement with Soviet reality.

Rural films did not provide an accurate depiction of postwar reality; nor did they create a countryside completely divorced from reality. Instead, filmmakers, studios, the Ministry of Cinema, and the Central Committee collaborated to apply *lakirovka* to ameliorate particular historical conditions in specific ways. As outlined in this chapter, the primary problems that were covered over for the camera were legacies of the recent conflict, meaning that rural cinema was in continuous, if implicit, dialogue with the war. Postwar films did not simply resume prewar methods of engaging with the rural sphere; instead, they developed new emphases and strategies appropriate to the postwar context. As seen in the comparative case studies in this chapter, postwar films indicated clearly that the Soviet Union had reached a new stage in its development—one where the supposed stability of the village was extended to all of Soviet society through the absorption of potentially disruptive elements into its bucolic embrace. Developments in characterization and plot structure, likewise instigated by the war and the struggle for victory, gave rise to a new formulation of Soviet heroism centered on maturity and mastery. The result of these new emphases and strategies was a sharp distinction between prewar and postwar socialist realism in cinema. In this way, late Stalin-era rural films were peculiarly postwar in their conception; they were films of recovery.

LOOKING AT *COSSACKS OF THE KUBAN*

True to the escapist tendencies of cinema in general, and the political sensitivity of authoritarian state cinema more particularly, postwar rural films skipped over the social and political disruption caused by demobilization, wartime occupation, and destruction. But these were not the areas of whitewashing that earned the collective farm comedies and dramas of the late Stalin era such infamy. Instead, an altogether cruder application of lacquer darkened the legacy of rural cinema: namely, the treatment of the postwar crisis of privation. Wartime economic disruption spilled over into the postwar period as shortages persisted and famine set in, tainting the recent victory with the everyday defeats of hunger and impoverishment. According to Khrushchev, cinema dealt with these debilitating circumstances by "varnishing reality" with films that "pictured collective farm life such that tables groaned from the weight of turkeys and geese."[1] This characterization has proven the prevailing view of rural films, with Pyr'ev's *Cossacks of the Kuban* serving as the illustration pointed to repeatedly as the embodiment of Soviet cinema's distortion of historical reality. This is understandable given that the film features such mountains of produce and manufactured plenitude that the actors are practically pushed out of the frame to make way for the new screen sensation, Comrade Commodity. What is more, it was also the first film targeted for de-Stalinization and was banned by Khrushchev in 1957 (despite his earlier enthusiasm for it) on the grounds of its egregious varnishing of reality.[2] In short, *The Fall of Berlin* may have

1. Khrushchev, "Speech to 20th Congress of the C.P.S.U."
2. Prior to castigating it in 1957, Khrushchev had used the film as a campaign tool, screening it to audiences of collective farmers in the southern regions on the heels of his political speeches.

been the "Ultimate Stalin Film," but *Cossacks of the Kuban* was the most *notorious* Stalin film, credited with typifying Stalinist excess and all that was rejected in the de-Stalinizing impetus of the Thaw.[3]

The problem with this characterization, however, is that *Cossacks of the Kuban* is not in fact typical of postwar rural cinema but is instead unique in terms of its plot, setting, and presentation of material abundance. This chapter explores each of these three areas of exceptionality in Pyr'ev's controversial film by contrasting *Cossacks of the Kuban* with the remaining collective farm comedies and dramas that topped the box office alongside it. The result is a more accurate picture of the relationship between cinematic and Soviet rural reality in Stalin's final years.

Varnished Plots

Rural life after the war was shaped by material absences—by shortages, requisitioning, and the removal of safety nets, both public and private. A housing shortage plagued formerly occupied rural areas, with, for instance, nearly a third of the twenty-nine thousand residents of Novgorod still living in basements, temporary barracks, and dugouts in 1948. Eleven years after Victory Day, thousands of rural families continued to make do in dugouts and other improvised shelters. Even for those with adequate housing, the dearth of basic amenities like fuel for heating and necessities such as soap, clothing, and footwear rendered living conditions insalubrious to say the least. Most acute were the food shortages that left essential sources of fat like meat, milk, butter, and lard practically unattainable to the average Soviet, while bread became a precious commodity even for those with ration cards.

While all the recently warring nations suffered from an inadequate food supply and the continuation of rationing, the situation was worsened in the Soviet Union by a harvest so poor in 1946 that it barely achieved two-fifths of that in 1940, making it the lowest in a century. Weather conditions combined with inadequate agricultural equipment to ensure a shortfall, as farm workers were often forced to reap by hand what little they could amid destructive downpours in the north and east, and drought in the west. Too long had tanks and the machinery of war been the

Rimgaila Salys, *The Strange Afterlife of Stalinist Musical Films* (Washington, DC: National Council for Eurasian and East European Research, 2003), 3.

3. The International Historical Films DVD release of *The Fall of Berlin* describes it in these terms. On *Cossacks of the Kuban*'s notoriety, see: Richard Taylor, "'But Eastward, Look, the Land Is Brighter': Toward a Topography of Utopia in the Stalinist Musical," in *The Landscape of Stalinism: The Art and Ideology of Soviet Space*, ed. Evgeny Dobrenko (Seattle: University of Washington Press, 2003), 214; Woll, *Real Images*, 12, 27; Liehm and Liehm, *Most Important Art*, 63; First, *Ukrainian Cinema*, 23–24.

priority of Soviet heavy industry, and the consequences were visible in the fleets of tractors and combines that languished in disrepair. Even so, according to the leading historian of the famine, V. F. Zima, the harvest crisis did not in itself guarantee famine conditions in the USSR; instead, the state's response to the 1946 shortfall exacerbated the situation, much as it had done during the Great Famine or Holodomor of 1932–33. As it did then, the state continued to export grain during the crisis of 1946–47, supplying 6 percent of the 1946 harvest to France and several Central and East European nations as food aid, before increasing the rate sharply in 1947. In another revival of earlier strategies, the Soviet government also added a procurement surcharge on top of the regular taxes in kind due from collective and state farms. These surcharges were most often satisfied by surrendering the grain earmarked for paying farmworkers' wages. Simultaneously, an October 1946 resolution revoked the ration cards of 86 percent of rural recipients, bringing to an end state food subsidies for anyone living outside urban centers, even those working in industry. The result was, according to Zima's reckoning, approximately two million deaths due to malnutrition from 1946 to 1948.[4]

Although the harvest of 1947 showed a considerable improvement and set Soviet agriculture on the road to recovery, rural areas were the last to benefit, since bread supply to the cities was prioritized.[5] Further, while the commercial prices of some goods improved with the complete abolishment of rationing in December 1947, the monetary reform of that same month, which introduced a new ruble, curtailed rural buying power severely. In the estimation of the social historian Donald Filtzer, this reform targeted the rural population deliberately, being "designed to soak up the cash savings which many had accumulated during the war," or at least which they were thought to have accumulated, according to traditional stereotypes concerning secreted peasant wealth.[6] Under the reform, individuals were permitted to exchange their old rubles for the new currency at a favorable rate (ranging from 1:1 to 1:2, depending on the total amount) only when that money was held in a savings account as opposed to cash, which was exchanged at a rate of 1:10. Since the vast majority of peasants eschewed the bank (unlike workers), they immediately lost 90 percent of their savings with the introduction of the new currency. Taken together, these reforms meant that within fourteen months,

4. Zubkova, *Russia after the War*, 40–43, 47, 102; Filtzer, *Soviet Workers and Late Stalinism*, 45, 95; Donald Filtzer, "The Standard of Living of Soviet Industrial Workers in the Immediate Postwar Period, 1945–1948," *Europe-Asia Studies* 51, no. 6 (1999): 1019–22; Julie Hessler, "Postwar Normalisation and Its Limits in the USSR: The Case of Trade," *Europe-Asia Studies* 53, no. 3 (2001): 447; Channon, "Stalin and the Peasantry," 201, 204; V. F. Zima, *Golod v SSSR 1946–1947 godov: Proiskhozhdenie i posledstviia* (Moscow: Rossisskaia akademiia nauk, 1996), 11, 20. Although collective farm workers were never part of the ration system, rural specialists, industry workers residing in the countryside, and a few other groups were included before the system was revoked.

5. Hessler, "Postwar Normalisation," 458.

6. Filtzer, *Soviet Workers and Late Stalinism*, 77–78.

rural Soviets were stripped of both state food subsidies in the form of rationing and their own personal savings, all while famine stalked the land. The repercussions of these months of hardship persisted into the early 1950s, as food and other goods remained scarce outside the capitals, rural wages were chronically left unpaid, and genuine buying power remained elusive in the countryside.[7]

Needless to say, postwar cinema did not touch on the formidable challenges facing the rural population. Indeed, the resolution of September 1946 (discussed in chapter 1), guaranteed cinema's silence on the theme of privation, having condemned Lukov's *A Great Life Part II* and Kozintsev and Trauberg's *Simple People* for merely intimating the most innocuous example of postwar shortages, namely, the lack of machinery to aid in reconstruction.[8]

The absence of shortages and famine from the screen did not equate to a cinema stripped of all reference to contemporary problems, however. In fact, plots were propelled by problems: the lack of electricity (*Cavalier of the Golden Star*) and running water (*The Country Doctor*), unproductive farming and animal husbandry techniques (*Bountiful Summer, The Return of Vasilii Bortnikov*), broken equipment (*The Return of Vasilii Bortnikov*), and unproductive industry (*Miners of the Don*). In fact, the depiction of hardship met with official approval, as indicated by a report from Agitprop to the Central Committee praising Pudovkin's final film, *The Return of Vasilii Bortnikov* (still under production at the time), for its engagement with the actual problems of contemporary collective farm life.[9] The distinction is that the challenges shaping cinematic plots were always resolvable through implementing existing party resolutions, be they on electrification, collective farm amalgamation, the improvement of rural industrial culture through education, the green conveyor method of dairy cow foraging, or Stalin's canalization program. Only problems with existing "solutions" made it onto the screen.

Emphasizing the resolution of such practical problems was apparently considered crucial by censors. For instance, the same Agitprop report on Pudovkin's film went on to criticize it for centering the dramatic tension on the rectification

7. Zubkova, *Russia after the War*, 42, 104; Filtzer, *Soviet Workers and Late Stalinism*, 78–79, 88; Hessler, "Postwar Normalisation," 462. Julie Hessler dates the transition to more normalized (albeit Stalinist) economic patterns to 1949 and explains that the persistent shortages after 1950 were due to new pricing irregularities rather than the legacy of wartime policies (452).

8. Of course, films were not unique in their failure to address serious contemporary hardships. The Soviet state never acknowledged the postwar famine, leaving it to the Russian government of the 1990s to confirm officially Khrushchev's revelation on the topic in the Western release of his 1971 autobiography. Instead, postwar Soviet officials (particularly in the Ministry of Public Health) scrubbed records clean of any mention of famine, referring only to "provisioning problems" (*problemy podgotovki*). See Channon, "Stalin and the Peasantry," 201, 203; Zubkova, *Russia after the War*, 47.

9. RGASPI 17/133/383/260.

of personal issues rather than tractor supply problems.[10] Not only were all problems resolvable, but their resolution required simply the introduction of new techniques and (apparently readily available) technology, meaning that improvements in rural conditions relied solely on a change in the community's mindset and its willingness to modernize. Contemporary Soviet rurality was shown therefore as imperfect, yet in the process of perfection—as beset with problems, but only those that could be overcome within ninety minutes. As a result, the dramatic tension of these films was dissipated since the films' conclusions were foreordained. In the case of rural films, all practical problems faced by collective farm workers were solved by the inspiration of the party, which was channeled through the leadership of the matured positive hero and embraced by a community willing to grow and adapt. Rural cinema's plots were therefore varnished in a very precise manner: glossing over systemic, chronic, and complex problems while embracing limited problems of technology and technique as a means by which to convey an image of Soviet progress.

Cossacks of the Kuban is a different story. It features no challenges or practical problems, and no returning veteran to apply his hard-won political maturity to resolving them. Instead of adhering to the postwar version of the master plot, Pyr'ev's film is structured (albeit loosely) around a generically defined plot— that of the classic musical. According to Rick Altman, musicals are not designed to be read in a linear manner, tracing a cause-and-effect relationship between consecutive scenes (as with the socialist realist master plot), but rather in parallel, with a dual focus on the male and female protagonists.[11] The montage juxtaposes the experiences of the woman and the man so that it is clear from the beginning that they are destined to come together despite representing opposing values. These opposing values constitute the main stumbling block to the romance, which is overcome as each character transforms, becoming more like the other, until they meld in the climactic (metaphoric or actual) wedding scene.

Although rooted in an analysis of Hollywood musicals, this model resonates with Soviet musicals like *Cossacks of the Kuban*, which echoes the parallel structure and in fact doubles it by contrasting the courtship of the main middle-aged couple with that of a much younger couple. Pyr'ev's wife, Marina Ladynina, and the then little-known stage actor Sergei Luk'ianov star as socialistically competitive and mutually besotted neighboring collective farm chairpersons Galina Peresvetova and Gordei Voron, whose romance blossoms during the harvest

10. RGASPI 17/133/383/260.
11. Classic musicals are those that feature bespoke compositions with lyrics that further the plot and deepen characterization. Although song was a common feature of late Stalin-era cinema, and particularly of films set in rural spaces, only *Cossacks of the Kuban* and Aleksandrov's *Spring* (*Vesna*, 1947) satisfy this definition of classic musicals. On "reading" classic musicals, see, Rick Altman, *Film/Genre* (London: BFI Publishing, 1999).

festival. Peresvetova, with her drive to electrify and bring culture to her collective farm, represents modernity; Voron, with his pride and competitive approach to the market and sporting festivities, represents tradition. Both are cautious in expressing their feelings for the other, in contrast to the younger lovers, Hero of Socialist Labor Dasha Shelest (Voron's surrogate daughter) and Kolia Kovylev, Peresvetova's lead horse breeder. Unlike in the Hollywood musical, however, there are no transformations in *Cossacks of the Kuban*. Neither lead protagonist changes his or her ways. There is a moment of potential for transformation during the sulky race, when Peresvetova noses ahead of Voron. Ultimately it is not the prideful Voron but the modest Peresvetova who hauls back on the reins of her horse, however, enabling Voron to overtake her near the finish line and thereby shielding him from the opportunity (or need) for character development. A lively rearrangement of Peresvetova's song to Voron, "As You Were, so You Have Remained," dominates the soundtrack in this scene, underlining Voron's unchanging nature. True transformation would have seen Voron throw the race in favor of his love or at the very least humble himself and confess his deep affection to her; instead, as the film's hundred-minute mark approaches, Voron simply appears on his horse and Peresvetova confirms that she loves him. A harmonious duet ensues. Meanwhile, the young couple need simply wait for Voron to overcome his reluctance to lose a daughter and lead worker to a neighboring collective farm in order for their romance to result in a happy union. In both cases, it is all just a matter of timing. The film has the trappings of a plot—opposing values, contrasting couples, neighborly competition—but it fails to exploit these elements in any meaningful way, rendering the film essentially plotless.

Varnished Sets

Khrushchev's accusation against cinema for varnishing reality was less concerned with plot, however, than with the imagery of rural films: it was the groaning tables, the turkey and geese that misrepresented the countryside so reprehensibly. By this diagnosis, set decor rather than story was at the heart of cinema's falsified reality. Although Khrushchev himself did not name a particular exemplar, Pyr'ev's comedy has, in accordance with scholarly consensus, earned the dubious honor of epitomizing the varnishing of reality in cinema.[12]

12. James von Geldern and Richard Stites, eds., *Mass Culture in Soviet Russia: Tales, Poems, Songs, Movies, Plays, and Folklore, 1917–1953* (Bloomington: Indiana University Press, 1995), 411; Dmitry Shlapentokh and Vladimir Shlapentokh, *Soviet Cinematography, 1918–1991: Ideological Conflict and Social Reality* (New York: Aldine De Gruyter, 1993), 124; Liehm and Liehm, *Most Important Art*, 62–63; Taylor, "'But Eastward, Look, the Land Is Brighter,'" 14; Richard Taylor, "Singing on the Steppes

Cossacks of the Kuban is indeed spectacular in its depiction of the material plenty and irrepressible exuberance of life on the collective farm. In the opening sequence, not simply mounds but mountains of grain burst from the fields of Kuban, practically overloading the contingent of modern harvest machinery deployed at Galina Peresvetova's collective farm. The chairwoman leads her brigades in joyous song over this abundance, as a wizened farmer announces their dedication to reap every grain, losing not a single seed. Their faces beam into the camera, breaking the fourth wall and making eye contact with the viewer in their eagerness to impart their enthusiasm. The film's action—such as it is— unfolds amid successive wonderlands of produce, first in the harvest fields, then on the roads atop trucks and carts laden with the autumn's takings, and, most dramatically, at the *osenniaia iarmarka*, or autumn fair, where food and manufactured items spill out of the stalls and stores.

On display here is the fullness of Soviet plenty, which includes everything from fruit and vegetables to household articles, including teapots, samovars, linens, and crockery; cultured goods such as books; radios and bicycles; and specialized regional items such as horse harnesses (figure 7.1). There is even a musical instrument store, outfitted with a salesman styled after Charlie Chaplin who demonstrates the quality of the grand piano by playing his way right off the end of the keyboard. Carnival rides, a cinema, and a theater for live performances round out the *iarmarka*'s facilities, creating a colorful and cultured portrait of Soviet material plenty. At the time of filming in 1949, conditions in the Kuban region had improved since the famine but had not done so to the extent enjoyed by Peresvetova, Voron, and their fellow collective farm workers as they courted and roistered their way about the fair. Indeed, according to accounts from local villagers who served as extras in the film, much of the food on display was actually artificial.[13] *Cossacks of the Kuban* quite literally plastered and papier-mâchéd Soviet reality into existence.

The film's reputation in scholarship as "emblematic" or the "apotheosis" of postwar cinema's idealization of reality is nevertheless problematic on two counts, beginning with the assumption that the film was intended as a representation of Soviet reality.[14] Ivan Pyr'ev—who served as both screenwriter and director on the project—painted a very different picture of the purpose of the film in letters and telegrams written while production was underway. The following excerpt from a letter to Grigorii Mar'iamov (assistant to Minister of Cinema

for Stalin: Ivan Pyr'ev and the Kolkhoz Musical in Soviet Cinema," *Slavic Review* 58, no. 1 (1999): 143–59; Salys, *Strange Afterlife of Stalinist Musical Films*, 6–7.

13. T. Arkhangel'skaia, "V gostiakh u pisatelia: Elizar Mal'tsev: ne izmeniaia sebe," *Literaturnaia Gazeta*, February 18, 1987; Salys, *Strange Afterlife of Stalinist Musical Films*, 7.

14. For examples of this reputation, see First, *Ukrainian Cinema*, 23–24; Taylor, "'But Eastward, Look, the Land Is Brighter,'" 14.

FIGURE 7.1. The material abundance of *Cossacks of the Kuban* (Pyr'ev, 1950).

Bol'shakov), expresses Pyr'ev's desire to reconcile the reality of what he saw at the model collective farm Mar'inskoe in Krasnodar with the type of film that could pass censorship yet nevertheless remain meaningful for audiences:

> Yes, Grisha, we are filming! We are living on the banks of the river Zelenchuk [a tributary of the Kuban River in the North Caucasus]. The air here is wonderful: dry like the steppe and most important there is no ministry, no studio, no explaining to do, no "political intrigues," squabbling, or nuisances. In a word, Grisha, it isn't bad here and I would even say it's good, if it weren't for my doubts . . . (they are with me always). How to make the film? The devil only knows! Showing the whole truth—how the collective farm workers live and work—is impossible [*nel'zia*]. Yes, yes, one cannot! . . . So it is necessary to find some middle ground between "singing praises and poeticizing" and the truth. But where is that middle ground? How does one take hold of it? And how does one do so in a way that will render the film interesting for viewers but also acceptable to the Old Square [*Staraia Ploshchad'*, a euphemism for the Central Committee, which was housed at 4 Old Square in Moscow]? Therein lies my main difficulty and the cause of my doubts and concerns. I will, of course, do everything I can so that I will have the

material necessary for a poetic scenario—labor [montages] and so on. To do this, I must compose and finish writing all the scenes here. Otherwise, I won't be able to complete it. I must, absolutely must, make a good film. It is essential for our [Soviet] Union and for me.[15]

It was this final sentiment that shaped how Pyr'ev conceived of *Cossacks of the Kuban* and its purpose, namely, as a film that showed life not as it was or even—in classic socialist realist terms—as it soon would be but rather "as it should be, according to our conceptions and aspirations."[16] It was, in a sense, a gift to the Soviet audience: an image of what they had earned, what they deserved, and what should be theirs, though it was not so in reality.[17]

Confirming the film as an intentional break from reality is its temporality. *Cossacks of the Kuban* is purged of today, existing instead in the temporality of the fairy tale, caught between a romanticized past ("once upon a time") and the promise of an ideal future (the imminent "happily ever after" of socialist realism). Rather than the idealized present of other rural films or the timelessness of landscape montages, it depicts a Sovietized past projected into the future. This fantastical temporality is most clearly signaled by the film's setting, the *iarmarka*, or autumnal fair, which was highlighted in the original title of the film, *The Jolly Fair* (*Veselaia iarmarka*). The *iarmarka* had no real-life equivalent in the USSR. Instead, the Cossacks' autumn fair was birthed out of Pyr'ev's disappointment with reality when he visited a collective farm fair in Vereia in the Moscow region. Holding that "art must not only reflect that which is, but also call for the good, the new, and that which should be," Pyr'ev wove together memories of childhood visits to Siberian *iarmarki* in Uzhur, Bogotol, and Krutikha, with stories of the famous Irbitskaia fair and literary sketches by Viacheslav, Shishkov, and Gogol' to bring into being the fair he believed should exist in the USSR.[18]

The film does not simply re-create a prerevolutionary reality, however, but Sovietizes it: launching the fair with a political speech; punctuating it with announcements from the ubiquitous Soviet loudspeaker, delivered in familiar imperatives; and incorporating a brief sequence demonstrating the collective farmers' resolution of the Marxian problems of surplus labor and product (simply lower the

15. Quoted in Grigorii Mar'iamov, "Boitsovskii kharakter," in *Ivan Pyr'ev v zhizni i na ekrane: Stranitsy vospominanii* (Moscow: Kinotsentr, 1994), 188–89.

16. Ivan Pyr'ev, *Izbrannye proizvedeniia v dvukh tomakh*, vol. 1 (Moscow: Iskusstvo, 1978), 114.

17. Rimgaila Salys's study of perestroika-era debates about *Cossacks of the Kuban* reveals that many viewers remembered receiving the film as just that, "an expression of hope" and "a noble impulse" (quoted in Salys, *Strange Afterlife of Stalinist Musical Films*, 6–7). Other respondents, however, condemned it as *lakirovka*, while still others insisted that it was true to life.

18. Pyr'ev, *Izbrannye proizvedeniia*, 1:129–31. The bazaars and flea markets of the late Stalin period persisted only in cities and were centers of trade in used and handmade goods rather than the new manufactured goods available to Voron and Peresvetova. For a discussion of marketplaces during the Stalin era, see chapter 6 of Hessler, *Social History of Soviet Trade*, 251–95.

prices). Pyr'ev's fair displaces the past into the future, unsettling the established horology of socialist realism—of the revolutionary, socialist realist present as anticipating and embodying the imminent future, which is defined in rural cinema through the depiction of today's problems being resolved through the application of the most recent party resolutions.[19] In *Cossacks of the Kuban*, today is obfuscated because there are no problems, and therefore no party-based solutions by which to recognize the day. The result is not reality or even socialist reality but "first and foremost, spectacle—colorful, bright, inviting spectacle," as Pyr'ev himself explained.[20] This was his solution to the dilemma he expressed to Grisha. In this sense, the *iarmarka* was a means of escaping a reality that brought disillusionment and instead furnishing holidaymakers—both the collective farm workers celebrating the harvest on screen, and filmgoers enjoying a respite from daily life in the cinema hall—with a fantastical moment where fairy tales came true.[21]

Rather than the filmmaker, it was Soviet reviewers who insisted *Cossacks of the Kuban* was a depiction of contemporary reality. Setting the tone was the *Pravda* reviewer Arkadii Perventsev, who extolled the film as depicting the "authentically real Kuban collective farm reality" that was representative "of all Soviet collective countryside."[22] Although no other reviews were quite so explicit in their assertions, subsequent pieces in *Literaturnaia gazeta*, *Sovetskoe iskusstvo*, and *Izvestiia* expressed a general assumption as to the accuracy of the film's representation of the countryside, describing it as being "about the universal success of Soviet collective farm peasantry" and "the happy life of the Soviet collective countryside," "devoted to the workers of the socialist fields."[23] An *Iskusstvo kino* editorial eulogized it as a "cheerful comedy about the contemporary collective village and its people," while I. Khrenov, the chairman of the Moscow region collective farm Trud (Labor) asserted in *Ogonek*: "It is possible to debate with the filmmakers of *Cossacks of the Kuban* on this or that particular detail. But the main point in the film—our power, our wealth, our culture—is reflected truly."[24] Taking the opposite approach, Rostislav Iurenev, whose review for *Iskusstvo kino* was the first to be

19. One of the Soviet reviewers of the film noted the old-world flavor of the *iarmarka*, while First also comments on Pyr'ev's appreciation of the past in *Cossacks of the Kuban*. Vsevolod Vishnevskii, "Sila kolkhoznaia . . . ," *Literaturnaia Gazeta*, March 4, 1950; First, *Ukrainian Cinema*, 23.

20. Pyr'ev, *Izbrannye proizvedeniia*, 1:129.

21. The *New York Times* review of the American release of *Cossacks of the Kuban* picks up on the fairy-tale escapism of the film, slating it not for propagandizing but for being too Hollywood-like in "spirit." "The Screen: Life on a Soviet Farm," *New York Times*, October 30, 1950. The Soviet film critic Maia Turovskaia also reads Pyr'ev's musical as folklore and fairy tale. Maiia Turovskaia, "I. A. Pyr'ev i ego muzykal'nye komedii: K probleme zhanra," *Kinovedcheskie zapiski* 1 (1988): 127–28.

22. Arkadii Perventsev, "Schast'e kolkhoznoi zhizni," *Pravda*, March 1, 1950.

23. Vishnevskii, "Sila kolkhoznaia . . ."; Gleb Grakov, "Kubanskie kazaki," *Sovetskoe iskusstvo*, March 4, 1950; Mikhail Dolgopolov, "Kubanskie kazaki," *Izvestiia*, March 2, 1950.

24. "Uspeshno vypolnit' zadachi, stoiashchie pered kinoiskusstvom!," *Iskusstvo kino*, no. 1 (1951): 2; I. Khrenov, "Sila kolkhoznaia," *Ogonek*, September 1951, n.p.

published, went to pains to reject the notion that the film was a fairy tale, quashing any such readings preemptively, and instead condemned bourgeois cinema as the purveyor of such sickly sweet productions.[25] In this way, it was the official reading of the film promulgated in the review press that provided the clearest rationale for its later condemnation as a falsification of reality. As conceived by Pyr'ev, however, the film was not such a facile work of propaganda but instead knowingly depicted what was exceptional to Soviet reality: a festive escape from daily life.

The second problem with treating the film as emblematic of Stalinist cinema is the fact that subsequent films did not follow in its footsteps, even though it was the first release in the new wave of collective farm comedies and dramas and was tremendously popular with viewers, securing second place at the box office for the entire late Stalin period. It even boasted more than twice the attendance of each of the three other collective farm films, *Cavalier of the Golden Star*, *Bountiful Summer*, and *The Return of Vasilii Bortnikov*.[26] Yet, the vision of plenty displayed in *Cossacks of the Kuban* remained unique throughout the Stalin era, as subsequent films presented an image of material sufficiency rather than abundance. The *iarmarka* as a display of material wealth and the diversity of Soviet rural production was not replicated on screen. While *The Train Goes East* briefly incorporates a market, its purpose is not to demonstrate Soviet plenty but rather to showcase the lively character of the protagonist, Zina, who attracts a crowd of admirers with her banter (and, in so doing, manages to miss her train). The market itself remains in the background throughout the short scene and consists only of a carousel, a *Pravda* newsstand, a *bubliki* stall, and a sparse table selling a few unidentifiable goods—a pale shadow of the autumn fair in the Kuban (figure 7.2).

In place of a market, the average rural comedy featured a feasting scene—something that *Cossacks of the Kuban* lacks noticeably. Yet, even in this ideal vehicle for displaying Soviet plenty, the films refrained from indulging in excess produce. Instead of abundant food, rural feasts tended to host abundant empty place settings, at times even lacking plates. The food was invariably about to be served or had already (presumably) been consumed when the camera was rolling. There were two interesting exceptions to this pattern, the first being when Sergei Tutarinov is served a plate of what may be fish when he joins an outdoor feast at the outset of *Cavalier of the Golden Star*, yet does not partake of it, instead leaving

25. Rostislav Iurenev, "Kubanskie kazaki," *Iskusstvo kino*, no. 1 (1950): 15.

26. Ticket sales for *Cossacks of the Kuban* in the year of its release totaled 40.6 million and rose to 52 million by the end of the following year. *Cavalier of the Golden Star* sold 21.5 million tickets, and *Bountiful Summer* and *The Return of Vasilii Bortnikov* sold 20.9 million each. Only *The Young Guard Part I* (42.4 million) and *The Brave Ones* (41.2 million) ranked higher than *Cossacks of the Kuban*. Zemlianukhin and Segida, *Domashniaia sinemateka*; Pyr'ev, *Izbrannye proizvedeniia*, 1:114. See also *Nashe kino*, "Kubanskie kazaki," *Nashe kino*, accessed November 8, 2013, http://nashekino.ru/data.movies?id=2623.

FIGURE 7.2. Zina and Nikolai race to catch their train after dallying too long at the sparsely stocked market. *The Train Goes East* (Raizman, 1948).

the table to check on his friend Semen. When he returns, the plate is nowhere to be seen. The second case is in *Bountiful Summer*, where Nazar's mother pulls plate after plate of prepared food out from a cupboard. Here the camera does capture the food that will be consumed, and there is plenty! Nevertheless, the many dishes—excessive if intended only for Nazar and his mother—prove to be merely sufficient for the large group of guests they are pressed into satisfying (though such consumption is itself unfilmed). In any case, there were no tables groaning under the weight of turkeys and geese to be seen in these films, contrary to Khrushchev's claims. This shift away from the type of feasting pictured in Ermler's *Peasants* (*Krest'iane*, 1935), where the cast gorge on *pel'meni* in an almost grotesque manner, was in keeping with a similar trend in painting where, apart from a few exceptions, the popular pastoral feasting scenes of the 1930s disappeared in favor of more modest fare as traditional themes were revived.[27]

In another key forum for the display of material wealth—the harvest fields and barns—the emphasis likewise remains on sufficiency rather than excess. For example, with regard to technological resources, only two or three tractors on

27. Bassin, "Greening of Utopia," 162–68.

average are involved in cinematic harvests, which is nothing like the profusion of machinery evident in war films, where tanks frolic together by the dozen. Even the MTS headquarters in *The Return of Vasilii Bortnikov* houses but a lone tractor, sadly in need of repair. Indeed, sufficiency is a major theme of this film as a whole, as the MTS is found to have exactly what it needs (and no more) to bring in the harvest: a bright young engineer to solve the vexing mechanical failure plaguing the tractors, enough machinery to complete the job before the destructive storm hits as long as harvest continues through the night and, conveniently, a skilled night driver. There is no need to harvest by hand, as Bortnikov initially fears. The one exception to mechanical sufficiency is found in the epilogue of *Cavalier of the Golden Star*, where there is a wider selection of new technology on display than in the entire oeuvre of postwar rural cinema taken together. Yet this closing sequence is set clearly in the future as Sergei and Irina tour on all the developments on the collective farm, meaning that truly advanced technology—in this case, electric tractors, irrigation sprinklers, and semiautomated shearing and milking equipment—is the domain of the future rather than contemporary Soviet reality. It is worth noting that this image of the future was rooted in reality. Electric tractors were not fabricated for the film to create a "reality in art" that satisfied party resolutions, as has been supposed; rather, the technology pictured in the epilogue actually did exist at the time of filming, although it was by no means widespread. By May 1949, three MTS outposts in the Moscow region were equipped solely with electric tractors of the sort shown in the film, while plans were underway to gradually phase out diesel-powered tractors in favor of an even newer and more efficient electric version. Rather than portraying conditions that existed only in socialist realism, the film's epilogue anticipates a time when the prototype has become the standard—or, to paraphrase *Pravda*'s review of the film, when the model collective farm has become the typical collective farm. It is thus not fantastical so much as aspirational.[28]

The theme of sufficiency on the collective farm extended beyond the machinery of production to actual products and produce as well. Modest piles rather than mountains of grain were pictured in the harvest scenes of films by Pudovkin and Boris Barnet, despite the latter's title of *Bountiful Summer*. Harvest trucks, though numerous, did not appear overburdened with produce, while nothing like the profusion of manufactured goods displayed in *Cossacks of the Kuban* appeared in other cinematic renderings of rural life. In place of the well-stocked musical instrument shop from Pyr'ev's *iarmarka*, or even the well-equipped collective farm orchestra of his earlier film *The Rich Bride*, a single accordion suf-

28. Cf. Liehm and Liehm, *Most Important Art*, 65. See "Pervye elektro-mashinno-traktornye stantsii," *Pravda*, May 30, 1949: 1; V. Fil'chev, "Moskovskii elektrotraktor," *Pravda*, June 2, 1949: 1; M. Kuznetsov, "Fil'm o liudiakh kolkhoznoi derevni," *Pravda*, July 11, 1951: 1.

fices for the majority of rural communities (with *Tale of a Siberian Land* being the only exception as pianos conveniently crop up wherever concert pianist Andrei travels). The instrument is well guarded and highly valued, and it is played only by one designated character. In *Tale of a Siberian Land*, the accordion originally belongs to a young soldier who can neither play nor sing. Recognizing his own inability and the contrasting skill of Andrei, the lad gifts the accordion to the musician, in effect delivering it to its rightful owner. It is not one of many, but rather a uniquely invested item and as such must belong to the one who can fulfill its potential to entertain and move an audience. Similarly, other manufactured goods displayed in profusion in *Cossacks of the Kuban*, such as bicycles, radios, and crockery, appear only occasionally—and singly rather than plurally—in the other popular rural films. One gramophone entertains the entire MTS outpost in *The Train Goes East*, for instance, while characters invariably walk or ride in carts rather than cycling.

Postwar cinema was not alone in this restrained rendering of consumer goods. As Helena Goscilo has observed, advertising posters—the most natural medium for the depiction of material abundance—likewise did not offer a fantastical utopian wonderland of manufactured plenty but instead depicted one or two items on a plain background, often leaving great swaths of the poster empty.[29] This represented a clear break from both avant-garde advertisements of the 1920s and postwar political posters, wherein every inch of the sheet was drafted into service to advertise ideology. Unlike Western advertisements, which provided a glimpse of the bliss the consumer's life would be transported to if only he or she purchased a particular brand of margarine or shaving cream, Soviet advertisements simply announced the existence of products, and rather modestly at that. The single bottle of orange juice, Soviet champagne, or Poppy perfume, the pair of nylons or lone hamburger in a small bun—these items existed but were not profuse; they were possibilities rather than probabilities, since they were clearly limited in number. Presumably, nothing more than this simple testament to the existence of manufactured goods was necessary, since the Soviet consumer was already meant to be living in the socialist utopia and did not need to purchase his or her way into a better life. It was socialism itself and not a particular brand or consumer product that guaranteed a happy, fulfilling life.

Indicative of this fundamental principle was the rarity with which the figure of the Soviet consumer appeared in postwar advertisements before 1952, highlighting the problem of associating consumption with a happy life in the era when it was (implicitly) Stalin who had initiated the better, happier life of the

29. Helena Goscilo, "Luxuriating in Lack: Plenitude and Consuming Happiness in Soviet Paintings and Posters, 1920s–1953," in *Petrified Utopia: Happiness Soviet Style*, ed. Evgeny Dobrenko and Marina Balina (London: Anthem Press, 2009), 65.

Soviet people. It was political posters, often with slogans drawn from Stalin quotations, that fulfilled the function commonly associated with advertisements in the West and indicated the way to and source of a better life.[30] It was therefore no coincidence that the political poster captioned "We'll arrive at abundance" (Viktor Ivanov, 1949) was illustrated not by material wealth but by a portrait of Stalin standing in his office looking off into the distance. The implication was that for now, abundance was abstract and only visible to Stalin, meaning that it would fall to him to lead the Soviet Union into plenty. The Soviet viewer was therefore closest to (the as yet invisible) abundance when fixing his or her gaze on Stalin.

In sum, while *Cossacks of the Kuban* undoubtedly provided an image of a new level of bounty, it was ultimately one that was not imitated by subsequent films. Instead, popular rural films offered up a different shade of varnish: that of material sufficiency. Less fantastical, this image was nonetheless as fictional as the splendid bountifulness of Pyr'ev's *iarmarka*. After all, in a time and place dogged by hardship, material sufficiency constituted relative plenty. Eating one's fill while real-life rural communities verged on starvation in some areas (even as late as 1950 and 1951, when the majority of late Stalin-era collective farm dramas were released) was certainly abundance. Having access to enough functional tractors to avoid harvesting by hand likewise constituted abundance. Yet it remained a relative abundance, rather than the abstract plenty of Pyr'ev's *iarmarka* and Khrushchev's groaning tables.

An Abundance of Potential

This is not to say that rural films lacked abundance. Instead, their representation of plenty was not material but conceptual. Soviet rurality was distinguished on screen by an abundance of *potential*, which was rendered visible through characterization and plotting. Potential was expressed in three modes, as a state, a process, and a result: it was a characteristic of protagonists, a force that powered the plot, and an outcome of the plot.

In the first and most basic mode of representation, protagonists were shown to be brimming with potential for artistic, cultural, and intellectual achievement as well as physical accomplishment. The aptitude for such feats is represented by the villagers' many hobbies and interests. Musical talent is a given in the melodious countryside of rural comedies (only the young accordion player in *Tale of a Siberian Land* demonstrates anything less than perfect pitch), as is a knack

30. Dobrenko, *Political Economy of Socialist Realism*, 292.

for traditional dance, while individual protagonists excel also in languages (Nadia Voronova in *The Brave Ones*, Liubov' Shertsova in *The Young Guard*, both of whom speak German) and agitational art (Fros'ka in *The Return of Vasilii Bortnikov*). The rural population absorbs education with ease, particularly scientific training, with Irina Liubasheva moving effortlessly from goose herding to training as the power station controller (*Cavalier of the Golden Star*), and Dunia Bortnikova holding her own with two gray-haired academicians on the subject of fodder for dairy cows. It is even implied that it will be Dunia, the stalwart dairy farmer, rather than the big-city scientists, who will ultimately solve the problem of uneven clover growth (a challenge relevant to the real world, where the "Great Stalinist Plan to Transform Nature" included planting clover as a key undertaking).[31] Elderly village uncles also pursue formal education with enthusiasm, as in *Cavalier of the Golden Star*, while the children of *The Village Teacher* multiply the effects of their schooling by becoming educators and professors themselves.

The potential represented by these abilities is highlighted even more sharply by the plots of the films, which center on outworking such talents and skills and converting them into productivity. Not only the master plot—with its development of leadership skills—but also the more idiosyncratic subplots follow this trajectory, as both main and supporting protagonists labor to outwork who they are and fulfill their potential. For instance, Irina refrains from accepting Sergei's proposal of marriage (in *Cavalier of the Golden Star*) until she has fulfilled her intellectual potential to become a trained specialist for the new local electric substation. Meanwhile, in *The Brave Ones*, Nadia's skill with languages is put to use against the German invaders (at least in theory, considering we do not actually see her at work!).

Even the natural world is presented in terms of harnessing potential. The improving performance of the dairy cows in *Bountiful Summer*, for example, is less about the amount of milk—these numbers, even graphed neatly, hold little meaning for a viewer not involved in dairy production—than the fact that the potential of Krasunia and her fellow bovines is being tapped; that this potential is far greater than the former dairy manager ever believed possible; and that it is being accessed through the application of the latest developments in Soviet animal husbandry, the green conveyor method. It is under Soviet power that the people's (and nature's) innate richness is able to flourish and develop into something productive.

The result of this outworking of potential is not so much the achievement of a tangible aim as it is the production of additional potential. In *Cavalier of the*

31. Jeffrey Brooks, *Thank You, Comrade Stalin! Soviet Public Culture from Revolution to Cold War* (Princeton, NJ: Princeton University Press, 2000), 213.

Golden Star, the protagonists build an electric power station not so that their quality of life will improve—enabling them to have televisions and so forth— but so that in the future, they can bring in the harvest more efficiently using electric tractors and sheer the sheep and milk the cows more methodically using electric equipment. In each film, protagonists labor to establish the circumstances under which the local collective farm would become more productive. The outcome of labor in rural films is therefore to secure the potential for future labor to produce abundance rather than to attain abundance itself. It is an ideological outcome rather than a material one.

It is not, however, a circular outcome. The potential that is produced when protagonists apply their talents and skills to labor is distinct from that belonging to the heroes themselves. What begins as individual potential is transformed into collective potential through its application to rural labor. To return to the example of Raizman's film *Cavalier of the Golden Star*, the potential represented by the power station is not simply that of local leader Sergei Tutarinov, or even of him, his mentor, and subordinates taken together, but rather that of Soviet power writ large. When harnessed, the limited, personal potential of the protagonists accesses the fullness of Soviet potential, connecting the local collective farms to the transcendent potential of Soviet socialism and its promise of future material abundance.

In film, this connection between local effort and Soviet power is signaled through the visual politicization of the rural labor sequences in which the villagers outwork their potential, and which are embellished with markers of the regime. The flags, banners, portraits, and posters of Soviet iconography accompany feats of rural labor (as discussed in chapter 4), while the inauguration and completion of each project are almost invariably attended by political speeches. It is in this manner that feast scenes function in rural films. Although Khrushchev describes them in such vivid material terms, the focus of cinematic feasts is neither food nor consumption (which is rarely depicted) but rather the camaraderie of the occasion, which climaxes in a political speech. Feasts are about ideological fulfillment and not filled bellies (figure 7.3).

This is because feasts provide one of the primary venues for speechmaking on screen, which in turn supplies the ideological interpretation of what has happened in the film. The feast speech outlines explicitly why the people are gathered together, what they have accomplished, and how it relates to party principles, benefiting the USSR and representing a promise of what the future will hold. It is a type of dedication rite, committing rural labor and achievement to the party, the Soviet people, and Stalin. In other words, cinematic feasts celebrate the wealth of political fruit—rather than consumable fruit—of Soviet socialism. Far from

FIGURE 7.3. A feast of ideology and potential. (Note the empty tables, profusion of flags, and power station in the background.) *Cavalier of the Golden Star* (Raizman, 1951).

being a symbol of the material abundance falsely presented by rural cinema, feasts are the epitome of how postwar film resists engaging with abundance in material terms and instead abstracts it, conceptualizing it as a product of the future. What is achieved on screen is simply the potential for excess production next year or the year after that.

Pyr'ev's musical comedy does not adhere to this conceptualization of abundance. Instead, *Cossacks of the Kuban* is set in a landscape of fulfilled potential, from the overflowing fields and harvest trucks to the *iarmarka* and its shops, theater, and racetrack. What is more, the excess fruit (both literal and metaphoric) of *Cossacks of the Kuban* is tied only weakly to labor. Unlike the other rural films with their frequent labor sequences, Pyr'ev's musical incorporates very little work—only the opening scene where the collective farmers spend more time singing about working than actually toiling, and the closing scene wherein they plow the land in preparation for the next year's planting. Instead, the film portrays the collective farm workers at leisure.

This irregularity apparently caused film critics some distress. Smirnova, writing in *Iskusstvo kino*, questions the absence of labor in the film directly, asking

why the film did "not show how these heroes work, how they labor in order to earn the right to the joyful festival depicted at the collective farm fair?"[32] Gleb Grakov echoes this sentiment, questioning, "But where is the work? Where is the pathos of labor?" before responding resoundingly: "In every frame of the film!" He continues, "Before us is presented not some kind of party, but a jolly fair of collective farm workers in all its vivid wealth and beauty. And this jolly fair, its goods and merriment, are all the fruit of strenuous, selfless labor."[33] Not only here but throughout the review, he underlines the protagonists' connection to labor even in the midst of their leisure activities by referring to them explicitly as workers (*truzheniki*) rather than collective farmers (*kolkhozniki*) or simply people (*liudi*).

Other critics pick up Grakov's response and similarly undertake an impressive amount of creative ideological work to justify Pyr'ev's *iarmarka* as a symbol of labor. Lengthy reviews in *Pravda*, *Izvestiia*, *Literaturnaia gazeta*, *Sovetskoe iskusstvo*, *Iskusstvo kino*, and *Ogonek* dedicate a disproportionate number of column inches to the opening labor sequence as if to redress the film's imbalanced focus on leisure time. They also stress the association between labor and the leisure and harvest fruits enjoyed by the Cossacks. Perventsev insists, "We well know that this festive imagery, the mighty abundance of the collective farm, results from the great productive work of Soviet patriots," while the collective farm chairman Khrenov, reviewing the film for *Ogonek*, similarly explains that "the collective farm fair in the film is perceived by the viewers as the result of the great, selfless work of thousands of collective farm workers."[34] Mikhail Dolgopolov is subtler, first establishing that Peresvetova's collective farmers had fulfilled their obligation to the state (and were in fact the first to do so in the region) before describing their hurried journey to the *iarmarka* to see and be seen.[35] The implication is that Peresvetova and her team have earned the right to attend the fair. Meanwhile, Iurenev simply attributes this understanding of the relationship between labor and leisure to the Soviet viewer, who he claims "does not forget for a moment that it is joyful, celebratory work that gave these people the right to laugh so infectiously, to live so expansively and merrily, that it is this work that fostered in these people their beautiful qualities." Iurenev continues, claiming that "this sense, of course, would have been lost if labor had not been the principle theme in the plot and characters of the film. But in fact, the fruit of this labor is indeed [present] in the abundance of the collective farm fair."[36] Iurenev comes close to acknowledging the film's weak connection to labor but

32. E. Smirnova, "Trud Sovetskogo cheloveka na ekrane," *Iskusstvo kino*, no. 2 (1950): 10.
33. Grakov, "Kubanskie kazaki."
34. Perventsev, "Schast'e kolkhoznoi zhizni"; Khrenov, "Sila kolkhoznaia."
35. Dolgopolov, "Kubanskie kazaki."
36. Iurenev, "Kubanskie kazaki," 17.

dismisses any doubts with a confident ideological diagnosis that defies the actual content of the film, which in actuality takes celebration and not work as its "principle theme." Meanwhile, Vsevolod Vishnevskii simply denies the existence of any problem whatsoever, describing the film counterfactually as the "apotheosis of collective labor."[37]

Cossacks of the Kuban is also distinguished by a weak link between Soviet power and labor, or, in this case, its apparent outcome, material abundance. The film as a whole is stripped of iconography. Apart from the requisite portrait of Stalin in the office of regional party secretary Mudretsov and a few fleetingly visible banners dedicated to the *rodina*, it contains none of the visual expressions of Soviet authority that were standard to rural films. There is also no feasting scene, meaning no accompanying political speech to clarify the relationship between local labor and the party-state. Apart from the opening ceremony of the fair that references Stalin and a brief flag raising, there is little time or space dedicated to the ideological message that was otherwise so central to rural films. As a result, *Cossacks of the Kuban* elicits the impression that the material wealth pictured on screen is primarily or even solely the outcome of the collective farmers' own labor. In other words, material abundance marks the realization of localized potential, not that of the Soviet system. What is more, there is no potential for future abundance remaining in Pyr'ev's Kuban—it has already been achieved, separately from (and ahead of) the fulfillment of the promise of Soviet socialism for material plenty. The abundance of *Cossacks of the Kuban* is thus triply problematic: it is atypical and is tied poorly to both labor and Soviet power.

The reviews of *Cossacks of the Kuban* navigate this dilemma using a twofold strategy: avoidance and exaggeration. In terms of avoidance, none of the reviews linger on the *iarmarka*, with most delimiting the film's abundance with the single word, *izobilie* (abundance), rather than a description. The most extensive engagement with Pyr'ev's cornucopia is found in the *Literaturnaia gazeta* review, which notes images "of fruit, vegetables, fabrics, [and] balloons." Yet the full quotation is highly critical of the montage of plenty—on aesthetic grounds: "All this [abundance] is good, yet in relation to the use of color here one might note an obvious overload, a gaudiness. The alternating pictures of fruit, vegetables, fabrics, [and] balloons are at times wearying. A sense of proportion, of strict selection—this is the rule of mastery, the imperative of art."[38] Vishnevskii's reference to fabrics here is the closest the reviewers approach to indicating the profusion of manufactured goods that dominates the *iarmarka* stalls. The longest description of the film's material plenty, penned by Chairman Khrenov,

37. Vishnevskii, "Sila kolkhoznaia. . . ."
38. Vishnevskii.

enumerates only "the mountains of fruit and vegetables and the rivers of premium grade seed of the new harvest"—a rather perfunctory paean to arguably the richest scenes in postwar Stalin-era cinema.[39]

In addition to avoiding discussion of abundance, reviews also tend to exaggerate the political content of the film, with Perventsev, for instance, creating a much larger role for regional party secretary Koren' on the pages of *Pravda* than he has in the film.[40] Vishnevskii politicizes the Kuban region (and thus the film as a whole) as the heartland of Soviet revolutionary and patriotic efforts in the Civil War, Great Patriotic War, and present-day resistance to the "new American 'strategy'" (that is, the Cold War).[41] Meanwhile, Grakov politicizes Pyr'ev himself, framing *Cossacks of the Kuban* in relation to the director's candidacy in the elections about to take place for deputies to the Supreme Soviet, thereby positioning the film in relationship to the Soviet hierarchy.[42] Perventsev too emphasizes Pyr'ev's patriotism, while references to *partiinost'*, or party-mindedness, the role of the party in agriculture, and the benefits of Soviet power also pepper the reviews in a bid to strengthen or even establish a clear ideological connection between the world of plenty on screen and Soviet power. Overall, the reviews transform this unique musical comedy into a film about labor, a film in which the material rewards of labor may or may not be depicted—the reader cannot tell—but wherein the ideological value of labor is demonstrated in detail. In short, reviewers interpolated *Cossacks of the Kuban* into an utterly average rural film, smoothing away both the problematic themes of abundance and leisure, and the ideologically disturbing lack of actual labor and political iconography in the film.

Rural cinema of the late Stalin years produced films of recovery—films that took historical reality as their starting point and applied *lakirovka* liberally yet strategically to draw reality closer to utopia and reassert the potential of the Soviet system for future prosperity. These films modeled a society fully recovered from the impact of four years of war and occupation, and the physical, material, and psychological legacies of prolonged violence. At least, this was generally the case—with one notable exception. *Cossacks of the Kuban* did the opposite, taking the socialist utopia of limited labor and abundant produce as its base and applying Soviet features to connect a fairy-tale future to life in the postwar USSR. These two renderings of the countryside—Soviet with utopian themes (national unity, social cohesion, sufficient material provision) versus utopian with Soviet

39. Khrenov, "Sila kolkhoznaia."
40. Perventsev, "Schast'e kolkhoznoi zhizni."
41. Vishnevskii, "Sila kolkhoznaia. . . ."
42. Grakov, "Kubanskie kazaki."

features (hints of iconography, moments of political ceremony, and mention of Marxist economics)—were worlds apart, and it was the latter world, depicted in *Cossacks of the Kuban*, that proved the most popular with Soviet viewers. Pyr'ev's musical and its unique depiction of rural life granted the average Soviet viewer access to what, according to the remainder of Soviet visual culture, the leader alone could see: imminent abundance.

Socialist plenty was pictured with surprising rarity during the postwar years. Advertising posters were spartan; rural feasting was phased out of films and paintings; even the ultimate display of Soviet production and produce, the All-Union Agricultural Exhibition (Vsesoiuznaia Sel'sko-Khoziaistvennaia Vystavka, later renamed Vystavka Dostizhenii Narodnogo Khoziaistva [VDNKh]), which had opened in 1939, was closed with the German invasion and did not reopen until after Stalin's death.[43] In place of the visual embodiment of plenty arose an abstracted conception of abundance, expressed most clearly by Ivanov's memorable poster, "We'll arrive at abundance," in which Stalin stands alone, eyes fixed on the unpictured abundance toward which "we"—he and the viewer(s)—are headed. *Cossacks of the Kuban* shifts the frame of this 1949 poster to the left, away from Stalin and onto the object of his perpetual gaze, namely, our abundance. Pyr'ev's film proves in this way to be transgressive in terms of its aberrant depiction of abundance and its lack of iconography to tie material plenty to Stalin and his leadership. Rather than being a tasteless misrepresentation of Soviet reality, *Cossacks of the Kuban* subtly undermines the official definition of the future as the location of excess and the invisibility of that plenitude to anyone other than the leader. It also resists making a connection between abundance and Soviet power, with only vague gestures toward the discourse of labor and the symbolic trappings of the regime that otherwise dominate rural films. The fact that the depiction of material plenty in Pyr'ev's film surpasses the established Soviet visual discourse of abundance launches the film into uncharted visual territory, as yet unmapped and uncontained by slogans, iconography, or political speeches. Perhaps it was this resolute disconnection from Soviet power that was at the heart of the film's appeal: when given the option, Soviet audiences preferred to consume a fairy tale of what should be rather than the familiar socialist realist fare of what soon would be.

43. Evgeny Dobrenko, "The Soviet Spectacle: The All-Union Agricultural Exhibition," in *Picturing Russia: Explorations in Visual Culture*, ed. Valerie Kivelson and Joan Neuberger (New Haven, CT: Yale University Press, 2008), 189–95.

CONCLUSION

I opened this book with an anecdote that was really only the predictable middle part of a far more fascinating story. In filling in the rest of that account, I proposed to do the same for the popular cinema of the late Stalin era as a whole: to look to the left and to the right of Stalin, toward postwar reality and the legacies of the war, on the one hand, and the official aesthetic, socialist realism, on the other, with the intent of breathing new life into a period of Soviet cinema hitherto considered dead. To this end, this book has pursued two central lines of inquiry in its examination of postwar popular films. First, it has investigated the dialogue between cinema and historical reality, examining the specific instances and ways in which films distorted contemporary Soviet life. Second, it has traced the engagement of cinema with the popular demand for a new socialist realist hero and master plot. Let us take stock now of what the war films, Stalin epics, and rural comedies and dramas of 1945–53 had to offer in regard to these two themes.

Postwar Cinema and Historical Reality

Late Stalin-era cinema varnished Soviet reality. Yet in smoothing over the rough surface of everyday life and fixing in place the brilliant colors, clean lines, and tidy patterns of socialist realism's "imminent reality," cinema did not obscure historical reality altogether. Neither did it completely block out the underlying substance of the postwar Soviet experience. Not all lacquer is created equal, nor is it applied evenly—at least not in the case of Soviet postwar cinema. In the

introduction to this book, I proposed to take a closer look at the varnishing of reality perpetrated by postwar cinema, and the ways in which these films engaged with contemporary reality, be it through demonstrating party resolutions put into action, solving the problems of the postwar period, or skirting them altogether. As a result, this book has revealed a wide range of lacquers and varnishing techniques, as it were, that were put to use in the war films, Stalin epics, and rural comedies and dramas that led the box office during Stalin's final years.

To begin, we have seen varnish applied to issues of political significance to the regime, but which nevertheless left filmmakers free to explore the medium and the metaphoric potential of cinematic imagery and sound, injecting their films with layers of nuance unflattened by ideological conformity. So while Gerasimov's *The Young Guard* adapted and even reshot scenes to create a larger role for the guiding hand of the Red Army and the party in the sacrificial heroism of the Krasnodon youths, the film also offers a creative, rich soundscape that foregrounds the cultural nature of wartime occupation and resistance. The result is a film that is far subtler and more artful in its sonic narrative than the story told through its trite dialogue. The same can be said of the war films and rural films that give prominence to landscape as a cipher for the positive hero's otherwise inaccessible inner world—films like *Son of the Regiment*, *Story of a Real Man*, and *The Return of Vasilii Bortnikov*. Sometimes, then, varnish served as a distraction, satisfying the ideological rubric and thereby purchasing some scope for more artistic endeavors.

We have also seen that not all varnish took. Sometimes the eye of the Soviet viewer seems to have skipped along the surface of the cinematic frame and failed to absorb the image therein. Such was the case with the Stalin cult classic *The Fall of Berlin*, as revealed by both its critical and popular reception. While reviewers sanctioned by the regime apparently missed the point of the film's depiction of Stalin as the Lone Leader, letter writers from among the wider public skimmed past Stalin's representation in the film and fixated instead on the character of greater interest to them, Alesha Ivanov. In both cases, viewers largely ignored the deific imagery that has marked Chiaureli's war film as the apotheosis of the Stalin cult for film scholars. In other words, it was possible for even the most heavily applied varnish to fail to elicit the desired effect.

Then there was also the varnish that was not of the state's making but which drew on other traditions or even a filmmaker's own vision. Such was the case with Pyr'ev and *Cossacks of the Kuban*, which was inspired in equal parts by memories from a prerevolutionary childhood, stories by the likes of Gogol', Viacheslav, and Shishkov, and a desire to provide a Hollywood-style happy ending to the Soviet people following the hardship of war. In pursuing his fairy tale of leisure amid the bounty of "socialist plenty," Pyr'ev foreswore the conventions

of rural cinema, namely, its emphasis on labor, state power, and productive potential, which displaced the attainment of abundance into the future. Pyr'ev plowed through the finely wrought ideological intricacies undergirding the image of the collective farm on screen and offered something altogether more fantastical. This was the wrong kind of lacquer and was scrupulously ignored by official reviewers, who instead transformed the film into a paean of tireless labor through their misleading descriptions.

This last example goes to show that despite the notorious ban on films in 1946 and persecution of Eisenstein, there was still sufficient leeway within the late Stalin-era film industry for the core of established, trusted directors to conceive and carry out their own cinematic projects. Iudin's *The Brave Ones* is another such film that was out of place when it premiered at the end of 1950.[1] The Soviet Western revived the war comedy and partisan film after such narratives had long since vacated the screen, daring to revisit the Great Patriotic War after the release of the film that was otherwise the final word on the official narrative of victory, *The Fall of Berlin*. Filmmakers were not merely victims of the regime and its censorial eye, after all, but also participated in the administration of the film industry as members of the Ministry of Cinema's Artistic Council (in its early permutation), as the heads of studios, and so on—posts that positioned them to find pockets of breathing space that made for some unique film productions.

Finally, there remained also the unvarnishable—the realities that cinema avoided altogether rather than attempt to idealize. The most profound example of such evasion concerned reconstruction, that is, the process at the very heart of the Soviet postwar experience. The vitriolic treatment by Zhdanov, Stalin, and the Orgburo of two early attempts to relate the story of heroic reconstruction is no doubt largely to account for the silence of postwar cinema on the nation's processes of recovery from the war. But what is most telling about the ban of Lukov's *The Great Life Part II* and Kozintsev and Trauberg's *Simple People* is not so much the leadership's charges against the films for the frivolity of their heroes and the insufficient mechanization of their endeavors to rebuild, but the fact that in the publicized discussions around the films, Stalin made it clear precisely what kind of reconstruction film he wanted to see. And yet, such films were never made. Perhaps no director dared brave the attempt after such public recrimination. Or perhaps Stalin's proposal that cinema should depict the fleets of efficient machines reconstructing Soviet cities and towns with plenteous supplies was too far a leap from reality for any filmmaker to countenance—the varnish simply would not stretch. Although it is common to define Stalin-era films as cinema

1. For more on the unconventional development of this film, see Belodubrovskaya's intriguing account in *Not According to Plan*, 195–203.

made for an audience of one, such was not actually the case in practice. (Indeed, the title of this book is rather tongue in cheek!) The film industry was equally preoccupied with selling films to the mass audience as to that lone critic in the Kremlin.

Regardless of the precise reasons, the most intense period of reconstruction, 1945–50, was essentially skipped over during a period of cinema that was otherwise very much concerned with depicting contemporary reality. Instead, films made during this initial phase of postwar recovery focused on the recent victory in the war. By the time cinema switched focus to engage with demobilization and life on the collective farm, progress toward reconstruction had been made in actuality, and films focused on further victories in agriculture rather than recovery from the war. Since many of these rural films open with the arrival of a veteran to the village, various excuses had to be made to explain the missing years: some positive heroes were among the last soldiers to be demobilized; others, like Vasilii Bortnikov, literally slept through the initial postwar years, having lost his memory due to a head wound and recovering only after several years—rather like Alesha Ivanov, who conveniently sleeps through the initial devastating phase of the Great Patriotic War in *The Fall of Berlin*. Filmmakers were clearly aware of the limits of cinematic lacquer and deemed certain topics best left alone—at least for a time, until reality could catch up a little.

In short, postwar cinema enjoys a complex and at times even nuanced relationship with its historical context. It does not simply layer on the obfuscation but instead prioritizes certain issues and themes, earmarking them for different kinds of treatment. The result is that postwar cinematic reality is idealized and stripped of major crises yet remains recognizable to the discerning eye. What is more, the variety of ways in which these films engage with the idealizing remit of the official aesthetic (and the official line) brings into sharp relief the variance in the priorities of the regime compared with those of filmmakers and, occasionally, when the archival record permits us a peek, those of Soviet audiences as well.

Postwar Cinema and the Positive Hero

Victory Day in the Soviet Union marked a turning point for socialist realism. As discussed at the outset of this book, Soviet victory in the Great Patriotic War served as a form of narrative completion for the official aesthetic as not just a single, representative positive hero but the entire Soviet population overcame the most fundamental challenge to socialist construction, thereby symbolically graduating to a mature state of political consciousness. In becoming a nation of victors, the Soviet people fulfilled the master plot and positive hero tropes of the

official aesthetic. Consequently, socialist realism after the war was in need of new direction. Cinema proved to be an intrepid explorer, as postwar films investigated a number of avenues for reformulating the master plot and positive hero in the search for a definition of Soviet heroism suited to the age of victors.

War films dominated these early experiments, just as they did the box office, proffering several distinct heroic arcs. First was the arc of resubjectification, which acknowledged (albeit rather mutedly) the trauma of war and the need to enfold estranged soldiers back into the embrace of the Great Soviet Family, restoring their humanity after the brutalities of war, and reinvigorating their identity as Soviets and Red Army men. Such was the focus of *Story of a Real Man* and *Son of the Regiment*. While the literary source material for these films retained elements of the classic master plot of spontaneity to consciousness, the cinematic adaptations edit them out, shifting the focus onto the process of reentry into Soviet subjectivity rather than political enlightenment. It was not only writers who were the healers of wounded souls after the war, as Anna Krylova has shown, but also filmmakers, if only fleetingly.[2]

The second heroic arc found in the war films took the opposite tack as it explored the theme of patriotic deception. Here, the focus was on a hero who was so secure in his—or more often her—Soviet identity as to be able to don the mask of an enemy in the course of duty, undermining the enemies of Soviet socialism from within. Rather than following the developmental arc of the protagonist, this narrative was task oriented, tracing the extraordinary skill and commitment of the Soviet secret agent in a thrilling, high-stakes scenario. This delusive positive hero was a postwar iteration of the partisan figure that had been so prevalent in wartime cinema, which is potentially why Soviet spies were so often women, as it was women partisans who starred in the most well-known films of 1943–44. By foregrounding the postwar secret agent's connectedness to Soviet officialdom, the postwar spy thrillers served as an implicit corrective to the prominent wartime narrative of spontaneous, partisan resistance, relocating responsibility for victory in occupied areas back firmly under the auspices of the state and its agents. Despite this advantage, the deceptive hero was ultimately too risky a figure because of the way in which it demonstrated the capacity for disconnection between inner self and outer self, between private and public—a tension that was anathema to socialist realism under Stalin. While it is no surprise that this iteration of the positive hero did not last long, it remains intriguing that it existed at all.

More predictable was the arc that centered on a hero who was not, in fact, Soviet at all—at least not in name. The heroic arc of Sovietization featured non-Soviet

2. On the characterization of Meres'ev as a spontaneous protagonist at the outset of Polevoi's novel, see Kaganovsky, *How the Soviet Man Was Unmade*, 127. On postwar writers, see Krylova, "'Healers of Wounded Souls.'"

protagonists who were aligned with Soviet ideals and who, through the course of the film, allied with the Red Army and Soviet power. These heroes hailed from nations that were subject to Sovietization after the war, and as such, this was a scenario in which a return of the prewar master plot of spontaneity to consciousness might most be expected. But not so. Rather than leading the non-Soviet positive hero through a forging process, the plot instead focused on his successful purging of the community (often his own family) of elements hostile to the Soviet Union. The crux of the plot was not transformation—neither of the hero nor of his nation—but rather elimination, as non-Soviet elements were exposed and executed. The implications of this arc for the actual, historic task of Sovietizing newly acquired territories and socialist allies were chilling, given that purging replaced the political education and wise mentorship of the classic master plot.

The arcs discussed so far each implicated a type of war hero who existed in actuality—traumatized soldier, spy, and non-Soviet sympathizer. The next two, however, are more abstract, being more an outworking of ideological orthodoxy than an attempt to engage with the variety of types who actually fought the war. That is to say, these two arcs provide a top-down definition of wartime heroism, with the first crediting the heroic state, as embodied by the military command system in films such as *The Great Turning Point*, *The Battle of Stalingrad*, and *Third Strike*, and the second, the heroic leader, Stalin himself, as in the trilogy of films directed by Chiaureli (*The Vow*, *The Fall of Berlin*, and the revolutionary war film *The Unforgettable Year 1919*). Though ideologically orthodox and vital to developing a regime-sanctioned narrative of the war, these definitions of heroism did not satisfy even the most basic premise of socialist realism, which was to model for the masses how to live out the ideal Soviet life. No master plot could attend to such heroes as the Soviet military command complex or the person of Stalin. These models of heroism had limited applicability and were not translatable to daily life. What is more, the image of Stalin as the Lone Leader was not particularly resonant with audiences, or at least not with viewers of the film that developed the image most fully, *The Fall of Berlin*.

Unlike the other Stalin epics, Chiaureli's films supplemented the abstracted leader hero by incorporating more traditional positive heroes, representative of the Soviet people. While the first and third films, *The Vow* and *The Unforgettable Year 1919*, both used regular Soviets as a framing device for Stalin's leadership, denying them any real arc apart from their growing intimacy with and respect for the *vozhd'*, Chiaureli's second Stalin epic, *The Fall of Berlin*, revived the classic enunciation of the positive hero and master plot in the figure of Alesha Ivanov, whose journey from spontaneity to consciousness follows the familiar prewar pattern. Yet this attempt to resuscitate the 1930s model of the heroic journey was an abject failure among critics and general viewers. Indeed, the letters

from viewers of *The Fall of Berlin* contain some of the most strident repudiations of the prewar characterization of the positive hero and most impassioned calls for a more mature positive hero to be preserved from this period. Chiaureli's attempt to revive the classic positive hero was rejected with finality, and none too few insults to poor Alesha as well.

While the war films of the late Stalin era may have shown the greatest diversity of experimentation in pursuit of a new conceptualization of Soviet heroism, it was ultimately the rural films, centered on life after victory rather than its achievement, that offered up a stable new definition of the positive hero and master plot. These films did not abstract heroism but instead repersonalized the story of victory in the form of the demobilized soldier. It was a story of a mature Soviet in pursuit of mastery, of the good versus the better, and followed a linear path rather than a dialectical one. It also made room for the personal life of the hero, meaning that the hero's arc consisted of twinned plotlines, public and private alike. Yet, this more personal approach did not equate to greater depth or complexity in the positive hero of the rural films. Whereas the brief glimpses into the personal lives and psychology of the spy and traumatized soldier had invested these iterations of the hero with the capacity for internal conflict, the personal life of the rural film protagonist simply reiterated what was already on display in his or her public life. Whether in labor or love, the rural positive hero faced only external challenges, and ones that were a function of timing, procedure, or climate rather than genuine conflict. In this sense, the mature positive hero addressed one major challenge to socialist realism after the war—the demand for a new model of Soviet heroism—only to fortify another: the creative crisis of conflictlessness and heroes whose progress was rather unexciting.

Ultimately, this answer to the search for a socialist realism suited to the age of victory did not last long. Even before Stalin's death, it was subjected to excoriating critique for producing dull, clichéd works, and the image of the mature hero in pursuit of mastery soon gave way to a more dynamic, psychological reconceptualization of the troubled positive hero during the Thaw. And yet, this was not the end of the postwar iterations of the positive hero. Instead, the conflict between the good and the better lived on during the Thaw, only in a manner fitting to the radically changed historical context: in the era that saw the birth of Soviet private life, the clash between the good and the better was internalized, resulting in a version of the positive hero whose challenges consisted of inner battles rather than external conflicts. In this way, the face of the late Stalin-era hero could still be glimpsed long after the last of Stalin's final films premiered.

BOX OFFICE RESULTS, 1945–MARCH 1953

While complete box office results for all Soviet feature films is not available, we do have data on the *lider prokata*, or box office leaders, of the period.[1]

Notes

Foreign films (imports and trophy films) are indicated with an * asterisk.

The release date refers to premiere screening for Soviet feature films, and the date of licensing for foreign films. Specific dates were not available for imports.

The number of viewers is given in millions.

Within a few weeks of Stalin's death, previously banned films began to be released, changing the composition of Soviet popular cinema. For this reason, only films released up to and during the month of Stalin's death, March 1953, are included below.

1. The following sources were used to compile this appendix: RGASPI 17/125/576/59-60; Zemlia-nukhin and Segida, *Domashniaia sinemateka*; Kudriavtsev, "Poseshchaemost' otechestvennykh i za-rubezhnykh fil'mov v sovetskom kinoprokate"; Ministerstvo kul'tury SSSR, "Catalogue of Foreign Sound Films Released on the Soviet Screen, 1927–1954"; Macheret, *Sovetskie khudozhestvennye fil'my*. This appendix does not claim to be a complete list.

1945	RELEASE DATE	VIEWERS (MILLION)
Guilty without Guilt (Bez viny vinovatye), Vladimir Petrov, Mosfilm	9/21/1945	28.9
*His Butler's Sister (Sestra ego dvoretskogo), Frank Borzage, Universal Pictures (USA, 1943)	1945	21.9
*Gibraltar (Seti shpionazha), Fedor Ozep, Ciné-Alliance (France, 1938)	1945	21.3
Twins (Bliznetsy), Konstantin Iudin, Mosfilm	12/21/1945	19.9
Four Hearts (Serdtsa chetyrekh), Konstantin Iudin, Mosfilm	1/5/1945	19.4
Duel (Poedinok), Vladimir Legoshin, Soiuzdetfilm	3/14/1945	18.6
*Spring Parade (Vesennii val's), Henry Koster, Universal Pictures (USA, 1940)	1945	18.6
Girl No. 217 (Chelovek No. 217), Mikhail Romm, Mosfilm	4/9/1945	17.2
Arshin Mal-Alan, Nikolai Leshchenko and Rza Takhmasib, Baku Film Studio	10/13/1945	16.3
1946		
The Stone Flower (Kamennyi tsvetok), Aleksandr Ptushko, Mosfilm	4/28/1946	23.2
The Sky Slow-Mover (Nebesnyi tikhokhod), Semen Timoshenko, Lenfilm	4/1/1946	21.4
*The Men in Her Life (Balerina), Gregory Ratoff, Columbia Pictures (USA, 1941)	1946	21.0
The Vow (Kliatva), Mikhail Chiaureli, Tbilisi Film Studio	7/29/1946	20.8
Sons (Synov'ia), Aleksandr Ivanov, Lenfilm and Riga Film Studio	5/31/1946	18.6
Zigmund Kolosovskii, Boris Dmokhovsky and Sigizmund Navrotsky, Kiev Film Studio	2/13/1946	18.2
Son of the Regiment (Syn polka), Vasilii Pronin, Soiuzdetfilm	10/16/1946	17.9
A Noisy Household (Bespokoinoe khoziaistvo), Mikhail Zharov, Mosfilm	5/15/1946	17.8
Fifteen-Year-Old Captain (Piatnadtsatiletnii kapitan), Vasilii Zhuravlev, Soiuzdetfilm	3/18/1946	17.6
*Die Frau meiner Träume (Devushka moei mechty), Georg Jacoby, UFA (Germany, 1944)	4/8/1946	15.7
1947		
The Scout's Feat (Podvig razvedchika), Boris Barnet, Kiev Film Studio	9/19/1947	22.7
*I am a Fugitive from a Chain Gang (Podbeg iz katorgi), Mervyn LeRoy, Warner Brothers (USA, 1932)	7/14/1947	19.1
First Glove (Pervaia perchatka), Aleksandr Frolov, Mosfilm	1/23/1947	18.6

Film	Date	Value
Cinderella (Zolushka), Nadezhda Kosheverova, Lenfilm	5/16/1947	18.3
The Village Teacher (Sel'skaia uchitel'nitsa), Mark Donskoi, Soiuzdetfilm	10/30/1947	18.1
Spring (Vesna), Grigorii Aleksandrov, Mosfilm	7/2/1947	16.2

1948

Film	Date	Value
The Young Guard, Part I (Molodaia gvardiia I), Sergei Gerasimov, Gor'kii	10/11/1948	42.4
The Young Guard, Part II (Molodaia gvardiia II), Sergei Gerasimov, Gor'kii	10/25/1948	36.7
Story of a Real Man (Povest' o nastoiashchem cheloveke), Aleksandr Stolper, Mosfilm	10/22/1948	34.4
Tale of a Siberian Land (Skazanie o zemle Sibirskoi), Ivan Pyr'ev, Mosfilm	2/16/1948	33.8
The Distant Bride (Dalekaia nevesta), Evgenii Ivanov-Barkov, Ashkhabad	2/8/1948	26.8
*Das indische Grabmal, Part I (Indiiskaia grobnitsa I), Richard Eichberg, Richard Eichberg-Film (Germany, 1938)	10/27/1948	19.1
*Das indische Grabmal, Part II (Indiiskaia grobnitsa II), Richard Eichberg, Richard Eichberg-Film (Germany, 1938)	11/25/1948	18.6
For Those Who Are at Sea (Za tekh, kto v more), Aleksandr Faintsimmer, Lenfilm	3/27/1948	16.1
The Train Goes East (Poezd idet na vostok), Iulii Raizman, Mosfilm	6/7/1948	16.1

1949

Film	Date	Value
Meeting on the Elba (Vstrecha na El'be), Grigorii Aleksandrov, Mosfilm	3/16/1949	24.2
The Secret Brigade (Konstantin Zaslonov), Aleksandr Faintsimmer and Vladimir Korsh-Sablin, Belorus Film Studio	9/12/1949	17.9
Honor Court (Sud chesti), Abram Room, Mosfilm	2/25/1949	15.2

1950

Film	Date	Value
The Brave Ones (Smelye liudi), Konstantin Iudin, Mosfilm	9/71950	41.2
Cossacks of the Kuban (Kubanskie kazaki), Ivan Pyr'ev, Mosfilm	2/27/1950	40.6
Fall of Berlin (Padenie Berlina), Mikhail Chiaureli, Mosfilm	1/21/1950	38.4
Secret Mission (Sekretnaia missiia), Mikhail Romm, Mosfilm	8/21/1950	24.2
Conspiracy of the Doomed (Zagovor obrechennykh), Mikhail Kalatozov, Mosfilm	6/26/1950	19.2

(continued)

(continued)

1951

In Peaceful Times (V mirnye dni), Vladimir Braun, Kiev Film Studio	4/16/1951	23.5
Cavalier of the Golden Star (Kavaler Zolotoi zvezdy), Iulii Raizman, Mosfilm	7/9/1951	21.5
Bountiful Summer (Shchedroe leto), Boris Barnet, Kiev Film Studio	3/8/1951	20.9
Sporting Honor (Sportivnaia chest'), Vladimir Petrov, Mosfilm	6/11/1951	20.3
*Janika (Janika), Márton Keleti, Magyar Filmgyártó (Hungary, 1949)	1951	19.3
Miners of the Don (Donetskie shakhtery), Leonid Lukov, Gor'kii	5/16/1951	18.9
Taras Shevchenko, Ihor Savchenko, Kiev Film Studio	12/17/1951	18.4
*Fruhling auf dem Eis (Vesna na l'du), Georg Jacoby, Wien Film (Austria, 1950)	1951	17.5
*Past (Zapadnia), Martin Frič, Czechoslovak State Film (Czechoslovakia, 1950)	1951	16.1
*V trestném území (Shtrafnaia ploshchadka), Miroslav Hubáček, Czechoslovak State Film (Czechoslovakia, 1951)	1951	15.1

1952

*Tarzan the Ape Man (Tarzan, chelovek-obez'iana), W. S. Van Dyke, MGM (USA, 1932)	2/12/1952	42.9
*Tarzan Escapes (Tarzan v zapadne), Richard Thorpe, MGM (USA, 1936)	2/14/1952	41.3
*Tarzan's New York Adventure (Prikliocheniia Tarzana v N'io-Iorke), Richard Thorpe, MGM (USA, 1942)	3/4/1952	39.7
*Tarzan Finds a Son! (Tarzan nakhodit syna), Richard Thorpe, MGM (USA, 1939)	2/26/1952	38.6
The Unforgettable Year 1919 (Nezabyvaemyi 1919 god), Mikhail Chiaureli, Mosfilm	5/3/1952	31.6
The Dance Teacher (Uchitel' tantsev), Tat'iana Lukashevich, Mosfilm, 1952 (fil'm-spektakl')	8/11/1952	27.9
The Living Corpse (Zhivoi trup), Vladimir Vengerov, Lenfilm, 1952 (fil'm-spektakl')	6/16/1952	27.5
The Breakup (Razlom), Pavel Bogoliubov and Iurii Muzykant, Lenfilm (fil'm-spektakl')	10/13/1952	24.4

1953 (JANUARY–MARCH ONLY)

Liubov' Iarovaia, Ian Frid, Lenfilm (fil'm-spektakl')	3/16/1953	46.4
Maksimka, Vladimir Braun, Lenfilm	2/10/1953	32.9
The Magic Voyage of Sinbad (Sadko), Aleksandr Ptushko, Mosfilm	1/5/1953	27.3
An Ardent Heart (Goriachee serdtse), Gennadii Kazanskii, Lenfilm (fil'm-spektakl')	2/20/1953	25.4
The Return of Vasilii Bortnikov (Vozvrashchenie Vasiliia Bortnikova), Vsevolod Pudovkin, Mosfilm	3/23/1953	20.9

Filmography

Dates refer to the year of release rather than the year of production.

Admiral Nakhimov. Vsevolod Pudovkin, Mosfilm, 1947.
Aerograd. Aleksandr Dovzhenko, Mosfilm and Ukrainfilm, 1935.
Aleksandr Parkhomenko. Leonid Lukov, Kiev Film Studio (in Tashkent), 1942.
Alone (Odna). Grigorii Kozintsev and Leonid Trauberg, Soiuzkino, 1931.
An Ardent Heart (Goriachee serdtse). Gennadii Kazanskii, Lenfilm, 1953.
Arshin Mal-Alan. Nikolai Leshchenko and Rza Takhmasib, Baku Film Studio, 1945.
The Battle of Stalingrad (Stalingradskaia bitva I & II). Vladimir Petrov, Mosfilm, 1949.
Bountiful Summer (Shchedroe leto). Boris Barnet, Kiev Film Studio, 1951.
The Brave Ones (Smelye liudi, aka The Horsemen and The Brave Men). Konstantin Iudin, Mosfilm, 1950.
The Breakup (Razlom). Pavel Bogoliubov and Iurii Muzykant, Lenfilm, 1952. (*fil'm-spektakl'*)
Cavalier of the Golden Star (Kavaler Zolotoi zvezdy, aka Dream of a Cossack). Iulii Raizman, Mosfilm, 1951.
Cinderella (Zolushka). Nadezhda Kosheverova, Lenfilm, 1947.
City of Youth (Komsomol'sk). Sergei Gerasimov, Lenfilm, 1938.
Conspiracy of the Doomed (Zagovor obrechennykh). Mikhail Kalatozov, Mosfilm, 1950.
Cossacks of the Kuban (Kubanskie kazaki). Ivan Pyr'ev, Mosfilm, 1950.
The Country Doctor (Sel'skii vrach). Sergei Gerasimov, Gor'kii, 1952.
The Courageous Seven (Semero smelykh aka Seven Brave Men). Sergei Gerasimov, Lenfilm, 1936.
The Dance Teacher (Uchitel' tantsev). Tat'iana Lukashevich, Mosfilm, 1952. (*fil'm-spektakl'*)
Dark Is the Night (Odnazhdy noch'iu). Boris Barnet, Yerevan Film Studio, 1945.
Days and Nights (Dni i nochi). Aleksandr Stolper, Mosfilm, 1945.
The Defense of Tsaritsyn Part I and II (Oborona Tsaritsyna, aka Fortress on the Volga). Sergei Vasil'ev and Georgii Vasil'ev, Lenfilm, 1942. (Part II was banned)
The Distant Bride (Dalekaia nevesta). Evgenii Ivanov-Barkov, Ashkhabad, 1948.
Duel (Poedinok, aka Military Secret). Vladimir Legoshin, Soiuzdetfilm, 1945.
Enough Stupidity in Every Wise Man (Na vsiakogo mudretsa dovol'no prostoty). Anatolii Dormenko, Gor'kii, 1952. (*fil'm-spektakl'*)
The Fall of Berlin (Padenie Berlina I & II). Mikhail Chiaureli, Mosfilm, 1950.
Far from Moscow (Daleko ot Moskvy). Aleksandr Stolper, Mosfilm, 1950.
The Fires of Baku (Ogni Baku). Zarkhi, Takhmasib and Iosif Kheifits, Baku Film Studio, 1958. (banned in 1950)
The First Cavalry (Pervaia konnaia). Efim Dzigan, Mosfilm, banned.
First Glove (Pervaia perchatka, aka The Winner). Aleksandr Frolov, Mosfilm, 1947.
The Forest (Les). Vladimir Vengerov, Lenfilm, 1953. (*fil'm-spektakl'*)
For Those Who Are at Sea (Za tekh, kto v more). Aleksandr Faintsimmer, Lenfilm, 1948.
Four Hearts (Serdtsa chetyrekh). Konstantin Iudin, Mosfilm, 1945. (banned in 1941)
Girl No. 217 (Chelovek No. 217). Mikhail Romm, Mosfilm, 1945.
Girl with Character (Devushka s kharakterom). Konstantin Iudin, Mosfilm, 1939.

Glinka (*Kompozitor Glinka*, aka *Man of Music*). Grigorii Aleksandrov, Mosfilm, 1952.

The Great Dawn (*Velikoe zarevo*, aka *They Wanted Peace*). Mikhail Chiaureli, Tbilisi Film Studio, 1938.

The Great Life (*Bol'shaia zhizn', Part II*). Leonid Lukov, Soiuzdetfilm, 1958.

The Great Turning Point (*Velikii perelom*). Fridrikh Ermler, Lenfilm, 1946

His Name Is Sukhe-Bator (*Ego zovut Sukhe-Bator*). Aleksandr Zarkhi and Iosif Kheifits, Lenfilm (in Tashkent), 1942.

Honor Court (*Sud chesti*). Abram Room, Mosfilm, 1949.

Iakov Sverdlov. Sergei Iutkevich, Soiuzdetfilm, 1940.

In Peaceful Times (*V mirnye dni*). Vladimir Braun, Kiev Film Studio, 1951.

In the Mountains of Yugoslavia (*V gorakh Iugoslavii*). Abram Room, Mosfilm, 1946.

In the Name of Life (*Vo imia zhizni*). Aleksandr Zarkhi, Lenfilm, 1947.

In the Ukrainian Steppe (*V stepiakh Ukrainy*). Timofei Levchuk, Kiev Film Studio, 1952. (*fil'm-spektakl'*)

The Invasion (*Nashestvie*). Abram Room, Mosfilm, 1945.

It Happened in the Donbas (*Eto bylo v Donbasse*). Leonid Lukov, Soiuzdetfilm, 1945.

Ivan Nikulin: Russian Sailor (*Ivan Nikulin Russkii matros*). Ihor Savchenko, Mosfilm, 1945.

Keto and Kote (*Keto i Kote*). Vakhtang Tabliashvili and Shalva Gedevanishvili, Tbilisi Film Studio, 1953.

The Last Masquerade (*Poslednii maskarad*). Mikhail Chiaureli, Tbilisi Film Studio, 1934.

Lenin in 1918 (*Lenin v 1918 godu*). Mikhail Romm, Mosfilm, 1939.

Lenin in October (*Lenin v Oktiabre*). Mikhail Romm, Mosfilm, 1937.

The Liberated Earth (*Osvobozhdennaia zemlia*). Aleksandr Medvedkin, Sverdlov Film Studio, 1946.

Life in the Citadel (*Elu tsitadellis/Zhizn' v tsitadeli*). Gerbert Rappaport, Lenfilm, 1948.

Light over Russia (*Svet nad Rossiei*). Sergei Iutkevich, Mosfilm, banned.

Liubov' Iarovaia. Ian Frid, Lenfilm, 1953. (*fil'm-spektakl'*)

The Living Corpse (*Zhivoi trup*). Vladimir Vengerov, Lenfilm, 1952. (*fil'm-spektakl'*)

The Lower Depths (*Na dne*). Andrei Frolov, Mosfilm, 1952. (*fil'm-spektakl'*)

The Magic Voyage of Sinbad (*Sadko*). Aleksandr Ptushko, Mosfilm, 1953.

Maksimka. Vladimir Braun, Lenfilm, 1953.

The Man with the Gun (*Chelovek s ruzhem*). Sergei Iutkevich, Lenfilm, 1938.

Marite. Vera Stroeva, Mosfilm, 1947.

May Nights (*Maiskaia noch', ili Utoplennitsa*). Aleksandr Rou, Gor'kii, 1952.

Meeting on the Elba (*Vstrecha na El'be*). Grigorii Aleksandrov, Mosfilm, 1949.

Michurin. Aleksandr Dovzhenko, Mosfilm, 1948.

Miners of the Don (*Donetskie shakhtery*). Leonid Lukov, Gor'kii, 1951.

The Nameless Island (*Ostrov Bezymiannyi*). Adolf Bergunker and Mikhail Egorov, Lenfilm, 1946.

Naval Battalion (*Morskoi batal'on*). Adolf Minkin and Aleksandr Faintsimmer, Lenfilm, 1946.

A Noisy Household (*Bespokoinoe khoziaistvo*, aka *Trouble Business*). Mikhail Zharov, Mosfilm, 1946.

The Old and the New (*Staroe i novoe*, aka *The General Line*). Sergei Eisenstein, Sovkino, 1929.

Our Heart (*Nashe serdtse*). Aleksandr Stolper, Mosfilm, 1947.

Peasants (*Krest'iane*). Fridrikh Ermler, Lenfilm, 1935.

The Precious Seed (*Dragotsennye zerna*). Aleksandr Zarkhi and Iosif Kheifits, Lenfilm, 1948.

Private Alexander Matrosov (*Riadovoi Aleksandr Matrosov*). Leonid Lukov, Soiuzdetfilm, 1948.

Rainbow (*Raduga*). Mark Donskoi, Ashkhabad, 1944.

The Red Necktie (*Krasnyi galstuk*). Mariia Sauts and Vladimir Sukhobokov, Soiuzdetfilm, 1948.

The Return of Vasilii Bortnikov (*Vozvrashchenie Vasiliia Bortnikova*). Vsevolod Pudovkin, Mosfilm, 1953.

The Rich Bride (*Bogataia nevesta*). Ivan Pyr'ev, Kiev Film Studio, 1938.

Robinson Crusoe (*Robinzon Kruzo*). Aleksandr Andrievskii, Tbilisi Film Studio, 1947.

The Russian Question (*Russkii vopros*). Mikhail Romm, Mosfilm, 1948.

The School for Scandal (*Shkola zloslovaiia*). Abram Room, Mosfilm, 1952. (*fil'm-spektakl'*)

The Scout's Feat (*Podvig razvedchika*, aka *Secret Agent*). Boris Barnet, Kiev Film Studio, 1947.

The Secret Brigade (*Konstantin Zaslonov*). Aleksandr Faintsimmer and Vladimir Korsh-Sablin, Belorus Film Studio, 1949.

Secret Mission (*Sekretnaia missiia*). Mikhail Romm, Mosfilm, 1950.

The Siberians (*Sibiriaki*). Lev Kuleshov, Soiuzdetfilm, 1940.

Simple People (*Prostye liudi*). Grigorii Kozintsev and Leonid Trauberg, Lenfilm, 1956.

Sinegoriia. Erast Garin, Soiuzdetfilm, 1946.

The Sky Slow-Mover (*Nebesnyi tikhokhod*, aka *Heavenly Slug* and *Celestial Sloth*). Semen Timoshenko, Lenfilm, 1946.

The Sleepless Road (*Doroga bez sna*). Kamil Iarmatov, Tashkent Film Studio, 1947.

Son of the Regiment (*Syn polka*). Vasilii Pronin, Soiuzdetfilm, 1946.

Sons (*Synov'ia*, aka *The Road Home*). Aleksandr Ivanov, Lenfilm and Riga Film Studio, 1946.

Sorochinskii Market (*Sorochinskaia iarmarka*). Nikolai Ekk, Kiev Film Studio, 1939.

Sporting Honor (*Sportivnaia chest'*). Vladimir Petrov, Mosfilm, 1951.

Spring (*Vesna*). Grigorii Aleksandrov, Mosfilm, 1947.

The Star (*Zvezda*). Aleksandr Ivanov, Lenfilm, 1953. (banned in 1949)

Stolen Happiness (*Ukradennoe schast'e*). Isaak Shmaruk, Kiev Film Studio, 1952. (*fil'm-spektakl'*)

The Stone Flower (*Kamennyi tsvetok*). Aleksandr Ptushko, Mosfilm, 1946.

Story of a Real Man (*Povest' o nastoiashchem cheloveke*). Aleksandr Stolper, Mosfilm, 1948.

Story of the "Neistov" (*Povest' o "Neistovom"*). Boris Babochkin, Mosfilm, 1947.

Swineherd and Shepherd (*Svinarka i pastukh*, aka *They Met in Moscow*). Ivan Pyr'ev, Mosfilm, 1941.

Tale of a Siberian Land (*Skazanie o zemle Sibirskoi*, aka *Symphony of Life*). Ivan Pyr'ev, Mosfilm, 1948.

Taras Shevchenko. Ihor Savchenko, Kiev Film Studio, 1951.

The Third Strike (*Tretii udar*). Ihor Savchenko, Kiev Film Studio, 1948.

Tractor Drivers (*Traktoristy*). Ivan Pyr'ev, Kiev Film Studio, 1939.

The Train Goes East (*Poezd idet na vostok*). Iulii Raizman, Mosfilm, 1948.

Truth Is Good, but Happiness Is Better (*Pravda—khorosho, a schast'e luchshe*). Sergei Alekseev, Gor'kii, 1952. (*fil'm-spektakl'*)

The Unforgettable Year 1919 (*Nezabyvaemyi 1919 god I & II*). Mikhail Chiaureli, Mosfilm, 1952.

The Unvanquished (*Nepokorennye*, aka *The Taras Family*). Mark Donskoi, Kiev Film Studio, 1945.

Valerii Chkalov. Kalatozov, Lenfilm, 1941.

Victorious Return (*Vosvrashchenie s pobedoi*). Aleksandr Ivanov, Riga Film Studio, 1948.

The Village Teacher (*Sel'skaia uchitel'nitsa*). Mark Donskoi, Soiuzdetfilm, 1947.

The Vow (*Kliatva*). Mikhail Chiaureli, Tbilisi Film Studio, 1946.

The Vyborg Side (*Vyborgskaia storona*). Grigorii Kozintsev and Leonid Trauberg, Lenfilm, 1939.

Woe from Wit (*Gore ot uma*). Sergei Alekseev, Gor'kii, 1952. (*fil'm-spektakl'*)

Wolves and Sheep (*Volki i ovtsy*). Vladimir Sukhobokov, Gor'kii, 1953. (*fil'm-spektakl'*)

The Young Guard (*Molodaia gvardiia I & II*). Sergei Gerasimov, Gor'kii, 1948.

Zigmund Kolosovskii. Boris Dmokhovsky and Sigizmund Navrotsky, Kiev Film Studio, 1946.

Bibliography

PRIMARY SOURCES

Archival Sources

Russian State Archive for Social and Political History (RGASPI). Moscow
fond 17 Communist Party Central Committee
opisi:
116 Organizational Bureau (Orgburo) and Secretariat of the Central Committee of the All-Union Communist Party of Bolsheviks (CC CPb), Eighteenth Congress, 1939–52
118 Orgburo and Secretariat, CC CPb, Eighteenth Congress, 1948–50
125 The Directorate of Agitation and Propaganda for the CC CPb, 1938–48
132 The Department of Agitation and Propaganda for the CC CPb, 1948–53
133 The Department of Science and Universities of the CC CPb, 1951–55
Russian State Film Foundation (Gosfilmofond) Archive. Belye Stolby, Moscow Region
opisi:
395 *Vstrecha na El'be* (*Meeting on the Elba*)
814 *Zvezda* (*The Star*)
1001 *Kliatva* (*The Vow*)
1119 *Kubanskie kazaki* (*Cossacks of the Kuban*)
1306 *Molodaia gvardiia* (*The Young Guard*)
1457 *Nebesnyi tikhokhod* (*The Sky Slow-Mover*)
1652 *Padenie Berlina* (*The Fall of Berlin*)
1755 *Povest' o nastoiashchem cheloveke* (*Story of a Real Man*)
2304 *Stalingradskaia bitva* (*The Battle of Stalingrad*)
2358 *Vozvrashchenie Vasiliia Bortnikova* (*The Return of Vasilii Bortnikov*)
2473 *Synov'ia* (*Sons*)
2476 *Syn polka* (*Son of the Regiment*)
2554 *Tretii udar* (*The Third Strike*)
2817 *Shchedroe leto* (*Bountiful Summer*)

Periodicals

Iskusstvo kino
Izvestiia
Kul'tura i zhizn'
Literaturnaia gazeta
Ogonek
Pravda
Sovetskoe iskusstvo

Published Archival Sources

Anderson, K. M., and L.V. Maksimenkov. *Kremlevskii kinoteatr: 1928–1953: Dokumenty.* Moscow: ROSSPEN, 2005.

Artizov, Andrei, and Oleg Naumov, eds. *Vlast' i khudozhestvennaia intelligentsiia: Do-kumenty TSK RKP(b)-VKP(b), VChK-OGPU-NKVD o kul'turnoi politike: 1917–1953 gg.* Moscow: Demokratiia, 1999.

Bagrov, Petr, and Vera Kuznetsova, eds. "Iz stenogrammy obsuzhdeniia khudozhestven-nym sovetom 'Lenfil'ma' fil'ma 'General armii' [Velikii perelom], 24 Novem-ber 1945." *Kinovedcheskie zapiski* 72 (2005). http://www.kinozapiski.ru/ru/article/sendvalues/455/.

Bagrov, Petr, and Vera Kuznetsova, eds. "Ob"iasnitel'naia zapiska k proektu tematichesk-ogo plana studii 'Lenfil'm' na 1945–1946 gody." *Kinovedcheskie zapiski* 72 (2005). http://www.kinozapiski.ru/ru/article/sendvalues/454/.

Bone, Ann, trans. *The Bolsheviks and the October Revolution: Minutes of the Central Committee of the Russian Social-Democratic Labour Party (Bolsheviks) August 1917–February 1918.* London: Pluto Press, 1974.

Fomin, Valerii. *Kino na voine: Dokumenty i svidetel'stva.* Moscow: Materik, 2005.

SECONDARY SOURCES

Alexievich, Svetlana. *The Unwomanly Face of War.* Translated by Richard Pevear and La-rissa Volokhonsky. Reprint. London: Penguin Classics, 2017.

Altman, Rick. *Film/Genre.* London: BFI Publishing, 1999.

Arkhangel'skaia, T. "V gostiakh u pisatelia: Elizar Mal'tsev: Ne izmeniaia sebe." *Literat-urnaia Gazeta*, February 18, 1987.

Bagrov, Petr. "Ermler, Stalin, and Animation: On the Film *The Peasants* (1934)." Trans-lated by Vladimir Padunov. *KinoKultura* 15 (2007). http://www.kinokultura.com/2007/15-bagrov.shtml.

Baraban, Elena. "The Battle of Stalingrad in Soviet Films." In *Fighting Words and Im-ages*, edited by Elena Baraban, Stephan Jaeger, and Adam Muller, 233–58. Toronto: University of Toronto Press, 2012.

Baraban, Elena "Filming a Stalinist War Epic in Ukraine: Ihor Savchenko's *The Third Strike*." *Canadian Slavonic Papers* 56, no. 1–2 (2014): 17–41.

Baraban, Elena. "The Return of Mother Russia: Representations of Women in Soviet Wartime Cinema." *Aspasia* 4, no. 1 (2010): 121–38.

Barber, John. "The Image of Stalin in Soviet Propaganda and Public Opinion during World War 2." In *World War 2 and the Soviet People*, edited by Carol Garrard and John Gordon Garrard, 38–49. Basingstoke: Macmillan, 1993.

Barbotkina, Antonina. "Glubokoe vpechatlenie." *Pravda*, January 25, 1950: 3.

Barbusse, Henri. *Stalin: A New World Seen through One Man.* Translated by Vyvyan Hol-land. London: John Lane the Bodley Head, 1935.

Bartig, Kevin. "Kinomuzyka: Theorizing Soviet Film Music in the 1930s." In *Sound, Speech, Music in Soviet and Post-Soviet Cinema*, edited by Lilya Kaganovsky and Masha Salazkina, 181–92. Bloomington: Indiana University Press, 2014.

Bassin, Mark. "The Greening of Utopia: Nature, Social Vision, and Landscape Art in Stalinist Russia." In *Architectures of Russian Identity: 1500 to the Present*, edited by James Cracraft and Daniel Rowland, 150–71. Ithaca, NY: Cornell University Press, 2003.

Bathrick, David. "From Soviet Zone to Volksdemokratie: The Politics of Film Culture in the GDR, 1945–1960." In *Cinema in Service of the State: Perspectives on Film Cul-ture in the GDR and Czechoslovakia, 1945–1960*, edited by Lars Karl and Pavel Sko-pal, 15–38. New York: Berghahn Books, 2015.

Beliavskii, Mikhail. "Vypolniaia pozhelaniia zritelei." *Sovetskoe iskusstvo*, January 5, 1952: 2.

Belodubrovskaya, Maria. *Not According to Plan: Filmmaking under Stalin*. Ithaca, NY: Cornell University Press, 2017.

Bernshtein, Aron. *Mikhail Gelovani*. Moscow: Kinotsentr, 1991.

Beumers, Birgit, Nikolai Izvolov, Natalia Miloserdova, and Natalia Riabchikova, eds. "Margarita Barskaia and the Emergence of Soviet Children's Cinema." Translated by Jamie Miller and Birgit Beumers. *Studies in Russian and Soviet Cinema* 3, no. 2 (2009): 229–62.

Bol'shakov, Ivan. "Blizhaishie zadachi sovetskoi kinematografii." *Izvestiia*, July 14, 1948: 3.

Bonnell, Victoria. *Iconography of Power: Soviet Political Posters under Lenin and Stalin*. Berkeley: University of California Press, 1999.

Brandenberger, David. *National Bolshevism: Stalinist Mass Culture and the Formation of Modern Russian National Identity 1931–1956*. Cambridge, MA: Harvard University Press, 2002.

Brandenberger, David. *Propaganda State in Crisis: Soviet Ideology, Indoctrination, and Terror under Stalin, 1927–1941*. New Haven, CT: Yale University Press, 2011.

Brandenberger, David. "Stalin as Symbol: A Case Study of the Personality Cult and Its Construction." In *Stalin: A New History*, edited by Sarah Davies and James Harris, 249–70. Cambridge: Cambridge University Press, 2005.

Bratchikov, A. "Fil'm o liudiakh, vospitannykh Stalinym." *Pravda*, January 25, 1950: 3.

Brewster, Ben, and Lea Jacobs. *Theatre to Cinema: Stage Pictorialism and the Early Feature Film*. Oxford: Oxford University Press, 2003.

Brooks, Jeffrey. "Pravda Goes to War." In *Culture and Entertainment in Wartime Russia*, edited by Richard Stites, 9–27. Bloomington: Indiana University Press, 1995.

Brooks, Jeffrey. *Thank You, Comrade Stalin! Soviet Public Culture from Revolution to Cold War*. Princeton, NJ: Princeton University Press, 2000.

Bulgakowa, Oksana. "Kollektive Tagträume/Collective Daydreaming." In *Traumfabrik Kommunismus: Die visuelle Kultur der Stalinzeit/Dream Factory Communism: The Visual Culture of the Stalin Era*, edited by Boris Groys and Max Hollein, 256–71. Frankfurt: Schirn Kunsthalle, 2003.

Burton, Christopher. "The Labour Region in Late Stalinist Population Dynamics." *Russian History* 36, no. 1 (2009): 117–40.

Caute, David. *The Dancer Defects: The Struggle for Cultural Supremacy during the Cold War*. Oxford: Oxford University Press, 2003.

Central Statistical Board of the USSR Council of Ministers. *Cultural Progress in the USSR: Statistical Returns*. Moscow: Foreign Languages Publishing House, 1958.

Channon, John. "Stalin and the Peasantry: Reassessing the Postwar Years, 1945–53." In *Politics, Society and Stalinism in the USSR*, edited by John Channon, 185–209. London: Palgrave Macmillan, 1998.

Chen, Tina Mai. "Film and Gender in Sino-Soviet Cultural Exchange, 1949–1969." In *China Learns from the Soviet Union, 1949–Present*, edited by Thomas P. Bernstein and Hua-Yu Li, 421–48. Lanham, MD: Rowman and Littlefield, 2010.

Chiaureli, Mikhail. "Voploshchenie obraza velikogo vozhdia." *Iskusstvo kino*, no. 1 (1947): 7–10.

Chion, Michel. *Audio-Vision: Sound on Screen*. Translated by Claudia Gorbman. New York: Columbia University Press, 1994.

Christie, Ian. "The Director in Soviet Cinema." In *Stalinism and Soviet Cinema*, edited by Derek Spring and Richard Taylor, 142–70. New York: Routledge, 1993.

Christie, Ian, and Richard Taylor, eds. *The Film Factory: Russian and Soviet Cinema in Documents 1896–1939*. London: Routledge, 1994.

Clark, Katerina. "Aural Hieroglyphics? Some Reflections on the Role of Sound in Recent Russian Films and Its Historical Context." In *Soviet Hieroglyphics: Visual*

Culture in Late Twentieth-Century Russia, edited by Nancy Condee, 1–21. Bloomington: Indiana University Press, 1995.

Clark, Katerina. *Moscow, the Fourth Rome: Stalinism, Cosmopolitanism, and the Evolution of Soviet Culture, 1931–1941*. Cambridge, MA: Harvard University Press, 2011.

Clark, Katerina. "Socialist Realism with Shores: The Conventions for the Positive Hero." In *Socialist Realism without Shores*, edited by Thomas Lahusen and Evgeny Dobrenko, 27–50. Durham, NC: Duke University Press, 1997.

Clark, Katerina. *The Soviet Novel: History as Ritual*. Chicago: University of Chicago Press, 1981.

Clark, Katerina, Evgeny Dobrenko, A. Artizov, M. Schwartz, and O. V Naumov. *Soviet Culture and Power: A History in Documents, 1917–1953*. New Haven, CT: Yale University Press, 2007.

Corbesero, Susan. "History, Myth, and Memory: A Biography of a Stalin Portrait." *Russian History* 38, no. 1 (2011): 58–84.

Dale, Robert. *Demobilized Veterans in Late Stalinist Leningrad: Soldiers to Civilians*. London: Bloomsbury Academic, 2015.

Dale, Robert. "'No Longer Normal': Traumatized Red Army Veterans in Post-war Leningrad." In *Traumatic Memories of the Second World War and After*, edited by Peter Leese and Jason Crouthamel, 119–41. London: Palgrave Macmillan, 2016.

Dashkova, Tat'iana. "Liubov' i byt v kinofil'makh 1930-nachala 1950-kh gg." In *Istoriia strany/Istoriia kino*, edited by C. Sekirinskii, 218–34. Moscow: Znak, 2004.

David-Fox, Michael. *Showcasing the Great Experiment: Cultural Diplomacy and Western Visitors to the Soviet Union, 1921–1941*. New York: Oxford University Press, 2012.

Davies, Sarah. "The 'Cult' of the Vozhd': Representations in Letters from 1934–1941." *Russian History* 24, no. 1/2 (1997): 131–48.

Davies, Sarah. *Popular Opinion in Stalin's Russia: Terror, Propaganda, and Dissent, 1934–1941*. Cambridge: Cambridge University Press, 1997.

Deriabin, Aleksandr, and P. V. Fionov, eds. *Letopis' rossiiskogo kino, 1946–1965*. Moscow: Kanon+, 2010.

Devlin, Judith. "A Case Study in Censorship: Stalin's Early Film Image." In *Central and Eastern European Media under Dictatorial Rule and in the Early Cold War*, edited by Olaf Mertelsmann, 27–48. Frankfurt am Main: Peter Lang, 2011.

Devlin, Judith. "The End of the War in Stalinist Film and Legend." In *The Fiction of History*, edited by Alexander Lyon Macfie, 106–17. Oxford: Routledge, 2014.

Devlin, Judith. "The Iconography of Power: Stalin and His Images." In *Power in History: From Medieval Ireland to the Post-modern World*, edited by Anthony McElligott, Liam Chambers, Ciara Breathnach, and Catherine Lawless, 231–58. Dublin: Irish Academic Press, 2011.

Devlin, Judith. "Stalin's Death and Afterlife." In *Death, Burial and the Afterlife*, edited by Phillip Cottrel and Wolfgang Marx, 65–88. Dublin: Carysfort Press, 2014.

Devlin, Judith. "Visualizing Political Language in the Stalin Cult: The Georgian Art Exhibition at the Tretyakov Gallery." In *Political Languages in the Age of Extremes*, edited by Willibald Steinmetz, 83–102. Oxford: Oxford University Press, 2011.

Dickerman, Leah. "Camera Obscura: Socialist Realism in the Shadow of Photography." *October*, no. 93 (2000): 138–53.

Dikii, Aleksei. "Pochetnyi dolg sovetskikh khudozhnikov." *Iskusstvo kino*, no. 6 (1949): 9–12.

"Divlius' ia na nebo, ta y dumku gadaio. . . ." *Vikipediia*, January 17, 2021. https://w.wiki/j9i.

Dobrenko, Evgeny. *Late Stalinism: The Aesthetics of Politics*. Translated by Jesse M. Savage. New Haven, CT: Yale University Press, 2020.

Dobrenko, Evgeny. "Late Stalinist Cinema and the Cold War: An Equation without Un-knowns." *Modern Language Review* 98, no. 4 (2003): 929–44.

Dobrenko, Evgeny. *Political Economy of Socialist Realism*. New Haven, CT: Yale University Press, 2007.

Dobrenko, Evgeny. "The Soviet Spectacle: The All-Union Agricultural Exhibition." In *Picturing Russia: Explorations in Visual Culture*, edited by Valerie Kivelson and Joan Neuberger, 189–95. New Haven, CT: Yale University Press, 2008.

Dolgopolov, Mikhail. "Kubanskie kazaki." *Izvestiia*, March 2, 1950: 3.

Edele, Mark. "More Than Just Stalinists: The Political Sentiments of Victors 1945–1953." In *Late Stalinist Russia: Society between Reconstruction and Reinvention*, edited by Juliane Fürst, 168–91. London: Routledge, 2006.

Edele, Mark. "Soviet Veterans as an Entitlement Group, 1945–1955." *Slavic Review* 65, no. 1 (2006): 111–37.

Edele, Mark. *Soviet Veterans of World War II: A Popular Movement in an Authoritarian Society, 1941–1991*. Oxford: Oxford University Press, 2008.

Edele, Mark. *Stalinist Society, 1928–1953*. Oxford: Oxford University Press, 2011.

Edele, Mark. "Veterans and the Village: The Impact of Red Army Demobilization on Soviet Urbanization, 1945–1955." *Russian History* 36, no. 2 (2009): 159–82.

Egorova, Tatiana. *Soviet Film Music*. New York: Routledge, 2014.

Eikhenbaum, Boris. "Problems of Cine-Stylistics." In *The Poetics of Cinema*, edited by Richard Taylor, translated by Richard Sherwood, 5–31. Oxford: RPT Publications, 1982.

Eisenschitz, Bernard. "A Fickle Man, or Portrait of Boris Barnet as a Soviet Director." In *Inside the Film Factory: New Approaches to Russian and Soviet Cinema*, edited by Richard Taylor and Ian Christie, 151–64. London: Routledge, 1991.

Eisenschitz, Bernard. *Gels et dégels*. Paris: Centre Pompidou, 2002.

Fay, Laurel. *Shostakovich: A Life*. New York: Oxford University Press, 1999.

Feigelson, Kristian. *L'U.R.S.S. et sa télévision*. Paris: Institut national de l'audiovisuel, 1990.

Fil'chev, V. "Moskovskii elektrotraktor." *Pravda*, June 2, 1949: 1.

Filtzer, Donald. *Soviet Workers and Late Stalinism*. Cambridge: Cambridge University Press, 2002.

Filtzer, Donald. "The Standard of Living of Soviet Industrial Workers in the Immediate Postwar Period, 1945–1948." *Europe-Asia Studies* 51, no. 6 (1999): 1013–38.

First, Joshua. *Ukrainian Cinema: Belonging and Identity during the Soviet Thaw*. London: Bloomsbury Academic, 2015.

Fitzpatrick, Sheila. *Everyday Stalinism: Ordinary Life in Extraordinary Times: Soviet Russia in the 1930s*. Oxford: Oxford University Press, 1999.

Fitzpatrick, Sheila. *On Stalin's Team: The Years of Living Dangerously in Soviet Politics*. Princeton, NJ: Princeton University Press, 2015.

Fitzpatrick, Sheila. *Tear Off the Masks! Identity and Imposture in Twentieth-Century Russia*. Princeton, NJ: Princeton University Press, 2005.

Frolova-Walker, Marina. *Stalin's Music Prize: Soviet Culture and Politics*. New Haven, CT: Yale University Press, 2016.

Fürst, Juliane, ed. *Late Stalinist Russia: Society between Reconstruction and Reinvention*. London: Routledge, 2006.

Fürst, Juliane. *Stalin's Last Generation: Soviet Post-war Youth and the Emergence of Mature Socialism*. Oxford: Oxford University Press, 2010.

Gasiorowska, Xenia. *Women in Soviet Fiction, 1917–64*. Madison: University of Wisconsin Press, 1968.

Geldern, James von, and Richard Stites, eds. *Mass Culture in Soviet Russia: Tales, Poems, Songs, Movies, Plays, and Folklore, 1917–1953*. Bloomington: Indiana University Press, 1995.

Gillespie, David C. "The Sounds of Music: Soundtrack and Song in Soviet Film." *Slavic Review* 62, no. 3 (2003): 473–90.

Gorlizki, Yoram. "Party Revivalism and the Death of Stalin." *Slavic Review* 54, no. 1 (1995): 1–22.

Gorlizki, Yoram, and Oleg Khlevniuk. *Cold Peace: Stalin and the Soviet Ruling Circle, 1945–1953*. Oxford: Oxford University Press, 2005.

Goscilo, Helena. "Luxuriating in Lack: Plenitude and Consuming Happiness in Soviet Paintings and Posters, 1920s–1953." In *Petrified Utopia: Happiness Soviet Style*, edited by Evgeny Dobrenko and Marina Balina, 53–78. London: Anthem Press, 2009.

Graffy, Julian. "Boris Barnet." In *A Companion to Russian Cinema*, edited by Birgit Beumers, 509–32. Chichester: John Wiley and Sons, 2016.

Grakov, Gleb. "Kubanskie kazaki." *Sovetskoe iskusstvo*, March 4, 1950: 3.

Gudz', Evgenii. "Proizvedenie, poniatnoe kazhdomu." *Pravda*, January 25, 1950: 3.

Günther, Hans. "Wise Father Stalin and His Family in Soviet Cinema." In *Socialist Realism without Shores*, edited by Thomas Lahusen and Evgeny Dobrenko, 178–90. Durham, NC: Duke University Press, 1997.

Hakobian, Levon. *Music of the Soviet Era: 1917–1991*. Abingdon, Oxon: Routledge, 2017.

Halfin, Igal. *Terror in My Soul: Communist Autobiographies on Trial*. Cambridge, MA: Harvard University Press, 2003.

Haynes, John. *New Soviet Man: Gender and Masculinity in Stalinist Soviet Cinema*. Manchester: Manchester University Press, 2003.

Hellbeck, Jochen. "Fashioning the Stalinist Soul: The Diary of Stepan Podlubnyi (1931–1939)." *Jahrbücher für Geschichte Osteuropas* 44, no. 3 (1996): 344–73.

Hellbeck, Jochen. *Revolution on My Mind*. Cambridge, MA: Harvard University Press, 2006.

Hessler, Julie. "Postwar Normalisation and Its Limits in the USSR: The Case of Trade." *Europe-Asia Studies* 53, no. 3 (2001): 445–71.

Hessler, Julie. *A Social History of Soviet Trade: Trade Policy, Retail Practices, and Consumption, 1917–1953*. Princeton, NJ: Princeton University Press, 2004.

Hosking, Geoffrey. "The Second World War and Russian National Consciousness." *Past & Present*, no. 175 (2002): 162–87.

Hutchings, Stephen. "Ada/Opting the Son: War and the Authentication of Power in Soviet Screen Versions of Children's Literature." In *Film Adaptations of Literature in Russia and the Soviet Union, 1917–2001: Screening the Word*, edited by Stephen Hutchings and Anat Vernitski, 33–44. London: Routledge, 2004.

Iablochkina, Aleksandra. "Vo imia mira i schast'ia narodov." *Sovetskoe iskusstvo*, February 11, 1950: 4.

Iurenev, Rostislav. "Kubanskie kazaki." *Iskusstvo kino*, no. 1 (1950): 15–19.

Iurenev, Rostislav. "Obraz velikogo vozhdia." *Iskusstvo kino*, no. 6 (1949): 4–8.

Johnston, Timothy. *Being Soviet: Identity, Rumour, and Everyday Life under Stalin, 1939–1953*. Oxford: Oxford University Press, 2011.

Kaganovsky, Lilya. *How the Soviet Man Was Unmade: Cultural Fantasy and Male Subjectivity under Stalin*. Pittsburgh: University of Pittsburgh Press, 2008.

Kaganovsky, Lilya. "Stalinist Cinema 1928–1953." In *The Russian Cinema Reader* Vol. 1, *1908 to the Stalin Era*, edited by Rimgaila Salys, 208–34. Boston: Academic Studies Press, 2013.

Kapterev, Sergei. "Illusionary Spoils: Soviet Attitudes toward American Cinema during the Early Cold War." *Kritika: Explorations in Russian and Eurasian History* 10, no. 4 (2009): 779–807.

Karl, Lars. "Screening the Occupier as Liberator: Soviet War Films in the SBZ and GDR, 1945–1965." In *Cinema in Service of the State: Perspectives on Film Culture in the*

GDR and Czechoslovakia, 1945–1960, edited by Lars Karl and Pavel Skopal, 341–80. New York: Berghahn Books, 2015.

Kazyuchits, Maksim. "Sergei Gerasimov's *The Young Guard*: Artistic Method and the Conflict of Discourses of History and Power." *Studies in Russian and Soviet Cinema* 13, no. 2 (2019): 162–71.

Kelly, Catriona. *Comrade Pavlik: The Rise and Fall of a Soviet Boy Hero*. London: Granta, 2006.

Kenez, Peter. "Black and White: The War on Film." In *Culture and Entertainment in Wartime Russia*, edited by Richard Stites, 157–75. Bloomington: Indiana University Press, 1995.

Kenez, Peter. *Cinema and Soviet Society, 1917–1953*. Cambridge: Cambridge University Press, 1992.

Khrenov, I. "Sila kolkhoznaia." *Ogonek*, September 1951, n.p.

Khrushchev, Nikita. "Organizational-Economic Strengthening of the Collective Farms." *Current Digest of the Russian Press* 3, no. 7 (1951): 3–13.

Khrushchev, Nikita. "Speech to 20th Congress of the C.P.S.U." Nikita Khrushchev Reference Archive, 1956. https://www.marxists.org/archive/khrushchev/1956/02/24.htm.

Klefstad, Terry. "Shostakovich and the Peace Conference." *Music and Politics* 6, no. 2 (Summer 2012): 1–21. http://dx.doi.org/10.3998/mp.9460447.0006.201.

Knight, Claire. "Enemy Films on Soviet Screens: Trophy Films during the Early Cold War, 1947–52." *Kritika: Explorations in Russian and Eurasian History* 18, no. 1 (2017): 125–49.

Knight, Claire. "The Making of the Soviet Ally in British Wartime Popular Press." *Journalism Studies* 14, no. 4 (2013): 476–90.

Knight, Claire. "Nelli Morozova on Censors, Censorship and the Soviet Film Famine, 1948–52." *Slavonic and East European Review* 96, no. 4 (2018): 704–30.

Knight, Claire. "Stalin's Trophy Films, 1946–56: A Resource (Updated)." *KinoKultura*, no. 56 (April 2017). http://www.kinokultura.com/2015/48-knight.shtml.

Kohut, Zenon, Ivan Katchanovski, Bohdan Nebesio, and Myroslav Yurkevich. *Historical Dictionary of Ukraine*. Lanham, MD: Scarecrow Press, 2013.

Kolchin, L. "Vysokokhudozhestvennyi fil'm." *Pravda*, January 25, 1950: 3.

Kondakova, Irina. "Tarzan—chelovek, ne isporchennyi burzhuaznoi tsivilizatsiei." *Istochnik* 4 (1999): 99–101.

Kotkin, Stephen. *Magnetic Mountain: Stalinism as a Civilization*. Berkeley: University of California Press, 1995.

Krukones, J. "The Unspooling of Artkino: Soviet Film Distribution in America, 1940–1975." *Historical Journal of Film, Radio and Television* 29, no. 1 (2009): 91–112.

Krylova, Anna. "'Healers of Wounded Souls': The Crisis of Private Life in Soviet Literature, 1944–1946." *Journal of Modern History* 73, no. 2 (2001): 307–31.

Krylova, Anna. *Soviet Women in Combat: A History of Violence on the Eastern Front*. Cambridge: Cambridge University Press, 2010.

Kudriavtsev, Sergei. "Otechestvennyi fil'my v sovetskom kinoprokate." *Kinanet LiveJournal*. Accessed February 4, 2014. https://kinanet.livejournal.com/14172.html#cutid1.

Kudriavtsev, Sergei. "Poseshchaemost' otechestvennykh i zarubezhnykh fil'mov v sovetskom kinoprokate." *Kinanet LiveJournal*. Accessed February 4, 2014. http://kinanet.livejournal.com/689229.html.

"Kul'tura kolkhoznoi derevni." *Pravda*, October 6, 1949: 1.

Kuznetsov, M. "Fil'm o liudiakh kolkhoznoi derevni." *Pravda*, July 11, 1951: 3.

Laurent, Natacha. "Le Conseil Artistique du Ministère Soviétique du Cinéma (1944–1947)." In *Le cinéma "stalinien": Questions d'histoire*, edited by Natacha Laurent, 71–80. Toulouse: Presses universitaires du Mirail, 2003.

Laurent, Natacha. *L'œil du Kremlin: Cinéma et censure en URSS sous Staline, 1928-1953*. Toulouse: Privat, 2000.

Lebedev-Kumach, Vasilii. "Ego portret." *Pravda*, December 5, 1937: 1.

Lefebvre, Martin. "Between Setting and Landscape in the Cinema." In *Landscape and Film*, edited by Martin Lefebvre, 19-60. New York: Routledge, 2006.

Leffler, Melvyn. "The Cold War: What Do 'We Now Know'?" *American Historical Review* 104, no. 2 (1999): 501-24.

Lévesque, Jean. "'Into the Grey Zone': Sham Peasants and the Limits of the Kolkhoz Order in the Post-war Russian Village, 1945-1953." In *Late Stalinist Russia: Society between Reconstruction and Reinvention*, edited by Juliane Fürst, 103-19. London: Routledge, 2006.

Leyda, Jay. *Kino: A History of the Russian and Soviet Film*. London: Allen and Unwin, 1960.

Liehm, Mira, and Antonín Liehm. *The Most Important Art*. Berkeley: University of California Press, 1980.

Liencourt, François de. "Le théâtre, le pouvoir et le spectateur soviétiques." *Cahiers du monde russe et soviétique* 2, no. 2 (1961): 166-211.

Logan, Robert. *The Great Patriotic War: A Collection of World War II Soviet Propaganda Posters*. Guelph: University of Guelph Library, 1984.

Lunghi, Hugh. "Reminiscences of the Big Three." Paper presented at the conference "The Cold War and Its Legacy," Churchill College, Cambridge, UK, November 18, 2007.

Lunghi, Hugh. "Reminiscences of the Big Three." In *Out of the Cold: The Cold War and Its Legacy*, edited by Michael R. Fitzgerald and Allen Packwood, 16-19. London: Bloomsbury Academic, 2013.

Macheret, Aleksandr Veniaminovich, ed. *Sovetskie khudozhestvennye fil'my: Annotirovannyi katalog*. Vol. 2, *Zvukovye fil'my, 1930-1957*. Moscow: Iskusstvo, 1961.

Manevich, I. "Spektakl' na ekrane." *Iskusstvo kino*, no. 7 (1953): 90-98.

Mares'ev, Aleksei. "Velichestvennyi obraz vozhdia." *Pravda*, January 25, 1950: 3.

Mar'iamov, Grigorii. "Boitsovskii kharakter." In *Ivan Pyr'ev v zhizni i na ekrane: Stranitsy vospominanii*, 182-96. Moscow: Kinotsentr, 1994.

Mar'iamov, Grigorii. *Kremlevskii tsenzor: Stalin smotrit kino*. Moscow: Konfederatsiia soiuzov kinematografistov "Kinotsentr," 1992.

Margolit, Evgenii "Landscape, with Hero." In *Springtime for Soviet Cinema: Re/Viewing the 1960s*, edited by Alexander Prokhorov, translated by Dawn Seckler, 29-50. Pittsburgh: Russian Film Symposium, 2001.

Margolit, Evgenii. *Zhivye i mertvoe: Zametki k istorii sovetskogo kino 1920-1960s*. St. Petersburg: Masterskaia "Seans," 2012.

Mayorov, Nikolai. "A First in Cinema . . . Stereoscopic Films in Russia and the Soviet Union." *Studies in Russian and Soviet Cinema* 6, no. 2 (2012): 217-39.

Merridale, Catherine. "The Collective Mind: Trauma and Shell-Shock in Twentieth-Century Russia." *Journal of Contemporary History* 35, no. 1 (2000): 39-55.

Mikoian, Anastas. "Stalin—eto Lenin segodnia." *Pravda*, December 21, 1939: 6.

Miller, Jamie. *Soviet Cinema: Politics and Persuasion under Stalin*. London: I. B. Tauris, 2010.

Morozova, Nelli. "A sud'i—kto?" *Iskusstvo kino*, no. 1 (1994): 136-46.

Nakachi, Mie. "Gender, Marriage, and Reproduction in the Postwar Soviet Union." In *Writing the Stalin Era: Sheila Fitzpatrick and Soviet Historiography*, edited by Golfo Alexopoulos, Julie Hessler, and Kiril Tomoff, 101-16. New York: Palgrave Macmillan, 2011.

Näripea, Eva. "A View from the Periphery: Spatial Discourse of the Soviet Estonian Feature Film: The 1940s and 1950s." In *Via Transversa: Lost Cinema of the Former*

Eastern Bloc, edited by Eva Näripea and Andreas Trossek, 195–210. Tallinn: Estonian Academy of Arts, 2008.

Neuberger, Joan. *This Thing of Darkness: Eisenstein's Ivan the Terrible in Stalin's Russia*. Ithaca, NY: Cornell University Press, 2019.

Novikova, Irina. "Baltic Cinemas—Flashbacks in/out of the House." In *Via Transversa: Lost Cinema of the Former Eastern Bloc*, edited by Eva Näripea and Andreas Trossek, 247–68. Tallinn: Estonian Academy of Arts, 2008.

"Novyi fil'm-spektakl'." *Sovetskoe iskusstvo*, June 21, 1952: 3.

Pechatnov, Vladimir. "Exercise in Frustration: Soviet Foreign Propaganda in the Early Cold War, 1945–47." *Cold War History* 1, no. 2 (2001): 1–27.

Perventsev, Arkadii. "Schast'e kolkhoznoi zhizni." *Pravda*, March 1, 1950, 5.

"Pervye elektro-mashinno-traktornye stantsii." *Pravda*, May 30, 1949, 1.

Petrone, Karen. "Motherland Calling? National Symbols and the Mobilization for War." In *Picturing Russia: Explorations in Visual Culture*, edited by Valerie A. Kivelson and Joan Neuberger, 196–200. New Haven, CT: Yale University Press, 2008.

Petrov, Vladimir. "Kontury novogo zhanra." *Iskusstvo kino*, no. 4 (1947): 5–7.

Pisch, Anita. *The Personality Cult of Stalin in Soviet Posters, 1929–1953: Archetypes, Inventions and Fabrications*. Acton, ACT: ANU Press, 2016.

Plamper, Jan. "Georgian Koba or Soviet 'Father of Peoples'? The Stalin Cult and Ethnicity." In *The Leader Cult in Communist Dictatorships: Stalin and the Eastern Bloc*, edited by Balázs Apor, Jan C. Behrends, Polly Jones, and E. A. Rees, 123–40. London: Palgrave Macmillan, 2004.

Plamper, Jan. *The Stalin Cult: A Study in the Alchemy of Power*. New Haven, CT: Yale University Press, 2012.

Pogozheva, Liudmila. "Dialog v stsenarii i fil'me." *Iskusstvo kino*, no. 2 (1947): 19–21.

Pogozheva, Liudmila. "Missiia, perestavshaia byt' secretnoi." *Iskusstvo kino*, no. 5 (1950): 12–15.

Pogozheva, Liudmila. "Padenie Berlina." *Iskusstvo kino*, no. 1 (1950): 10–14.

Polian, Pavel. *Against Their Will: The History and Geography of Forced Migrations in the USSR*. Budapest: Central European University Press, 2004.

Prokhorov, Alexander. "Arresting Development: A Brief History of Soviet Cinema for Children and Adolescents." In *Russian Children's Literature and Culture*, edited by Marina Balina and Larissa Rudova, 129–52. New York: Routledge, 2008.

Pyr'ev, Ivan. *Izbrannye proizvedeniia v dvukh tomakh*. Vol. 1. Moscow: Iskusstvo, 1978.

Riley, John. *Dmitri Shostakovich: A Life in Film*. London: I. B.Tauris, 2005.

Robin, Régine. *Socialist Realism: An Impossible Aesthetic*. Stanford, CA: Stanford University Press, 1992.

Rokhlin, A. *Istoriia otechestvennogo televideniia*. Moscow: Aspekt Press, 2008.

Roth-Ey, Kristin. "Finding a Home for Television in the USSR, 1950–1970." *Slavic Review* 66, no. 2 (2007): 278–306.

Roth-Ey, Kristin. *Moscow Prime Time: How the Soviet Union Built the Media Empire That Lost the Cultural Cold War*. Ithaca, NY: Cornell University Press, 2011.

Sal'nikova, Ekaterina. "Evolutsiia vizual'nogo riada v sovetskom kino, ot 1930-kh k 1980-m." In *Vizual'naia antropologiia: Rezhimy vidimosti pri sotsializme*, edited by Elena Iarskaia-Smirnova and Pavel Romanov, 335–58. Moscow: Variant, TsSPGI, 2009.

Salys, Rimgaila. "Grigorii Aleksandrov's *Spring*: The Last Musical Hurrah." *Studies in Russian and Soviet Cinema* 12, no. 2 (2018): 114–35.

Salys, Rimgaila. *The Musical Comedy Films of Grigorii Aleksandrov: Laughing Matters*. Chicago: University of Chicago Press, 2013.

Salys, Rimgaila. *The Strange Afterlife of Stalinist Musical Films*. Washington, DC: National Council for Eurasian and East European Research, 2003.

"The Screen: Life on a Soviet Farm." *New York Times*, October 30, 1950.

Shaw, Tony, and Denise Youngblood. *Cinematic Cold War: The American and Soviet Struggle for Hearts and Minds.* Lawrence: University Press of Kansas, 2010.

Shcherbina, Vladimir. "Fil'm o velikoi pobede." *Pravda*, January 25, 1950: 3.

Shepilov, Dmitrii. "Vospominaniia." *Voprosy istorii* 5 (1998): 3–27.

Sherry, Samantha. *Discourses of Regulation and Resistance: Censoring Translation in the Stalin and Khrushchev Era Soviet Union.* Edinburgh: Edinburgh University Press, 2015.

Shlapentokh, Dmitry, and Vladimir Shlapentokh. *Soviet Cinematography, 1918–1991: Ideological Conflict and Social Reality.* New York: Aldine De Gruyter, 1993.

Smirnova, E. "Trud Sovetskogo cheloveka na ekrane." *Iskusstvo kino*, no. 2 (1950): 7–10.

Solov'ev, A. "Puti razvitiia novogo zhanra." *Iskusstvo kino*, no. 4 (1949): 17–20.

"Sovetskie fil'my-spektakli na zarubezhnykh ekranakh." *Sovetskoe iskusstvo*, May 16, 1953: 1.

Ssorin-Chaikov, Nikolai. "On Heterochrony: Birthday Gifts to Stalin, 1949." *Journal of the Royal Anthropological Institute* 12, no. 2 (2006): 355–75.

Staiger, Janet. *Interpreting Films: Studies in the Historical Reception of American Cinema.* Princeton, NJ: Princeton University Press, 1992.

Stalin, Joseph. "On the Death of Lenin." Marxist Internet Archive, January 30, 1924. https://www.marxists.org/reference/archive/stalin/works/1924/01/30.htm.

Stalin, Joseph. "A Year of Great Change: On the Occasion of the Twelfth Anniversary of the October Revolution." In *Works*, 12:124–41. Moscow: Foreign Languages Publishing House, 1954.

Stites, Richard. *Russian Popular Culture: Entertainment and Society since 1900.* Cambridge: Cambridge University Press, 1992.

Stites, Richard. "Soviet Russian Wartime Culture." In *The People's War: Responses to World War II in the Soviet Union*, edited by Robert Thurston and Bernd Bonwetsch, 171–84. Urbana: University of Illinois Press, 2000.

Stone, O. M. "The New Fundamental Principles of Soviet Family Law and Their Social Background." *International and Comparative Law Quarterly* 18, no. 2 (1969): 392–423.

Swayze, Harold. *Political Control of Literature in the USSR, 1946–1959.* Cambridge, MA: Harvard University Press, 1962.

Taylor, Richard. "'But Eastward, Look, the Land Is Brighter': Toward a Topography of Utopia in the Stalinist Musical." In *The Landscape of Stalinism: The Art and Ideology of Soviet Space*, edited by Evgeny Dobrenko, 201–15. Seattle: University of Washington Press, 2003.

Taylor, Richard. *Film Propaganda: Soviet Russia and Nazi Germany.* 2nd ed. London: I. B. Tauris, 1998.

Taylor, Richard. "Singing on the Steppes for Stalin: Ivan Pyr'ev and the Kolkhoz Musical in Soviet Cinema." *Slavic Review* 58, no. 1 (1999): 143–59.

Thaisy, Laurence. *La politique cinématographique de la France en Allemagne occupée, 1945–1949.* Villeneuve-d'Ascq: Presses universitaires du Septentrion, 2006.

Toropova, Anna. *Feeling Revolution: Cinema, Genre, and the Politics of Affect under Stalin.* Oxford: Oxford University Press, 2020.

Troshin, A. S. "Iz stenogrammy konferentsii po tsvetnomu kino." In *Istoriia otechestvennogo kino: Khrestomatiia*, edited by A. S. Troshin, 378–82. Moscow: Kanon+, 2012.

Tsentral'noe statisticheskoe upravlenie, Otdel perepisi. *Vsesoiuznaia perepis' naseleniia 1926 goda/Recensement de la population de l'U.R.S.S. 1926.* Vol. 6. Moscow: Izdanie TsSU Soiuza SSR, 1928.

Tumarkin, Nina. *The Living and the Dead: The Rise and Fall of the Cult of World War II in Russia*. New York: BasicBooks, 1994.

Turovskaia, Maiia. "I. A. Pyr'ev i ego muzykal'nye komedii: K probleme zhanra." *Kinovedcheskie zapiski* 1 (1988): 111–46.

Turovskaya, Maya. "The 1930s and 1940s: Cinema in Context." In *Stalinism and Soviet Cinema*, edited by Richard Taylor and Derek Spring, 34–53. New York: Routledge, 1993.

Turovskaya, Maya. "Soviet Films of the Cold War." In *Stalinism and Soviet Cinema*, edited by Derek Spring and Richard Taylor, 131–41. New York: Routledge, 1993.

Unattributed. "'The Motherland Is Calling Us!': What's behind Famous WWII Poster?" Agenda.ge, May 9, 2015. https://www.agenda.ge/en/news/2015/1016.

"Uspeshno vypolnit' zadachi, stoiashchie pered kinoiskusstvom!" *Iskusstvo kino*, no. 1 (1951): 1–4.

Vardac, A. Nicholas. *Stage to Screen: Theatrical Method from Garrick to Griffith*. Cambridge, MA: Harvard University Press, 1949.

Vasilevskii, A. "Prikaz Voennogo Ministra Soiuza SSR." *Stalinskii sokol*, July 16, 1950: 1.

Virilio, Paul. *War and Cinema: The Logistics of Perception*. London: Verso, 1989.

Vishnevskii, Vsevolod. "Sila kolkhoznaia. . . ." *Literaturnaia Gazeta*, March 4, 1950.

"V khudozhestvennom sovete Ministerstva kinematografii SSSR." *Sovetskoe iskusstvo*, August 20, 1952: 4.

Volin, Lazar. "The Turn of the Screw in Soviet Agriculture." *Foreign Affairs* 30, no. 2 (1952): 277–88.

Volkov, Solomon, and Antonina W. Bouis. *Shostakovich and Stalin: The Extraordinary Relationship between the Great Composer and the Brutal Dictator*. New York: Knopf, 2004.

Voronov, N. V. "Predystoriia stroitel'stva semi moskovskikh vysotok." Iz Istorii Moskovskikh Stalinskikh vystok, 2000. Accessed June 28, 2019. http://retrofonoteka.ru/skyscrapers/moscow_skyscrapers.htm.

Waschik, Klaus, Nina Baburina, and Konstantin Kharin. "Real'nost' utopii: Iskusstvo russkogo plakata." 2001. http://www.russianposter.ru.

Widdis, Emma. "'One Foot in the Air?' Landscape in the Soviet and Russian Road Movie." In *Cinema and Landscape*, edited by Graeme Harper and Jonathan Rayner, 73–88. Bristol: Intellect Books, 2010.

Widdis, Emma. *Visions of a New Land: Soviet Film from the Revolution to the Second World War*. New Haven, CT: Yale University Press, 2003.

Wilson, Joshua. "The Enigmas and Facts of a Social Experiment: A Reconsideration of Soviet Era Dramatic Texts 1920–1980." MA thesis, Idaho State University, 2003.

Woll, Josephine. *Real Images: Soviet Cinema and the Thaw*. London: I. B. Tauris, 2000.

Youngblood, Denise. *Russian War Films: On the Cinema Front, 1914–2005*. Lawrence: University Press of Kansas, 2007.

Zajicek, Benjamin. "Scientific Psychiatry in Stalin's Soviet Union: The Politics of Modern Medicine and the Struggle to Define 'Pavlovian' Psychiatry, 1939–1953." PhD dissertation, University of Chicago, 2009.

Zaks, Boris. "Censorship at the Editorial Desk." In *The Red Pencil: Artists, Scholars and Censors in the USSR*, edited by Marianna Tax Chodlin and Maurice Friedberg, 155–61. Winchester, MA: Unwin Hyman, 1989.

Zemlianukhin, Sergei, and Miroslava Segida, eds. *Domashniaia sinemateka: Otechestvennoe kino 1918–1996*. Moscow: Dubl'-D, 1996.

Zhdanov, A. A. "Doklad t. Zhdanova o zhurnalakh 'Zvezda' i 'Leningrad.'" *Pravda*, September 21, 1946: 3–4.

Zima, V. F. *Golod v SSSR 1946–1947 godov: Proiskhozhdenie i posledstviia*. Moscow: Rossisskaia akademiia nauk, 1996.

Zimovets, Sergei. "Son of the Regiment." In *Socialist Realism without Shores*, edited by Thomas Lahusen and Evgeny Dobrenko, translated by John Henriksen, 191–202. Durham, NC: Duke University Press, 1997.

Zubkova, Elena. *Russia after the War: Hopes, Illusions, and Disappointments, 1945–1957*. London: M. E. Sharpe, 1998.

Index

Page numbers in italics refer to figures.

Zhdanovshchina, 26, 98, 100
Zhivoi trup. See The Living Corpse
*Zhizn' v tsitadeli (Elu tsitadellis). See Life in the
 Citadel*
Zhukovskii, 3, 12

Zhukovskii, Nikolai, 2–3
Zigmund Kolosovskii, 85, 86–89
Zima, V. F., 204
Zubkova, Elena, 9, 191
Zvezda, 25

Milton Keynes UK
Ingram Content Group UK Ltd.
UKHW030621030824
446389UK00005B/72/J